Art by Edward Binkley

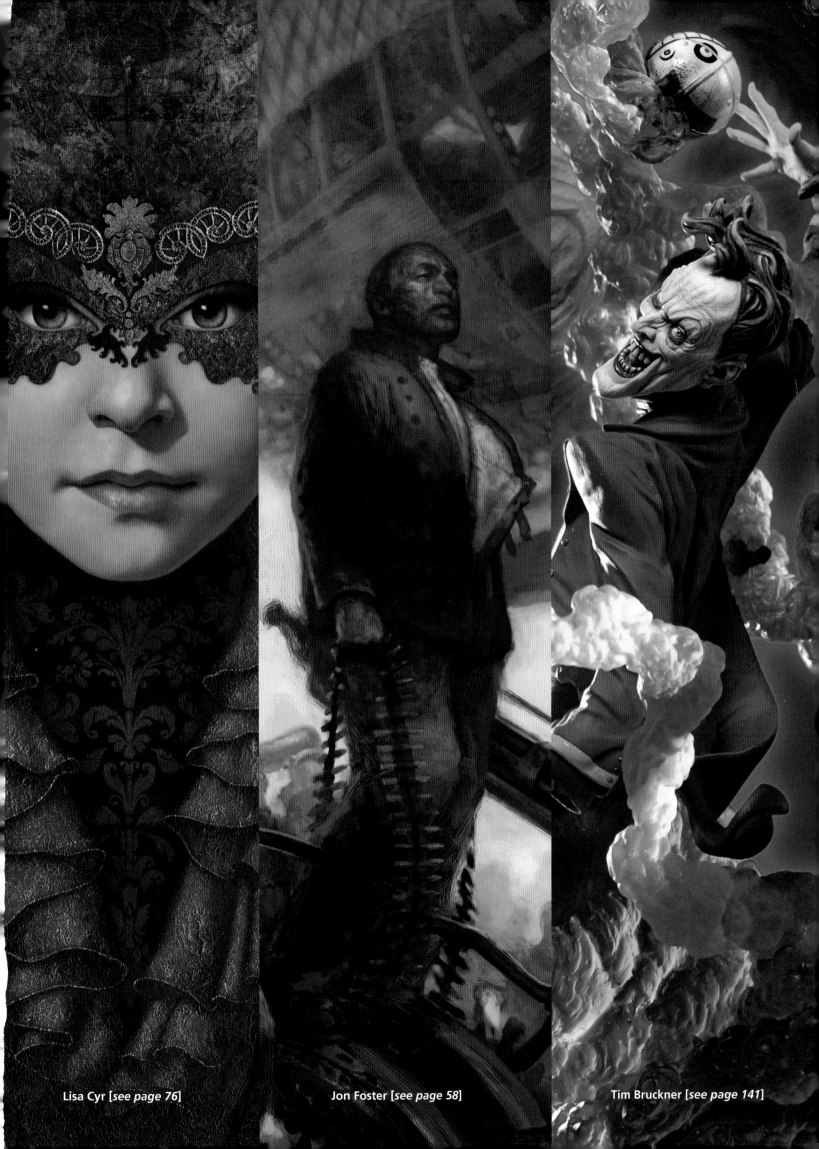

Lisa Cyr [*see page 76*]

Jon Foster [*see page 58*]

Tim Bruckner [*see page 141*]

SPECTRUM 18

THE BEST IN CONTEMPORARY FANTASTIC ART

Edited by

CATHY FENNER & ARNIE FENNER

UNDERWOOD BOOKS
Fairfax, CA

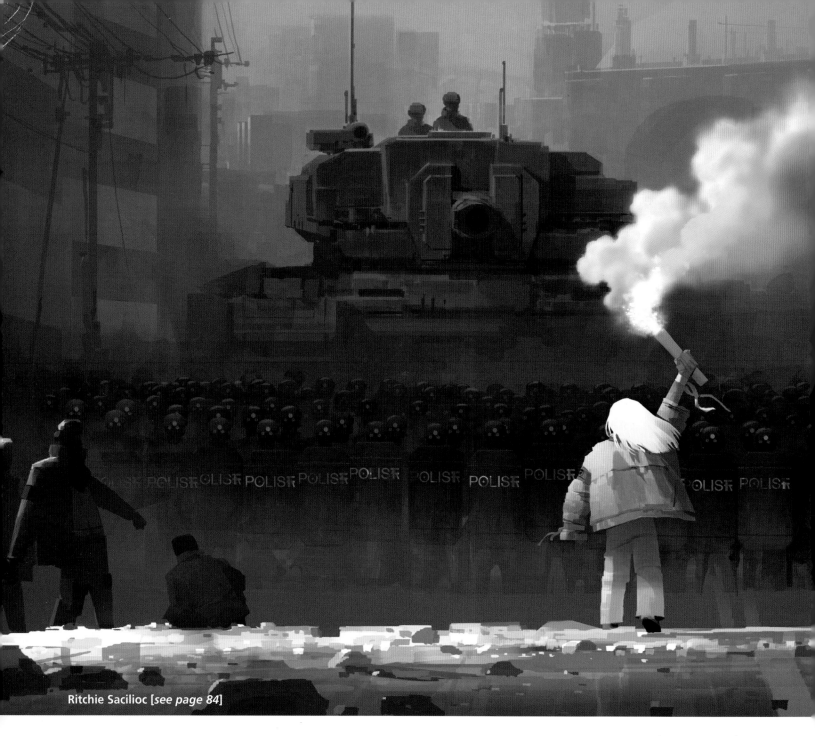

Ritchie Sacilioc [*see page 84*]

Trade Softcover Edition ISBN 1-59929-058-8 ISBN-13: 978-1599290584
Hardcover Edition ISBN 1-59929-059-6 ISBN-13: 978-1599290591

10 9 8 7 6 5 4 3 2 1

Artists, art directors, and publishers interested in receiving entry information for the next Spectrum competition should send their name and address to:
Spectrum Fantastic Art, LLC, P.O. Box 4422, Overland Park, KS 66204
Or visit the official website for information & printable PDF entry forms: **www.spectrumfantasticart.com**
Call For Entries posters (which contain complete rules, list of fees, and forms for participation) are mailed out in October each year.

PUBLISHED BY
UNDERWOOD BOOKS, P.O. Box 459, Fairfax, CA 94978 www.underwoodbooks.com **Tim Underwood**/*Publisher*

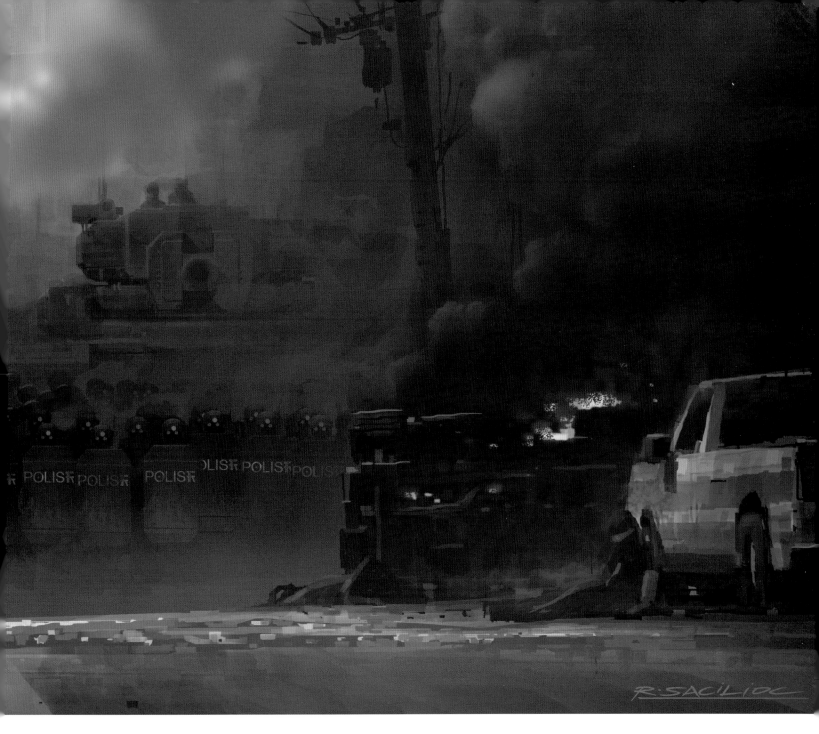

C o n t e n t s

2011

by Cathy Fenner

Cathy & Arnie Fenner at the Museum of American Illustration. Photo by Irene Gallo.

I used to have a boss named George Parker who would describe a career in art as being much like the ancient statue of the Colossus straddling the harbor at Rhodes: in his metaphor the artist had one foot planted in the world of Commerce while the other rested in the land of Creativity (or Fine Art). The point being, I suppose, that there are really no distinctions, no one way or the other, because an artist has to have the sensibilities of both the illustrator and the gallery painter in order to attain and maintain an audience and achieve success. While I would always look at my boss with a raised eyebrow as a matter of course whenever he made the statement (me and authority figures have never been close pals), I understood the point George was making. And in many ways, as it turns out, it describes the way we have always thought about *Spectrum* (not that I would ever have admitted it to George, even if he were still alive: he passed away several years ago).

Intentionally, this is a forum for *artists*, be they illustrators or painters or comics artists or toy designers or gallery sculptors. The idea of a distinction of class for artists, the designation of significance or irrelevance, is little more than an artificial marketing conceit concocted by a minority (and a relatively recent one at that) and definitely not a reflection of quality, skill, taste, or interest. Or of reality, for that matter. *Spectrum* has always been intended to be the melting pot, one in which it's the *art* that matters without having to contend with the air of pretension. Anyone who turns up their nose at the word "illustration" shows their ignorance; anyone who isn't thrilled by the art created outside of traditional genre venues is missing out; anyone that decries one medium in favor of another is little more than a pathetic boob.

Art is art, regardless of venue, regardless of sensibilities, regardless of intent, regardless of medium.

And *that* is what *Spectrum* has *always* been about: the art *and* the artists. For 18 years now and counting.

Which is also the reason that we've added even more to our hectic agenda by organizing Spectrum Fantastic Art Live! (yes, the exclam is intentional). A gathering of the tribes, so to speak, coming in 2012. A place where it's about *all* artists of the fantastic. Are we excited? You bet. Check out the last page of the book for more information.

Meanwhile, back to the volume you're holding: the *Spectrum* jury met on Friday, March 11 in Kansas City—a little bit later than normal, thanks to the hotel booking someone else in our space on our traditional weekend. Fortunately, everyone arrived on time and we hosted a Friday night get-to-know-each-other dinner at the revolving Skies restaurant at the top of the Hyatt Regency (just to give everyone a panoramic view of Kansas City). The jury was a mixture of people we know well and people we've known only by reputation: happily, it was yet another group of talented, delightful creators that got along like carrots and peas. Master Painter Gregory Manchess was the returning judge and acted as Jury Chairman: we couldn't have asked for a better (or more qualified) person to keep the proceedings moving along through a very long and wearying day. On Saturday morning the jury gathered for an early breakfast before plunging into piles of art at 8:30 AM sharp. We utilized the same extremely large ballroom that we'd used last year—which, as it turned out, hadn't been set up properly when we arrived that morning. The hotel Staff got to experience a loud and furious dressing down by Arnie before they pulled in a dozen workers to correct the problem. (Anyone who mistakes my husband's generally calm demeanor as a sign of weakness are always taken aback when the tiger rears up to eat them for lunch. I try to warn people once, then take a step back to watch from a safe distance.) We broke for lunch at noon and then were back at it until the awards discussions ended around 6:00 PM. The awards debates were spirited, yet moved along fairly quickly. You never know until the very last minute which piece will be given the Silver or Gold; the judges again elected to present two additional Silver Awards this year. A video announcement of the winners by the jury was posted on the *Spectrum* web site following the final votes. After a short break everyone met in the hotel lobby for a brisk walk to Pierpont's in Union Station for our traditional dinner in a private dining room to conclude the event.

We were ably assisted by a group of great friends who graciously gave up their Saturday to help keep the judging moving along in an efficient and organized manner. Our thanks to Arlo Burnett, Lazarus Potter, Tracy Crawford, Armen Davis, Allison Muller, Gillian Titus, Bunny Muchmore, and Angela Wheeler for making the job much easier. We'll need them again in 2012!

Corrections: Dang it. We *know* we make mistakes every year, but we hate it when we make ones that are so obviously wrong that they jump out and slap us upside the head as soon as we open the latest volume of *Spectrum*. In #17 we oh-so-stupidly credited the art of **Patrick J. Jones** (on page 70) as being by "*Peter* J. Jones." Yesh. Sorry, Patrick. We also said that the Illustration Master Class took place at UMass in Amherst (on page 8) when actually Rebecca's Guay's incredibly vibrant summer workshop takes place at *Amherst University*. Doh! Our proofreader needs a proofreader! •

Android Jones [see page 25]

Julie Bell

Both an illustrator and a wildlife painter, Julie's work appears on book and magazine covers, and in a bestselling series of calendars.

Nathan Fox

llustrator, comics artist, and muralist, Nathan's clients run the gamut from *Entertainment Weekly* to Dark Horse Comics to MTV and beyond.

Photograph by Irene Gallo

Gregory Manchess Jury Chairman

Greg has regularly produced art for *National Geographic*, created stamps for the U.S. Postal Service, illustrated children's books, painted a multitude of book covers, and lectured at colleges around the country.

Brandon Shiflett & Jarrod Shiflett

The renowned Shiflett Brothers seamlessly blend their sculpting skills to create memorable garage model kits and statues (in resin and bronze) for both the commercial and the gallery markets.

Boris Vallejo

Legendary painter Boris Vallejo is widely regarded as one of today's most important (and popular) creators of fantastic art.

Shena Wolf

As senior editor for Universal UClick, Shena nurtures new talent while working closely with many of the country's most popular syndicated cartoonists.

GRAND MASTER AWARD
Ralph McQuarrie

"I just did my best to depict what I thought the film should look like, I really liked the idea. I didn't think the film would ever get made. My impression was it was too expensive. There wouldn't be enough of an audience. It's just too complicated. But George knew a lot of things that I didn't know."

Ralph McQuarrie in a 1999 interview

Although he has taken relatively few assignments in the literary field, Ralph McQuarrie has been one of the most important artists in the science fiction genre by virtue of his role as the conceptual designer responsible for the look of the tremendously popular and extremely influential *Star Wars* film trilogy. His impact was further extended through his concept designs and visualizations for the original *Battlestar Galactica* (TV series), *E.T. The Extra-Terrestrial*, and *Cocoon*, for which he won an Academy Award for Visual Effects in 1985.

McQuarrie was born June 13, 1929 in Gary, Indiana and was influenced by his grandfather (a small publisher) and his mother to pursue a career in illustration. Ralph began taking formal art classes at the age of ten and his talent showed

immediately. He graduated from high school in 1948 and signed up for technical art courses. He is a contemporary of Syd Mead, another conceptual designer/futurist, with whom he attended school. Ralph started work in 1950 for the Boeing Company in Seattle, the youngest of a group of nearly fifty artists, illustrating the latest designs in air and spacecraft. In the 1960s his work was used in animated sequences by NASA and CBS News for the coverage of the Apollo lunar missions. In 1965, McQuarries moved to California to work as a freelance artist in film and television.

Around 1975 George Lucas needed to convince 20th Century Fox to finance his upcoming project. The film was titled *Adventures of Luke Starkiller, as taken from the Journal of the Whills, Saga I: The Star Wars.* (During production, Lucas changed Luke's name to Skywalker and altered the title to simply *The Star Wars* and finally *Star Wars.*) To sell them on the idea he commissioned McQuarrie to create several paintings (which included main characters—such as R2-D2 and C-3PO—and scenes featuring desert planets, stormtroopers, and a duel with lightsabers) to show the studio executives.

Grand Master Honorees

Frank Frazetta Don Ivan Punchatz Leo & Diane Dillon James E. Bama John Berkey Alan Lee Jean Giraud Kinuko Y. Craft Michael Wm Kaluta

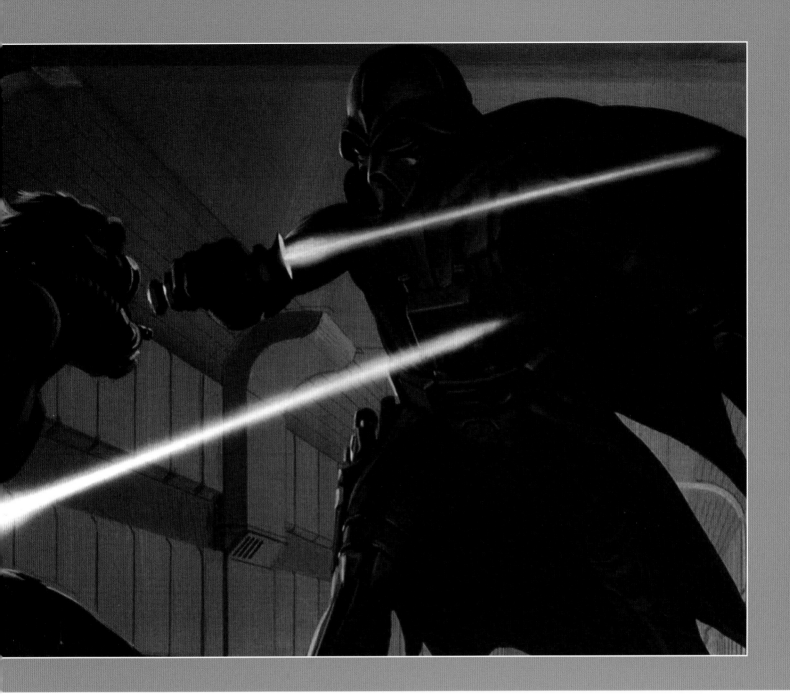

With just the script as reference, McQuarrie helped bring the vision of George Lucas to life and played a key role in creating the look of the film. Soon McQuarrie found himself creating additional concept art as well as helping with matte paintings during production and he became the design consultant and concept artist of record for the original *Star Wars* trilogy. One of Ralph's significant contributions to the saga is the design of the character Darth Vader, one of the most memorable and popular villains in cinematic history. For fun McQuarrie played the uncredited role of "General McQuarrie" in *Star Wars: Episode V—The Empire Strikes Back* (1980).

McQuarrie also has worked as a concept artist, illustrator, or visual consultant on such major films as *Close Encounters of the Third Kind* (1977), *Raiders of the Lost Ark* (1981), *E.T. The Extraterrestrial* (1982), *Cocoon* (1985), *Star Trek IV: The Voyage Home* (1986), **batteries not included* (1987), and *Total Recall* (1990); his television credits include work for *The Star Wars Holiday Special* (1978) and the previously mentioned *Battlestar Galactica* (1978).

In Addition to his film and television work, "RMQ" (as McQuarrie is known to sign original works) has created art for several *Star Wars*-related publications, including *The Illustrated Star Wars Universe*, as well as illustrations for Isaac Asimov's short story collections, *Robot Dreams* and *Robot Visions*. Raph also collaborated with Douglas Trumbull on the *Back to the Future* attraction as Universal Studios, creating the storyboards and concept art.

When George Lucas announced in 1995 that he was going to be making a series of *Star Wars* prequels, McQuarrie was invited to head up the design team, just as he had twenty years earlier. However, recognizing that the team of artists working at Lucasfilm Ltd. and Industrial Light and Magic were capable of working without him, he declined to participate (which disappointed many *Star Wars* fans). Now retired, Ralph lives in Berkely, California with his wife, Joan.

—*Jane Frank*

This profile is taken from *Science Fiction and Fantasy Artists of the Twentieth Century: A Biographical Dictionary* © 2009 Jane Frank and is used with the permission of McFarland & Company, Inc., Box 611, Jefferson NC 28640. **www.mcfarlandpub.com.**

Grand Master Honorees

Michael Whelan H.R. Giger Jeffrey Jones Syd Mead John Jude Palencar Richard V. Corben Al Williamson Ralph McQuarrie

Looking Forward, Looking Back

BY ARNIE FENNER

You used to ask a smart person a question. Now, who do you ask? It starts with **g-o**, and it's not God.
—**Steve Wozniak**, *co-founder of Apple Computer, criticizing the stranglehold technology has on our lives in an interview with CNN*

From the point of view of an author, if the future of the Internet is free, who is going to pay for the cheese sandwiches on which authors are known to subsist?
—**Margaret Atwood** *speaking at the Tools of Change Conference*

My job as an illustrator is to entertain, not to make things up out of my head. It's not a memory test.
—**Kyle Baker** *discussing artists using reference*

But then the Roman Empire fell like this: "*Oh, shit!*" And we went into what the historians called the Stupid Fucker Period.
—**Eddie Izzard**

Let's start by stating the obvious: everything changes.

Not that all change is good nor that everyone will be happy about the changes that take place. But, like it or not, things—culture, society, technology, the world—are changing and if there are any lessons to come out of 2010 they're probably all wrapped in some obtuse way around perspective or, perhaps more accurately, around variations on the themes of acceptance, adaptability, inevitability, and transition. (Bitching about things is *always* an option, but then we start to look like the cranks we grew up avoiding: "Things were better in *my* day when gas only cost $3 a gallon! And you kids get off my lawn!")

There's no denying, however, that in light of international economic woes, global tensions and conflicts, and natural and man-made disasters, an overall mood of pessimism colored the perceptions of many, leading to a malaise that, if left unchecked, becomes self-perpetuating. Years ago I had a friend whose often-repeated lament was, "Everything is shit and there's nothing we can do about it." I didn't agree then—which was in the 1980s—and I don't agree now. The challenge, naturally, is to convince everyone (ourselves included) that there *are* solutions, that we *can* make things better—and we can do so without disenfranchising the most vulnerable in society, without victimizing the weak, without widening the chasm between the haves and have-nots. The challenge is to remember that the needs of the many outweigh the needs of the few. (Okay, so Spock said it in *The Wrath of Khan*—he was undoubtedly channeling Aristotle's "The Aim of Man"— but that doesn't mean it's *not* a valid philosophy.) Anyway...

2010 was *not* the year that challenge was met (and it doesn't appear like 2011 is looking much better as I write this essay).

Unemployment in the U.S. remained somewhere in that stubborn 10%

Above: Frank Cho having far too much fun with model Jennifer Turkowski during a photo shoot for the cover of the *WP* [*Washington Post*] *Magazine*. Photograph by Andrew Cutraro. **www.washingtonpost.com** *Opposite:* Grand Master Frank Frazetta's cover for the 1973 edition of *Flashing Swords #1* edited by Lin Carter [Dell Books].

range; though there were improvements in job growth, most corporations were content to rely on overworked staffs (who were willing to work longer hours without raises or additional compensation because they were fearful of losing their jobs) and reap the profits for their investors rather than hire new employees. The housing market remained dismal and the number of bank foreclosures reached a record high. On the other hand, farm real estate prices shot up as investors kept an eye on the increased international demand for commodities. The national debt and an overall dissatisfaction with the government prompted voters to usher in a batch of new Mayors, Governors, Senators, and Congressmen in the hopes that problems would be speedily addressed; instead the results seemed to create more gridlock in Washington, more problems for the cities and states, and, sadly, more attempts to reverse hard-fought gains in civil rights.

An explosion on the Deepwater Horizon oil rig killed eleven crewman and caused nearly five million barrels of oil to gush into the Gulf of Mexico for 86 days until the well was successfully capped. The full environmental impact of the accident won't be evident for some years ahead, but the economic hit taken by Gulf Coast residents and businesses (along with the rig operator, British Petroleum) was obvious and immediate.

The war in Iraq continued to wind down (though military casualties from IED's climbed weekly) while the one in Afghanistan heated up with a surge of new troops. The embarrassing releases of classified documents obtained by WikiLeaks made things more difficult for the military and the government. Drone strikes and covert operations against Taliban and al-Qaeda members that have been operating without interference along the border with Pakistan caused anger and protests from the Pakistani

government while closer to home, an attempted terrorist attack with a bomb-laden SUV in New York's Times Square was thwarted, thanks both to alert citizens and to the ineptness of the bomber, Faisal Shahzad (who was arrested and pled guilty to all charges).

Tensions remained between North Korea and...everybody...and Iran experienced civil unrest (answered with government crack-downs) even as it continued to pursue its nuclear ambitions. Israel's commando raid on a flotilla of aid ships bound from Turkey trying to run a naval blockade of Gaza was roundly criticized by the U.N. Meanwhile the economic crisis in Greece, Portugal, Spain, and Ireland created protests in those countries as governments implemented austerity measures; the international financial dilemmas made the stockmarkets nervous as investors tried to figure out what was going to happen next.

The eruption of the volcano Eyjafjallajokull in Iceland disrupted air travel in Europe and the U.S. for six days (at an estimated cost of $1.2B), floods and tornados and mine disasters in the United States took their toll...and then there was Haiti, with a devastating earthquake that left 250,000 people dead, 300,000 injured, and a million homeless.

Damn. To put it mildly, 2010 had more than its share of troubles.

Just as it had it's share of good things to feel encouraged about, too.

Obviously, if you're employed—even if you hate your job, as a survey revealed more than 50% do—you were ahead of the game as official unemployment figures stayed over 9%. So working would make the list as Positive #1. Many companies began to give raises again after years of wage freezes, began to contribute to employee retirement funds, and hire new workers. Jot that down as Positive #2. A big fat Positive #3 was that (even if it is a mixed blessing for any number of reasons I'll mention a little further in) technology continued to advance: phones, TVs, and computers got cheaper and grew in interactivity. Networks got quicker (and Google announced it would launch its über ultra-high speed broadband network in the Kansas City area: in your *face*...uh...every place else) and apps for smart phones became a growth industry. And *do* I have to say how sweet a ride the iPad (and now, iPad 2) really is when compared to the other e-readers? I didn't think so.

I'm always fascinated that paleontologists keep discovering new species of dinosaurs (kids love the terrible lizards so I'm obviously a kid at heart). In '10 scientists from the University of Utah a pair of new sort of tricked out triceratops: Utahceratops and Kosmoceratops (which sported fifteen horns on its head). Paleoartists get cracking: I want pictures of these babies!

On the SF-turned-fact front, researchers created robotic "skin" that could literally "feel" objects as light as a butterfly. Beyond robots and artificial limbs, synthetic skin might be eventually be used for extremely responsive touch screens.

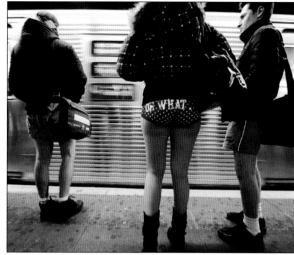

Above: A fantastic sight in NYC! New Yorkers celebrated the 10th Annual No Pants Day on January 9th. *Photo by Dunand/Getty.*

British astronomers identified the most massive star ever seen: a behemoth weighing 265 times as much as our sun, so huge that it challenges scientists' models of how stars are born. Science continues to catch up to science fiction: we'll be jumping to lightspeed in no time. Right?

Whether by design or accident it seems that 2010 was something of a cultural tipping point in many arenas. Just as various video rental chains drove out the move-and-pop stores, Redbox kiosks ate Blockbuster's and friends' proverbial lunch as they added one new location an hour and made twice as much back in revenue, pushing one chain after another into bankruptcy. Just as digital downloads devastated sales of music CDs, sales of DVDs and BluRay discs experienced similar nosedives as video streaming became easier to new LCD televisions via cable providers, Amazon, and, Netflix (whose CEO Reed Hastings said that his company is "now primarily a streaming company that also offers DVDs by mail"). Talk of Cloud off-site storage for personal digital information (private photos and info, music and film purchases) was all the rage, but we'll see where it goes. Obsolescence and upgrades are the bread and butter of computer and software makers (says the man staring at the $700 price tag for an upgrade to CS5): if you think that morphing data from one OS to another will be easy, cheap, and—of course!—*hacker-proof* in the future, allow me to show you this bridge I have for sale in Brooklyn. Barely used. Great price, too.

Oh, and when it comes to publishing...well, don't worry, I'll get there.

The biggest art heist of 2010 was the theft of Vincent Van Gogh's "Poppy Flowers" (a painting also known as "Vase with Flowers") from the Khalil Museum in Cairo, Egypt—for the second time in recent history. And then there was the lone robber who managed to grab five paintings (including pieces by Pablo Picasso and Henri Matisse said to have a value of just under 100million Euros) from the Musée d'Art Moderne de la Ville de Paris. Pop culture wasn't immune to sticky fingers either: comic artist Eric Basaldus reported than someone made off with two portfolios of his original art at the San Diego Comic-Con.

While the $106million realized for the sale of Picasso's "Nude, Green Leaves and Bust" set the year's record art sale price, the $1.5million paid by a private collector for "The Destroyer" (the reworked cover for *Conan the Buccaneer*) by the late Frank Frazetta set the all-time record for a contemporary book cover, genre or otherwise. The sale followed close on the heels of the previous record prices of $1million for the original *Conan the Conqueror* painting and $380,000 for the brush and ink cover for *Weird Science-Fantasy* #29.

And how could I *not* mention the big art-student-turned-superstar story of 2010: Lady Gaga (Stefani Joanne Angelina Germanotta) dominated the pop-culture music scene, not only with an ever changing wardrobe that made the pa-pa-paparacci giddy, but with songs that had nice hooks and driving beats. Which is great and all, but it was the way she embraced SF imagery in videos heavily inspired by H.R. Giger, *Metropolis*, and *Bladerunner* that really caught my attention. (Well, that *and* when she wears a see-through nun's habit and no pants.) You *know* you've attained immortality when Weird Al Yankovic does a parody of your hit song.

Fantastic-themed films once again owned the 2010 U.S. box office and included *Toy Story 3, Alice in Wonderland, Iron Man 2, The Twilight Saga: Eclipse* (I don't get it, but I'm not a teenage girl, either...at least the last time I looked), *Harry Potter and the Deathly Hallows Part 1* (incredibly affecting and, no, *goddamit*, I *wasn't* bothered when Dobby...when poor little Dobby...*no*, I wasn't, I tell you; there was something in my eye!), *Inception* (did the top stop spinning?), *Despicable Me, Shrek Forever* (please, God, no), *How to Train Your Dragon,* and *Tangled. The Last Airbender* was deservedly trounced by critics and audiences alike, but it was hard to figure out why the heavily-promoted and actually very-enjoyable *Scott Pilgrim vs. the World* crashed and burned. Go figure. Oh, and if you have the opportunity to see *Exit Through the Gift Shop*, a "prankumentary" masterminded by British street artist Banksy, you'll be amused or pissed or confused or entertained or some combination of all four.

ADVERTISING in its traditional form remained (with the exception of one area) flat last year, as the industry began to slowly recover

from the newspaper and magazine Armageddon of 2009. Of course, there has never been an outright shortage of ads in all medias, but everybody was obviously on a budget as they tried to figure out ways to reach consumers willing to spend their hard-earned cash without spending too much of their own. Digital delivery, with its entirely false perception of "free" continued to prove a complicated arena as the savvy were able to block or turn off ads at the sites they visited on-line (or, more and more, via their iPhones). The elusive customer has became everything from a critic to a content creator and have suddenly found themselves with the ability to control the "conversation" with the advertiser. Not that the customer is always right: remember the old maxim that a camel is a horse designed by committee. Still, we *are* in the 21st Century and change, as I said, has to be expected. If the past year is any indication, I think we'll probably see even more interactivity between the customers and providers; crowdsourcing will go even more mainstream (God help us); applications, utility, and platforms will sublimate messages in all manner of advertising; analytics will inform more and more decisions (even if the conclusions drawn are absolutely bogus); "quality" will be defined by speed and ready accessibility rather than sophistication and veneer; everything will have to be available via multiple social platforms, be they print, mobile, TV, or some goddamn thing still to be unveiled; creativity will be more important than ever (the power of consumers will demand that when they do plop on the couch, the ads they encounter will have to be both engaging and entertaining); and whoever hires the best developer—kid or geezer, it's the idea and ability to connect that counts—will win.

Back to the one area of growth: internet and mobile advertising surged to a record $26billion in '10, almost certainly hurting traditional media in the process. Remember the scene in *Minority Report* when the store ads recognized Tom Cruise when he passed by? We're closer than we thought. Tracking spending habits and locations via smartphones allowed companies to inform customers of special offers as they passed stores with wi-fi (Big Brother *is* watching), while seemingly abstract codes began to appear everywhere: when held up to a phone or laptop camera, vendor websites, offers, or coupons magically appear.

All of the foregoing, of course, assumes that consumers will continue to be intelligent, discerning, and sophisticated; they'll know when to disconnect from their devices and interact with, you know, *real* people and experience *real* places. In person. Face-to-face. Unfortunately ... *I'm* the one that needs to get "real." I mean, go to any restaurant on a Friday night and you'll undoubtedly see couples or families sitting

across from each other, not talking, but looking in their laps and texting (something brilliant and important and urgent, I'm sure) a message or playing *Farmville* or checking out what's on sale at Target or talking on the phone. Connectivity is fine, but not when it becomes the conduit to stupidity. But maybe that's just me.

Seen and noted ad-art last year included works by Chris Buzelli (*Mirage Cartography*, Radiation Records), John Cuneo (Southwestern Recorders), Michael Byers (Common Grackle), Jody Hewgill (*Every Tongue Confess*, Arena Stage), Simon Bisley (*Centurion*, Celador Films), and, naturally, by all of the worthies to be found in the Advertising Category ahead.

Next up is...ah...the **BOOK** industry. You may remember that 2009 was a real stinker: 2010, thankfully, was at least a *little* better. Sales ended 3.6% higher overall than '09, for a total of $11.67billion in revenues. E-books once again increased significantly on an annual basis, up 164.4% ($441.3million), representing 8.32% of the trade book market in '10 vs 3.20% the previous year.

The rapid growth of e-book sales was largely in the fiction category and the gains were at the expense of their print brethren; children's books

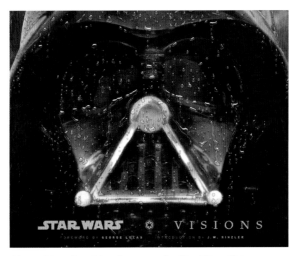

Above: Masey's outstanding cover for *Star Wars: Visions*.

made tentative moves toward digital delivery via the Nook and iPad, but the market remained modest. No major art books have made the leap to the e-format. Yet. It was encouraging to note that, when sales of e-books are subtracted from the mix, total sales of print titles for 2010 was slightly better than sales for 2009, indicating that there is still strong demand for physical books. (Which should make printers, binders, and artists feel a little better than they have for awhile.) There has always been the concern that the future of publishing was moving to a strictly digital world; fortunately the evidence would indicate that there's enough room for both.

But the storm cloud on 2010's horizon was, you guessed it, Borders.

Started with a single store in 1971, Borders helped to pioneer the book superstore concept along with its larger rival, Barnes & Noble.

But after hemorrhaging money for months and with $1.29billion in debt vs assets of $1.28billion, Borders filed for bankruptcy protection in February, 2011. Bad management, poor marketing, greater competition from discounters and online booksellers, as well as the growth in popularity of e-books, undoubtedly contributed to their troubles. After massive layoffs and closings, about 400 stores remained open, down from its peak in 2003 of 1,249 Borders and Waldenbooks. Observers remained pessimistic that they would ever be able to emerge from bankruptcy. And did it affect us? You bet. Borders' buyers continued to order books as if nothing was wrong, stocking their shelves with titles that, starting with October, 2010 shipments, they stopped paying for. Uh-huh: you've got it. Borders sold *thousands* of copies of *Spectrum 17*...and didn't pay for *one*. There's little consolation in the knowledge that we're not alone, that other artists and editors and writers got empty pay envelopes just as their publishers and distributors got stiffed for money owed—but there was a *lot* of rancor in watching Borders' executives hold out their hands to the court, expecting year-end bonuses while demanding that publishers start shipping books to them again as if nothing had happened. Doncha just love corporate thinking?

Favorite books of 2010? Why sure, I had a batch. Foregoing my attempts to come up with different adjectives to describe individual titles, let's just cut to the chase and say, if I mention it, I recommend it. With that out of the way, I heartily suggest you visit your bookstore and lay out some cash for *H.J. Ward* by David Saunders [The Illustrated Press], *Robert Fawcett: The Illustrator's Illustrator* by David Apatoff, edited by Manuel Auad [Auad Publications], *Harvey Dunn: Illustrator and Painter of the Pioneer West* by Walt Reed [Flesk Publications], *Color and Light: A Guide for the Realist Painter* by James Gurney [Andrews McMeel], *Animals Real and Imagined: Fantasy of What Is and What Might Be* by Terryl Whitlatch [Design Studio Press], *Battle Milk 2: Tangents and Transitions in Concept Art* by Jackson Sze, Kilian Plunkett, Thang Le, Wayne Lo, Le Tang, and David Le Merrer [Design Studio Press], *Syd Mead's Sentury II* by Syd Mead [why, yes, that's from Design Studio Press, too], *Drawings: Inspired By Life* by Dorian Vallejo [Open Palette Press], *Star Wars Art: Visions* [Abrams], *Eponymonstrous: Less Is More* by Ragnar [Ragnarama: Little Cartoons LLC] (okay, I'll make an exception to what I said at the outset and point out that this is one of the year's *best* books: I'm not kidding), *Cover Run: The DC Comics Art of Adam Hughes* by Adam Hughes [DC Comics] (sure, you got me; this is *another* of the year's best books, but since it sold like a mofo you probably already knew that), *The Art of Drew Struzan* by Drew Struzan and David

J. Schow [Titan Books] (alright, I'm not going to make a habit of this, but this is *yet another* of the year's best...oh, you know...and includes an eye-opening intro by director Frank Darabont), *Tony Harris: Art and Skulduggery* by Tony Harris [IDW], *Kris Kuksi: Divination and Delusion* by Kris Kuksi [BeinART], *Marion Peck: Animal Love Summer* by Marion Peck [Last Gasp], *Rolling Thunder: The Art of Dave Dorman* by Dave Dorman [IDW], *Middle-Earth: Visions of a Modern Myth* by Donato Giancola [Underwood Books], (alright: I swear I won't say anything else, but, *goddamn*, can Donato lay down the paint or what?), *James Bama Sketchbook: A Seventy Year Journey, Traveling from the Far East to the Old West* by James Bama [Flesk], *Aleksi Briclot: Worlds & Wonders* by Aleksi Briclot [CFSL Ink] (I know what I said, but...*c'mon*, some American Publisher: step up to the plate and do a U.S. edition of this *stunning* collection), *The Legend of Steel Bashaw* by Petar Meseldzija [Flesk], *OtherWorlds: How to Imagine, Paint and Create Epic Scenes of Fantasy* by Tom Kidd [Impact], *Illustrators 51* [Harper Design], *Exposé 8: The Finest Digital Art in the Known Universe* by Daniel P. Wade [Ballistic], *Art-Toys* by Brian McCarty and Douglas Rushkoff [Baby Tattoo], *Taking Beauty by Surprise* by Daniel Merriam [Monarch], *White Cloud Worlds* edited by Paul Tobin [Weta] (uhhh, I swear this is the *last* time I open my gob, but *run*, don't walk, to get a copy of this extraordinary collection by New Zealand's masters of fantasy art), *Frank Cho: Galerie 9E Art Exhibit Catalogue* by Frank Cho [Galerie 9E], *Rough Justice: The DC Comics Sketches of Alex Ross* by Alex Ross and Chip Kidd [Pantheon], the hilarious *Movies R Fun* by Josh Cooley [Josh Cooley], and, finally, a duo by Bill Stout: *William Stout: Inspirations,* and *William Stout: Hallucinations* [both from the always impeccable Flesk Publications].

As for outstanding book covers of 2010 (beyond what you'll find in the Books Category this year, naturally), my personal favorites included those by Jon Foster (*Museum of Thieves* by Lian Tanner [Delacorte]), Thomas Canty (*The Called* by Warren Rochelle [Golden Gryphon]), Peter Bollinger (*The Lost Fleet: Victorious* [Ace]), Kinuko Y. Craft (*Midsummer Night* by Freda Warrington [Tor]), Gordon Crabb (*Afterlife* by Merrie Destefano [Eos]), Dan Dos Santos (*Trolls in the Hamptons* by Celia Jerome [DAW]), Vance Kovacs (*Hawkmoon: The Jewel in the Skull* by Michael Moorcock [Tor]), Stephan Martiniere (*The Dervish House* by Ian McDonald [Pyr]), Anthony Palumbo (*Yarn* by Jon Armstrong [Night Shade]), and Sam Weber (*Five Odd Honors* by Jane Lindskold [Tor]).

Shifting smartly over to the world of **COMICS**, it was, let's say, an interesting year. Marvel and the Jack Kirby estate continued their legal maneuvering over copyright while DC and the Joe Siegel heirs continued theirs. Just as

overall traditional comics sales slipped 5.79% during the year, apps via midwife provider ComiXology (who handles both DC's and Marvel's digital titles) landed on Top 5 sales lists for both the iPhone and iPad. Then there was the media attention given the troubled (to put it politely) and obscenely expensive Broadway production of *Spider-Man: Turn Off the Night*; plagued by accidents, injuries, and disastrous reviews of preview performances made people wonder if Max Bialystock and Leo Bloom were back in business.

One of the funnier moments of the year was thanks to the decidedly unfunny folks behind the Westboro Baptist Church (yes, the ones who

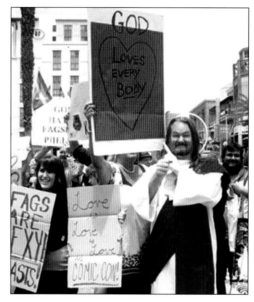

Above: Buddy Christ & Friends stood up to members of the Westboro Baptist Church during a counter-protest of the Phelps clan's appearance outside the San Diego Comic-Con. *Photo by Comic Alliance.*

give Topeka, KS a bad name, as if Topeka didn't have enough trouble). Infamous for its shameful "God hates fags" displays at the funerals of American soldiers, the Westboro group announced its intention to stage a similar protest at 2010's Comic-Con International in San Diego. Their reason was reportedly to condemn idolatry, the "worship" of mankind's own creations—i.e. Batman and Superman—rather than the Phelps gang's vision of a homo-phobic god. Comic-Con attendees were prepared for the Westboro minions in July, staging a counter-demonstration characterized by cosplay and homemade signs proclaiming "God Hates Kittens," "Kill All Humans," and "God Hates Fred Phelps." After a short while, the Westboro group seemingly gave up and wandered off, dragging their prejudice behind them (possibly to see if they could buy a ticket to the sold-out convention from a scalper).

The departure of Paul Levitz as President/ Publisher was the first step in the creation of DC Entertainment under Diane Nelson with the goal of expanding the multi-platform presence of the company's army of characters. Dan DiDio and Jim Lee became Co-Publishers, Geoff Johns was promoted to Chief Creative Officer,

Bob Harras assumed the Editor-in-Chief, and Mark Chiarello was promoted to Vice President: Art Direction & Design (they could not have made a better choice!). The downside were the announcements that DC would close its WildStorm, CMX, and Zuda imprints, shift its administration, multimedia and digital-content operations to Burbank, CA (while leaving the publishing division in New York City), and lay-off around 80 employees (including some good friends of ours).

At the top of my "favorites" list for 2010 was the hardcover compilation of DC's wonderful experiment, *Wednesday Comics* [DC]: it's nice to have such great work preserved in hardcover (way to go Mark Chiarello & Co.!). DC/Vertigo also boasted absolutely exceptional work by João Ruas, Tony Daniel, John Cassidy, Stanley "Artgerm" Lau, Esao Andrews, Bill Sienkiewicz, Brian Bolland, and Jock, among *many* others.

Of course, everybody that's been reading *Spectrum* through the years knows that I love Mike Mignola's *Hellboy* (and *Baltimore: The Plague Ships* and *B.P.R.D.*), so I was amply rewarded with art and stories by Mike, aided and abetted by Duncan Fegredo, Richard Corben, Ben Stenbeck, and Co. [all Dark Horse titles, naturally]. DH also did a solid job reviving *Creepy* and in their preservation of the original Warren comics with nicely printed archive editions. A special nod should also be given to Raymond Swanland's covers for the *Magnus* and *Predator* comics. And how could I not give props to Jim and Ruth Keegan's quietly authoritative and often affecting "Two-Gun Bob" Robert E. Howard biographical strip that runs in every issue of Conan the Barbarian? Truly outstanding (and under appreciated) work. Then there was (here's *that* description again) one of the *best* comics-related books of the year, *The Oddly Compelling Art of Denis Kitchen* by Charles Brownstein, Neil Gaiman and Denis Kitchen. Simultaneously funny and socially aware, this collection is a welcome celebration of one of the field's most important artists/publishers/advocates.

Marvel operated pretty much as they always have, despite the takeover by Disney (it probably helps that Disney/Pixar honcho John Lasseter is very creator-friendly). I was glad that the zombie stuff had apparently run its course and was happy to see nice work by Phil Noto, Gerald Parel, Leinil Francis Yu, Simone Bianchi, Terry Dodson, and Frank Cho.

As for everyone else, well, it's increasingly gotten to be rather hit-and-miss. Chain bookstores have repeatedly proven that they simply don't understand the comics market, shelving everything spine-out assuming you'll find what you're looking for. The flip side of the coin are the comics shops (at least the ones I frequent) who only order what's on their regular customer's "pull" lists and rarely stock titles that don't feature Spider-Man, Batman, or

the X-Men. I stumble across stuff by accident, great books by great talents like Joy Ang and Luis Royo and Ash Wood and Ben Templesmith and on and on—and I know others would enjoy them as much as I do, but... Retailers don't stock them, and the ones who *do* often don't know how to sell them. Not that I'm blaming the stores: ordering books that don't sell can be disastrous and any shop owner that takes a risk deserves a round of applause. What we need to do is join together to promote each other: no one's going to take care of our market so we have to do it ourselves, especially if we want diversity, if we want the interest to grow. And that starts with an order—and then showing what we order to friends (and strangers) in the shops. Order a copy of *Dead Moon*. Order a copy of *The Last Unicorn*. Order a copy of *The Last Phantom*—and *share* them. The key is to create new readers, new fans, for everything the field has to offer. If we care and want it to survive, *we* have to be the ambassadors.

Now that *that's* off my chest, let's briefly talk about **DIMENSIONAL**.

I admit it: if I had deep pockets and an enormous house (I have neither, unfortunately: as I've mentioned , some guy keeps winning my Lottery money over and over again), I'd fill it with works by Tom Kuebler (I'd have him do a new "Cletus & Shorty" to scare off the members of our Home Owners Association) and Mark Newman and Andrew Sinclair and Lawrence Northey and any number of other wonderfully gifted sculptors. As it is, well, I just have to sit back and wish.

The glum economy naturally had it's effect on the 3D field: mass-market releases became more infrequent, had fewer outlets for releases, and experienced lower sales figures—which in turn had an effect on the creative community. Another wrinkle was the growing popularity of the ZBrush program from Pixologic which allowed computer artists to "sculpt" digitally and deliver the data to vendors who would in turn produce CG molds for casting with nary a whiff of sculpey or clay in the air. Good gravy! But guess what? Sculptors need to eat as frequently as everyone else and I have a feeling that we're going to see more one-offs, commissions, limited edition gallery castings, and on-demand garage kits from the most talented 3D artists in the future.

For my taste, DC Direct produced some of the most outstanding direct-market pieces last year, led by their Jack Mathews-sculpted and Adam Hughes-designed *Cover Girls of the DC Universe* additions, including Poison Ivy and Harley Quinn. Tim Bruckner repeatedly showed he was at the top of his game with Wonder Woman, Superman, and Joker sculpts while Dave Cortes turned in a rock-solid Batman.

Dark Horse released Kent Melton's stunning interpretation of Dave Stevens' "Girl of Our Dreams" (Bettie Page, naturally) while Dynamite offered Joy and Tom Snyder's excellent sculpt of Frank Cho's "Red Sonja." At Comic-Con I made a bee-line to the Shiflett Brothers' booth to buy my copy of "Chloe Aviator for Hire" and who did I run into? Weta's Richard Taylor, who also had a "Chloe" tucked securely under his arm. (No, despite my chatting him up, Mr. Taylor did *not* offer me a complimentary *Dr. Grordbot's Goloathon 83 Infinity Beam Projector*...and I was so polite, too.)

There were a number of garage model kits (such as Tony Cipriano's "The Thing" from

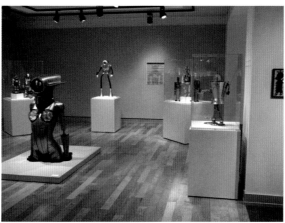

Above: The Mulvane Art Museum in Topeka, KS, hosted "The Art of the Robot" exhibition. *Spectrum* alumni Mike Rivamonte, Jon Foster, and Lawrence Northey were among the participants.

Forbidden Zone), collectible figures, and gallery works (props to Mike Rivamonte and Vincent Villiafranca), but, as with alternative comics and small press books, fewer places to easily find these remarkable artworks. Visit their websites and, if you can, become patrons; support Sideshow, support Weta, support the Fantasy Figure Gallery/Yamato USA (and their stunning Royo statues), Studio Oxmox (do I want their life-size T-Rex head? oh yes I most certainly do!), support the independent studios. *Everyone* will be glad if you do.

Hmmmm. **EDITORIAL**. Remember what I said last year: print is *not* dead. And, see? I was right. The newspaper industry seemed to stabilize (even if their advertising revenues remained in the doldrums) and "only" 176 magazines in the U.S. closed their doors in 2010 as opposed to 596 in 2009. New launches dropped, too: there were 193 last year while there were 324 in '09. Online-only titles also shrunk, with 28 publications going digital in '10 as opposed to 81 the year before. Though magazines and newspapers became more and more available via the iPad and the Nook, subscriptions remained negligible when compared to print. As I've said, what makes traditional newspapers and magazines attractive is that they're immediately accessible, relatively inexpensive, and can be read at your convenience without batteries.

One of the things I *do* worry about these days

is the current model of far too many magazines that get their visual content—i.e. the art that people buy the publications for—without compensating the artists themselves. The writers get paid, so should the artists, even if it's just an honorarium. Fair is fair. There is little promotional value in giving the art away indiscriminately—whether to a print magazine or to the internet—and in many ways it undermines the overall value of the art itself. It really is a simple matter of smart business: the common, free, and familiar aren't as exciting as the exclusive or rare.

Like the newspapers the short-fiction magazines stabilized a bit in 2010. *Realms of Fantasy, The Magazine of Fantasy & Science Fiction*, *Weird Tales*, *Asimov's SF,* and *Analog* continued to perk along as the genre's main fiction titles and featured art by Michael Whelan, Paul Youll, Bob Eggleton, Bryn Barnard, Dominic Harman, and Vincent Di Fate among others. My favorite artist-centric publications once again included Dan Zimmer's outstanding *Illustration, ImagineFX* (which included a workshop CD with each issue), *Juxtapoz, Communication Arts, Print, How, Art Scene International, Hi-Fructose, Amazing Figure Modeler, Giant Robot,* and *Blue Canvas.*

Fantastic art could naturally be found in other F&SF-leaning and non-genre magazines such as *Famous Monsters of Filmland* (risen from the grave once again), *Prehistoric Times*, and *Cinefex* on one side and *Entertainment Weekly, Discover, Time, National Geographic* (Wahoo! New paintings by Jon Foster and Greg Manchess!), *Cricket, Playboy,* and *Rolling Stone* on the other. For news, interviews, and reviews I found *Locus, Sci Fi, Empire,* and (increasingly) *SciFiNow* indispensable.

Then we come to the **INSTITUTIONAL** category (I'm not ignoring the **Concept Art** or **Unpublished** categories, I'm just hard-pressed to make a better suggestion than to visit those sections of the book: that's how *I* know anything at all about what's been going on). Art that was created for greeting cards, prints, package design, promotions, gallery shows, and an infinite number of other uses is what we mean my "institutional" (it sounds much classier than "Misc."). A few of the art calendars I saw and liked in '10 included those by William Stout, Daniel Merriam, Luis Royo, Ciruelo, Boris Vallejo & Julie Bell, and Michael Parkes. Wizards of the Coast remained as the most active source for fantastic art intended for the role-playing card game community, while artists for Bungie, Blizzard, Rockstar, and ArenaNet continued to create jaw-dropping graphics for the computer game market. Bob Chapman's Graphitti Designs T-shirts were regularly worn by the cast of the hit CBS TV show, *The Big Bang Theory* (just as prints by Eric Joyner could be seen hanging in the background every episode along with

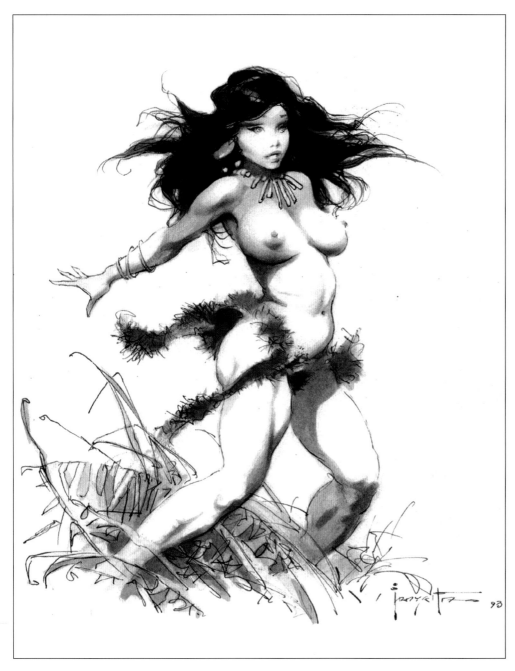

Fantastical Art of James Gurney." I'm talking about the intimate collector confab, IlluxCon, in Altoona, PA (their third enthusiastic gathering took place in the Fall of 2010). I'm talking about the fact that we've announced our own live artist-focused-and-intensive event for 2012 (be there or be square). Periodically I've gotten into debates with people who believe, with the changes in publishing and with the proliferation of digital work (because there aren't as many painted originals for people to buy), that fantastic art is in a state of decline. "Everything is shit and there's nothing we can do about it." My response is quite simply: *Bullshit*.

Despite changes, despite the economy, despite any perceptions to the contrary...

This is *our* time.

FRANK FRAZETTA [1928-2010]

The news of Frank Frazetta's death May 10th, 2010 was not unexpected; his health had not been good for more than a decade but, as friends and collaborators on his books and various projects, it still hit us hard.

Coming less than a year after his wife Ellie's passing and following six months of a family dispute painfully played out in the newspapers and on-line, I think everyone worried about the toll it was all taking on him. And yet somehow there was always the unspoken expectation that if anyone could beat the odds it was Frank. He was bigger than life, right? Our Art Hero. Fritz was the swaggering, self-confident, badass ladies' man with a paint brush in one hand and the throat of a scrawny critic in the other. He was a force of nature: he'd *always* be here.

As we were growing up with his art, we wanted him to be that something more; we *needed* him to be. We needed an iconic "Frank Frazetta" that could serve as a symbol of success and public acceptance. Frank was the outsider made good, the boy from Brooklyn courted by Clint Eastwood, Bo Derek, and Sylvester Stallone. A man's man as cool as his drawings, paintings, and comics, someone to look up to and aspire to be like (even if, truth be told, we knew very little about him personally). The Frazetta with movie-star good looks and athletic prowess who didn't take crap from anyone. If we couldn't *be* him then we somehow wanted to have our own interests in fantasy and science fiction and comics validated *through* his popularity.

Of course...Frank wasn't exactly all that we hoped and imagined him to be. There was more to the story than that. There always is.

Despite the numerous myths surrounding Frazetta (some perpetuated by zealous fans, some that were casually fostered by Frank and Ellie as marketing conceits), Frank was not a god. Everything did not come easily. Everything wasn't a success. He wasn't always "nice," he wasn't terribly moral, and the stories of "swinging" and philandering were widely

Above: An ink wash drawing that Frank Frazetta created in 1993. *At right:* A 1950s-era photo of Frank, courtesy of Dr. David Winiewicz. Time will ultimately tell how history will perceive Frazetta and what his legacy might be. As I've noted in various places, the Frazetta story is far more complex (and, in parts, unhappy) than most people realize and it will take an objective biographer to sift through all of the myths and nonsense to finally tell it truthfully. Will it ever be done? You've got me. In the meantime, all of the art still in the family's hands remains in storage while they hammer out their legal differences.

collectibles from DC Direct).

The mainstream is increasingly tumbling to the fact that people love fantastic art and that became even more apparent in 2010. I'm not just talking about the incredible success of the Comic-Con International in San Diego (and the media attention it gets); rather, I'm talking about the growing popularity of Baby Tattooville (the fourth sell-out collector event took place last October). I'm talking about record-setting prices set at Heritage Auctions in Dallas and Tajan in Paris for comics and fantasy art. I'm talking about wildly popular gallery shows—such as

"Zombies In Love" at Gallery Nucleus (and I envy whomever purchased Jeremy Enecio's painting, "Skin Deep"), Donato Giancola's "Water: A Parallel Universe" at the Richard J. Demato Gallery, "Dr. Grordbort's Exceptional Exhibition" in Hong Kong, and "Genesis" featuring the works of James Gurney, William Joyce, Adam Rex, Shaun Tan, and David Wiesner at the University of Wisconsin-Eau Claire. I'm talking about more educational opportunities like the Illustration Academy and the Illustration Master Class. I'm talking about the extravaganza at Florida's Norton Museum, "Dinotopia: The

known "secrets" among his friends. In a candid moment, Ellie once bluntly described Frank as "a terrible husband, a mediocre father—*but* an outstanding grandfather." Not everything he said (or that *Ellie* said, honestly) was Gospel and anyone who believed otherwise obviously didn't know Frank at all. His ego often got the best of him and he continued to believe, almost right up to the end, he was still in competition with other artists—and that he was "winning."

And yet he struggled. He had self-doubts. He had more than his share of disappointments in his life and every decision he made wasn't the right one. By his own admission he was lazy and played more than he painted: compare his body of work with that of his contemporaries and his admission would seem to be true. Frazetta's virtues were contrasted by his vices, his generosity sometimes blunted by his callousness. He masked his sensitivity with macho bravado and posturing, but that did little to alleviate his hurt feelings. For Frank, resentments lasted long and cut deep.

Frazetta became increasingly frustrated by people wanting not only more new paintings by him, but paintings on par with the work he had produced when he was thirty years younger and not partially paralyzed on his right side. He'd gesture at the paintings hanging on the Frazetta Museum's walls and ask, "Isn't that enough? What more do they want?" He didn't understand that he and Ellie had nurtured that Superman persona over the years and for his fans there could *never* be enough.

Nevertheless, Frank lived his life largely without remorse or regret—at least until the thyroid disease, then the strokes, took their toll. If he and Ellie increasingly seemed more like The Battling Bickersons than Romeo and Juliet to visitors to their home, well, that was the type of people they were; their personalities sometimes came to a boil and spilled over on the unwary. Each had talked about divorce multiple times, but after a cooling off period, they always wound up staying together. Despite everything, they (like the rest of us) couldn't honestly think of one without the other.

Frank Frazetta was human.

Acknowledging that, accepting his weaknesses and, yes, his failings, is what makes everything he accomplished all the more noteworthy, all the more remarkable. If the art had really been created with the ease that Frank always tried to convince fans it had been, it would have neither the power nor the resonance that it does. The struggle, the passion, the drama in Frazetta's art is a reflection of his life, of who he was. It's not all "made up" as he was wont to contend: there's a lot of truth in the paint.

Through his art Frank affected lives. His paintings of Conan and John Carter, of Tarzan and Kane, made thousands of us—tens of thousands of us—want to create, too. Whether

as artists or writers or filmmakers or publishers, Frazetta was an inspiration. Inadvertently, he showed us the way.

Almost single-handedly he changed the way publishers treated artists by insisting on the return of his originals. Almost single-handedly (I say "almost" because Ellie did much of the heavy lifting) he created opportunities for *other* artists by establishing a market for posters and portfolios and books that featured contemporary fantastic art. Almost single-handedly he changed readers' perceptions of what fantasy art could and possibly *should* be.

There are no absolutes in art and there are many wonderful painters in the world, equally important, skilled, and unique.

Frank Frazetta *is* wonderful, *is* important, *is* unique. He was presented with the first Spectrum Grand Master Award with good reason: there can be only one Frazetta.

And there will never be another like him.

Rest in peace, Frank.

AL WILLIAMSON
[1931-2010]

Comic art fans of my generation almost always lumped our favorites into tidy groups; one of my favorite "bunches" consisted of Frazetta/Williamson/Wood/Krenkel. Some might want to figure Jack Kirby and Steve Ditko into *their* mix; others would factor in John Romita and Will Eisner. But for me, and for many of my youthful friends, Frank, Al, Wally, and Roy were "our guys." Much of it had to do with the fact that they were, in Krenkel's parlance, *picture makers*; they were the artists who pushed beyond conventions, whose works transcended the scripts they were given to interpret or the books they were assigned to illustrate. They were the artists that often did things for the pure joy, the thrill, of *drawing*—even crusty, cranky, perpetually bitter Wallace Wood would put aside his cynicism every so often to produce works above and beyond the call, not for the money, but for *himself* and to impress his friends.

Al Williamson, perhaps more than any of them, always stood out. It wasn't because he became a professional artist as a teenager (so had Frazetta and Wood) or that he was more free-spirited (which, comparatively, he *was*) or that he was necessarily more talented (though he had talent to spare for sure); my guess is that

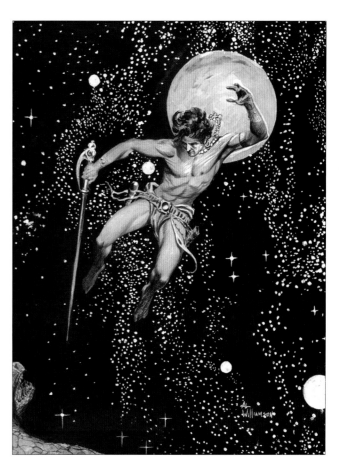

Above: A drawing by Al Williamson from the late 1950s featuring John Carter of Mars. *At right:* Al Williamson with newspaper comic strips from his collection (Hal Foster's legendary "Prince Valiant on the bridge" page is hanging on the wall behind him). Lovingly characterized in the fan press as a bohemian hippie-before-his-time, Williamson was actually a consummate professional who was universally respected by his clients.

what set Al Williamson apart from his friends was his down-to-earth sensibility. Throughout his life he maintained a realistic perspective of who he was as a person *and* as an artist. He went through his entire career without rancor or enemies and without egotistical outbursts: Al Williamson was the Class Act of the comics world. A professional who was confident in his own abilities, but who never expected special treatment or felt a sense of entitlement; the "good guy" who would help other artists that were down on their luck and who would take genuine delight in the successes of others.

And as an artist...he was second to none.

His clean, sophisticated, illustrative, ultimately realistic style made his science fiction—most notably seen in an adaptation of Ray Bradbury's "A Sound of Thunder" for *Weird Science-Fantasy* #25—adventure, war, western, and horror stories both exciting and unforgettable. It wasn't just Al's self-professed obsession with *Flash Gordon* that justifies people permanently linking him to the character; rather it's the fact that, after Alex Raymond, no other artist has ever had the same affinity for the character or so successfully captured the spirit of the original

stories as did Al. It's little wonder that George Lucas selected Williamson to draw the *Star Wars* newspaper strip; nor is it a surprise that Al was tapped to do comic adaptations of the Dino De Laurentiis' film version of *Flash Gordon* and Ridley Scott's *Blade Runner*. His ability to make the fantastic believable without sacrificing the humanity of his heroes and villains was always one of his strengths.

Above: John Schoenherr. *At right:* Schoenherr's cover painting for the 1965 paperback edition of *Dune* by Frank Herbert. Part illustrator, part naturalist, part gallery artist, John Schoenherr brought a sophisticated sensibility to the SF field. His many covers for Astounding/Analog are still powerful and relevant. He once said, "I gradually learned that my most satisfactory work was based on intuitive discovery, usually while painting and usually at the last minute."

Al's *other* admirable strength was his character. His sense of decency, compassion, and fair play were legendary; his friendships spanned generational divides. I think he was one of the few people his fellow Fleagle Gang member (and early collaborator) Frazetta was intimidated by—not that Al tried to make Frank feel that way and not that Fritz was exactly jealous of Williamson's success (Frazetta always made significantly more money). Rather it was because Al *knew* Frank better, perhaps, than anyone, treated him as an equal, and yanked him back to reality with jokes and teasing when Frazetta's ego got a little too inflated. Frank in turn envied Williamson's openness, his lack of pretense, and his innate honesty. Fritz admired Al (even if it was hard for him to admit) and in many ways looked up to his younger friend.

Which is understandable. When you think about it for a moment, *who wouldn't?*

If we looked to Frazetta as a symbol of public acceptance and success, we could do worse than look to Williamson as a symbol of success with *dignity*.

Al slowly disappeared in his last years as the Alzheimer's Disease robbed him of his memories, yet he was able to hold onto his charm and wit until nearly the end. He left us with a body of work that is affecting and with an attitude and an outlook toward life that is influential and far-reaching. You see Al Williamson—subtlety, gently, as it should be—in the works of Mark Schultz and Frank Cho and, yes, George Lucas,

and many, many others. And...isn't that what life after death is supposed to be all about?

JOHN SCHOENHERR [1935-2010]

Born in New York City in 1935, John Schoenherr began drawing at age 4 to communicate with his friends, few of whom spoke English in his neighborhood of Chinese and Italian emigrants. After high school, he attended the Pratt Institute

in Brooklyn where he studied under Richard Bové and Stanley Meltzoff. During the summers he returned to the Art Students League to study with Frank Reilly. He enjoyed painting wildlife for assignments at Pratt, but was initially "assured that my good drawing eliminated that possibility" as a career. (The joke at the time was that an ability to draw overqualified someone to be a Fine Artist.) After graduating from Pratt, Schoenherr began work in the field of SF illustration and quickly became a star with his covers for *Astounding Science Fiction* (which became *Analog* in 1960). The next decade saw a steady stream of Schoenherr covers and interior illustrations for the magazine.

In 1961 he started painting paperback covers for science fiction, horror, and fantasy, primarily for Pyramid and Ace. Some of the works he illustrated include *Bright New Universe* by Jack Williamson, *We Can Build You* by Philip K. Dick, and *Children of Tomorrow* by A. E. Van Vogt, but it was his series of paintings for Frank Herbert's *Dune* that became sophisticated icons for the field. John received the Hugo Award in 1965 and continued to paint hundreds of covers for the genre until the 1970s. Schoenherr also began illustrating children's books (and received the Caldecott Medal for his art for Jane Yolen's *Owl Moon* in 1987) and as well moved into the gallery market as a renowned wildlife painter.

Though he eventually left illustration entirely to paint for galleries, Schoenherr's work continued to reverberate with SF readers and

many of his paintings are widely considered as classics. Certainly John Schoenherr was one of the most important illustrators in the history of science fiction; for decades his depiction of alien landscapes were unparalleled. With a background in nature illustration, he could make even the strangest creatures seem not only plausible, but *real*. In trying to explain why people responded so positively to his art he once said, "By putting a lot of myself into a painting, something inside the frame comes to exist by itself—almost like another person."

REQUIEM

In 2010 we also sadly noted the passing of these valued members of our community:
Alex Anderson [b. 1920] animator
Hans Arnold [b. 1925] artist
Edward Ashley [b. 1922] cartoonist
Phillippe Bertrand [b. 1949] comic artist
Barry Blair [b. 1953] comic artist
John Callahan [b. 1951] cartoonist
Art Clokey [b. 1921] animator
Paul Conrad [b.1924] cartoonist
Leo Cullum [b. 1942] cartoonist
John D'Agotino [b. 1929] comic artist
Victor de la Fuente [b. 1929] comic artist
Weyni Deysel [b. 1951] cartoonist
Bill Dubay [b. 1948] comic artist
Mike Esposito [b. 1927] inker
Fernando Fernandez [b. 1940] comic artist
Oscar Forsgren [b. 1986] artist
Frank Frazetta [b. 1928] artist
Arnold Friberg [b. 1913] artist
Les Gibbard [b. 1945] cartoonist
Dick Giordano [b. 1932] comic artist
Jerry Grandenetti [b. 1927] comic artist
Stuart Hample [b. 1926] artist
John Hicklenton [b. 1967] comic artist
Frank Interlandi [b. 1924] comic artist
William Jaaska [b. 1961] comic artist
John D. Jeffries, SR [b. 1935] art director
José Maria Jorges [19??] artist
John Kane [b. 1935] cartoonist
Satoshi Kon [b. 1963] animator
Rik Levins [b. 1950] comic artist
Robert T. McCall 9b. 1919] artist
Joseph Hugh Messerli [b. 1930] cartoonist
Shintaro Miyawki [b. 1943] manga artist
Virgilio Muzzi [b. 1923] comic artist
R.P. Overmyer [19??] cartoonist
Howard Post [b. 1926] comic artist
Jonny Rench [b. 1982] colorist
Bill Ritchie [b. 1931] cartoonist
Chiyoko Satö [b. 1952] manga artist
Henry Scarpelli [b. 1931] comic artist
John Schoenherr [b. 1935] artist
Ian Scott [b. 1914] cartoonist
Van Snowden [b. 1939] puppeteer
Keiko Tobe [1957] manga artist
Kerala Varma [b. 1924] cartoonist
Brian Williams [b. 1956] artist
Al Williamson [b. 1931] comic artist †

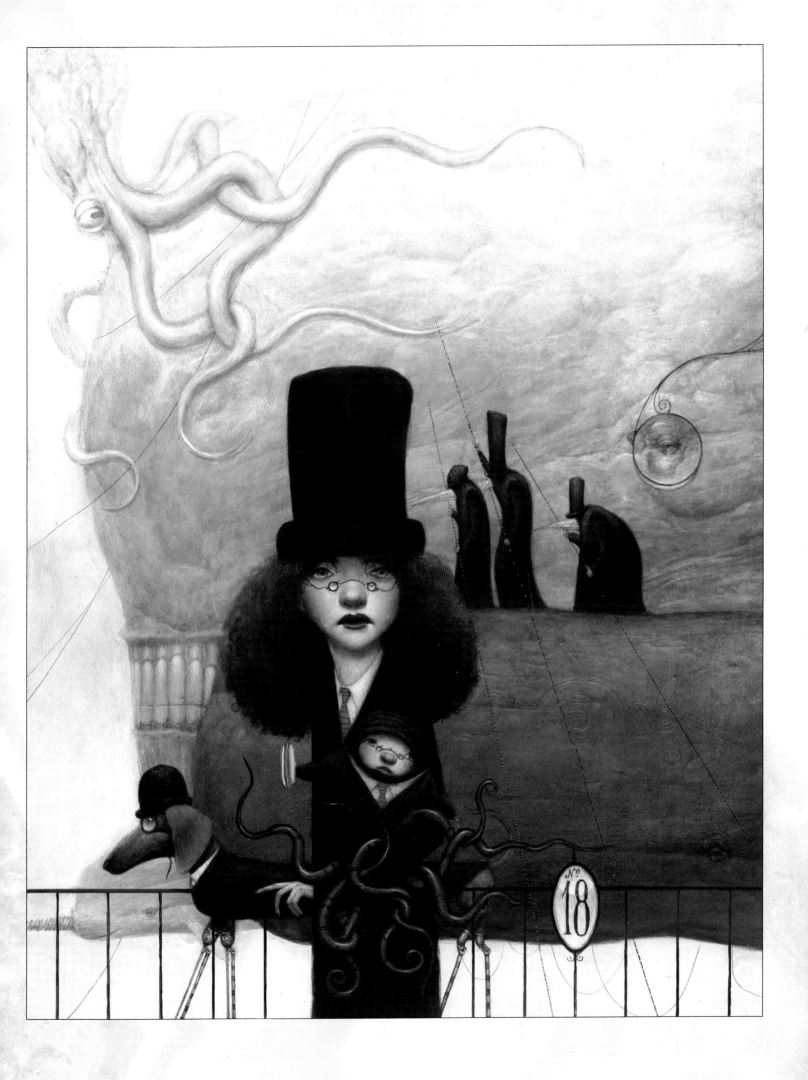

#18: Call For Entries Poster by Bill Carman

Medium: Oil on board

detail

Ryohei Hase

Art Director: Cody Tilson *Client:* Playboy Enterprises, Inc. *Title:* Narco Americano *Medium:* Digital

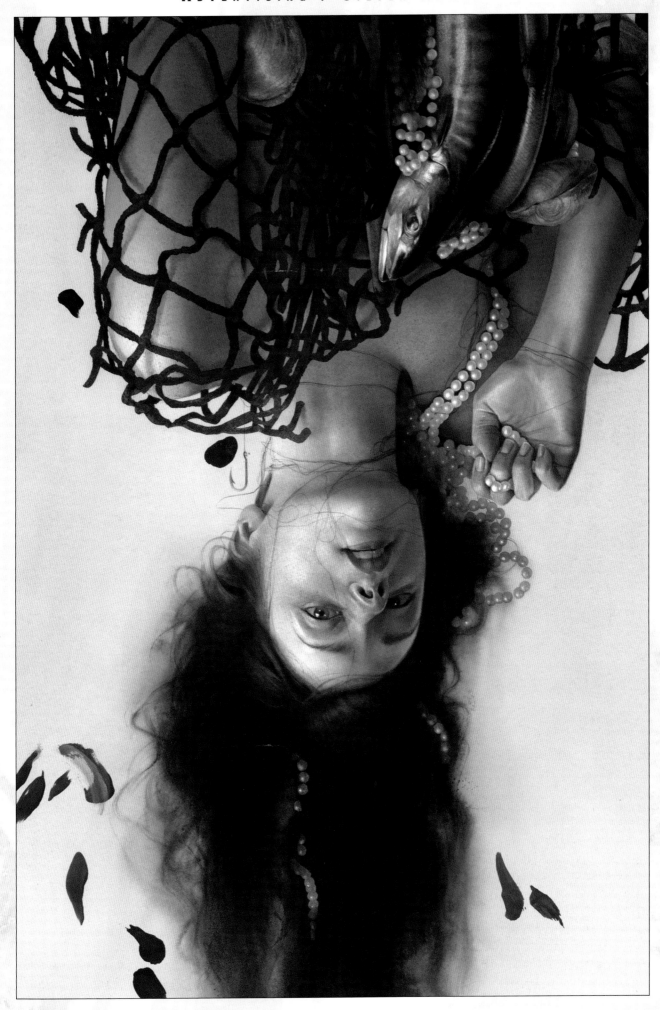

Sam Weber

Art Director: Edel Rodriguez *Designer:* Kim Bost *Client:* Society of Illustrators *Title:* The Fisherman's Wife *Medium:* Watercolor/digital

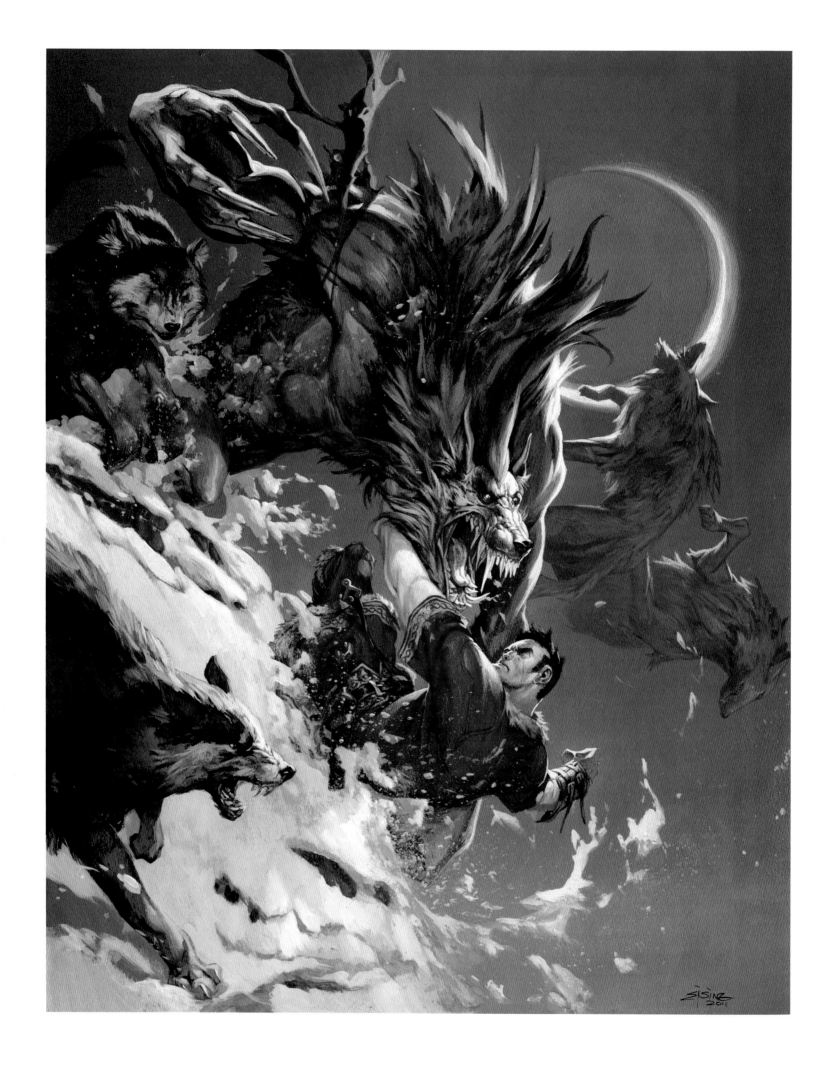

Jesper Ejsing
Art director: Mari Kolkowsky *Client:* Wizards of the Coast *Title:* Dungeons & Dragons: Ravenloft *Size:* 9"x12" *Medium:* Oil

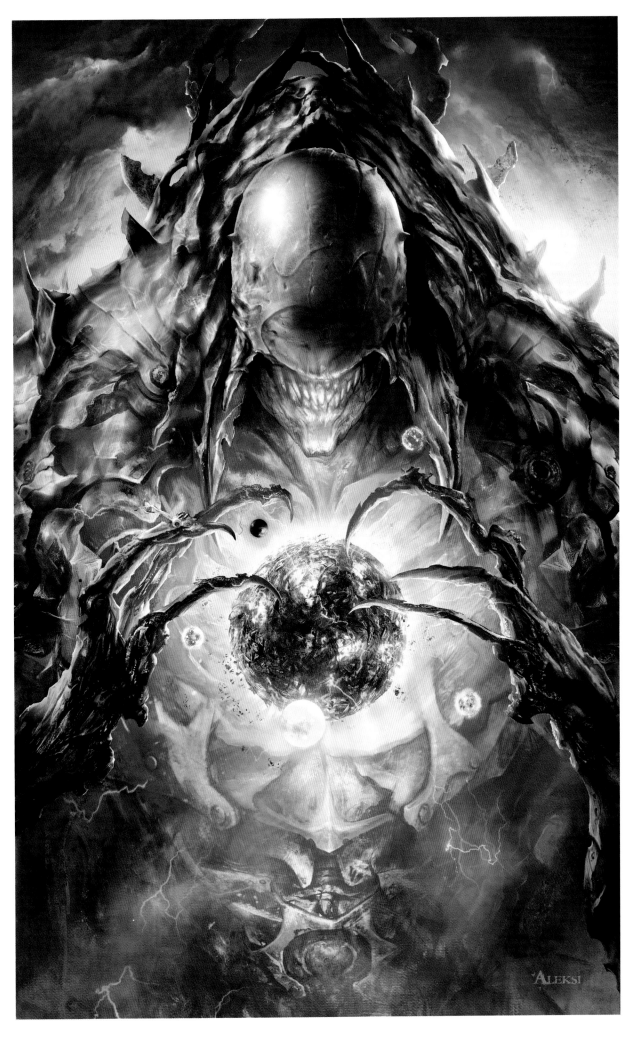

Aleksi Briclot

Art Director: Jeremy Jarvis *Client:* Wizards of the Coast *Title:* New Phyrexia *Medium:* Digital

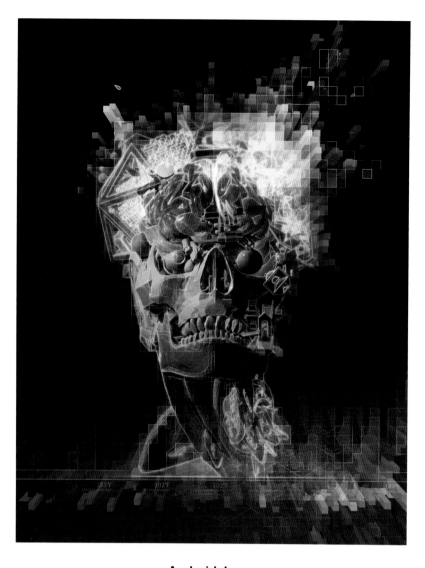

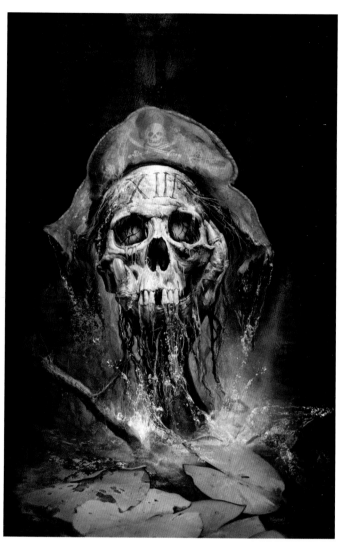

Android Jones
Art director: Phong *Client:* Dreamcatcher.net *Title:* Deus Ex
Medium: Corel Painter—Z Brush

Jeff Haynie
Designer: Adrian Woods *Client:* Big Fish Games *Title:* 13th Skull
Size: 14"x20" *Medium:* Digital

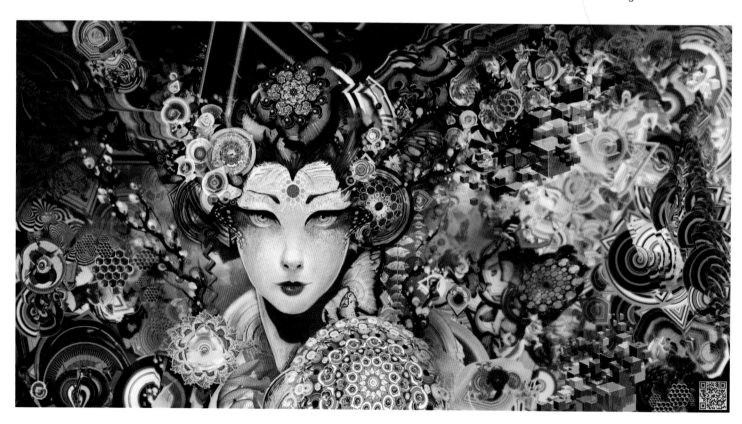

Android Jones
Art director: Andy Church *Client:* Corel Painter *Title:* Japandroid *Medium:* Corel Painter 12

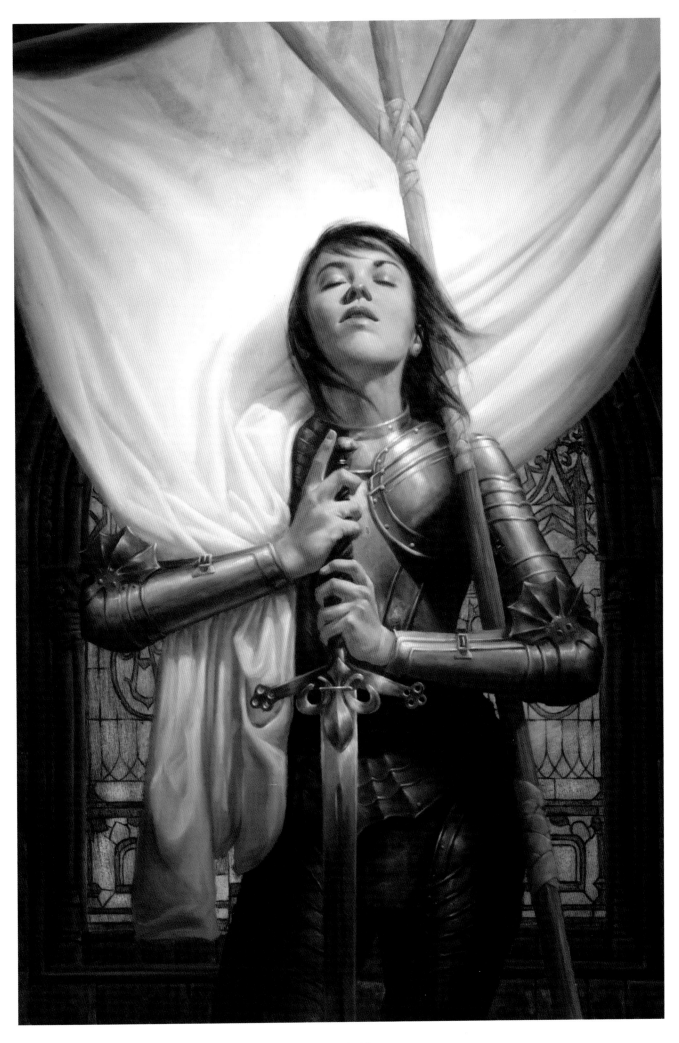

Michael C. Hayes

Art director: IMC 2010 Faculty *Client:* IMC *Title:* Joan of Arc *Size:* 16"x24" *Medium:* Oil on paper on board

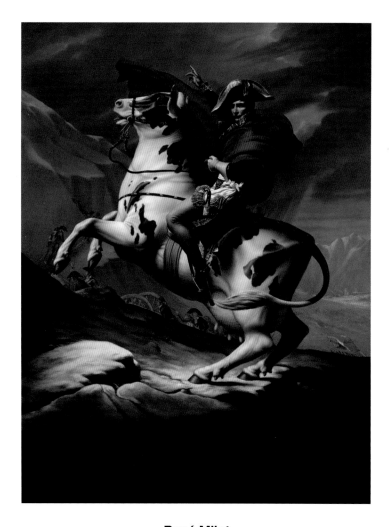

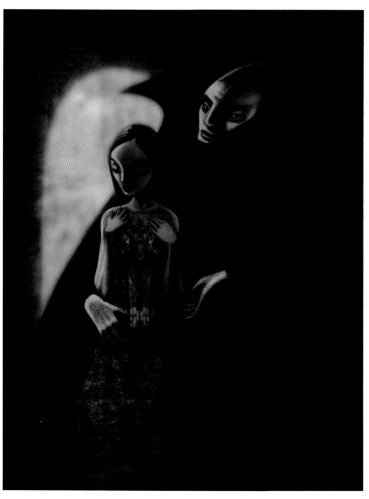

René Milot

Art Director: Adam Glickman *Client:* Chicago Field Museum
Title: Napoléon/cow *Size:* 48"x68" *Medium:* Digital

Grant Fuhst

Art Director: Kirsten Park *Client:* Pioneer Theater Co. *Title:* Dracula
Size: 11"x14" *Medium:* Digital

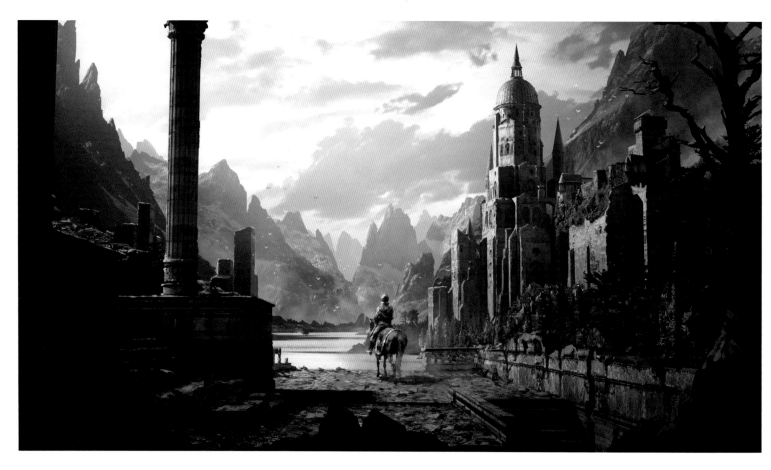

Raphael Lacoste
Client: Gnomon Workshop *Title:* Contemplative Knight *Size:* 11"x8.5" *Medium:* Mixed

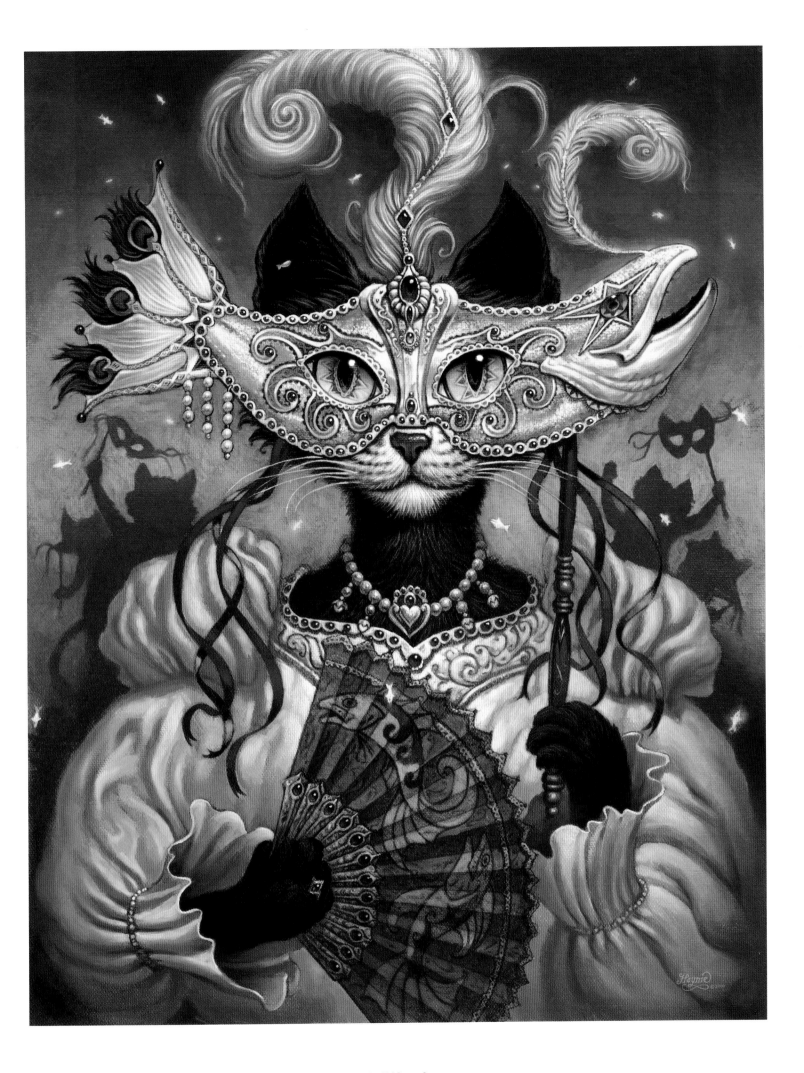

Jeff Haynie

Art Director: Jeff Haynie *Client:* "Purrfect Pals" Cat Rescue *Title:* Incatneato: Black Cat Ball Poster *Size:* 11"x14" *Medium:* Oil

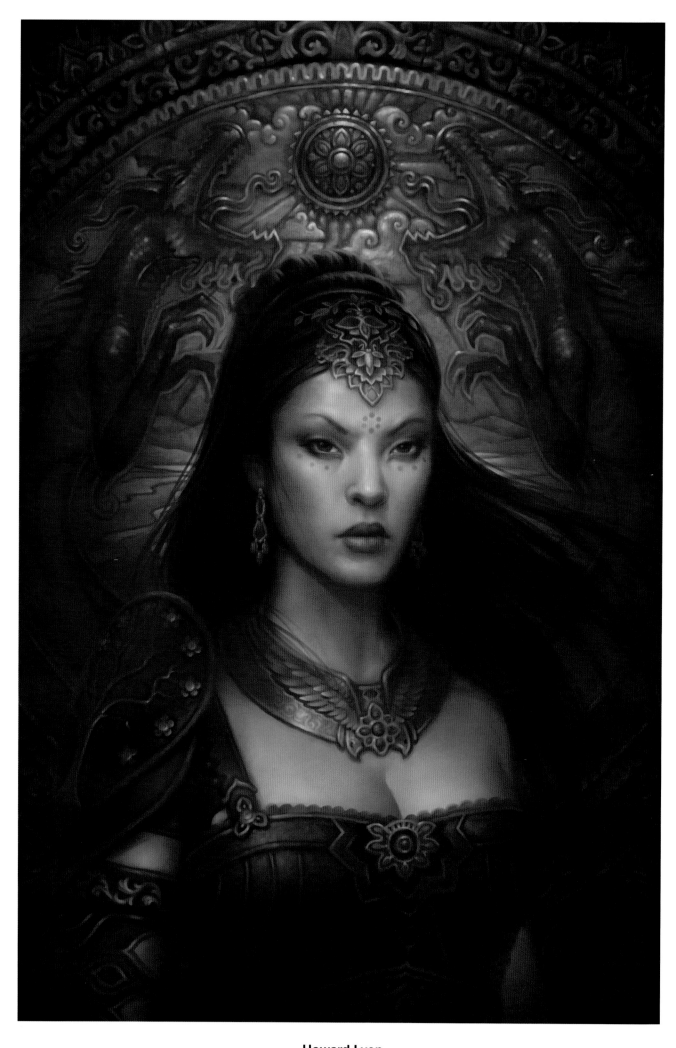

Howard Lyon

Art director: Michael McCloskey *Client:* Michael McCloskey *Title:* The Great Seal *Size:* 10"x15" *Medium:* Digital

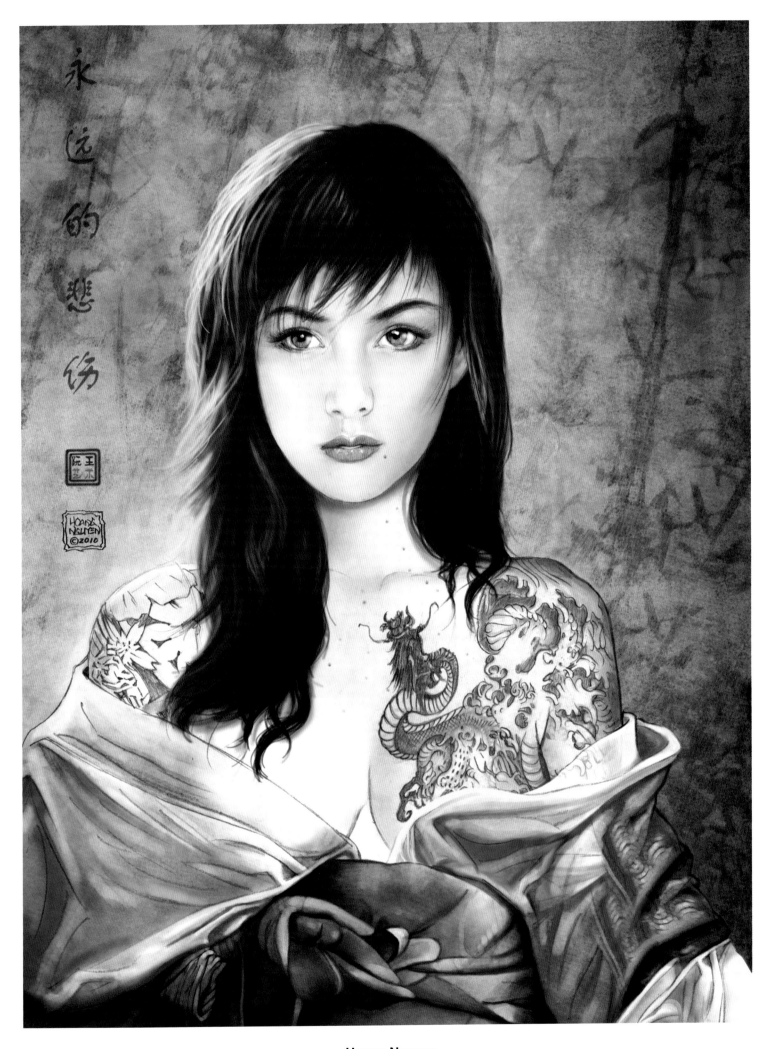

Hoang Nguyen

Client: ImagineFX *Title:* Mina *Size:* 10.5"x14" *Medium:* Digital/Photoshop

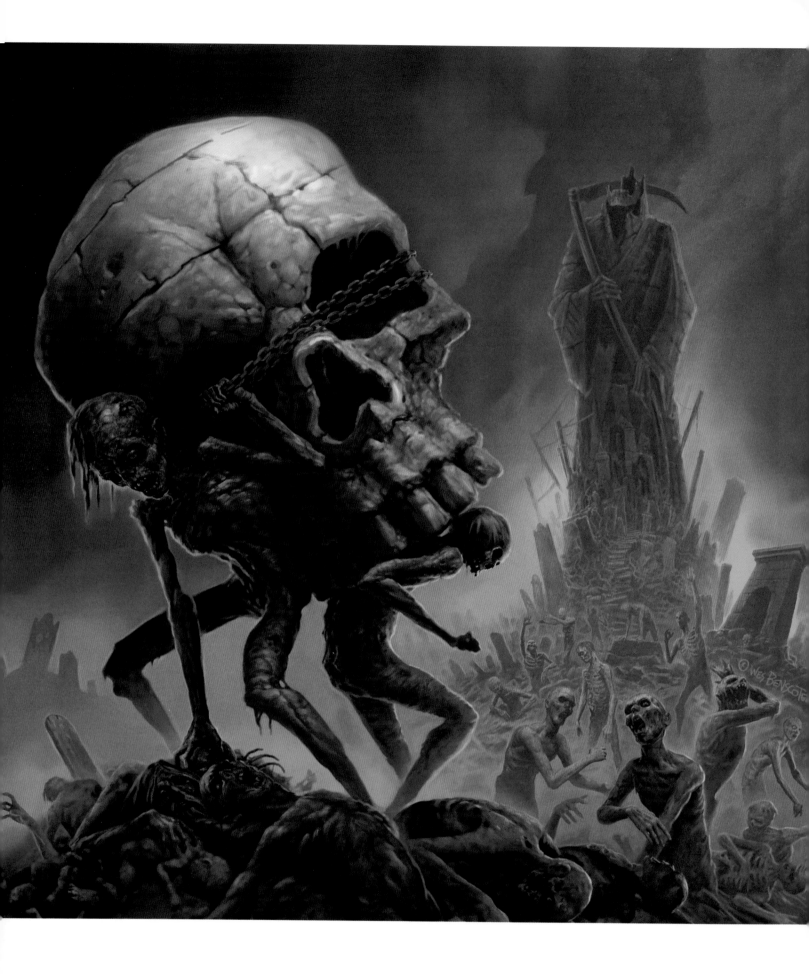

Wes Benscoter

Client: Peaceville Records *Title:* Autopsy *Size:* 18"x18" *Medium:* Acrylics & digital

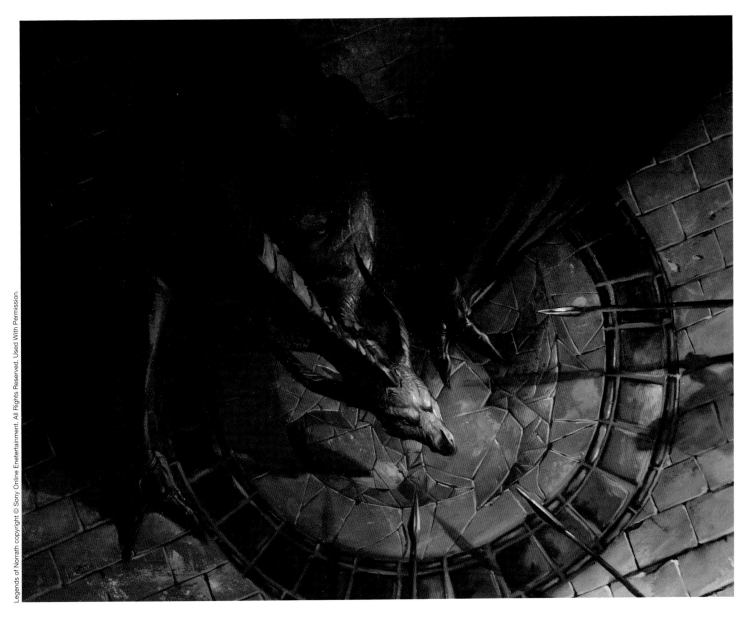

Lucas Graciano

Art Director: Derek Herring *Client:* Sony Online Entertainment *Title:* Amorphous Drake *Size:* 14"x11" *Medium:* Oil

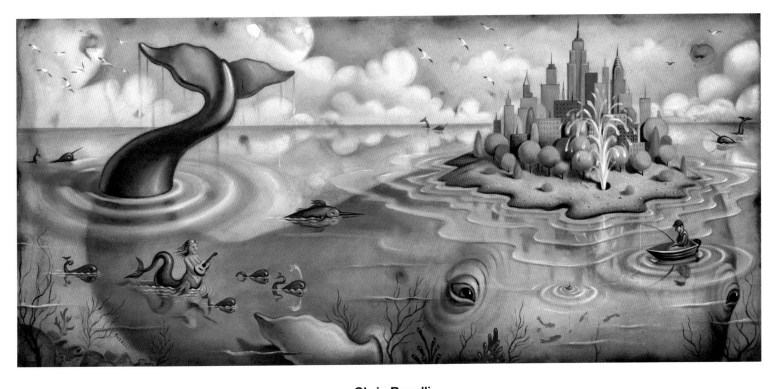

Chris Buzelli

Art Director: Paul Mark *Client:* Radiation Records *Title:* Mirage Cartography *Size:* 24"x11" *Medium:* Oil on board

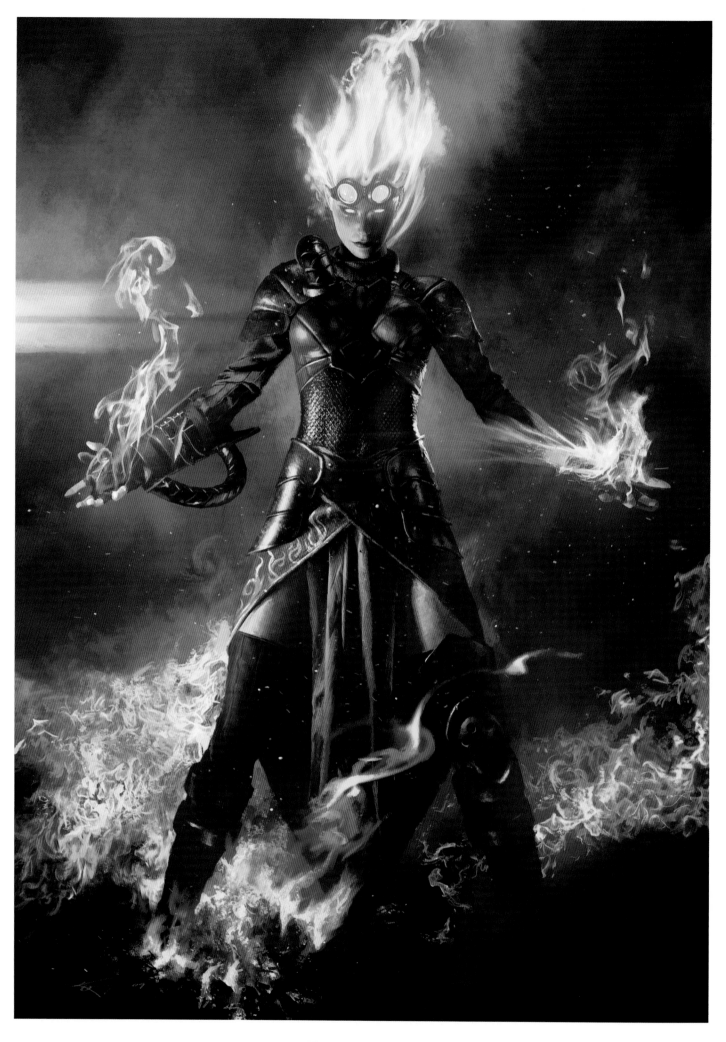

Michael Komarck

Art director: Roger Chamberlain/Mark Tuttle *Client:* S.O.E. & Wizards of the Coast *Title:* Chandra Nalaar *Medium:* Digital

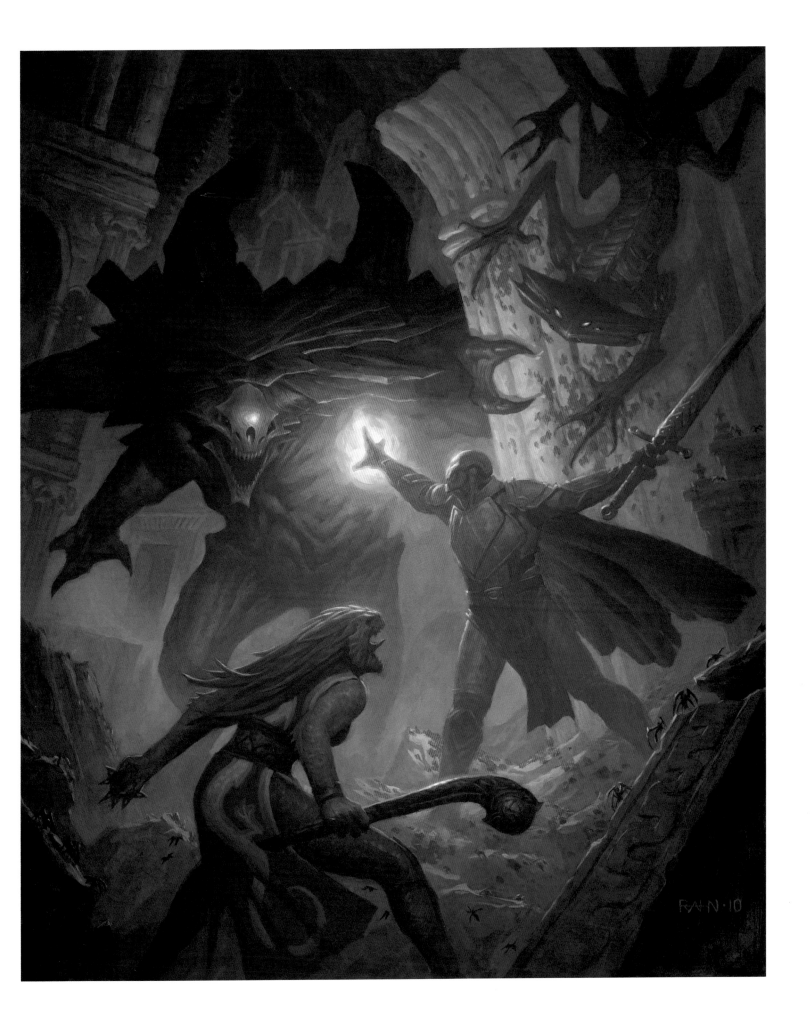

Lucas Graciano

Art director: Jon Schindehette *Client:* Wizards of the Coast *Title:* Dungeon #187 *Size:* 18"x22" *Medium:* Oil on masonite

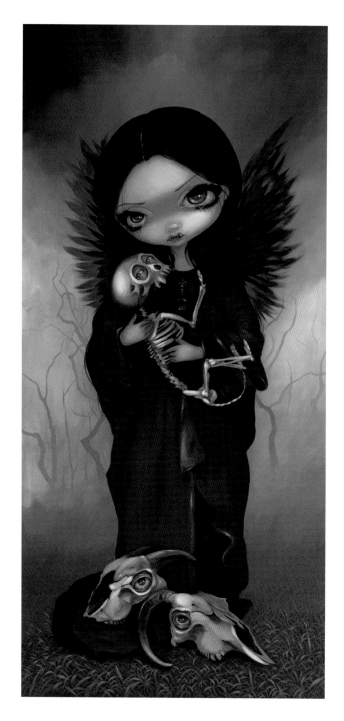

Jasmine Becket-Griffith
Client: Gothic Beauty Magazine
Title: I, Vampiri: Angelo della Morte *Size:* 16"x34"
Medium: Acrylic on wood

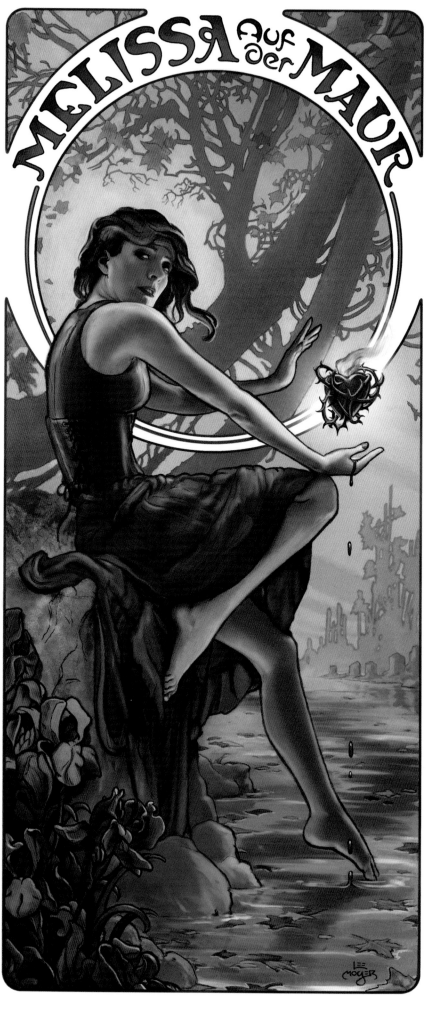

Lee Moyer
Art Director: Melissa Auf der Maur *Client:* Melissa Auf der Maur *Title:* Out of Our Minds
Size: 15"x30" *Medium:* Mixed *Typographer:* Tom Orzechowski

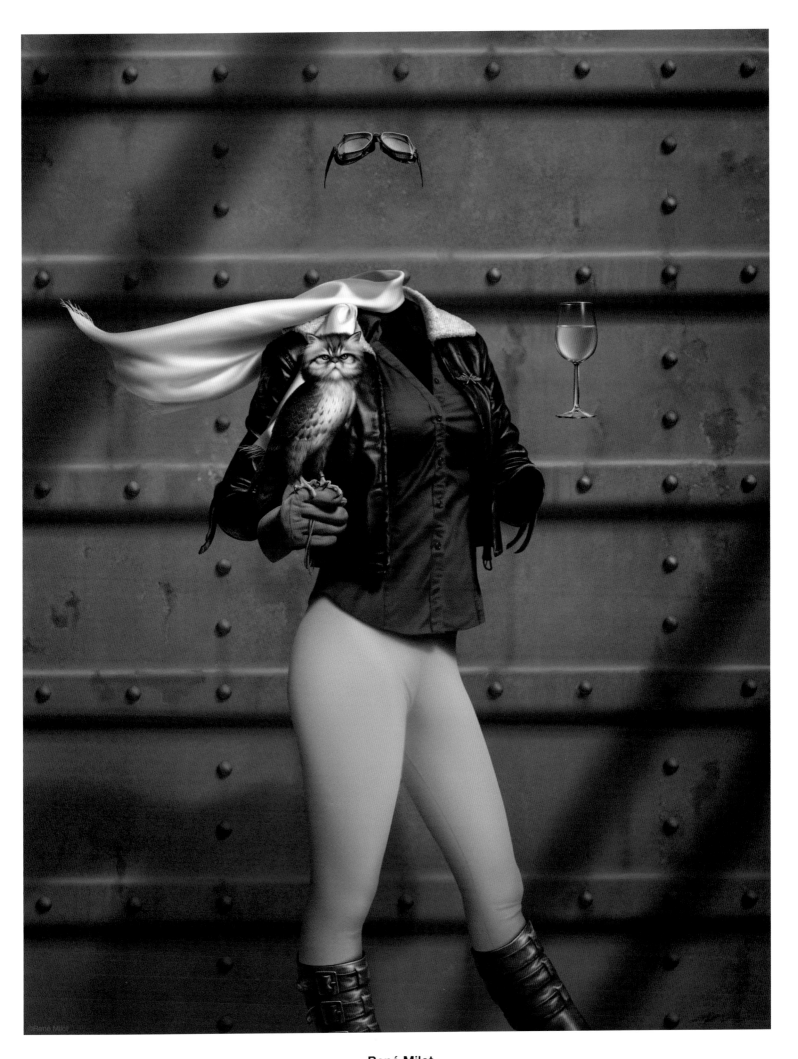

René Milot

Art director: Kristi Flango *Client:* Secret Sherry Society *Title:* Secret Sherry Society: The Aviator *Size:* 20"x26" *Medium:* Digital

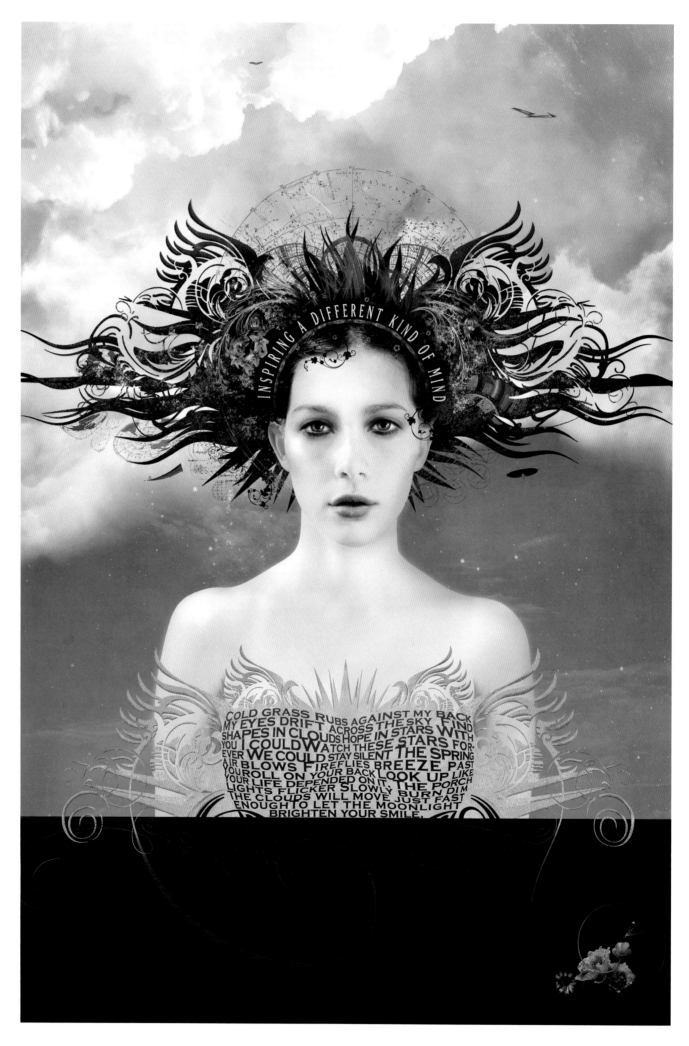

Greg Spalenka

Art director: Anthony Padilla *Designer:* Jeff Burne *Client:* Chester College *Title:* Inspiring a Different Kind of Mind *Medium:* Digital

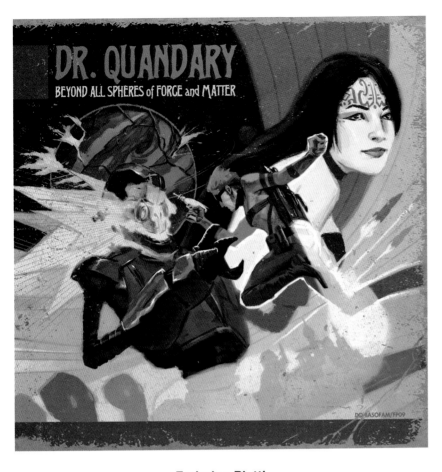

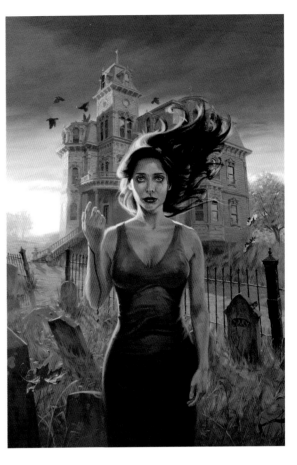

Federico Piatti

Client: Dr. Quandary *Title:* Beyond All Spheres of Force and Matter
Size: 12"x12" *Medium:* Digital

Rob Rey

Art Director: Martin P. Stevens *Client:* Metaphork Pictures
Title: The Haunting Presence *Size:* 24"x36" *Medium:* Oil

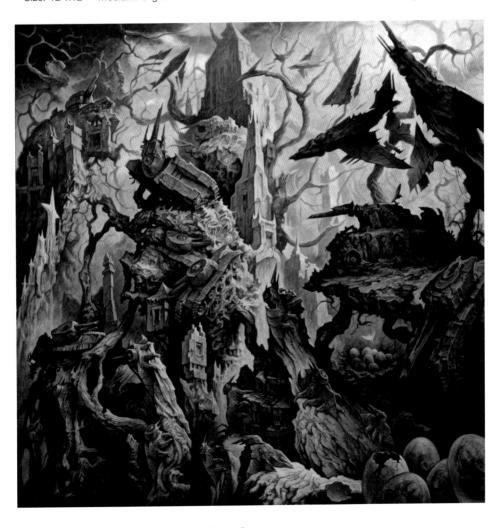

Dan Seagrave

Client: Requiem *Title:* Within Darkened Disorder *Size:* 15"x15" *Medium:* Acrylic on board

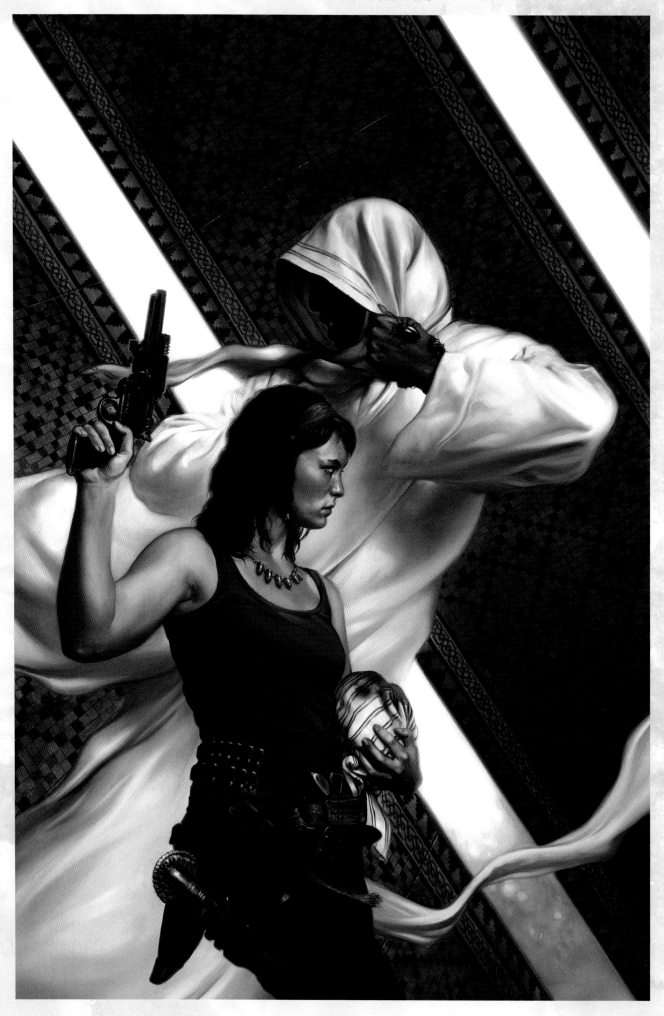

David Palumbo

Client: Night Shade Books *Title:* God's War *Size:* 18"x27" *Medium:* Oil

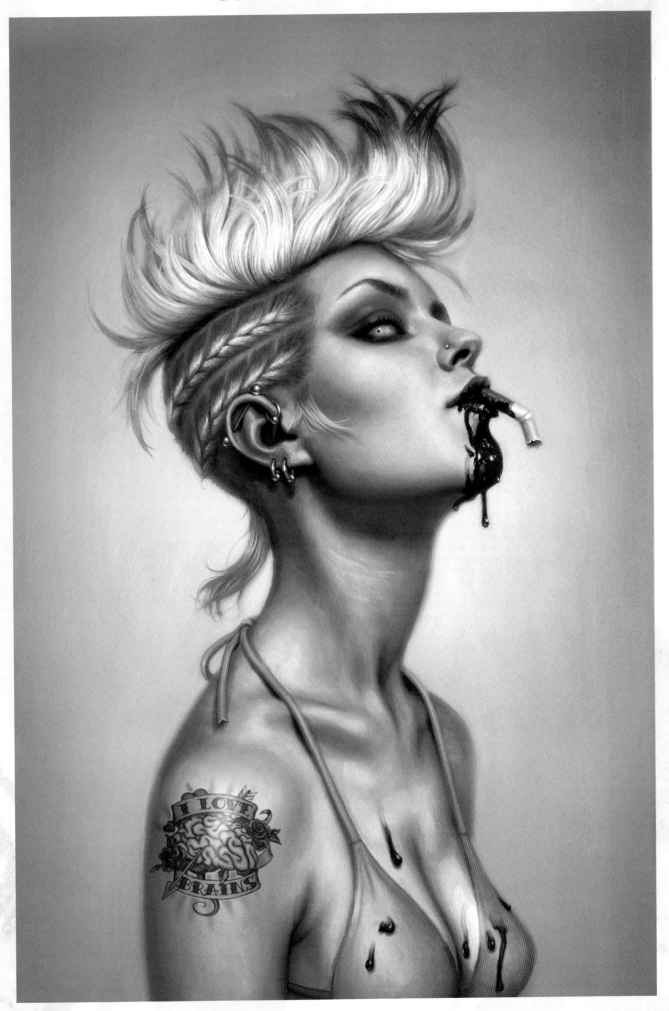

Dan Dos Santos

Art Director: Betsy Wollheim *Client:* DAW Books *Title:* White Trash Zombie *Medium:* Oil on board

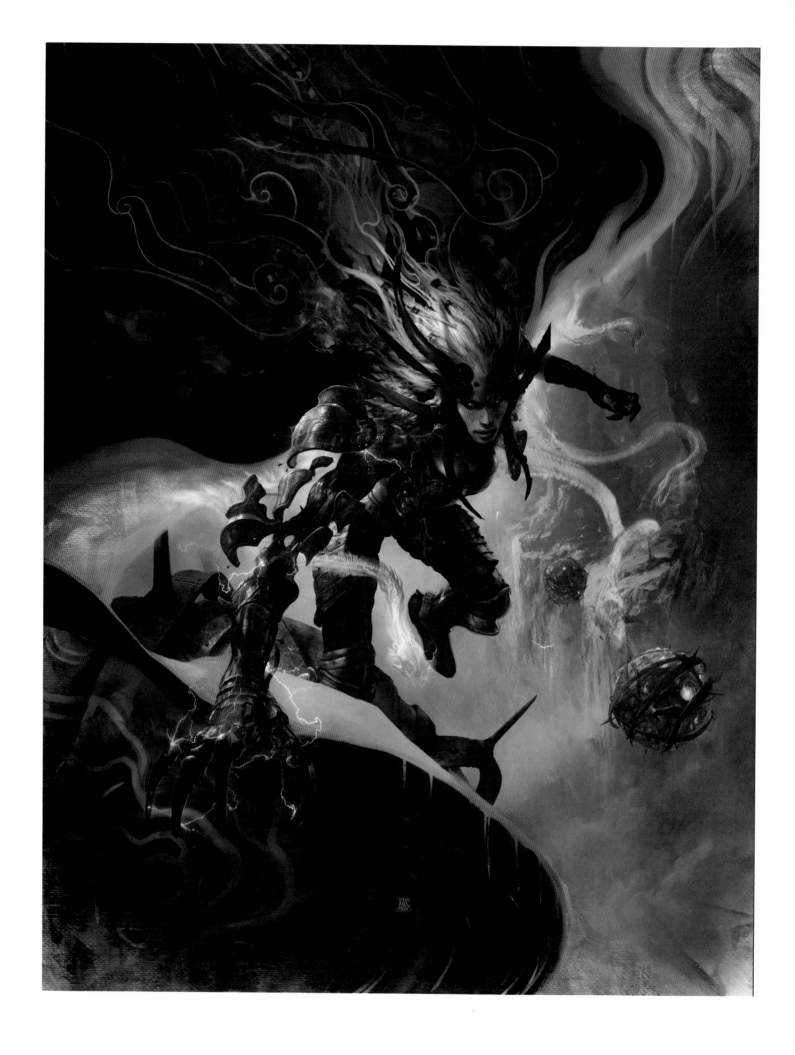

Aleksi Briclot

Art Director: Carlos "Made" Pardo *Client:* CFSL Ink *Title:* Worlds and Wonders *Size:* 10"x13" *Medium:* Digital

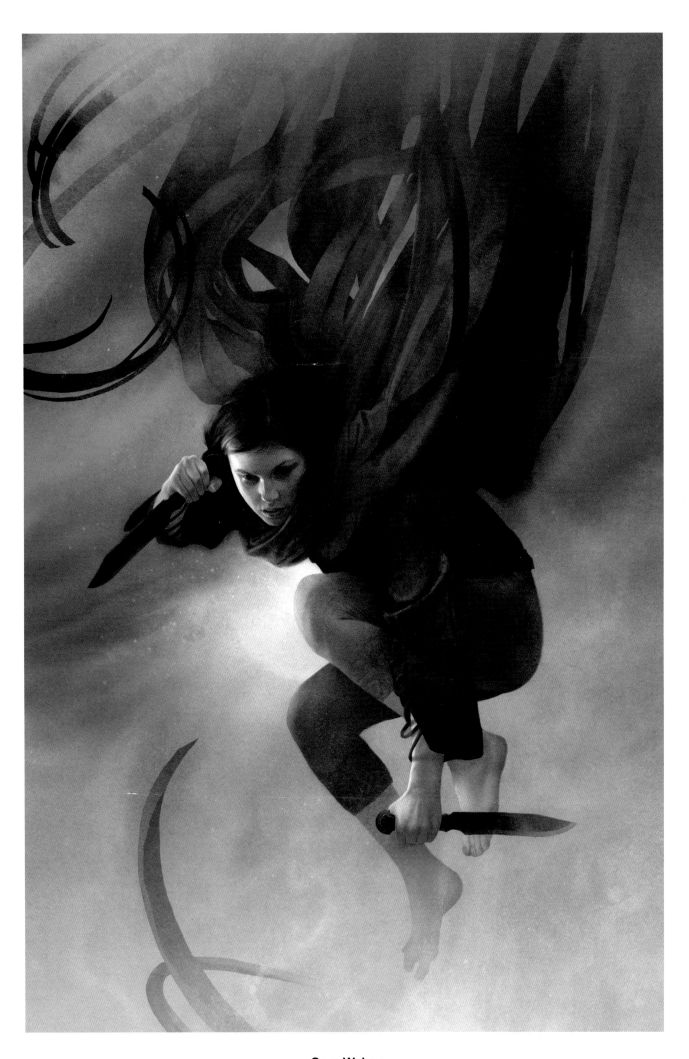

Sam Weber

Art Director: Irene Gallo *Client:* Tor Books *Title:* Beautiful Destroyer *Medium:* Watercolor/digital

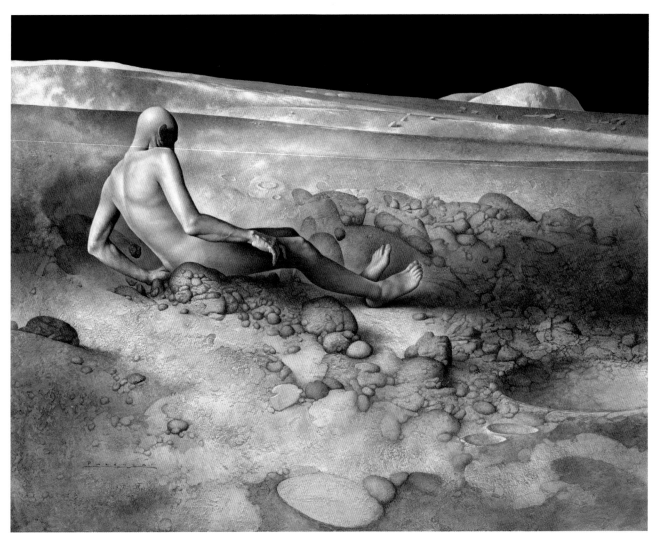

John Jude Palencar
Art director: Irene Gallo *Client:* Tor Books *Title:* "Steel Across the Sky" Luna Morte *Size:* 33"x25" *Medium:* Acrylic

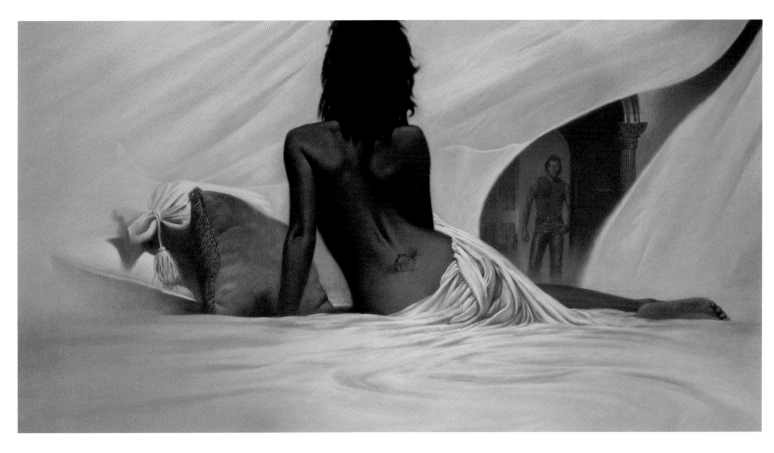

Vince Natale
Art director: Michael Storrings *Client:* St. Martin's Press *Title:* The Hunted *Size:* 20"x15" *Medium:* Oil

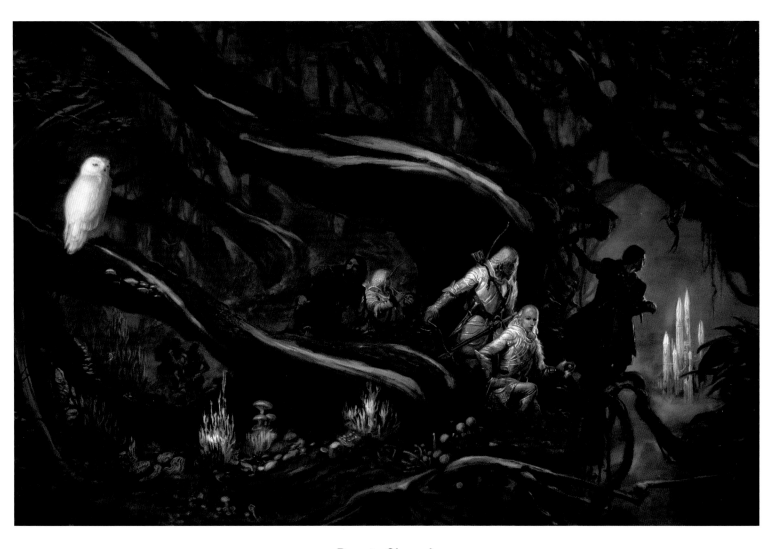

Donato Giancola
Art Director: Betsy Wollheim *Designer:* Stephen Youll *Client:* DAW Books *Title:* Blackveil *Size:* 36"x24" *Medium:* Oil on panel

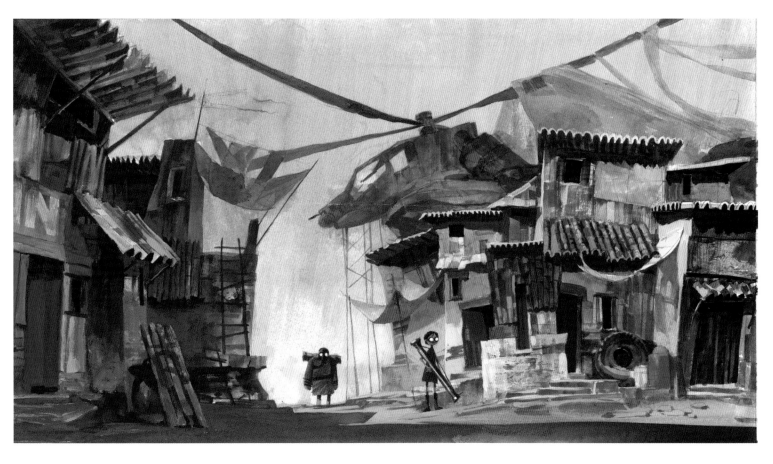

Tang Kheng Heng
Client: Moonshine *Title:* Crash Site *Size:* 9"x7" *Medium:* Acrylic

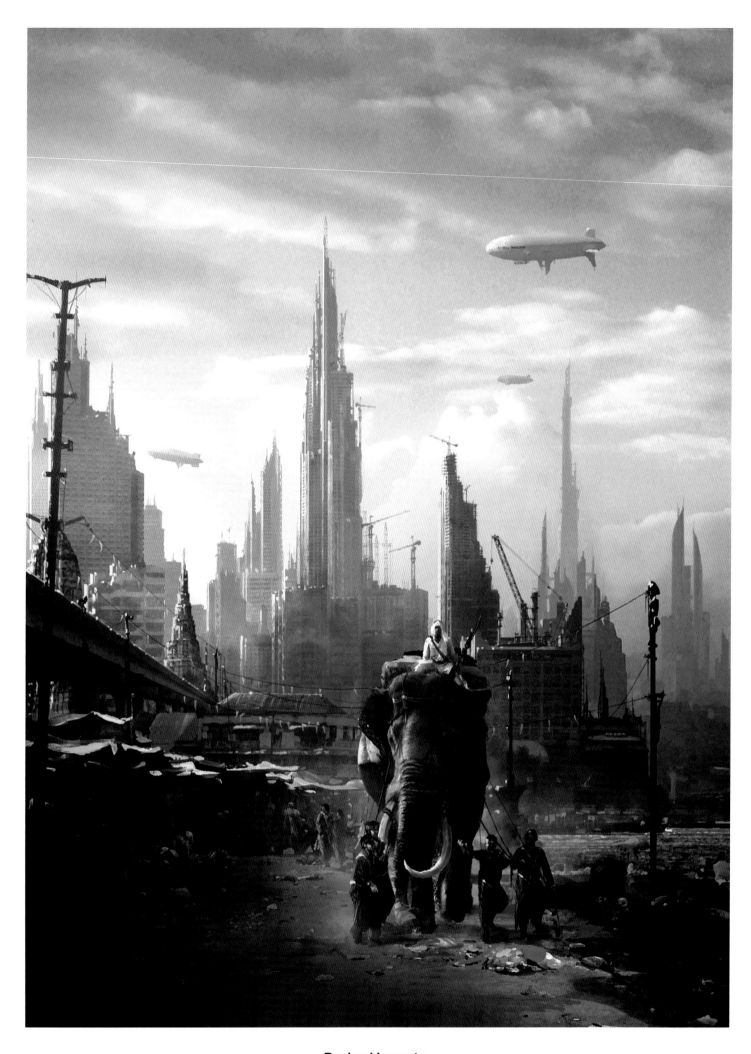

Raphael Lacoste

Art Director: Jeremy Lassen *Client:* Night Shade Books *Title:* The Windup Girl *Size:* 8.5"x11" *Medium:* Photoshop

James Gurney

Art Director: James Gurney *Client:* Andrews McMeel Publishing *Title:* "Asteroid Miner" from *Color and Light* *Size:* 20"x24" *Medium:* Oil

Jim Silke
Art Director: John Fleskes *Client:* Flesk Publications
Title: Jungle Girls *Medium:* Mixed

William Stout
Art Director: John Fleskes *Deisgner:* Randall Dahlk *Client:* Flesk Publications
Title: Vampyr *Size:* 7.25"x10.5" *Medium:* Ink and watercolor on board

Brian McCarty
Toy: Gama-Go *Client:* Baby Tattoo Books *Title:* Tiger Lilly *Medium:* Photography

Jason Chan

Art Director: Matt Adelsperger *Client:* Wizards of the Coast *Title:* Sooner Dead *Medium:* Digital

Scott M. Fischer

Art Director: Irene Gallo *Client:* Tor Books *Title:* Highest Frontier *Medium:* Digital

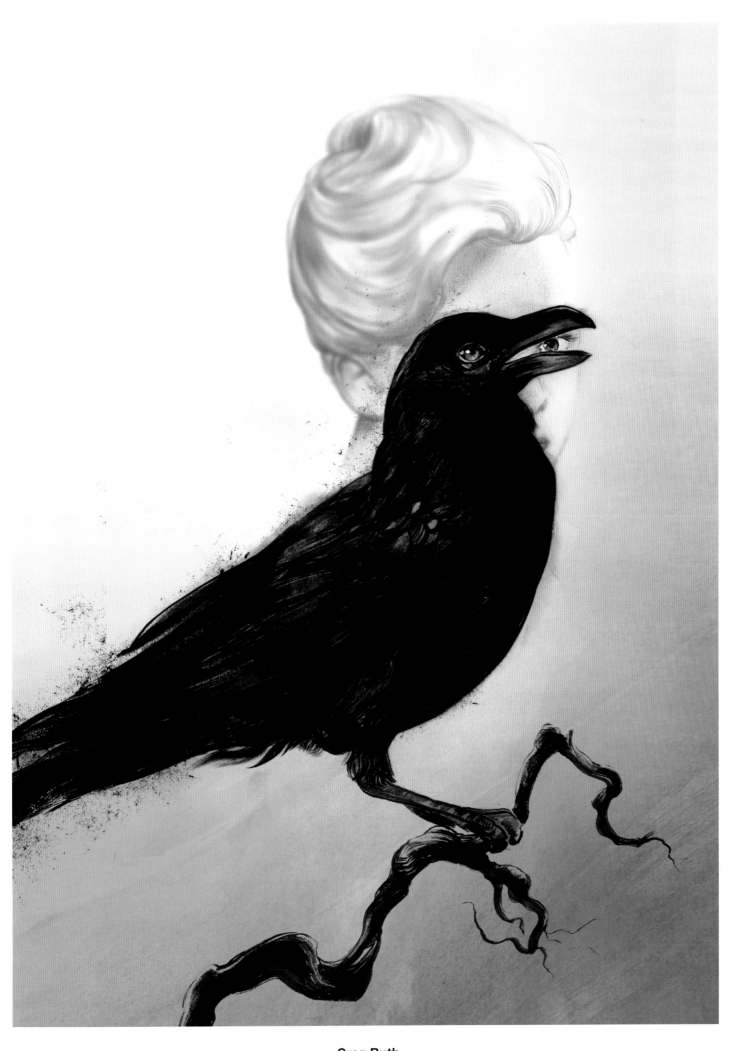

Greg Ruth

Art Director: Rachel Edidin *Designer:* Lia Ribacchi *Client:* Dark Horse Books *Title:* Super Natural Noir *Size:* 8.5"x11" *Medium:* Mixed

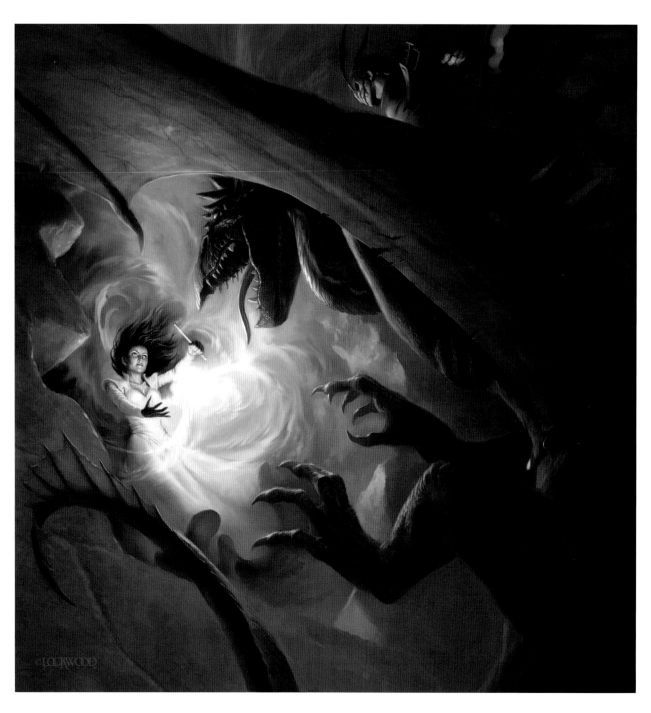

Todd Lockwood
Art director: Irene Gallo *Client:* Tor Books *Title:* The Gathering *Size:* 16"x16" *Medium:* Digital

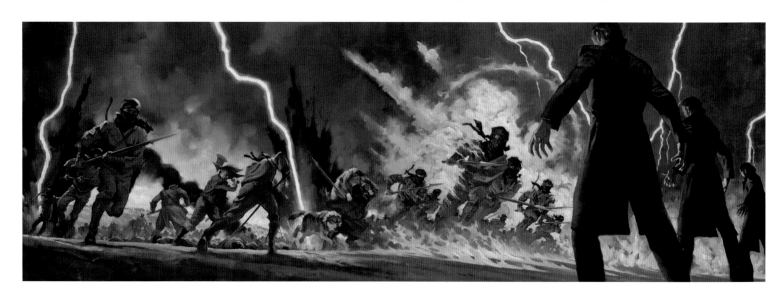

Gregory Manchess
Art director: Irene Gallo *Client:* Tor Books *Title:* Lord of Chaos *Size:* 62"x21" *Medium:* Oil on linen

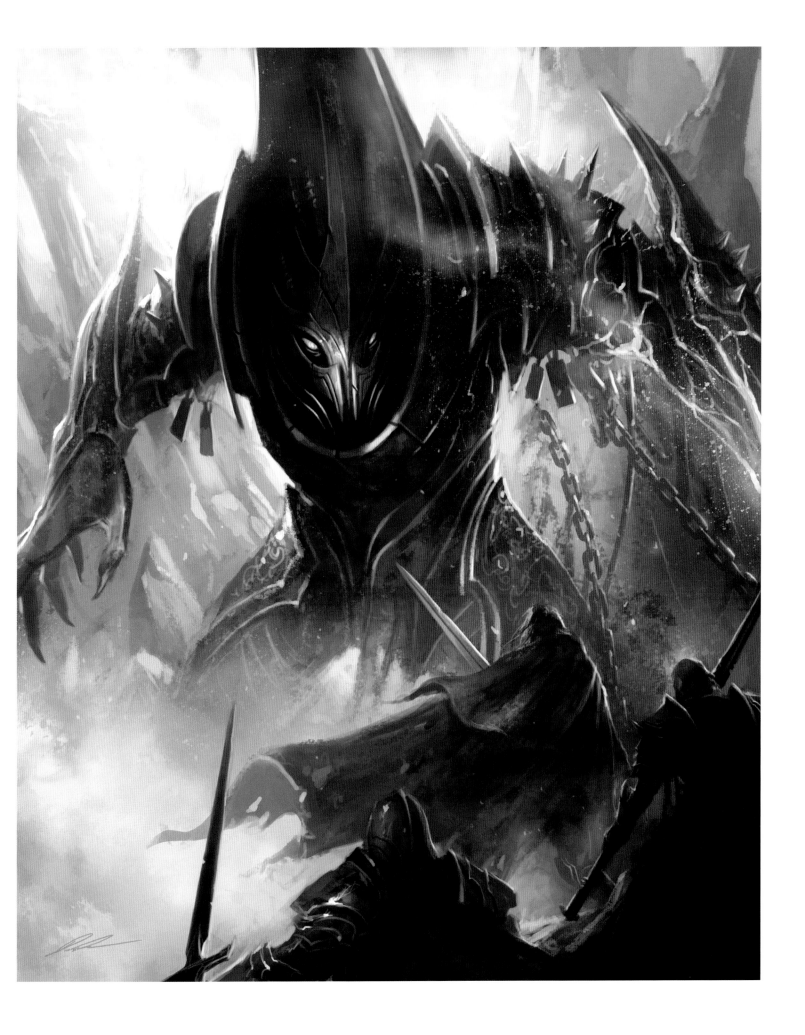

Daarken

Art director: Claire Howlett *Client:* ImagineFX *Title:* A Deadly Encounter *Size:* 13"x16" *Medium:* Photoshop

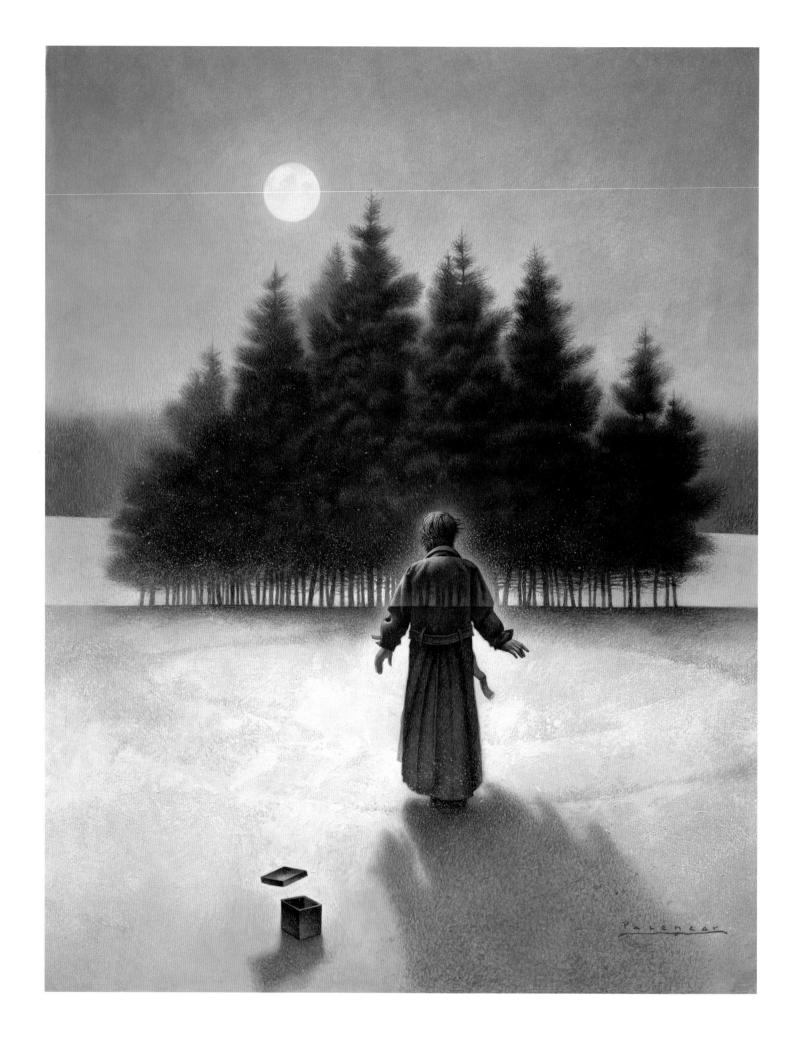

John Jude Palencar

Art Director: Irene Gallo *Client:* Tor Books *Title:* Muse & Reverie *Size:* 18"x22" *Medium:* Acrylic

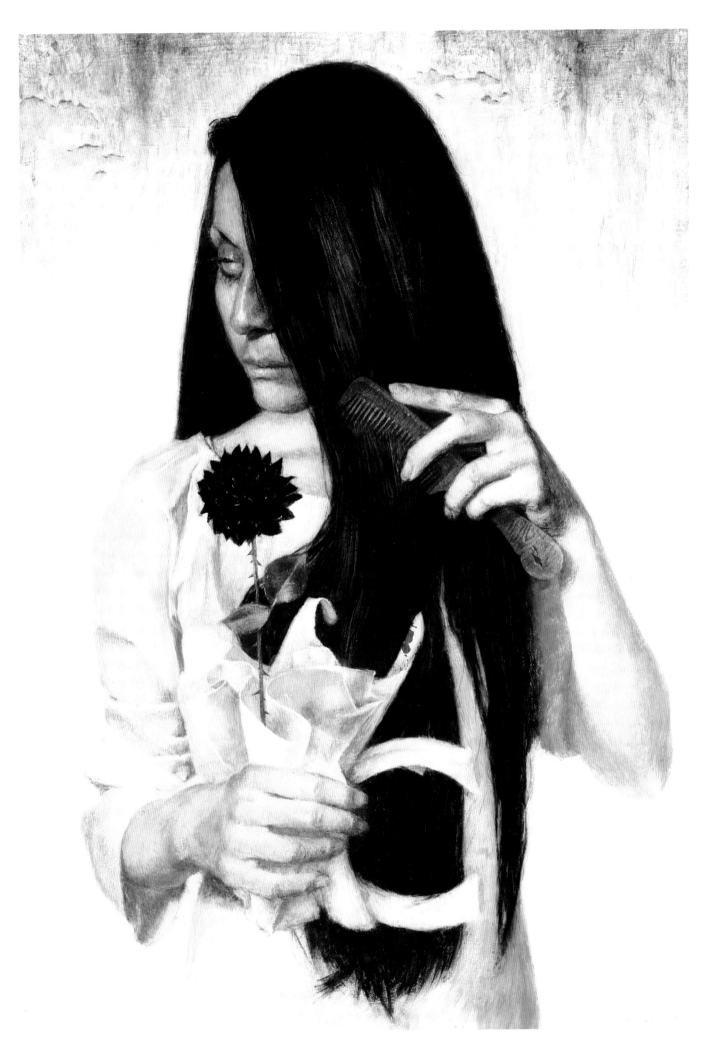

Dragan Bibin
Client: Orfezin Izdavastvo *Title:* Apparition *Size:* 35x50cm *Medium:* Egg Tempera

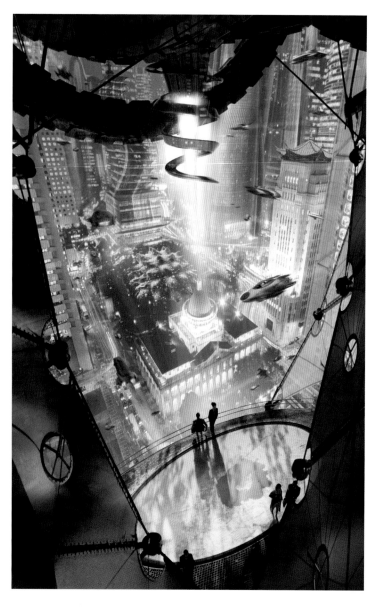

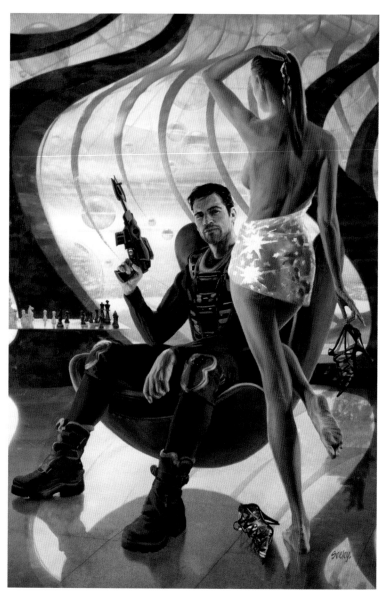

Dave Seeley
Art Director: Toni Weisskopf *Client:* Baen Books
Title: Cryoburn *Medium:* Digital

Dave Seeley
Art Director: Toni Weisskopf *Client:* Baen Books
Title: Cryoburn *Medium:* Digital

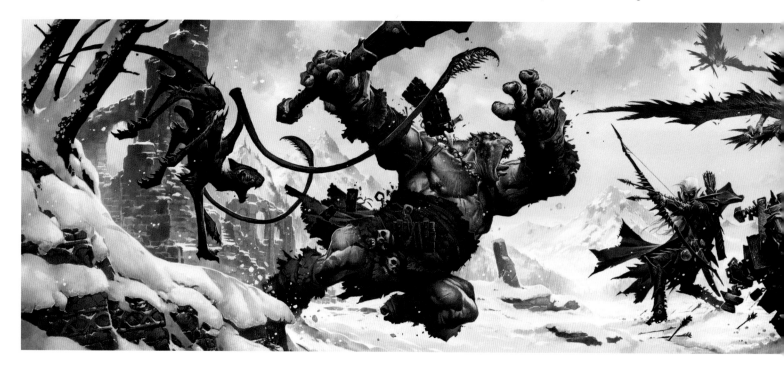

Chris Rahn

Art Director: Isabel Warren-Lynch *Client:* Random House
Title: Ambush *Size:* 14"x22" *Medium:* Oil on masonite

Chris McGrath

Art Director: Lisa Litwack *Client:* Simon & Schuster
Title: The Darkest Edge of Dawn *Medium:* Digital

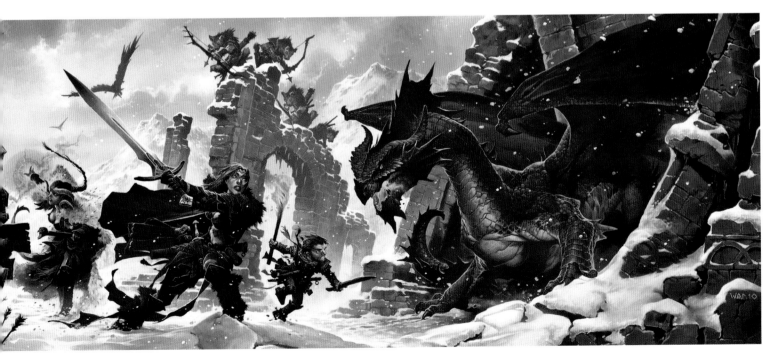

Wayne Reynolds

Art Director: Mari Kolkowsky *Client:* Wizards of the Coast *Title:* Dungeons & Dragons: Dungeon Master Screen *Size:* 44"x35" *Medium:* Gouache

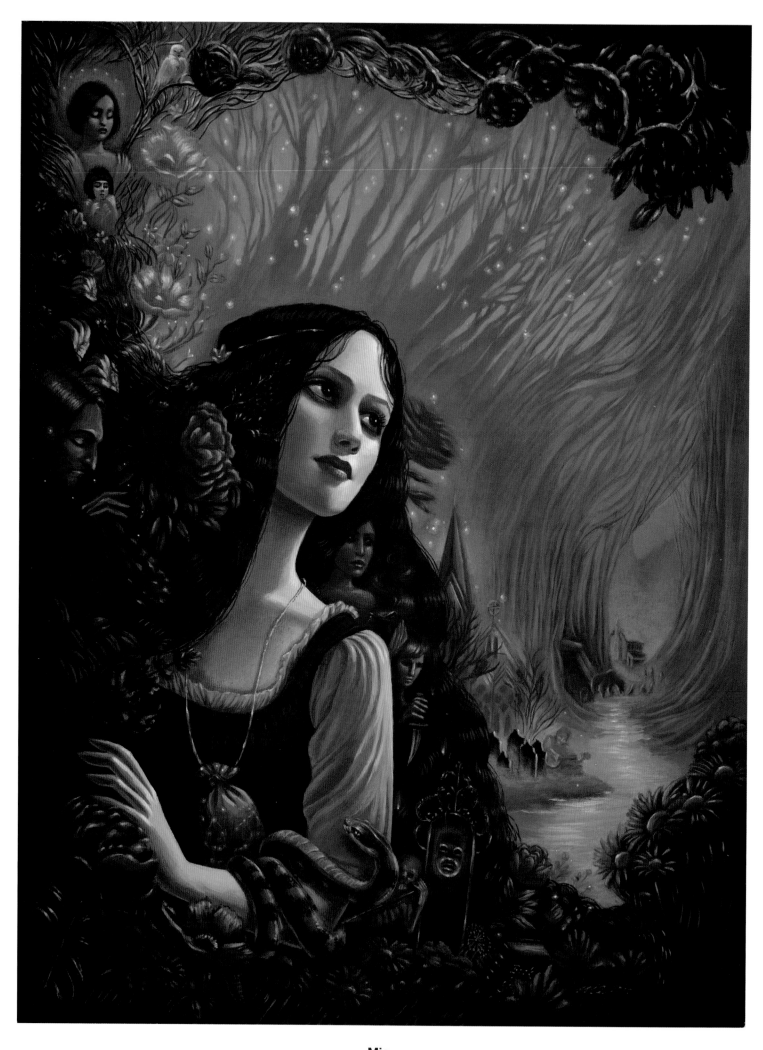

Mia

Art Director: Deborah Kaplan *Designer:* Kristin Smith *Client:* Penguin Group *Title:* Snow in Sumer *Size:* 9"x12" *Medium:* Acrylic on wood

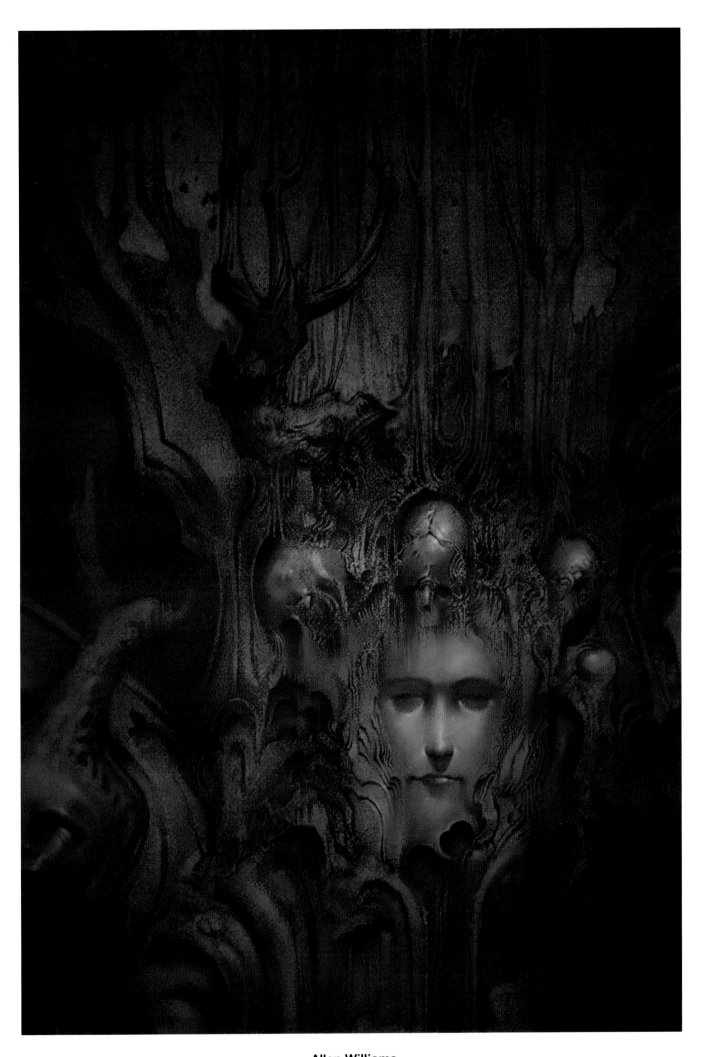

Allen Williams
Art Director: David Palumbo *Client:* Night Shade Books *Title:* The Briar Prince *Size:* 9"x12" *Medium:* Mixed

Michael C. Hayes
Art Director: David Palumbo *Client:* Night Shade Books
Title: Miserere: An Autumn Tale *Size:* 16"x24" *Medium:* Oil on paper

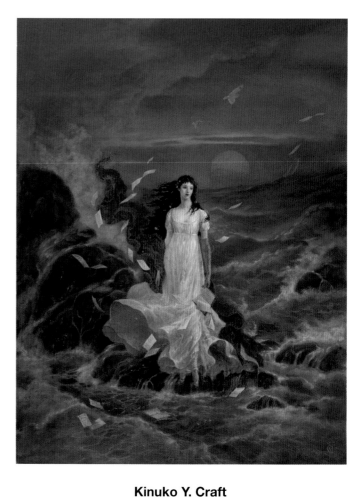

Kinuko Y. Craft
Art Director: Marietta Anastassatos *Client:* Simon & Schuster
Title: Jane and the Madness of Lord Byron *Size:* 18"x24" *Medium:* Oil

Jon Foster
Art Director: Bill Schaffer *Client:* Subterranean Press
Title: Clementine *Medium:* Digital

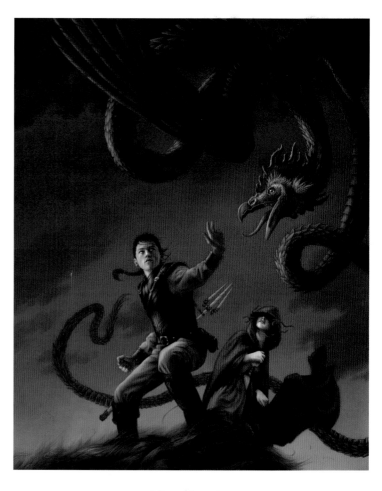

Allen Douglas
Art Director: Trish Parcell *Client:* Random House
Title: Amos Daragon The Mask Wearer *Medium:* Digital

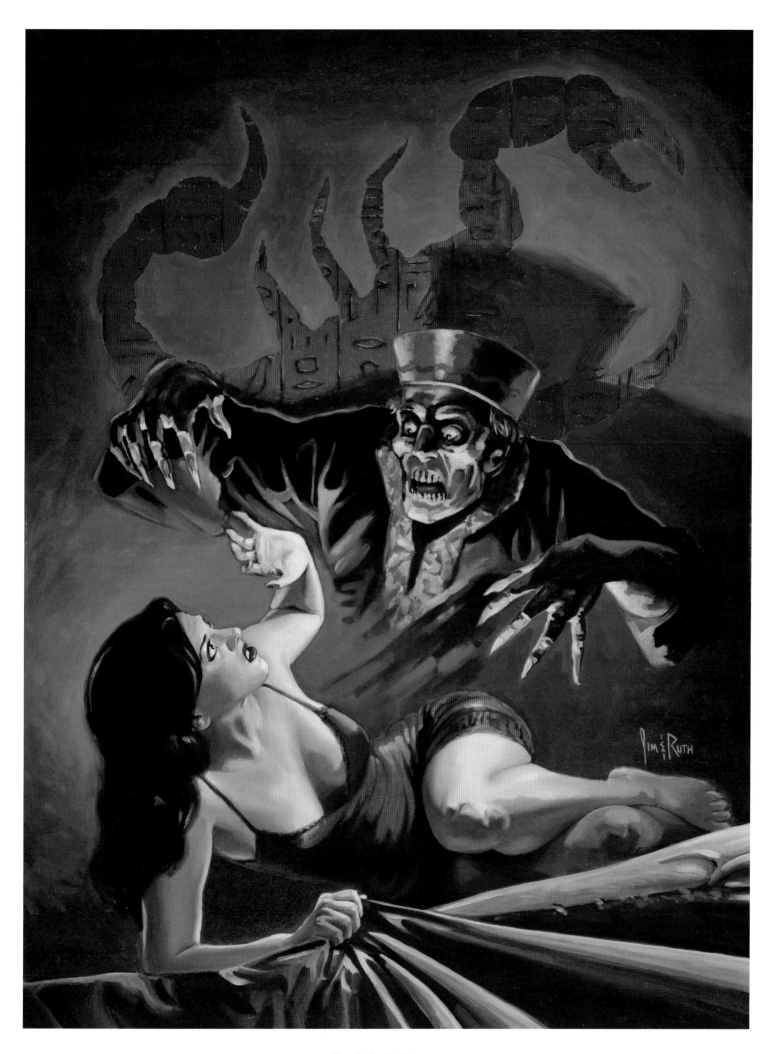

Jim & Ruth Keegan

Client: Robert E. Howard Foundation *Title:* Weird Menace *Size:* 18"x24" *Medium:* Oil on board

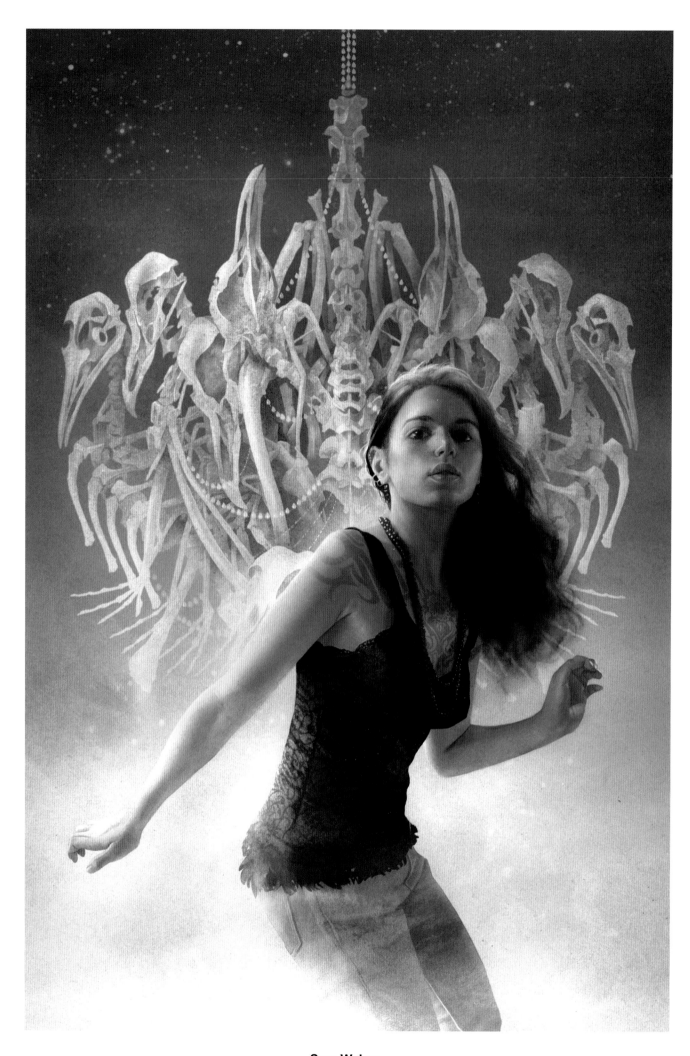

Sam Weber

Art Director: Lou Anders *Client:* Pyr Books *Title:* Light Bringer *Medium:* Watercolor/digital

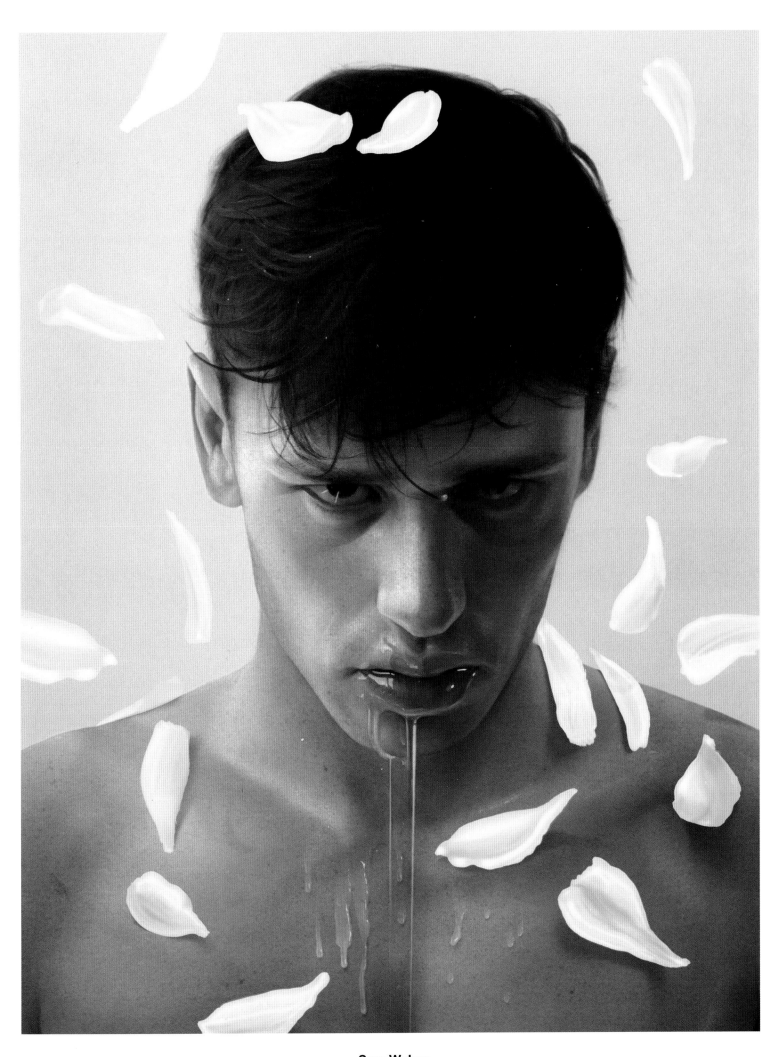

Sam Weber

Art Director: Rodrigo Corral *Client:* American Illustration *Title:* Honey *Medium:* Watercolor/digital

Scott M. Fischer
Art director: Irene Gallo *Client:* Tor Books *Title:* Above the Proper Station *Medium:* Digital

Petar Meseldžija
Client: Orfelin Izdavaštvo *Title:* Giants — The Bull Fight *Size:* 90x55cm *Medium:* Oil

Bob Eggleton

Client: Solaris Books *Title:* C'thulhu Mythos *Size:* 30"x20" *Medium:* Oil

Ryan Pancoast

Art Director: David Palumbo *Client:* Night Shade Books *Title:* At the Queen's Command *Size:* 30"x20" *Medium:* Oil (with digital color alterations)

William Martinez

Client: theartorer.com *Title:* The Shadow Over Innsmouth *Size:* 9"x11" *Medium:* Photoshop

Steve Fastner & Rich Larson
Designer: Rich Larson *Client:* SQ Productions, Inc.
Title: Beauties & Beasts *Size:* 8.5"x11" *Medium:* Airbrush & markers

Kurt Miller
Art Director: Toni Weisskopf *Client:* Baen Books
Title: Amaxon Legion *Medium:* Digital

Volkan Baga
Art Director: Christian Endres *Client:* Atlantis Verlag *Title:* Die Zombies von Oz *Size:* 26"x18.5" *Medium:* Oil

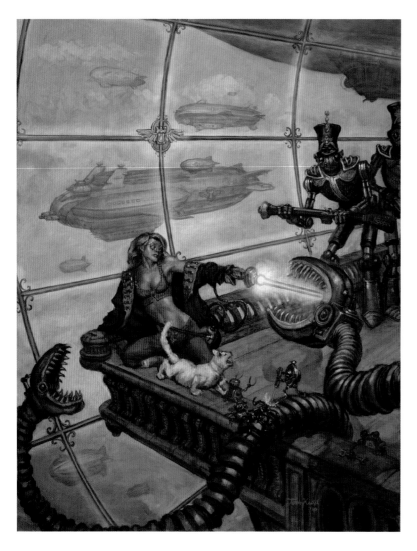

Tom Kidd
Art Director: David Palumbo *Client:* Night Shade Books
Title: Agatha & The Airship City *Size:* 16"x21" *Medium:* Oil

Tom Kidd
Art Director: Toni Weisskopf *Client:* Baen Books
Title: 1633: Saxon Uprising *Size:* 16"x22" *Medium:* Oil

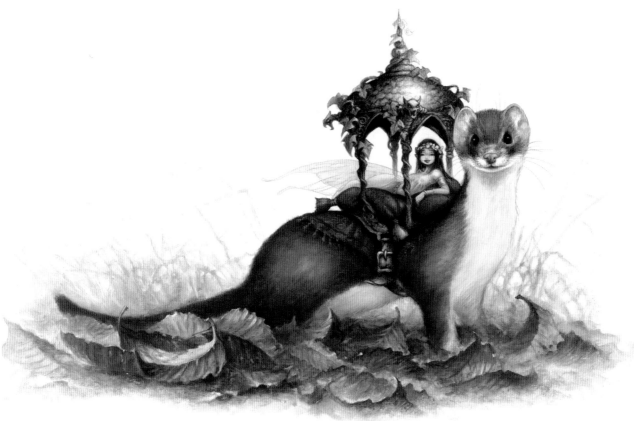

Pascal Moguérou
Client: Au Bord des Continents *Title:* La Belette Au Palanquin *Size:* 60x45cm *Medium:* Oil

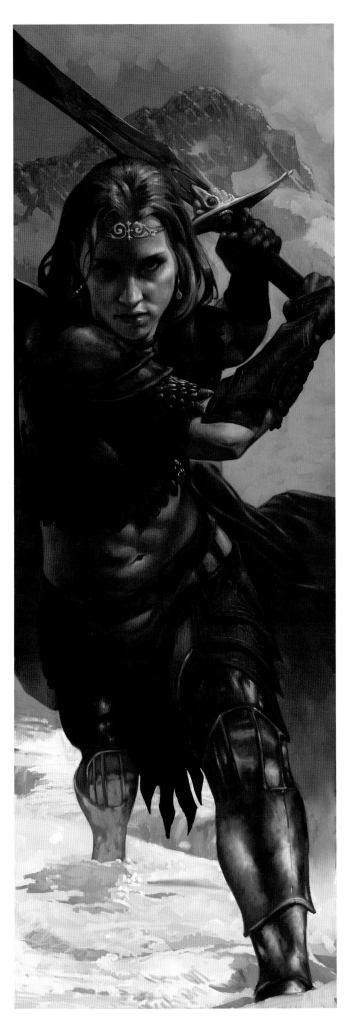

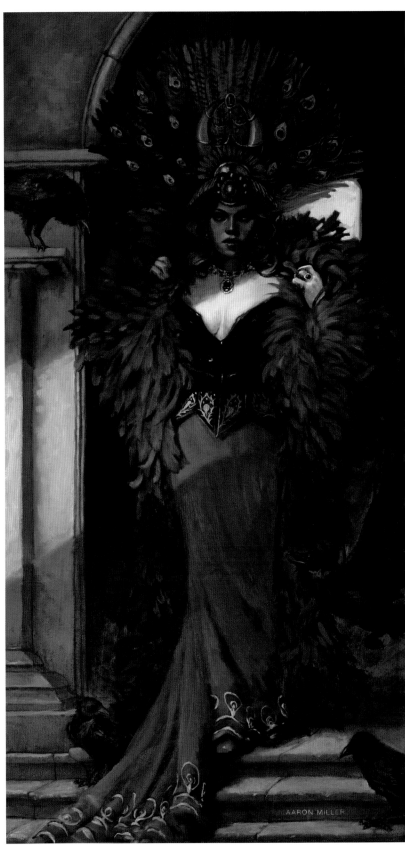

John Stanko
Art Director: Kate Irwin *Client:* Wizards of the Coast *Title:* Shara
Size: 20"x48" *Medium:* Digital

Aaron Miller
Client: ArtOrder: Discover a Muse *Title:* Raven Queen
Size: 24"x48" *Medium:* Oil on panel

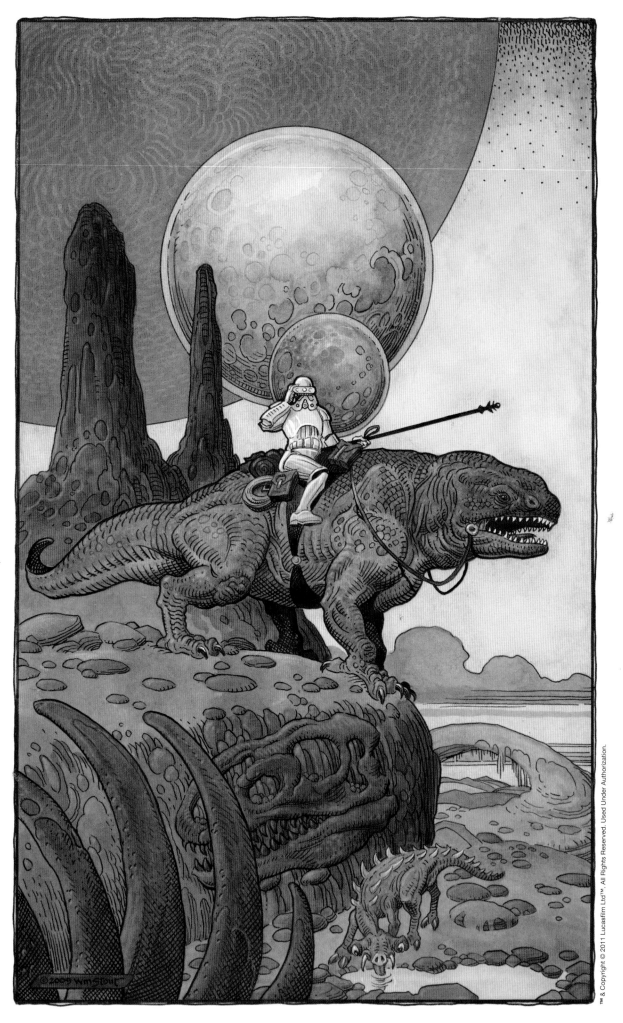

William Stout

Art Director: Troy Alders & Michelle Ishay *Designer:* Neil Egan with Francis Coy *Client:* Lucasfilm Ltd.™/Abrams *Title:* Searching for Anomalies
Size: 11"x18" *Medium:* Ink, watercolor, colored pencils on board

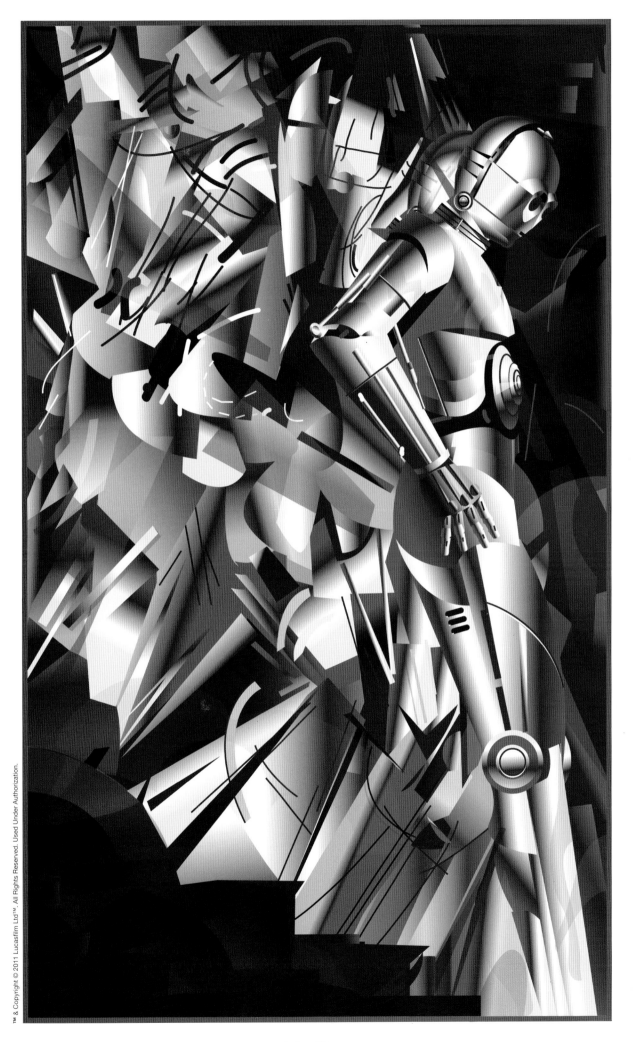

John Mattos

Art Director: Jon Rinzler *Client:* Lucasfilm Ltd.™/Abrams *Title:* C3PO Descending a Stairway *Size:* 24"x36" *Medium:* Digital

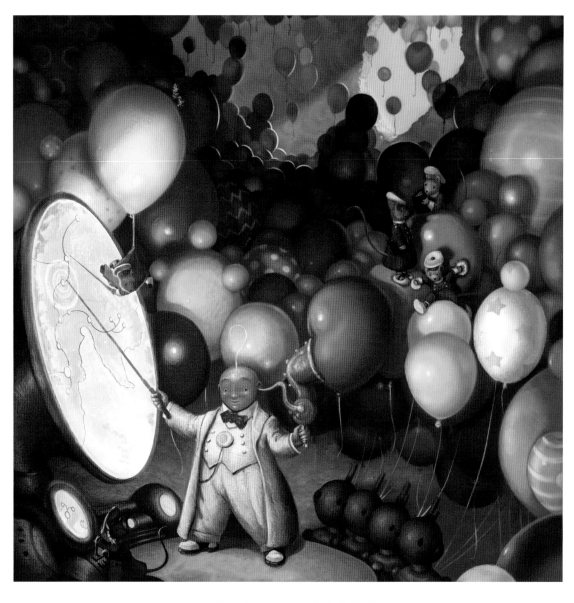

William Joyce/howdy ink, LLC
Client: Simon & Schuster *Title:* The Man ub the Moon [page 37] *Size:* 10"x10" *Medium:* CGI over oil

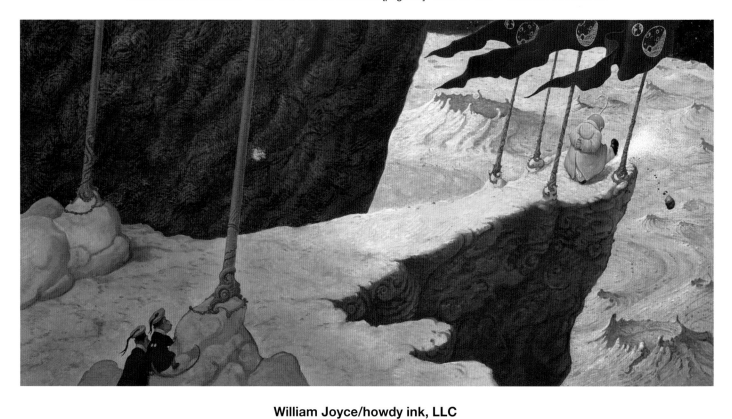

William Joyce/howdy ink, LLC
Client: Simon & Schuster *Title:* The Man ub the Moon [pages 42 & 43] *Size:* 10"x20" *Medium:* CGI over oil

Jon J Muth

Art Director: David Saylor *Designer:* David Saylor *Client:* Scholastic Press *Title:* Zen Ghosts [cover] *Size:* 14"x11" *Medium:* Watercolor

William Joyce/howdy ink, LLC

Client: Simon & Schuster *Title:* The Man ub the Moon [pages 46 & 47] *Size:* 10"x20" *Medium:* CGI over oil

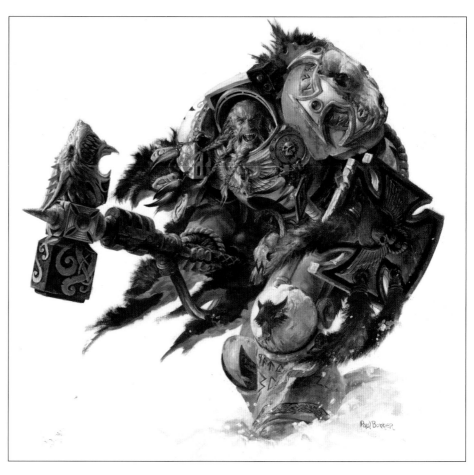

Vanja Todoric
Client: Orfelin Izdavastvo *Title:* Talason: Shadow Keeper
Medium: Digital

Paul Bonner
Art Director: Warwick Kinrade *Client:* Games Workshop
Title: Spacewolves Space Marine *Size:* 37"x34" *Medium:* Watercolor

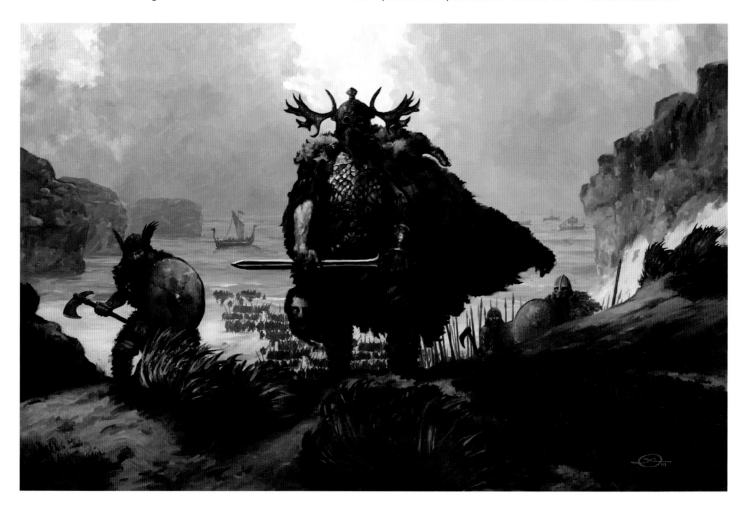

Benjamin von Eckartsberg
Client: Weltbild Verlag *Title:* Revenge of the Nibelungs *Medium:* Digital

Paul Bonner

Art Director: Warwick Kinrade *Client:* Games Workshop *Title:* Astral Claws Space Marine *Size:* 36"x51" *Medium:* Watercolor

Chris Gall

Art dirctor: Chris Thompson *Designer:* White Lady *Client:* Sterling Publishing *Size:* 5"x8" *Medium:* Digital

Leo & Diane Dillon

Art Director: Lauren Rille *Designer:* Caitlyn Dlovhy *Client:* Simon & Schuster *Title:* The Secret River Size: 7.5"x8.75" *Medium:* Acrylic on board

Lisa L. Cyr
Art Director: Guy Kelly *Client:* FTW Media/North Light Books
Title: Voyage to Michaelania *Size:* 16"x20" *Medium:* Mixed on board

Donato Giancola
Client: Underwood Books *Title:* The Taming of Smeagol
Size: 36"x48" *Medium:* Oil on panel

Benjamin von Eckartsberg
Client: Weltbild Verlag *Title:* Rune Shield *Medium:* Digital

Petar Meseldžija

Client: Orfelin Izdavaštvo *Title:* The Knight & The Dwarves *Size:* 32x58cm *Medium:* Oil

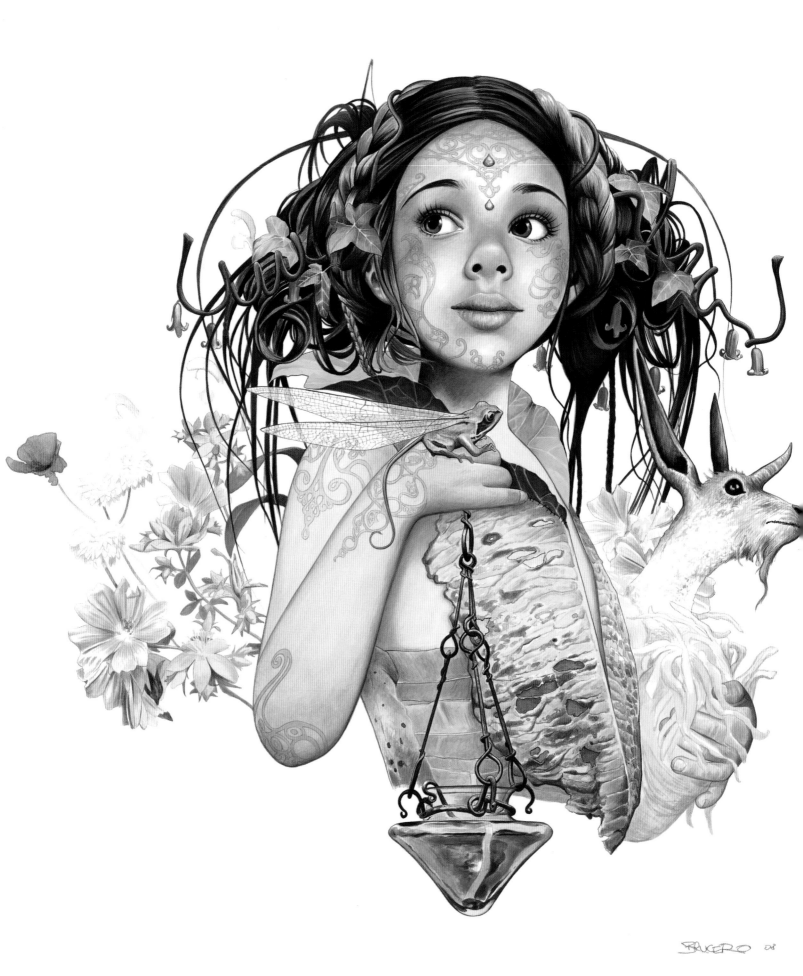

Brucero

Client: Drugstore/Glénat Publishing *Title:* La Fée aux Parfums *Size:* 35x36cm *Medium:* Acrylic on paper

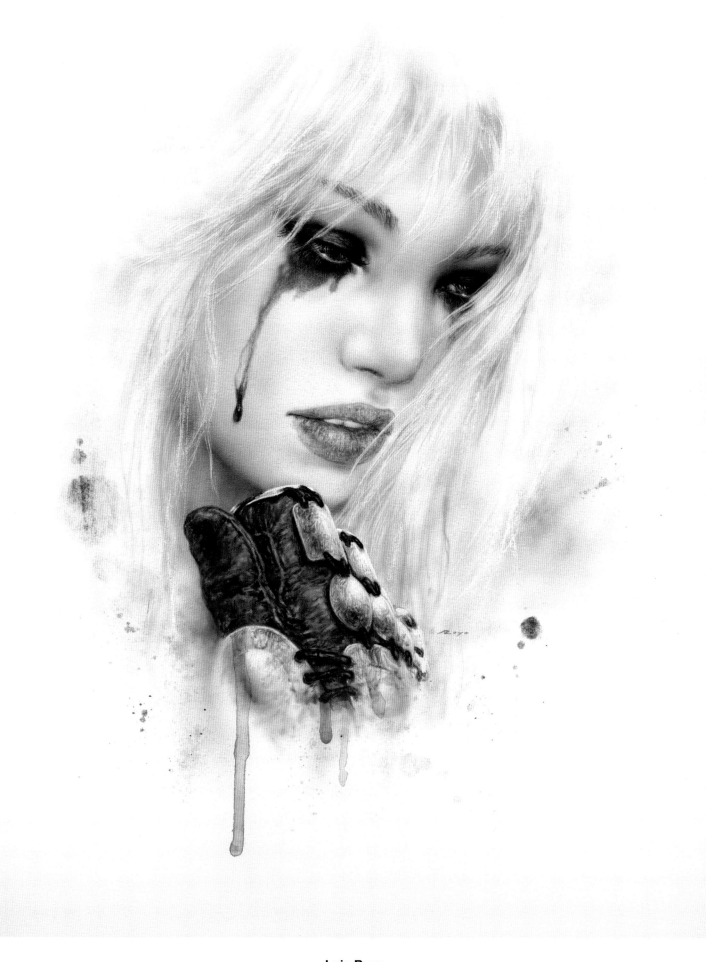

Luis Royo

Art Director: Luis Royo *Client:* Norma Editorial *Title:* From Malefic Time *Size:* 14"x20" *Medium:* Acrylic & ink

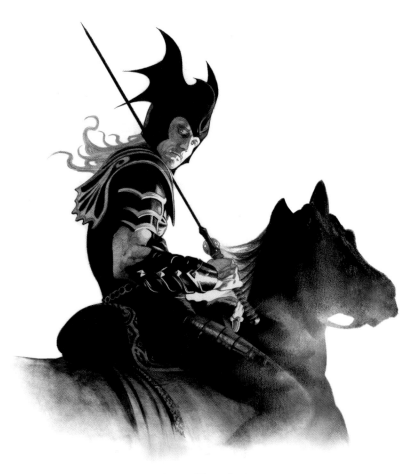

Petar Meseldžija
Client: Orfelin İzdavaštvo *Title:* Svjatogor *Size:* 27x56cm
Medium: Oil

John Picacio
Art Director: Betsy Mitchell *Client:* Del Rey Books
Title: Elric: Of Battle and Exile *Size:* 14"x14" *Medium:* Pencil/acrylic

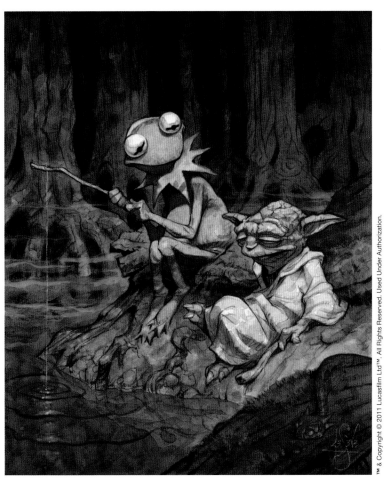

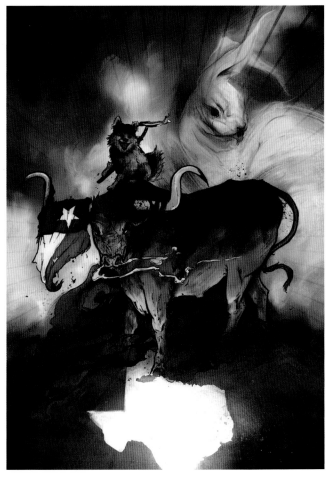

Peter de Sève
Art Director: Peter de Sève *Client:* Lucasfilm Ltd.™/Abrams
Title: Easy Being Green, It Is Not *Size:* 12"x18" *Medium:* Ink/watercolor

Cody Tilson
Art Director: David Palumbo *Client:* Night Shade Books
Title: Revolution World *Medium:* Ink/digital

Russell Walks

Title: Good Day, Sunshine *Size:* 10"x10" *Medium:* Acrylic and colored pencil

Craig Phillips

Art Director: Liz Casal *Designer:* Liz Casal *Client:* Poppy *Title:* Red Riding Hood *Medium:* Ink/Digital CS2

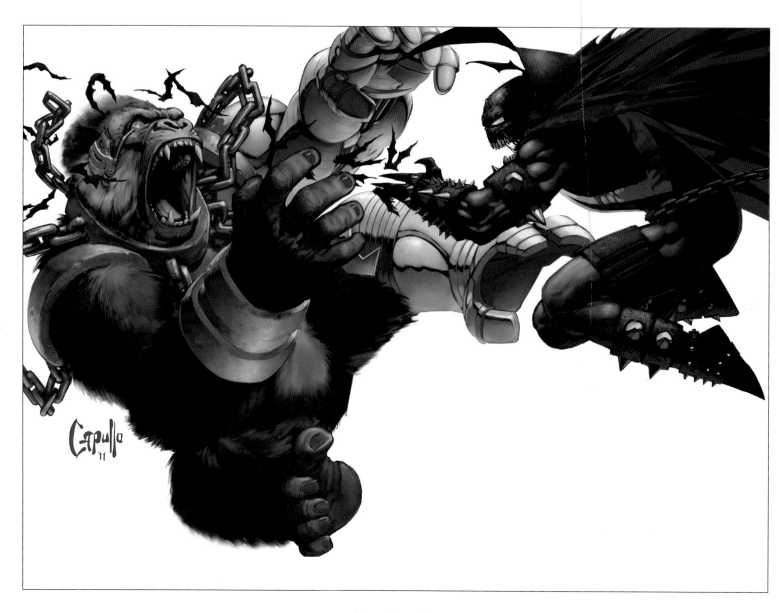

Greg Capullo
Art Director: Todd McFarlane *Client:* TMP, Inc. *Title:* Spawn Vs Cy-Gor *Size:* 32"x22" *Medium:* Digital

Ritche Sacilioc
Client: DreamWorks, LLC *Title:* The Oren Gate *Medium:* Digital

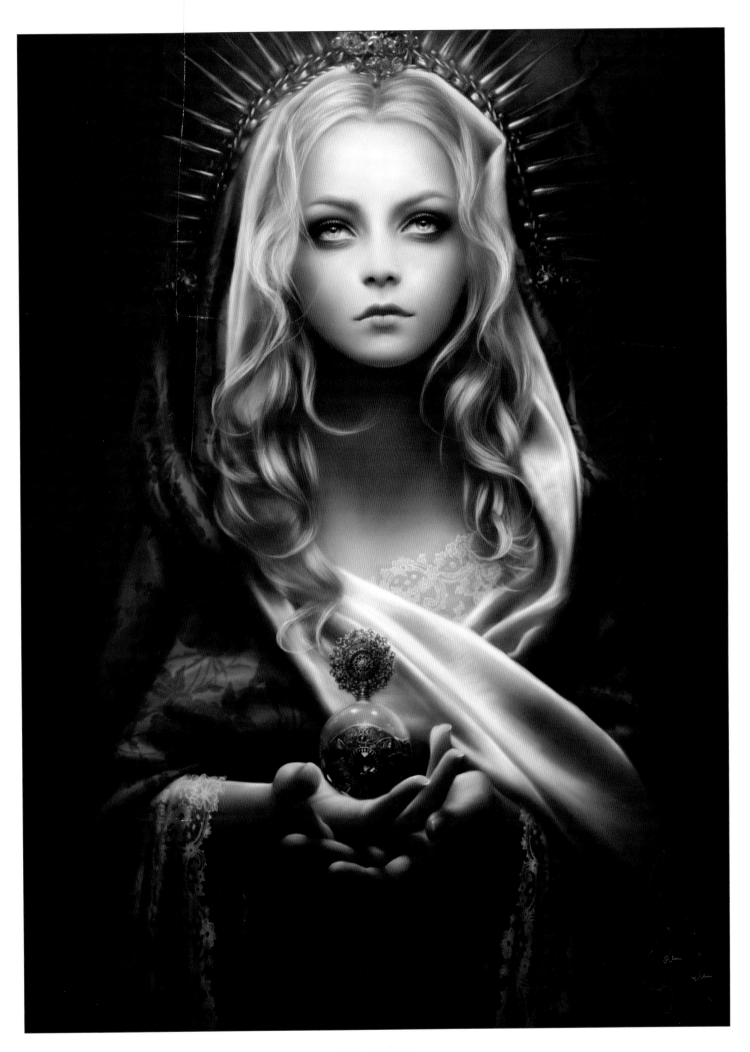

Mélanie Delon

Client: Norma Editorial *Title:* The Offering *from* Elixir 2 *Size:* 6"x9" *Medium:* Digital

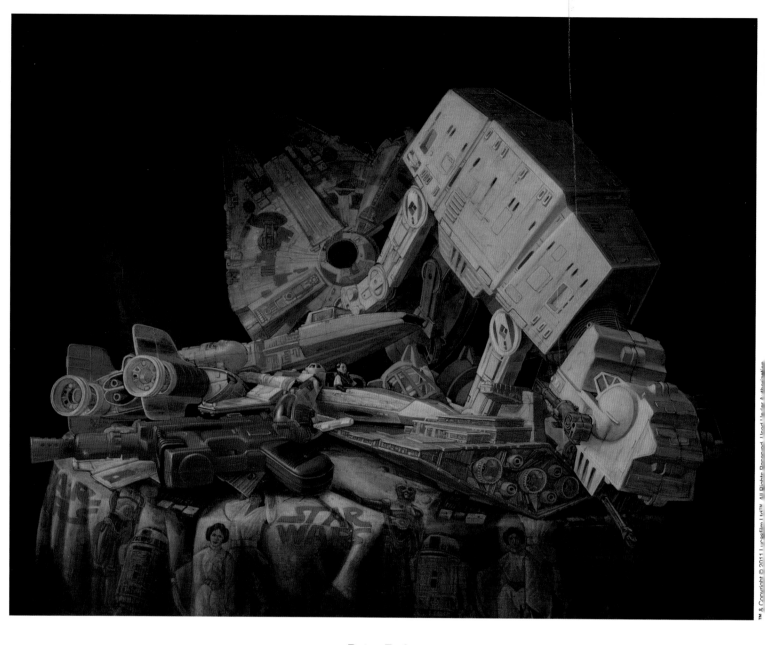

Peter Ferk
Client: Lucasfilm Ltd.™/Abrams *Title:* The Stuff That Dreams Are Made Of *Size:* 20"x16" *Medium:* Acrylic on gessoboard

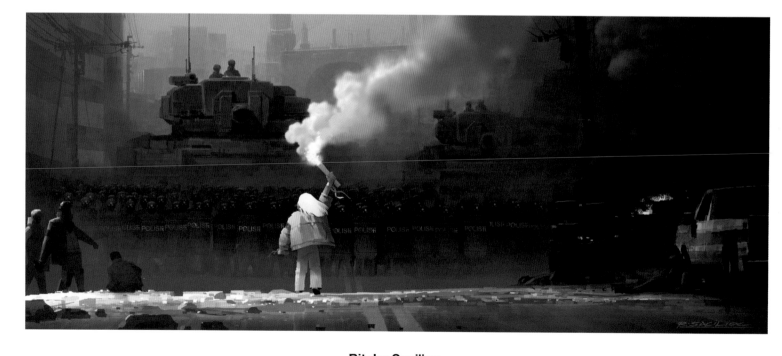

Ritche Sacilioc
Client: DreamWorks, LLC *Title:* The Signal *Medium:* Digital

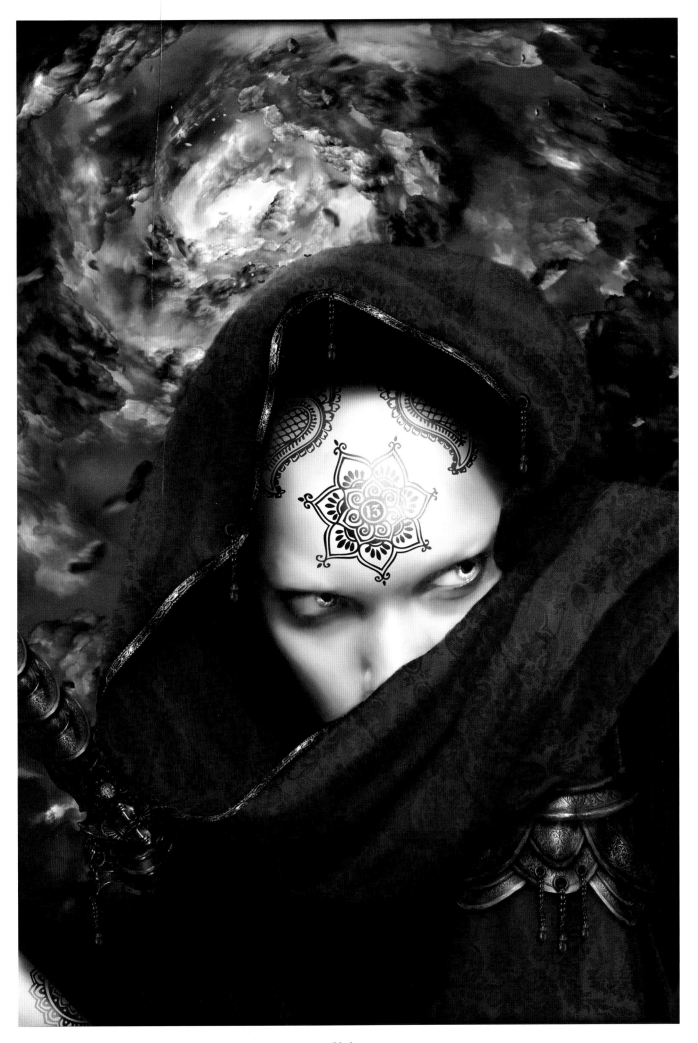

Nekro

Client: Norma Editorial *Title:* 13 Inches/Shadow *Medium:* Digital

Raoul Vitale
Title: Evening Vigil *Size:* 9.5"x13.5" *Medium:* Pencil

Dan Dos Santos
Client: Ace Books *Title:* River Marked *Medium:* Oil

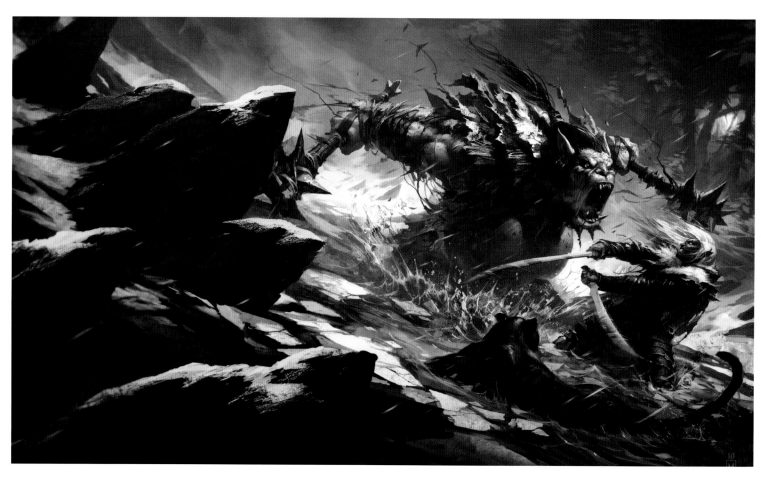

Raymond Swanland
Art Director: Matt Adelsperger *Client:* Wizards of the Coast *Title:* R.A. Salvatore: Collected Stories *Medium:* Digital

Cris Ortega
Client: Heavy Metal Books *Title:* Dome *from* Forgotten 3
Size: 6"x9" *Medium:* Digital

Omar Rayyan
Art Director: Sheri Gee *Client:* The Folio Society Ltd.
Title: The Lion and The Cat *Size:* 8.5"x11" *Medium:* Watercolor

Greg Ruth
Art Director: Irene Gallo *Client:* Tor Books *Title:* Crossroads of Twilight *Size:* 11"x8.5" *Medium:* Mixed

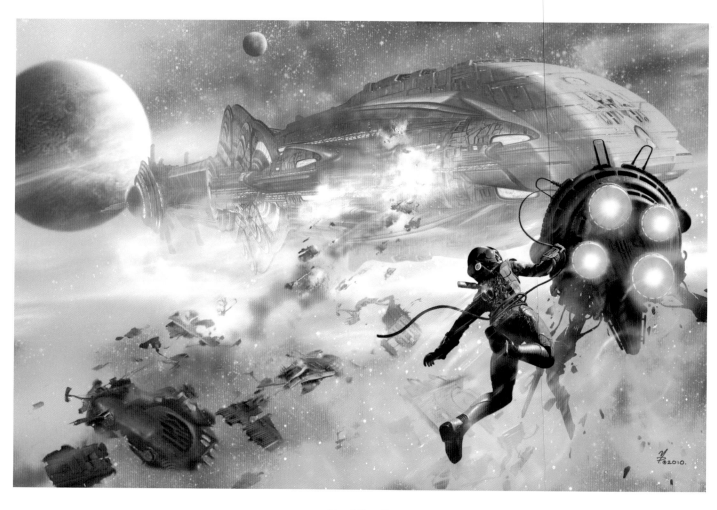

Paul Youll
Art Director: Sheila Gilbert *Client:* DAW Books *Title:* Truth of Valor *Medium:* Mixed

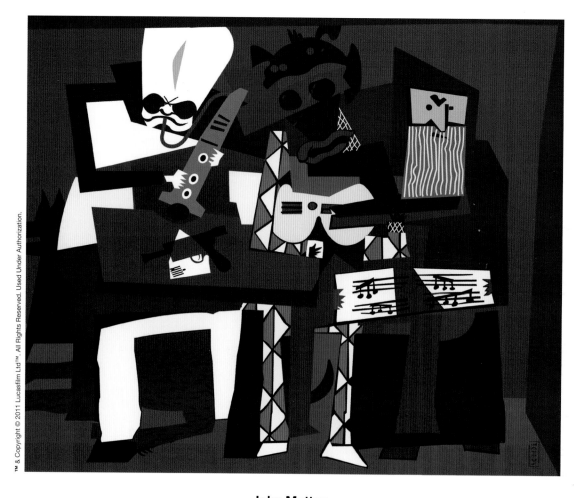

John Mattos
Art director: Jon Rinzler *Client:* Lucasfilm Ltd.™/Abrams *Title:* Pablo's Cantina *Size:* 36"x24" *Medium:* Digital

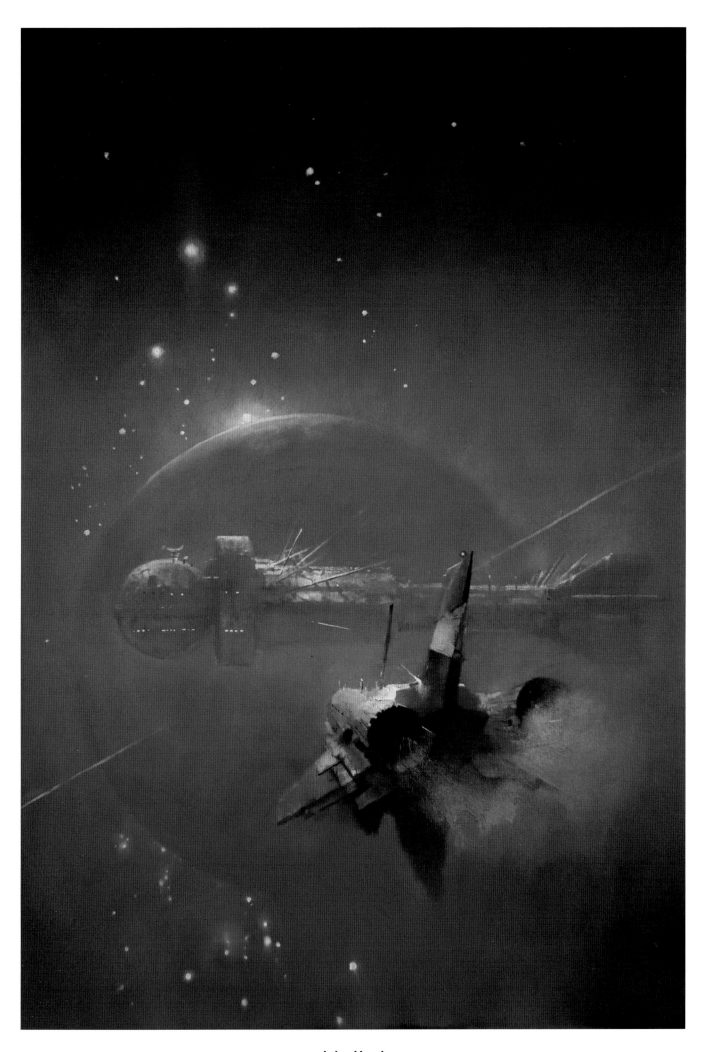

John Harris

Art Director: Irene Gallo *Client:* Tor Books *Title:* Count to a Trillion *Size:* 22"x30" *Medium:* Acrylics on canvas

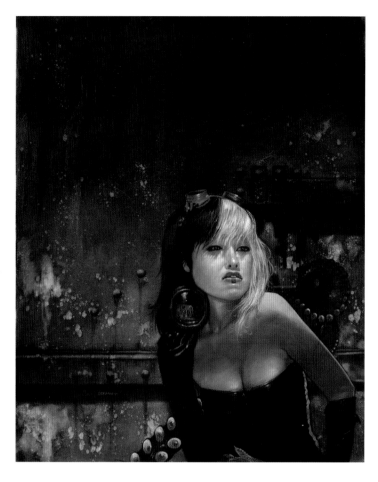

Dave Dorman
Art Director: Joe Pruett *Client:* Desperado/IDW *Title:* Reverie
Size: 24"x30" *Medium:* Oil/acrylic

Karen Hsiao
Model: Danni Luo *Client:* Baby Tattoo Books
Title: Youngest Sister *Size:* 6"x8.5" *Medium:* Photography

Dave McKean
Client: Fantagraphics/Delacourt Press *Title:* Celluloid [pages 102-103] *Size:* 22"x8.5" *Medium:* Mixed

Karen Hsiao

Model: Jill Evyn *Makeup:* L.B. Benson *Client:* Baby Tattoo Books *Title:* Sea Nymph *Size:* 6"x8.5" *Medium:* Photography

Haitao Su
Client: China Youth Press *Title:* Eve's Apple *Size:* 16"x12" *Medium:* Digital

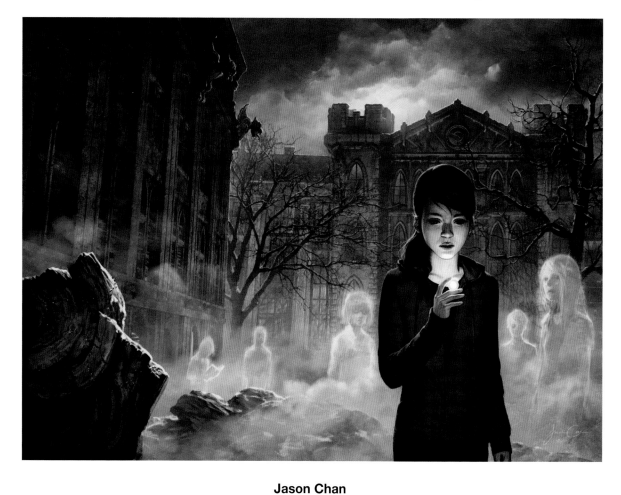

Jason Chan
Art Director: Lisa Vega *Client:* Simon & Schuster *Title:* Among Ghosts *Size:* 22.5"x16.5" *Medium:* Digital

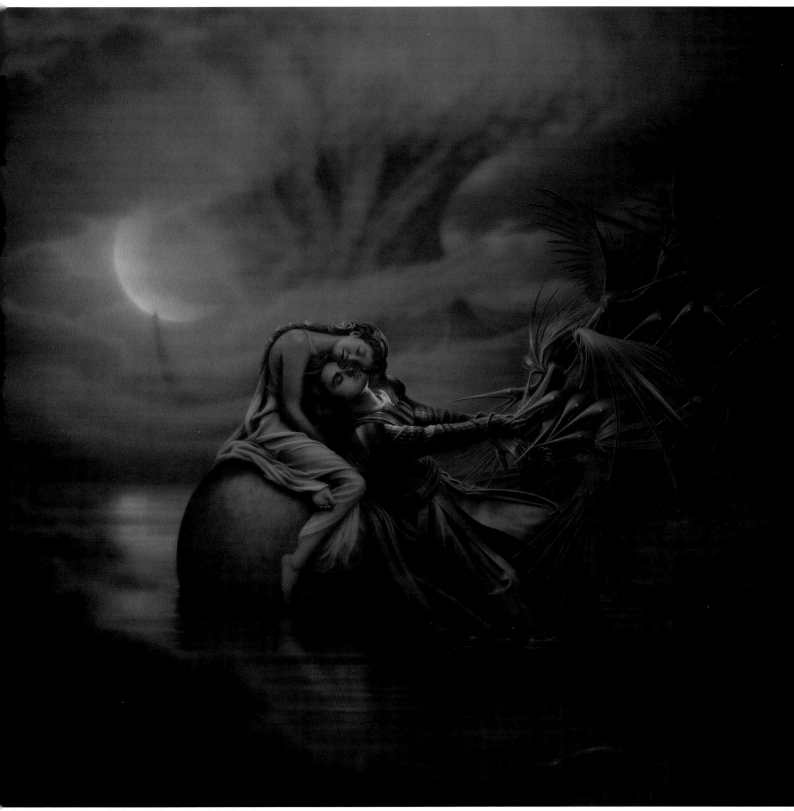

Kirk Reinert

Client: Lucasfilm Ltd.™/Abrams *Title:* Vader's Dream: A visitation from Padme *Size:* 44"x39" *Medium:* Acrylic

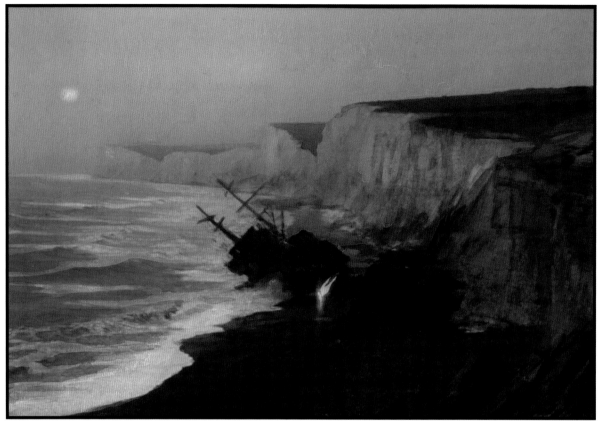

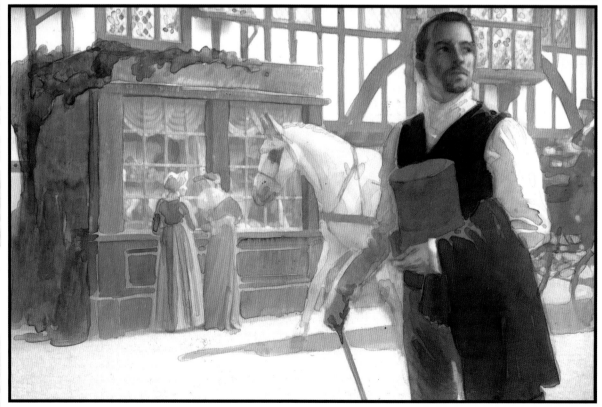

Rebecca Guay

Art Director: Karen Berger *Client:* DC Comics *Title:* A Flight of Angels *Size:* 11"x17" *Medium:* Mixed/gouache

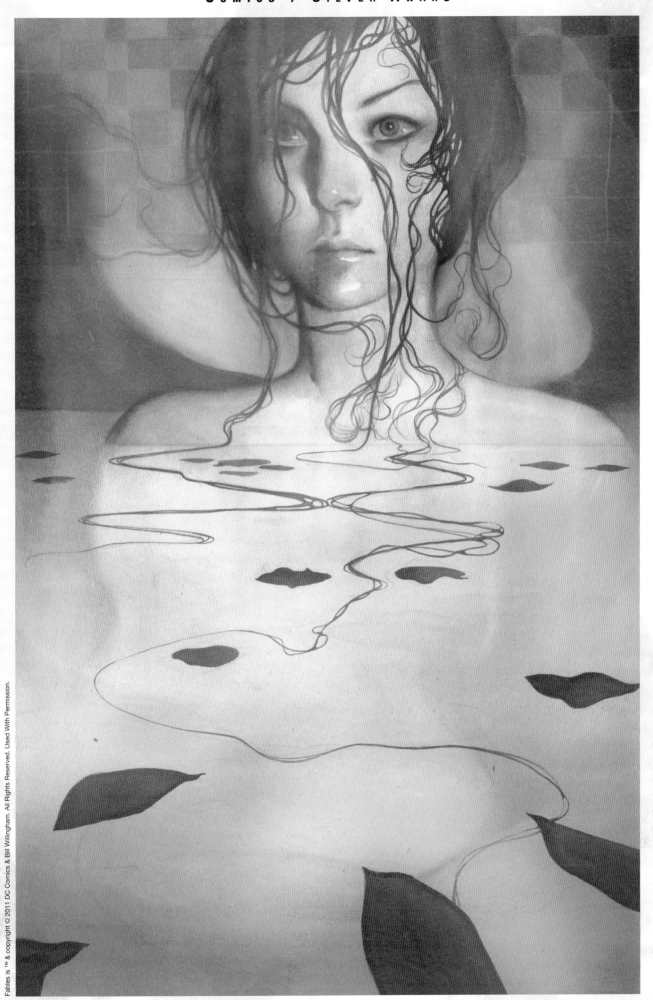

João Ruas

Art Director: Shelly Bond *Client:* DC Comics/Bill Willingham *Title:* Fables #96 *Size:* 9.8"x14.7" *Medium:* Watercolor/digital

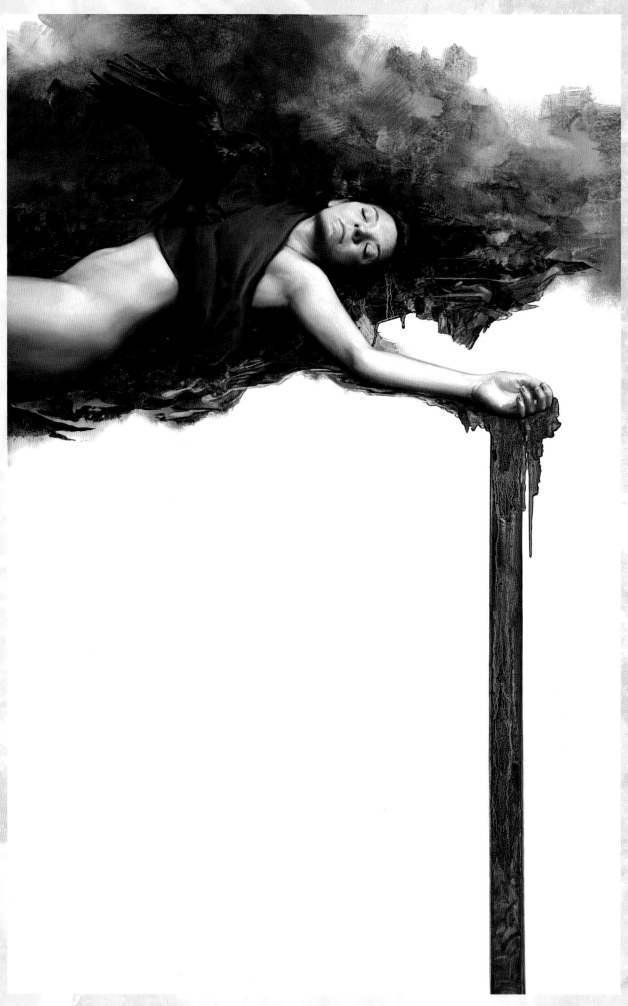

David Palumbo
Art Director: Rick Ritter *Client:* Last Minute Comics *Title:* Sleep *Size:* 15"x25" *Medium:* Oil

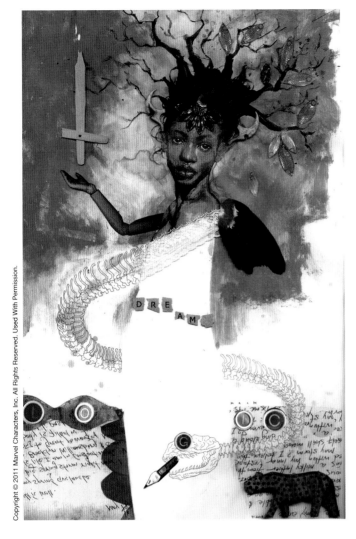

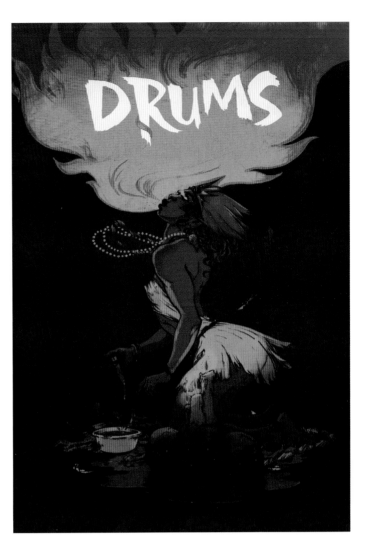

David Mack
Client: Marvel Comics *Title:* Dream Logic
Size: 6"x10" *Medium:* Mixed

Raul Allen
Art Director: Malaka Studio *Client:* Image Comics
Title: Drums *Size:* 11"x17" Medium: Pencil/digital

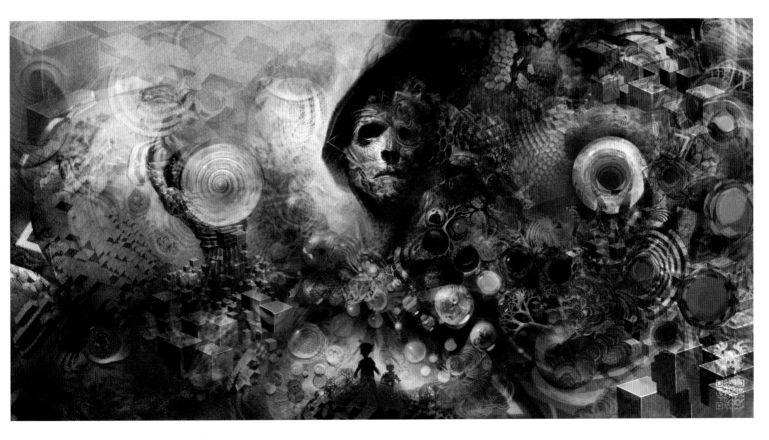

Android Jones
Art Director: *Jeremy Berger* Client: *Radical Publishing* Title: *Enter Nocturnus* *Medium:* Corel Painter

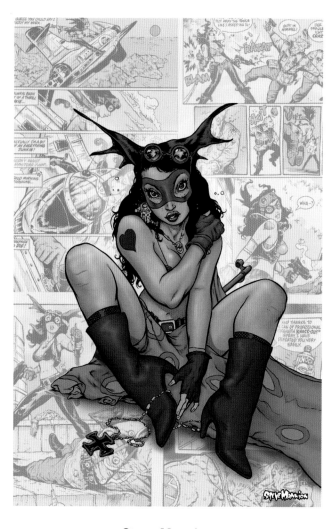

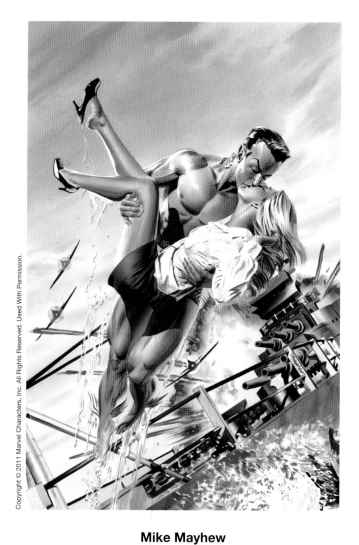

Steve Mannion

Art Director: Frank Forte *Designer:* Frank Forte Client: *Asylum Press*
Title: Fearless Dawn *Size:* 6.8"x10.5" *Medium:* Ink/digital

Mike Mayhew

Designer: Jody LeHeup Client: *Marvel Comics*
Title: Namor #5 [cover] *Size:* 11"x17" *Medium:* Watercolor

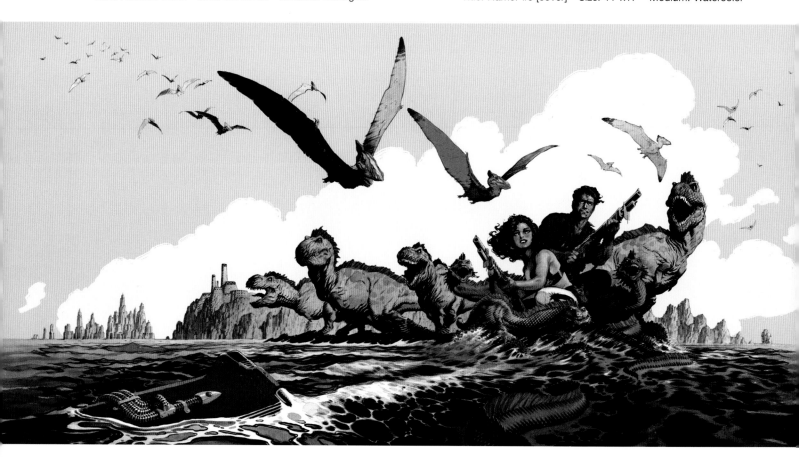

Mark Schultz

Art Director: John Fleskes *Client:* Flesk Publications *Title:* Xenozoic *Medium:* Brush & ink/watercolor

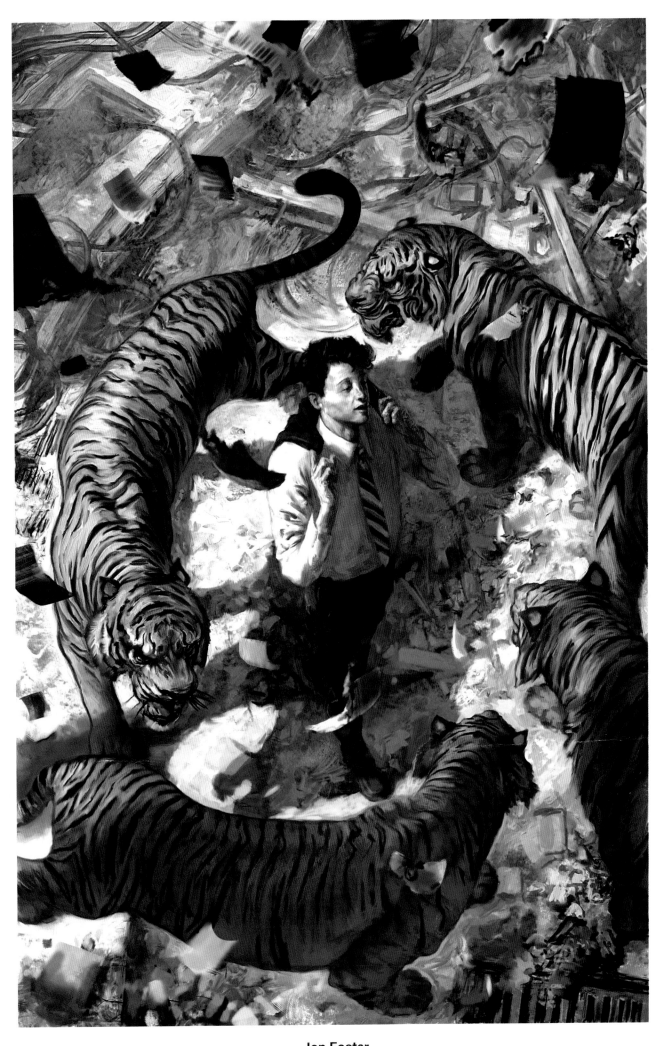

Jon Foster

Art Director: Courtney Huddleston *Client:* Penny Farthing Press *Title:* Big Man *Medium:* Digital

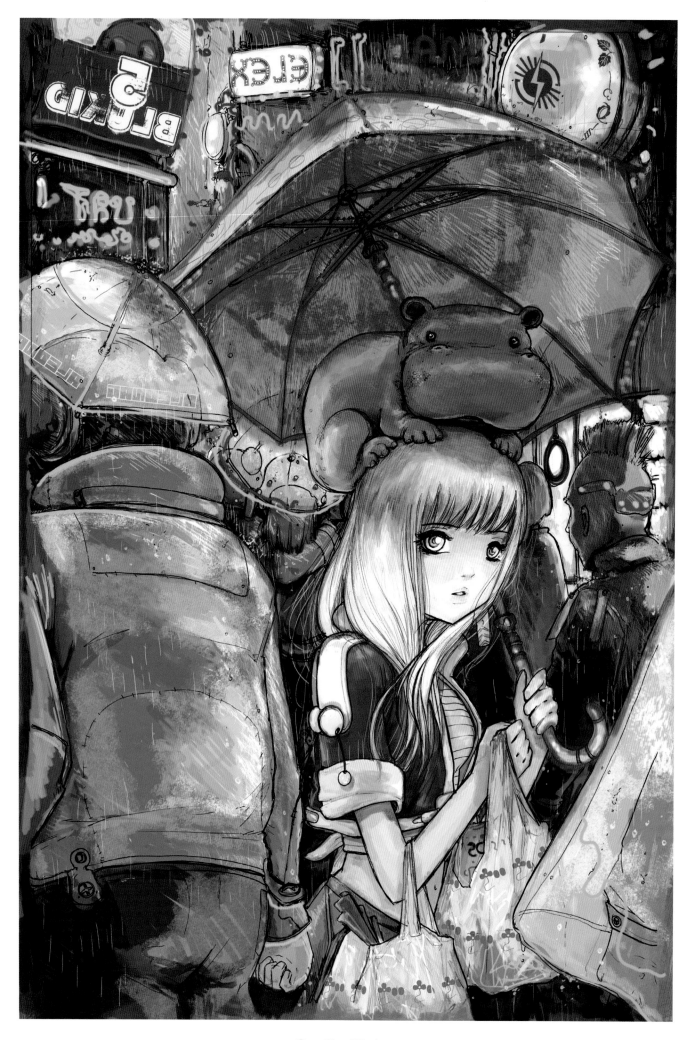

Camilla d'Errico

Client: Hipflask Productions/Elephantmen Magazine *Title:* Elephantmen #29 [cover] *Size:* 11"x17" *Medium:* Pencil/Photoshop

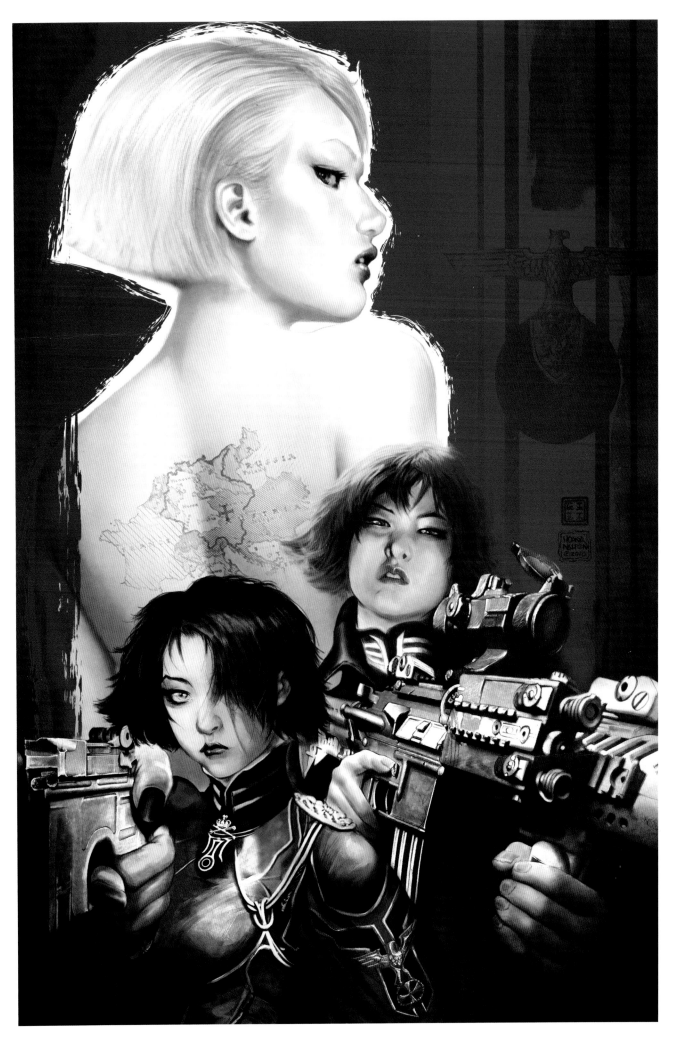

Hoang Nguyen
Client: Image Comics *Title:* Carbon Grey *Size:* 11"x17" *Medium:* Photoshop

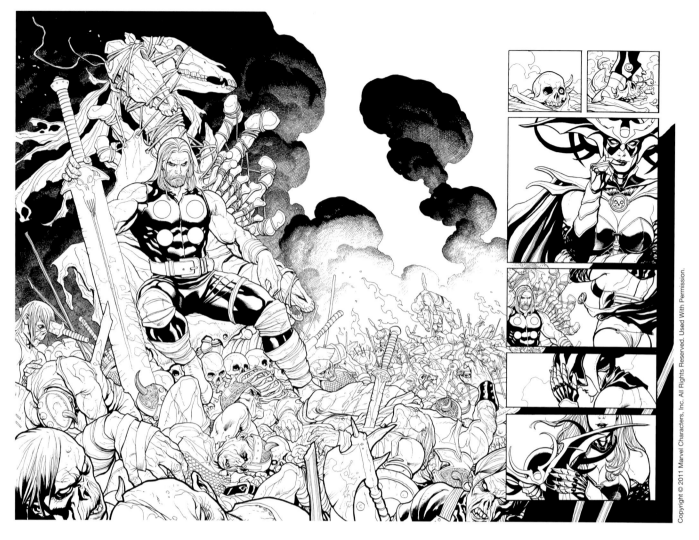

Frank Cho

Client: Marvel Comics *Title:* Thor in Hell: New Ultimates *Size:* 28"x21" *Medium:* Pen & ink

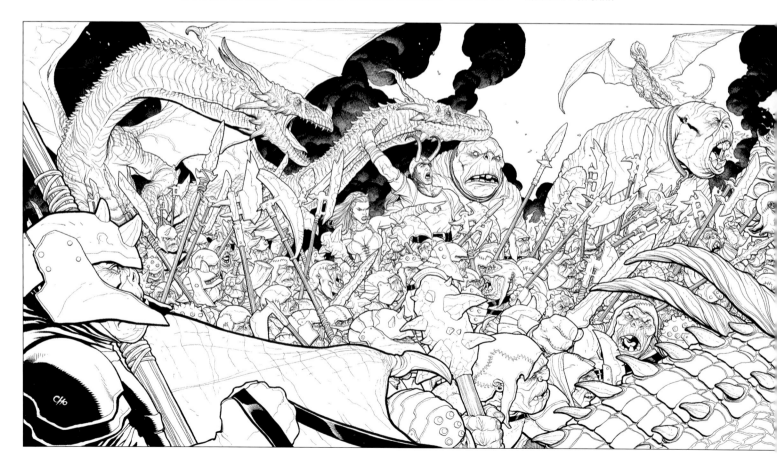

Frank Cho

Client: Marvel Comics *Title:* New Ultimates #1 [cover] *Size:* 84"x21" *Medium:* Pen & ink

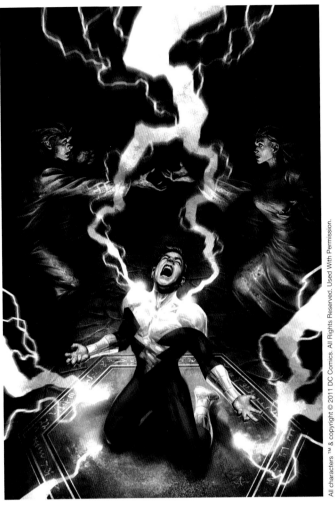

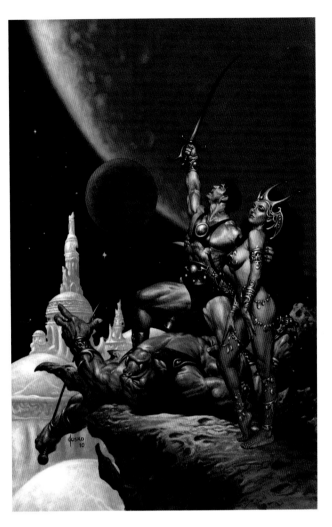

Alex Garner

Client: DC Comics *Title:* Titans: Villains For Hire Special [cover]
Size: 10.5"x15.8" *Medium:* Photoshop

Joe Jusko

Client: Dynamite Enetertainment *Title:* Warlord of Mars #1 [cover]
Size: 14"x22" *Medium:* Acrylic

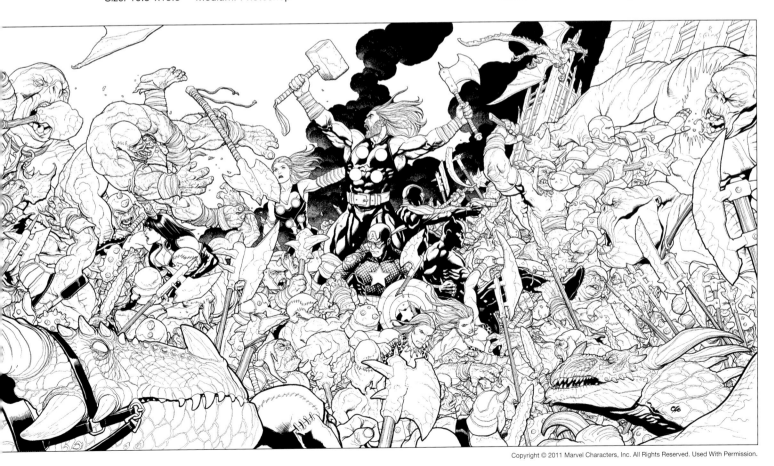

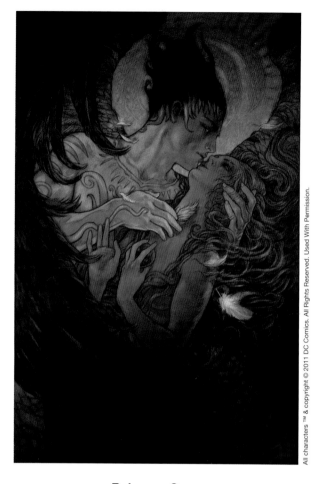

Rebecca Guay

Art Director: Karen Berger *Client:* Vertigo/DC Comics
Title: A Flight of Angels *Size:* 11"x17" *Medium:* Ink/oil

Menton 3

Client: IDW Publishing *Title:* Silent Hill: Past Life #3 [cover]
Size: 18"x24" *Medium:* Oil

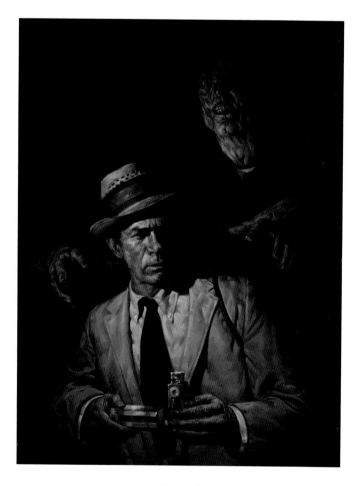

Viktor Koen

Art Director: Paul Hoppe *Client:* Rabid Rabbit
Title: Hell-O-Kitty *Size:* 8.5"x11" *Medium:* Digital

E.M. GIST

Art Director: Joe Gentile *Client:* Moonstone Books
Title: Kolchak: The Night Strangler *Size:* 16"x24" *Medium:* Oil

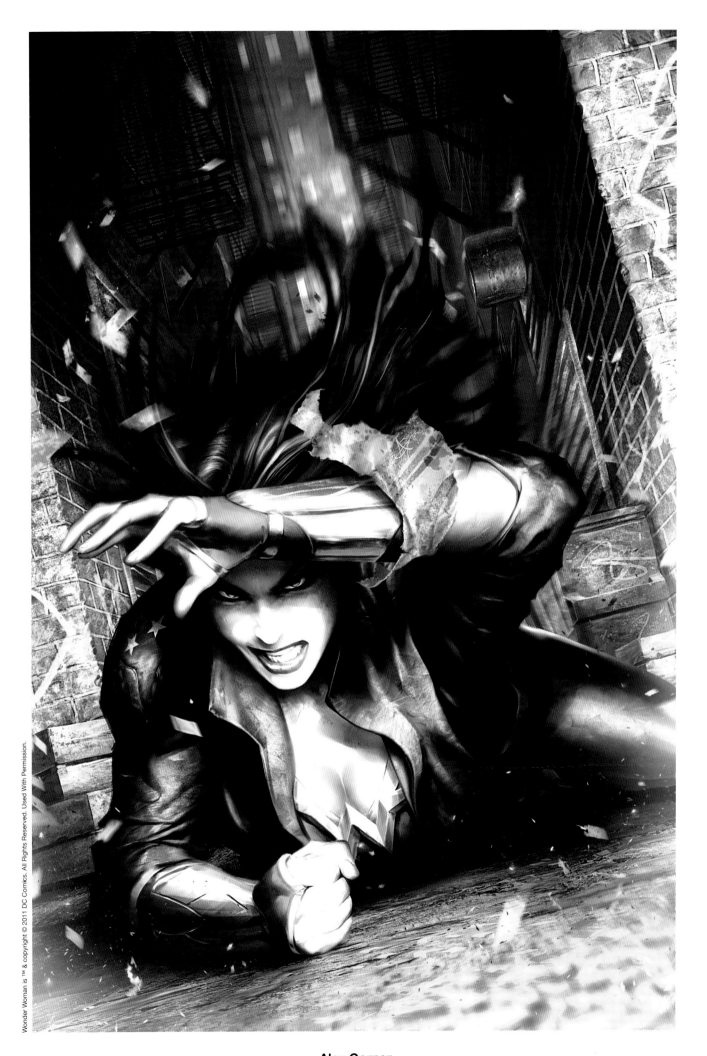

Alex Garner

Client: DC Comics *Title:* Wonder Woman #605 [cover] *Size:* 10.5"x15.8" *Medium:* Photoshop

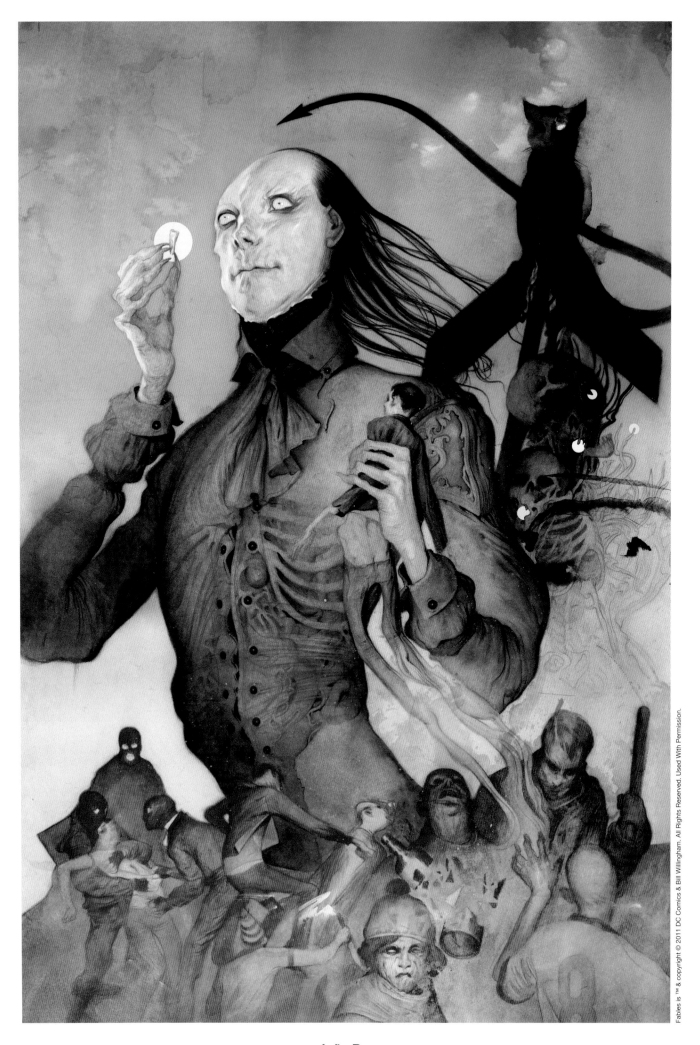

João Ruas
Art Director: Shelly Bond *Client:* DC Comics/Bill Willingham *Title:* Fables #99 *Size:* 12.2"x18" *Medium:* Watercolor/digital

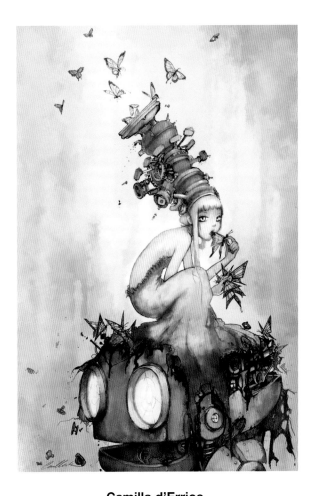

Sam Bosma

Client: The Anthology Project *Title:* Turtle Soup [page 8] *Medium:* Digital

Camilla d'Errico

Colorist: Edison Yan *Client:* Cloudscape Collective

Title: Exploded View [cover] *Size:* 11"x17" *Medium:* Pencil/Photoshop

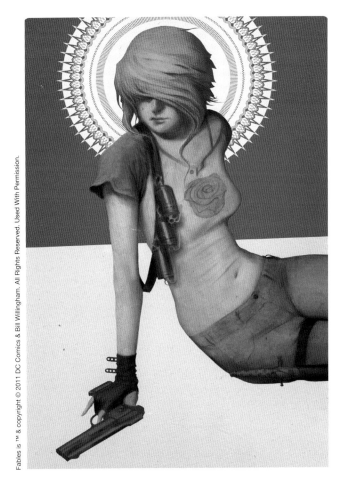

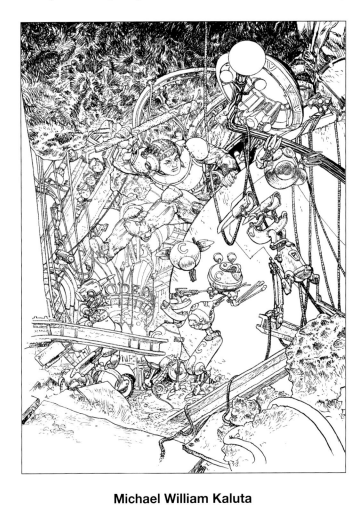

João Ruas

Art Director: Shelly Bond *Client:* DC Comics/Bill Willingham *Title:* Fables #97

Size: 9.7"x19.6" *Medium:* Watercolor/digital

Michael William Kaluta

Client: IDW *Title:* Get the Hell Out of My Way

Size: 11"x16" *Medium:* Pen & ink

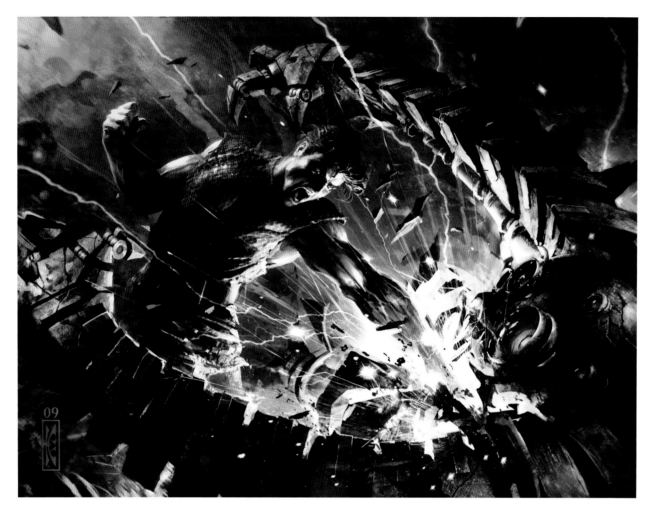

Raymond Swanland

Art Director: Chris Warner *Client:* Dark Horse Comics *Title:* Magnus FCBD 2010 *Medium:* Digital

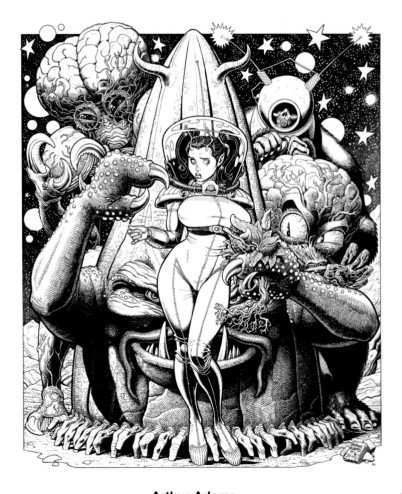

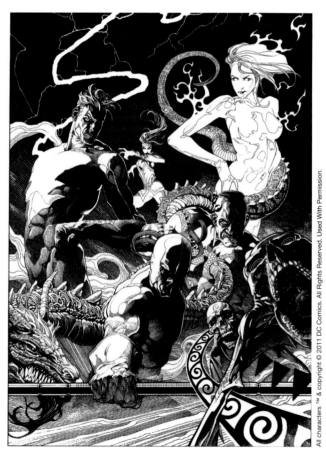

Arthur Adams

Title: Alieen Love *Size:* 14"x17" *Medium:* Pen & ink

Andy Brase

Art Director: Brian Cunningham *Client:* DC Comics *Title:* Titan Villains
Size: 11"x17" *Medium:* Ink

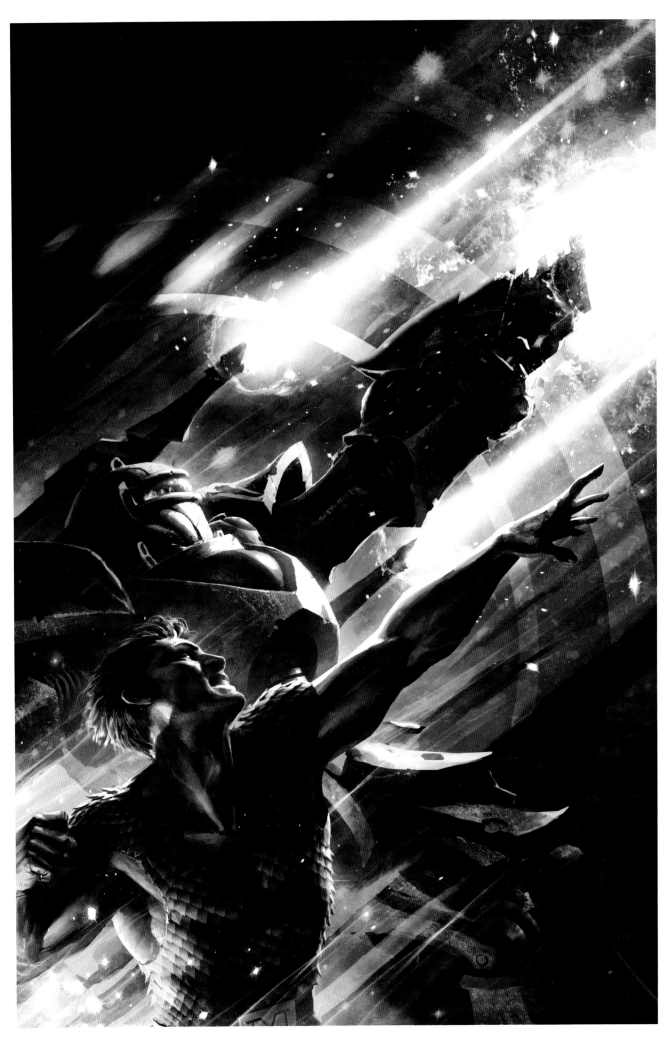

Raymond Swanland

Art director: Chris Warner *Client:* Dark Horse Comics *Title:* Magnus, Robet Fighter #5 [cover] *Medium:* Digital

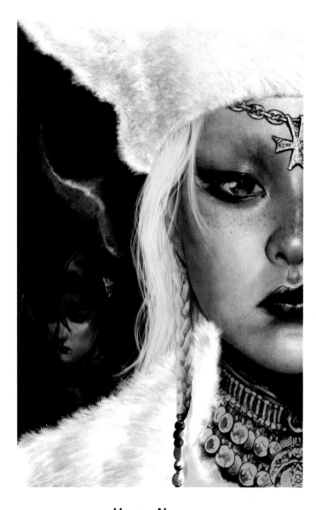

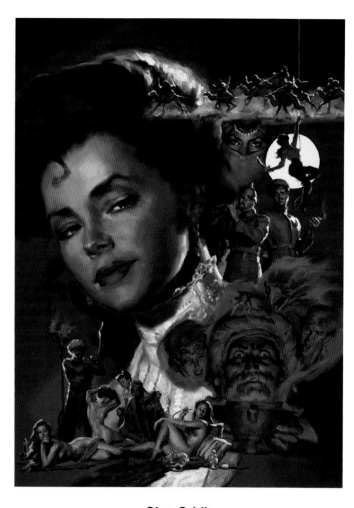

Hoang Nguyen
Client: Image Comics *Title:* Cossack Queen *Size:* 11"x17"
Medium: Photoshop

Glen Orbik
Art Director: Charles Hancock/Glen Orbik *Client:* Penny Farthing Press
Title: Anne Steelyard Book II *Size:* 18"x27" *Medium:* Oil

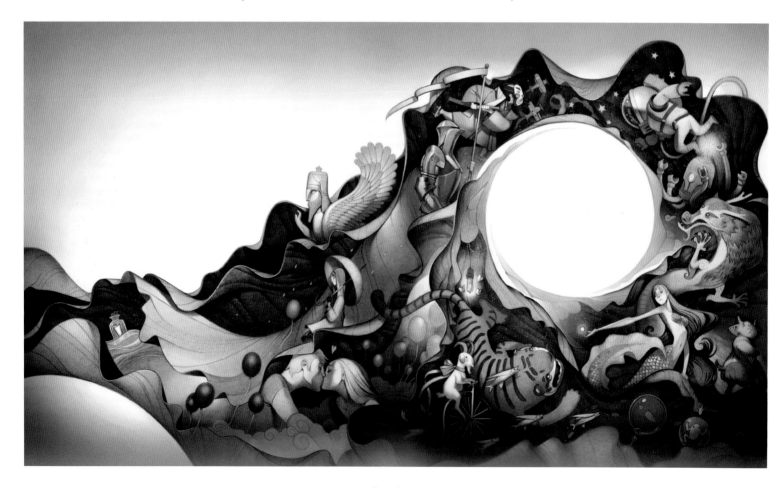

Joy Ang
Client: Lucidity Press *Title:* The Anthology Project #1 [cover] *Size:* 14"x8.5" *Medium:* Graphite/digital

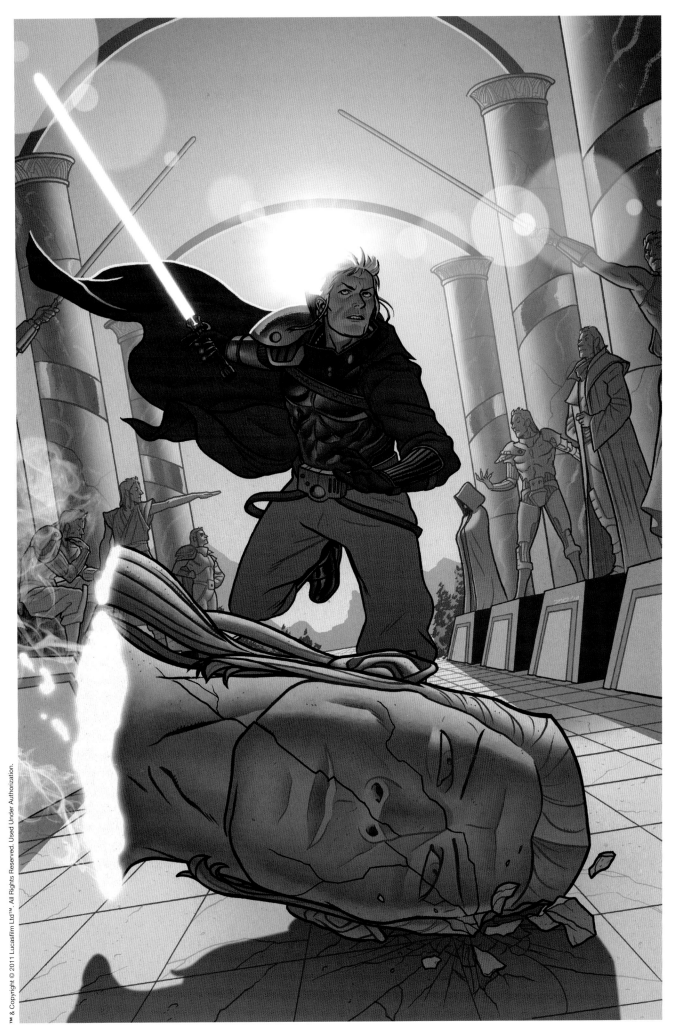

Joe Quinones

Art director: Dave Marshall *Client:* Dark Horse Comics *Title:* Star Wars: Knight Errant *Size:* 10.5"x15" *Medium:* Ink/digital

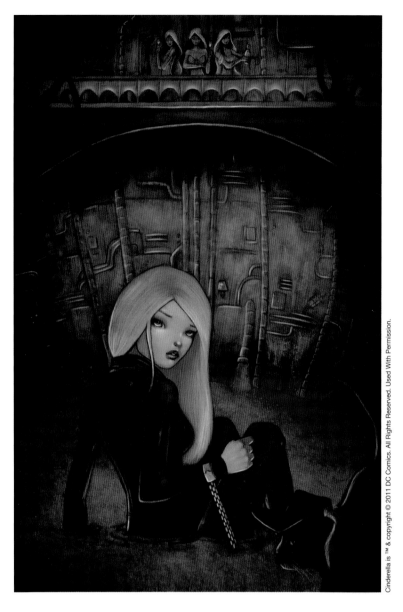

Chrissie Zullo
Art Director: Shelly Bond *Client:* DC Comics
Title: Cinderella: From Fabletown With Love #4 *Size:* 20"x30" *Medium:* Oil/digital

Doug Williams
Client: Undead Labs *Title:* Chance Encounter *Medium:* Digital

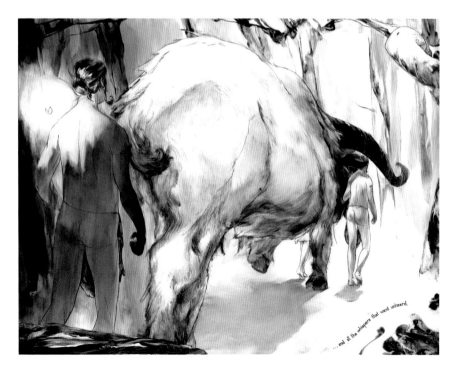

Grim Wilkins
Title: Love Story in the Woods [pages 35-36] *Size:* 26"x20" *Medium:* Ink & acrylic

João Ruas
Art Director: Shelly Bond *Client:* DC Comics/Bill Willingham
Title: Fables #94 *Size:* 9.5"x14.2" *Medium:* Watercolor/digital

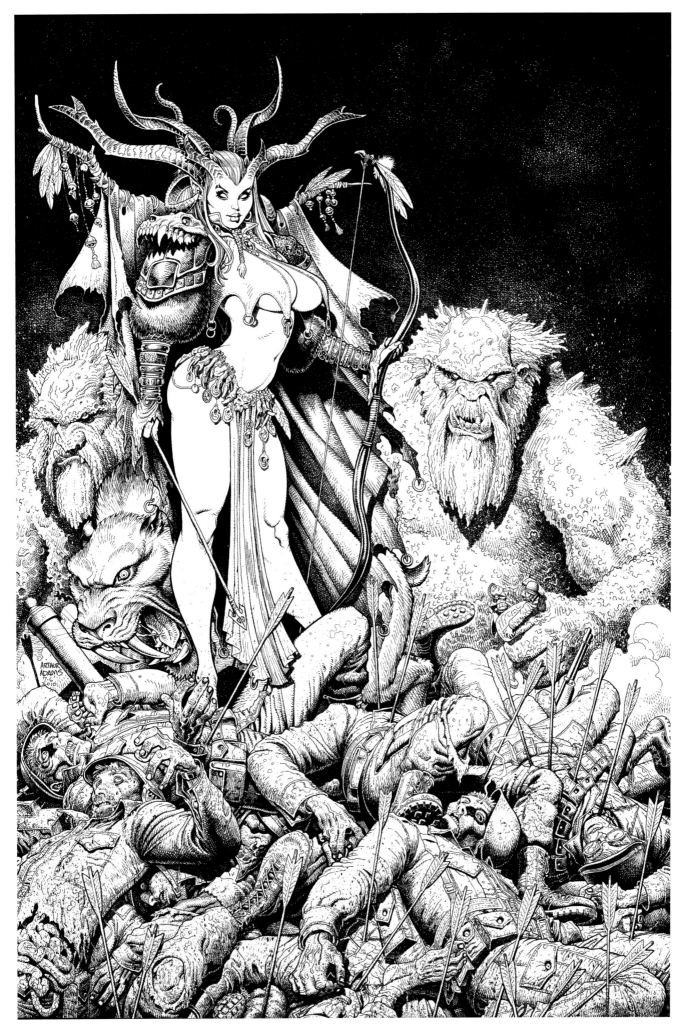

Arthur Adams

Title: Primitive Hella: Sketchbook #9 [cover] *Size:* 15.5"x23" *Medium:* Pen & ink

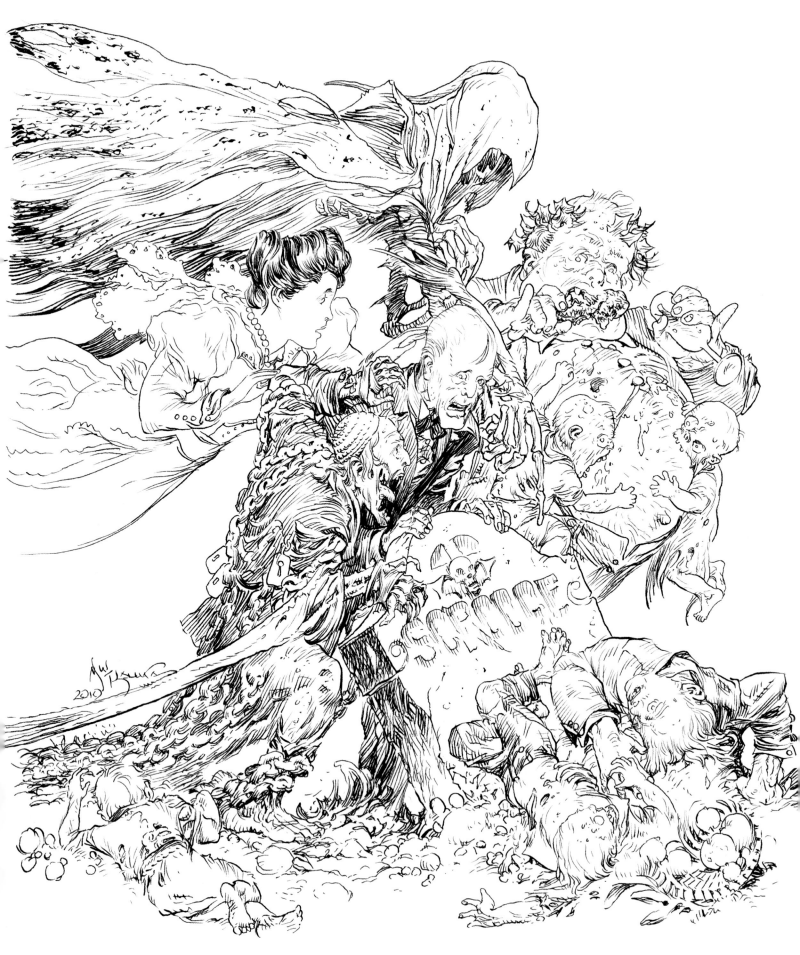

Michael William Kaluta

Art Director: Mark Paniccia & John Denning *Client:* Marvel Comics *Title:* A Zombie Christmas Carol *Size:* 12"x11" *Medium:* Pen & ink

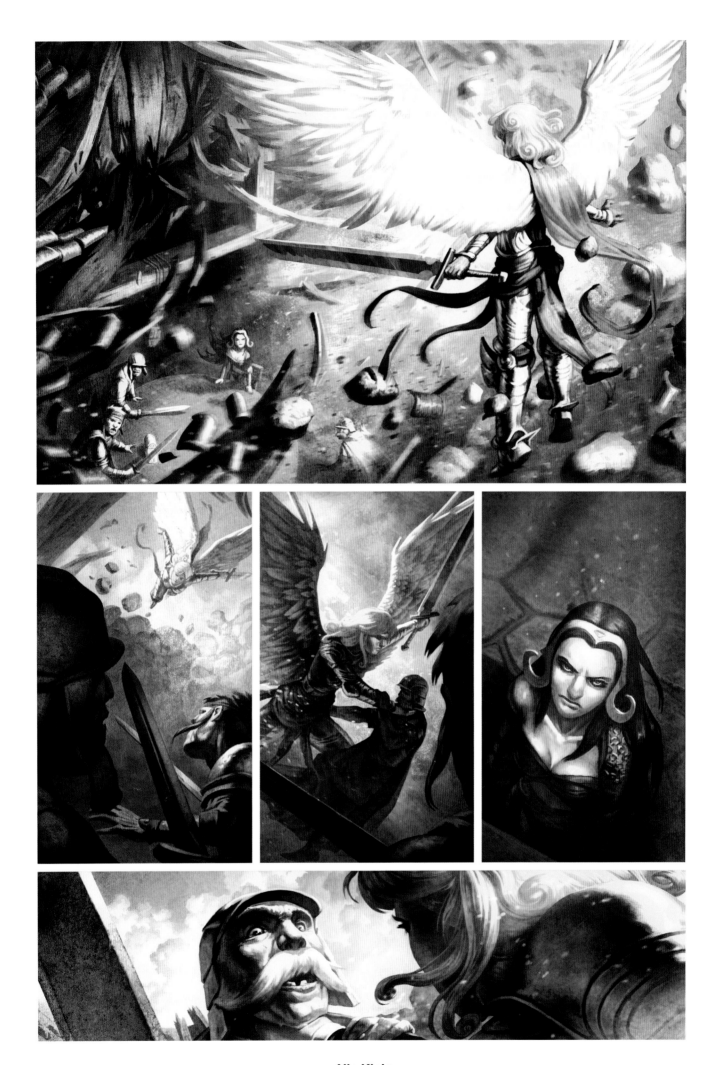

Nic Klein

Art Director: Jeremy Jarvis *Client:* Wizards of the Coast *Title:* Path of the Planeswalker Vol. 2 *Medium:* Digital

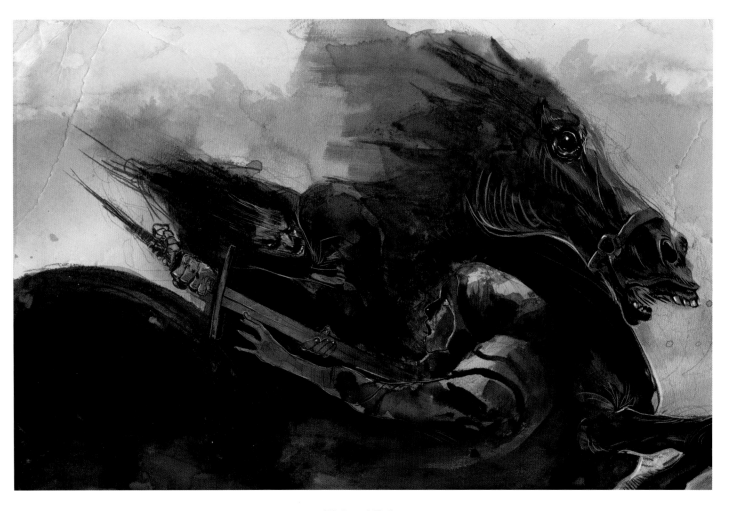

Richard Zela

Art Director: Carlos Sanchez *Designer:* Julian Romero *Client:* Axial *Title:* Zezolla *Size:* 17"x11" *Medium:* Ink/coffee/digital

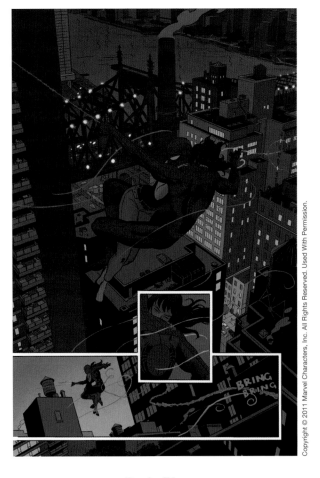

Paolo Rivera

Title: Amazing Spider-Man #640 [page 20] *Size:* 11"x17"
Medium: Ink with digital color

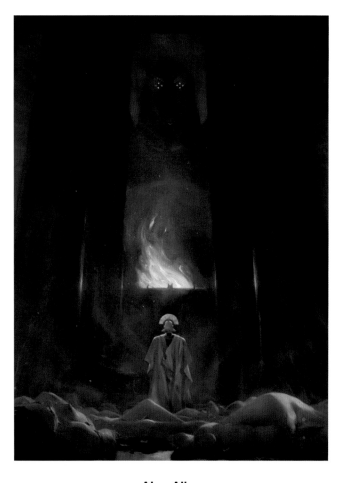

Alex Alice

Art Director: Jean-Michel Boxus *Client:* BD Must
Title: Le Troisieme Testament II *Size:* 18"x24" *Medium:* Oil

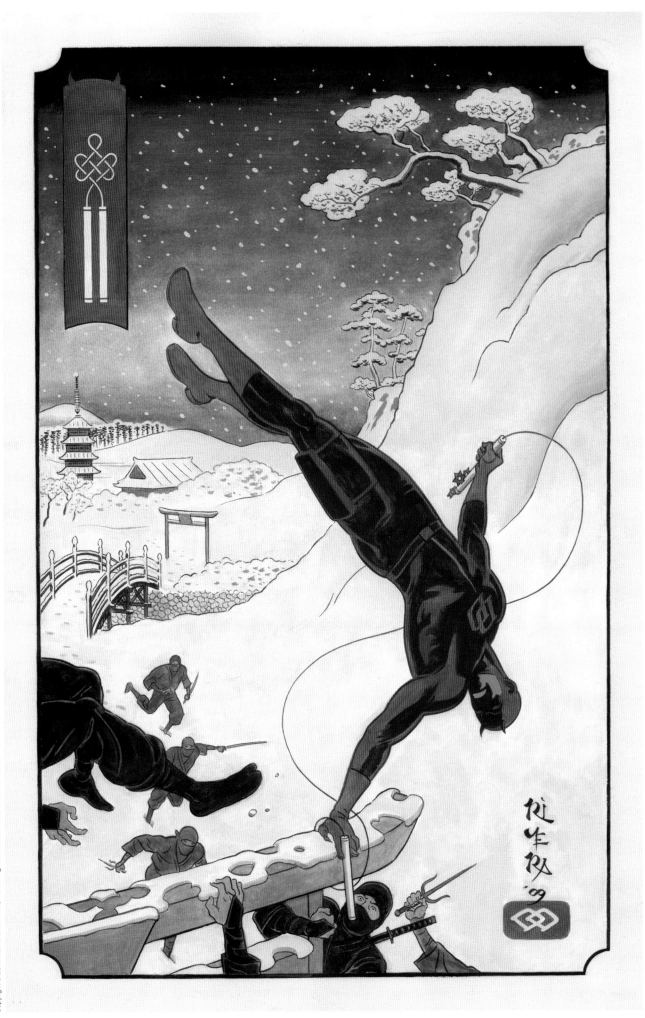

Paolo Rivera

Art Director: Steve Wacker *Client:* Marvel Comics *Title:* Daredevil #506 [cover] *Size:* 11"x17" *Medium:* Watercolor/gouache

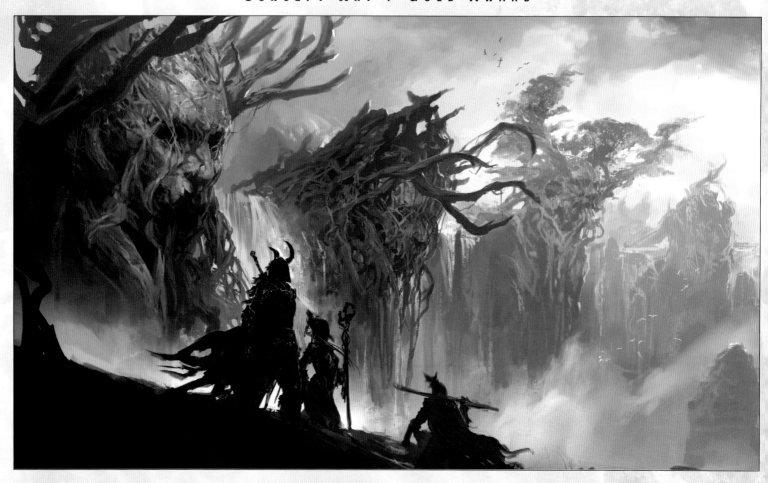

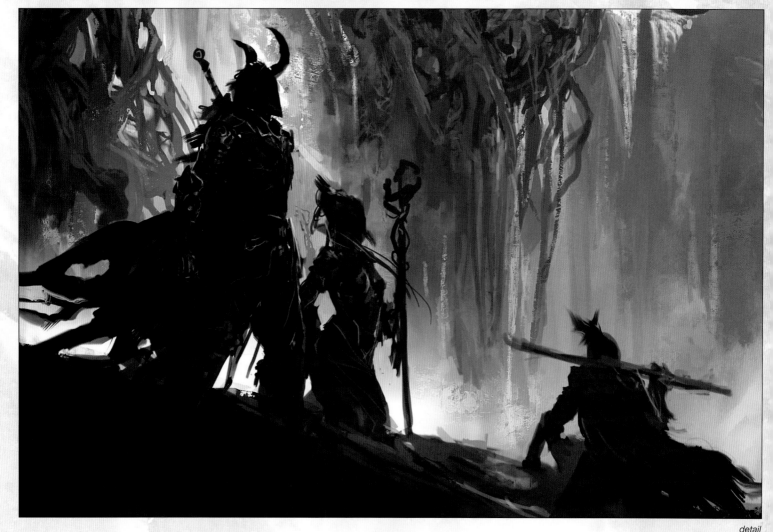

detail

Kekai Kotaki

Art Director: Daniel Dociu *Client:* ArenaNet *Title:* Riven Earth *Size:* 19"x13" *Medium:* Digital

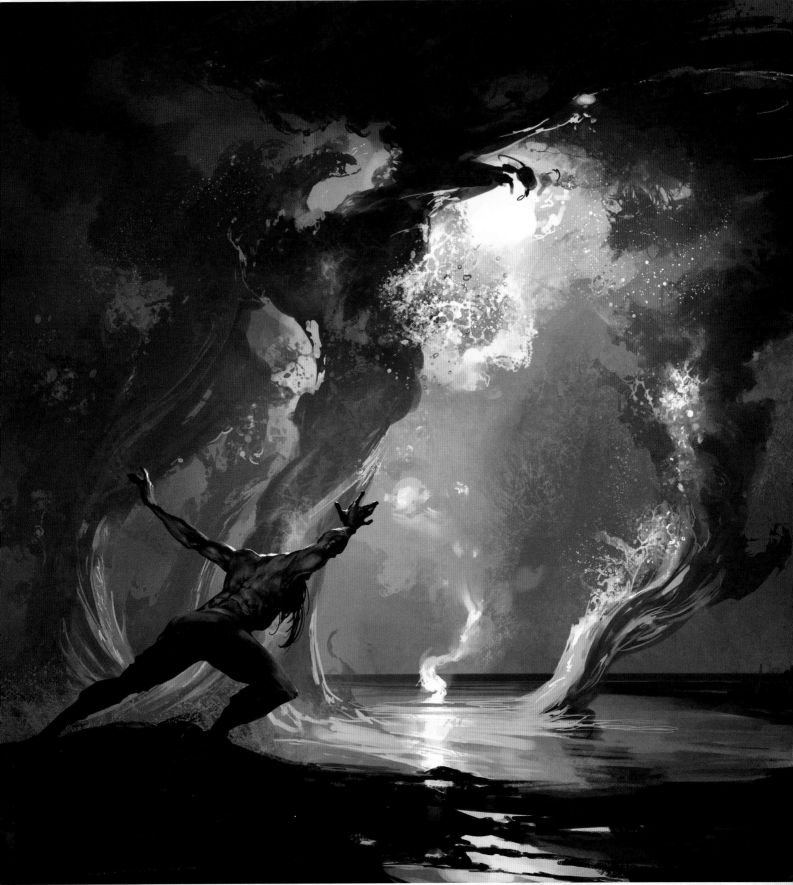

Tomasz Jedruszek

Art Director: Derek Herring *Client:* Sony Online Entertainment *Title:* Legends of Norrath: Elemental Pact *Medium:* Photoshop

Kekai Kotaki

Art Director: Daniel Dociu *Client:* ArenaNet *Title:* Valley of Gods & Heroes *Size:* 19"x13" *Medium:* Digital

Patrick J. Jones

Client: pjartworks.com *Title:* Carnival 3000 AD *Size:* 16"x8" *Medium:* Digital

Daniel Dociu

Client: ArenaNet Guild Wars 2 *Title:* Char Ghetto *Size:* 13"x19" *Medium:* Digital

Thomas Scholes

Art director: Daniel Dociu *Client:* ArenaNet Guild Wars 2 *Title:* The Commoners' Market *Medium:* Digital

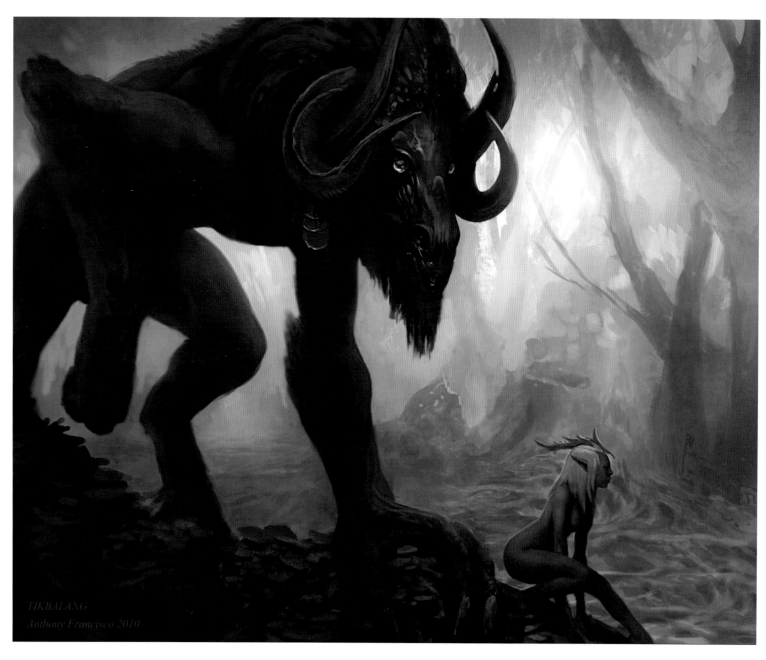

Anthony Francisco

Client: Übermonster Productions, Inc. *Title:* Tikbalang *Medium:* Digital

Kirsten Zirngibl

Title: Electropium Den *Size:* 16"x9" *Medium:* Digital

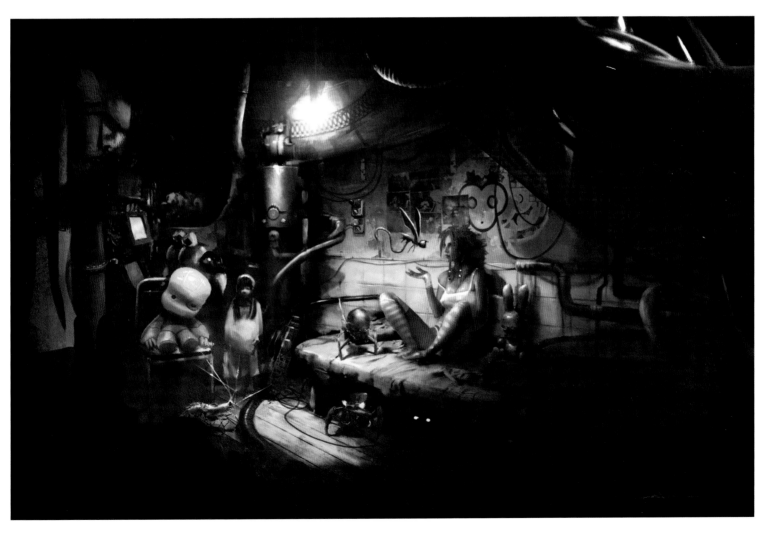

Alessandro "Talexi" Taini

Client: Namco Bandai Games *Title:* Trip Room—Enslaved *Size:* 11"x7" *Medium:* Photoshop

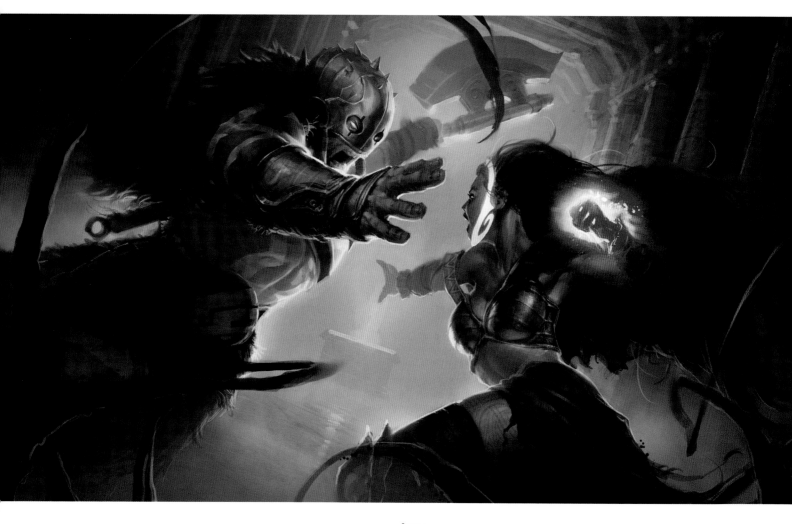

Izzy
Art Director: Jeremy Jarvis *Client:* Wizards of the Coast *Title:* Duels of the Planeswalkers: Garruk & Liliana *Medium:* Digital

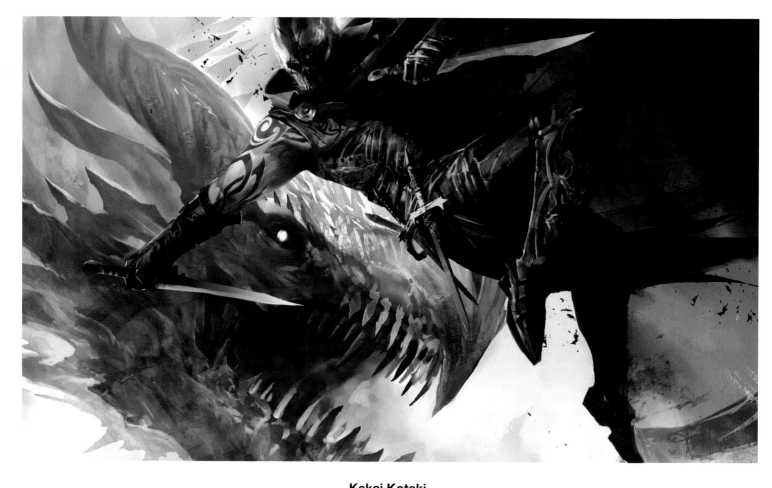

Kekai Kotaki
Art Director: Daniel Dociu *Client:* ArenaNet *Title:* Thief Strike *Size:* 19"x13" *Medium:* Digital

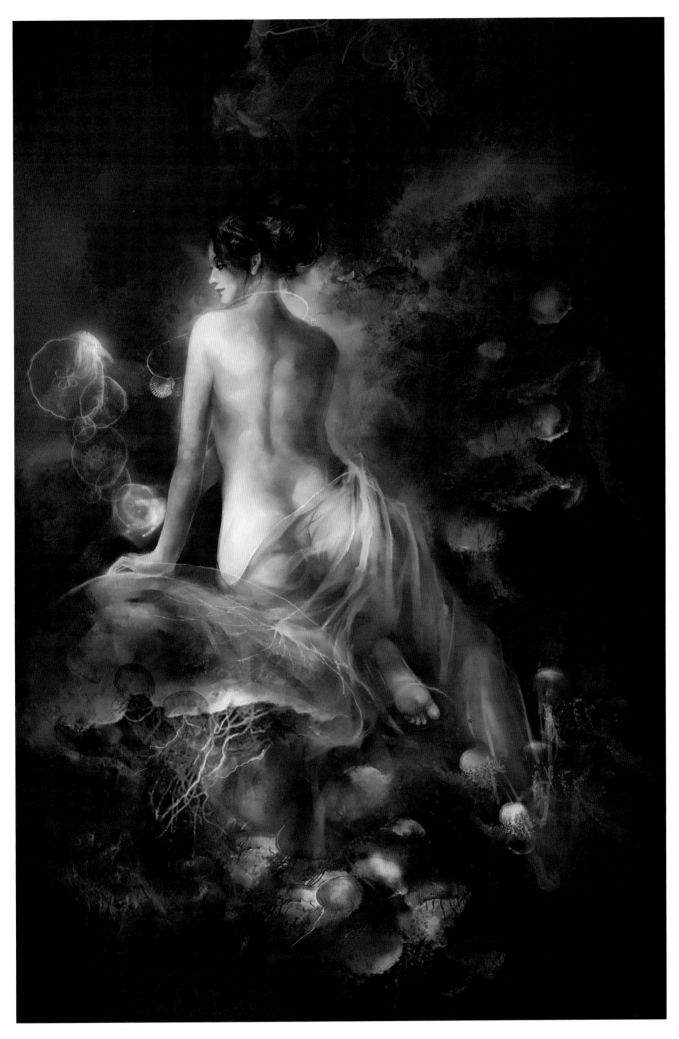

Te Hu

Title: Voyage *Medium:* Digital

Moonbot Studios Art Dept.
Art Director: William Joyce & Brandon Oldenburg *Client:* Moonbot Studios *Title:* Morris Enters the Library *Medium:* Digital over CGI miniature

Richard Smitheman
Title: Morning Practice *Size:* 10"x5" *Medium:* Digital

Georgi Simeonov

Art Director: Olivier Leonardi *Client:* Bethesda Softworks *Title:* Brink—Reactor Ventilation Shafts *Medium:* Digital

Sam Brown

Art Director: Coro *Client:* Massive Black *Title:* Space Station 05 *Medium:* Photoshop/Sketchup

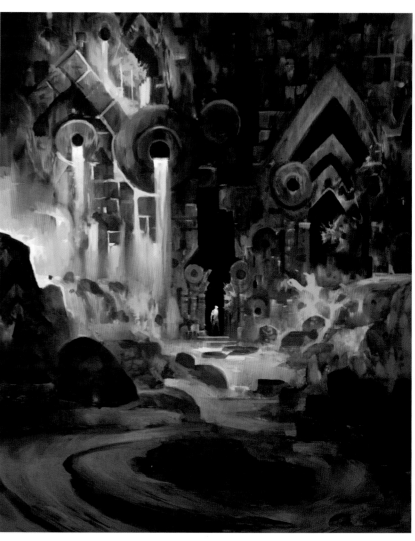

L.D. Austin

Art Director: Olivier Leonardi *Client:* Bethesda Softworks
Title: Brink—The Geezer *Medium:* Digital

Thomas Scholes

Art Director: Daniel Dociu *Client:* ArenaNet Guild Wars 2
Title: Risencave *Medium:* Digital

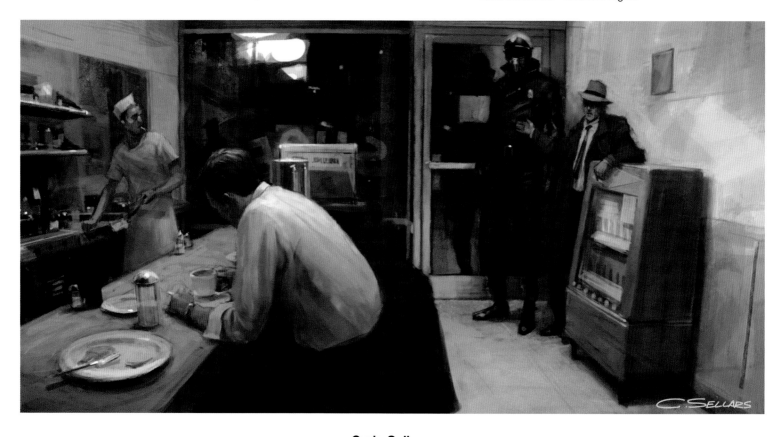

Craig Sellars

Title: Eggs and Toast *Size:* 11.5"x6" *Medium:* 2D digital

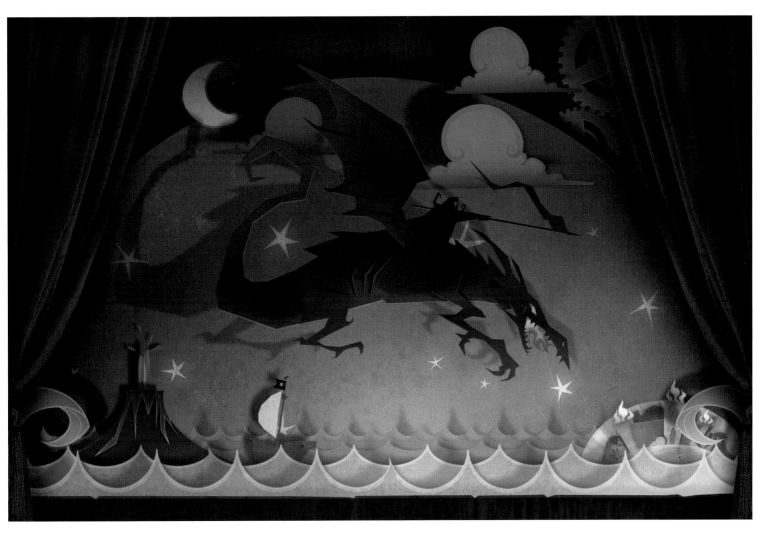

Brian Thompson & Hamzah Kasom Osman

Art Director: Brian Thompson *Client:* Big Fish Games *Title:* The Dragon: Act 1 [*from* Drawn: Dark Flight] *Size:* 17"x12" *Medium:* Photoshop

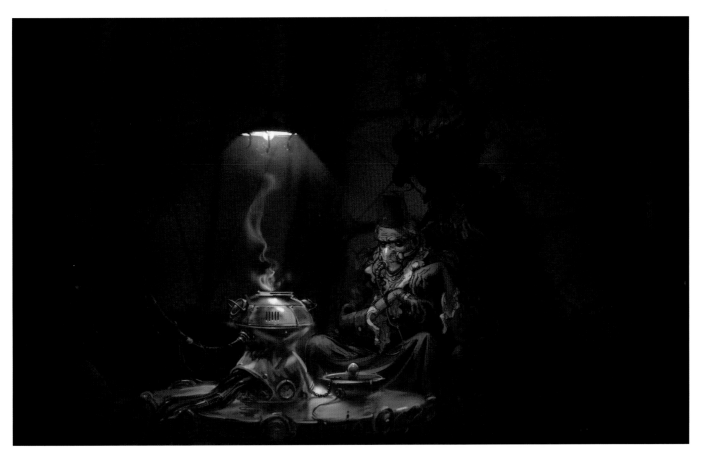

Hethe Srodawa

Title: The Prime Minister's Witch *Medium:* Digital

Richard Smitheman
Title: Marwa *Size:* 10"x5.4" *Medium:* Digital

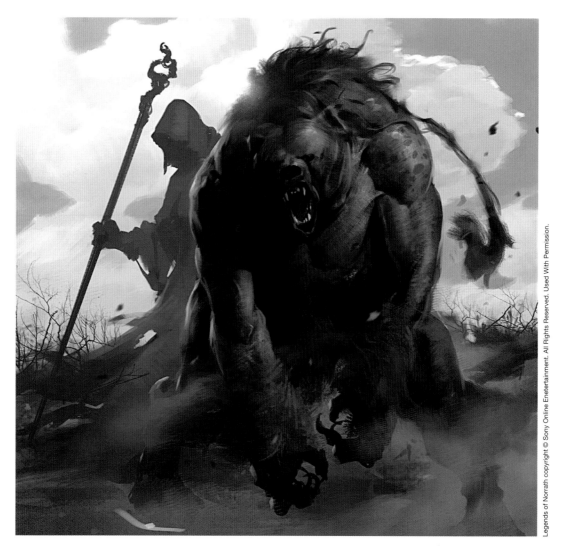

Slawomir Maniak
Art Director: Derek Herring *Client:* Sony Online Entertainment *Title:* Legends of Norrath: Mindreaver Hulk *Medium:* Photoshop

Daniel Dociu

Client: ArenaNet Guild Wars 2 *Title:* Lead Zeppelins *Size:* 19"x13" *Medium:* Digital

Vincent Proce

Art Director: Chip Sineni *Client:* Phosphore Games *Title:* Body Parts *Medium:* Pencil/digital

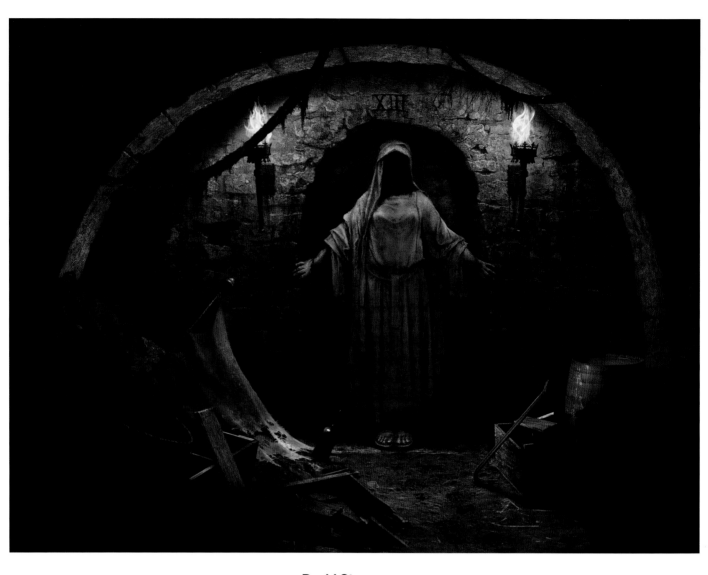

David Stevenson
Art Director: Jeff Haynie *Designer:* Adrian Woods *Client:* Big Fish Games *Title:* Secret Cellar [*from* MCF: 13th Skull] *Medium:* Digital

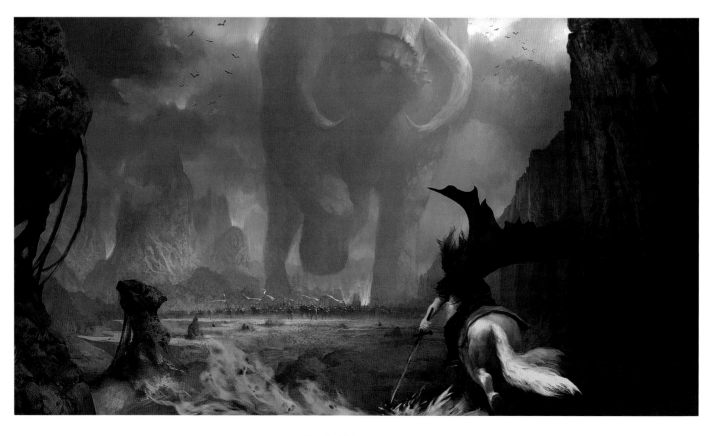

Daniel Ljunggren
Art Director: Stefan Ljungqvist *Client:* Avalanche Studios *Title:* Dark Future *Medium:* Digital

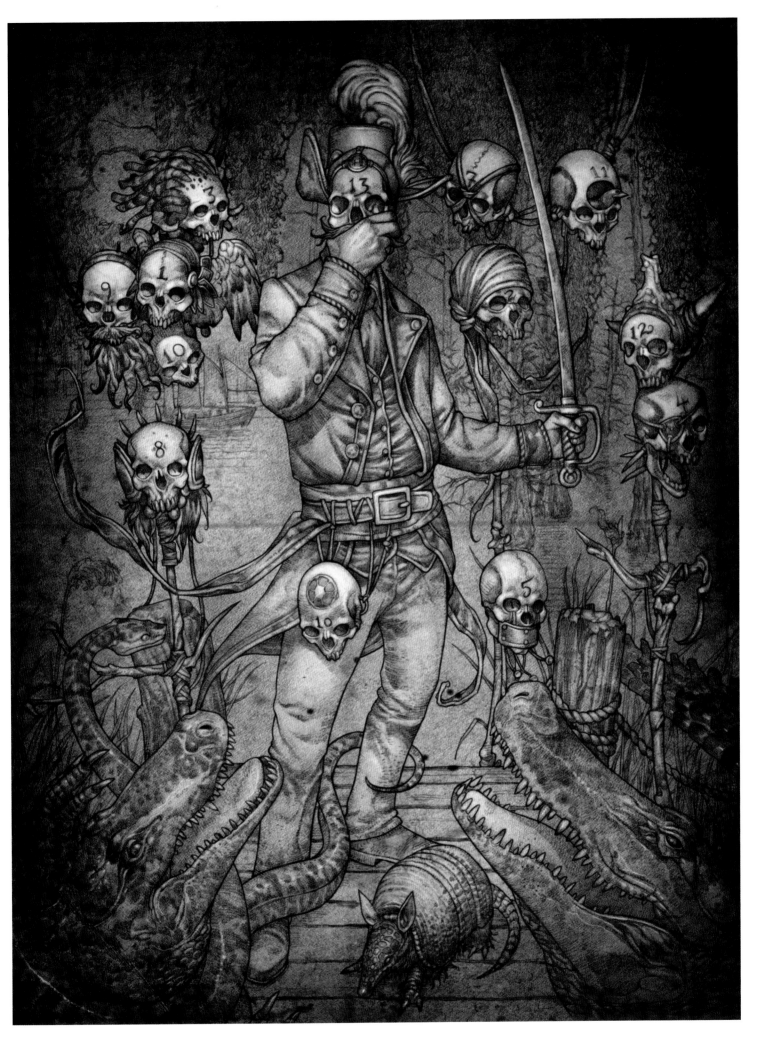

R.K. POST

Art Director: Jeff Haynie *Designer:* Adrian Woods *Client:* Big Fish Games *Title:* Phineas Crown [*from* MCF: 13th Skull] *Medium:* Pencil/digital

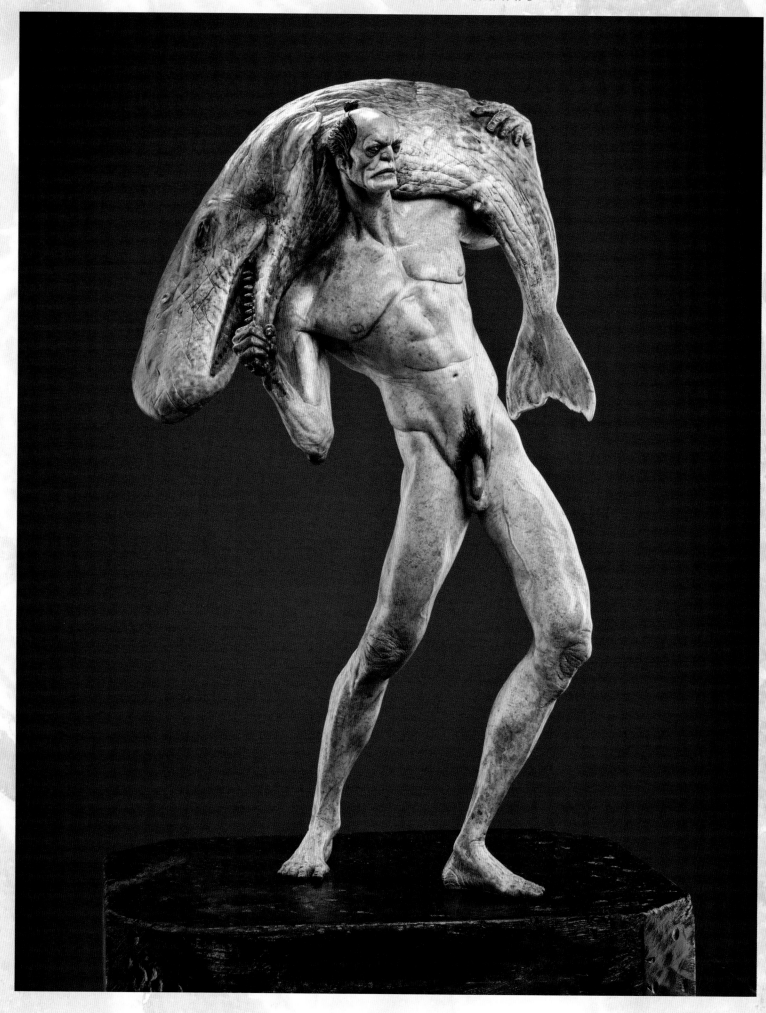

David Meng

Photographer: Steve Unwin *Title:* Giant Fisherman *Size:* 24" tall *Medium:* Resin

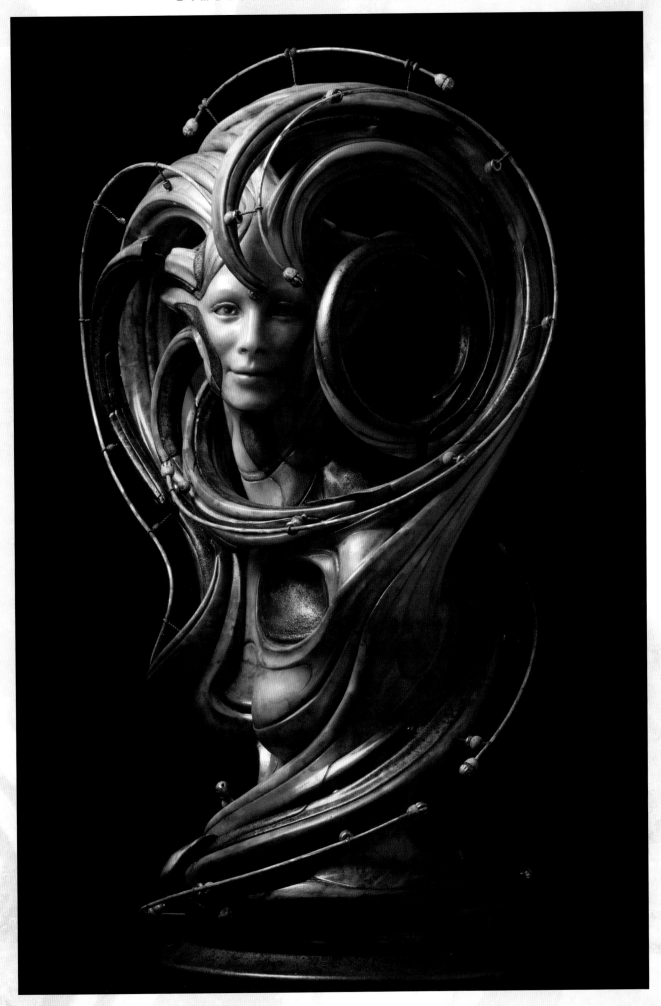

Akihito

Photographer: Tomoko *Title:* Wind Messenger *Size:* 26"Hx16"Wx10"D *Medium:* Resin

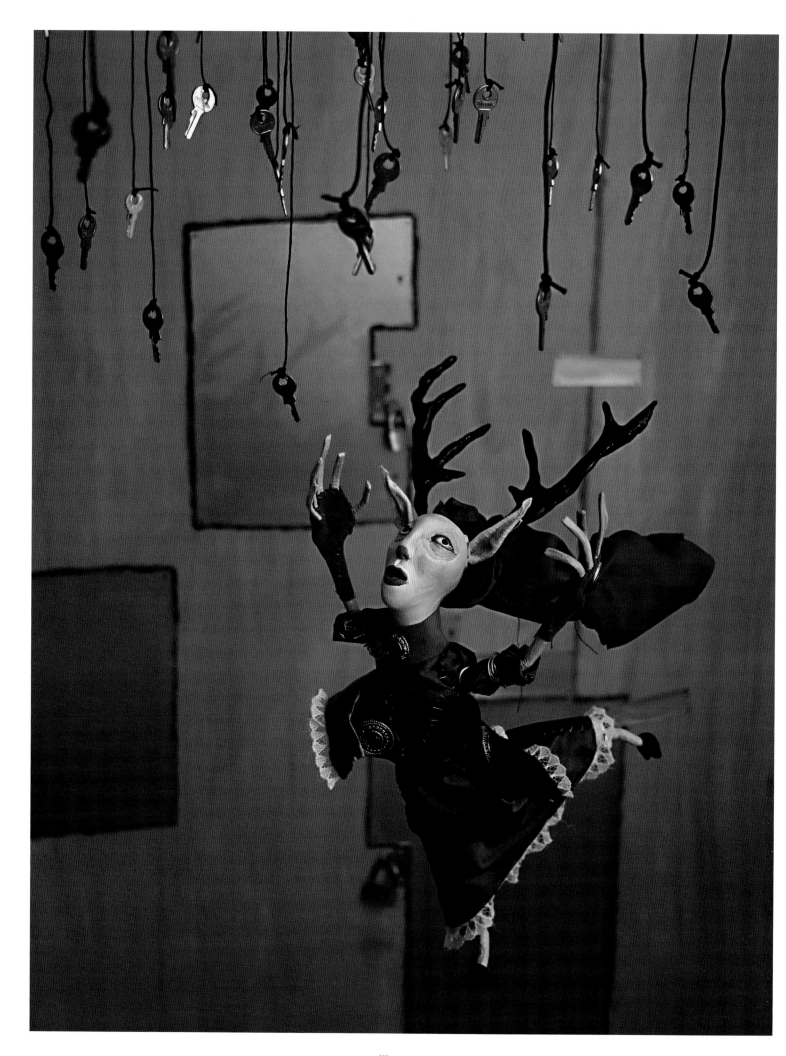

illworx
Title: Elusive Solutions *Medium:* Mixed

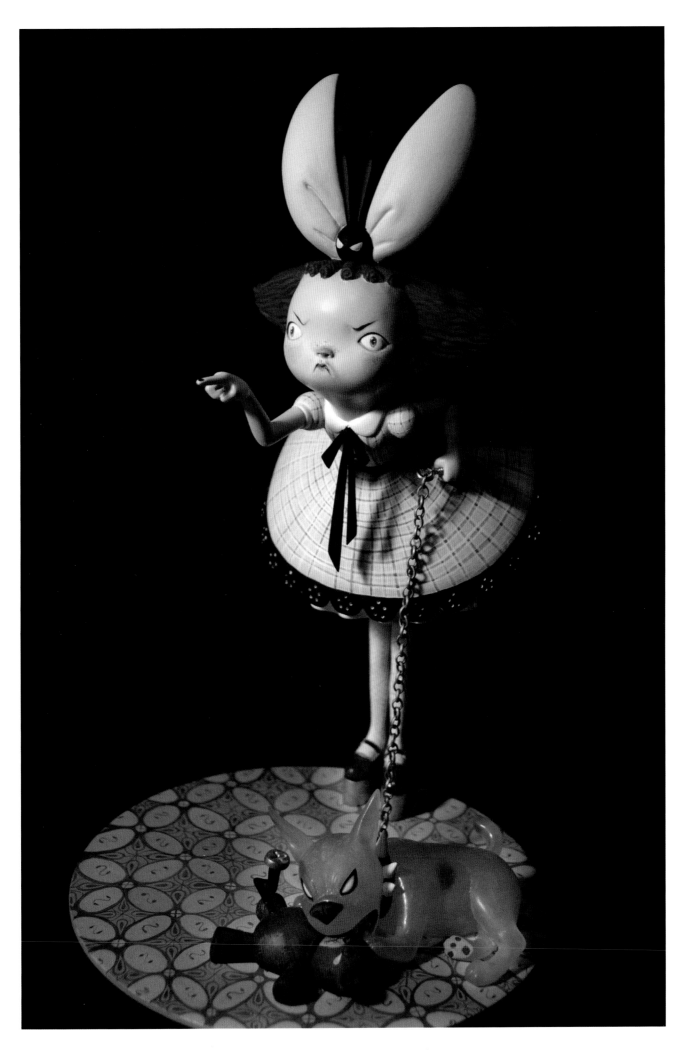

Frans Tedja Kusuma & Wei Ku Sung
Title: Dorothy and Toto of Oz *Size:* 14"x10" *Medium:* Mixed

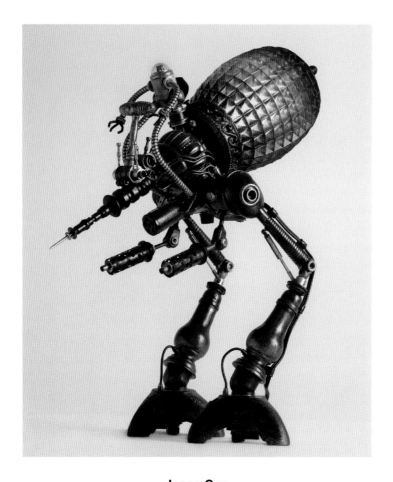

Jesse Gee

Title: Bipedal Injection Unit *Size:* 20"x8"x10" *Medium:* Mixed found objects

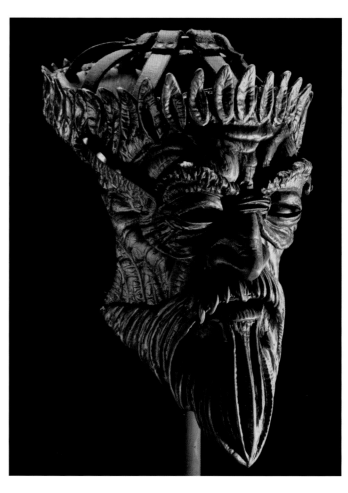

Bruce D. Mitchell

Photographer: Lola Mitchell *Title:* Poseidon
Size: 32Hx23Wx28Dcm *Medium:* Epoxy clay/leather

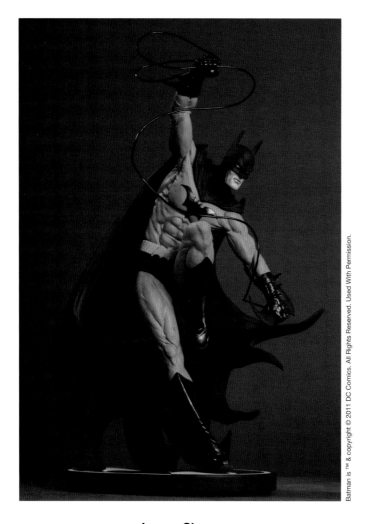

James Shoop

Art Director: Bryon Webster *Designer:* Tony Daniels *Painter:* Kim Murphy
Client: DC Direct *Title:* Batman B&W *Size:* 9"x6.5"x3.5" *Medium:* Resin

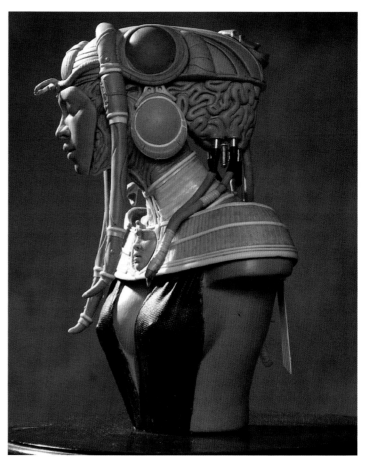

Sym 7

Designer: Lynn Yoshi/Sym 7 *Client:* Symbiosis Studio
Title: The Plague Queen *Medium:* Mixed

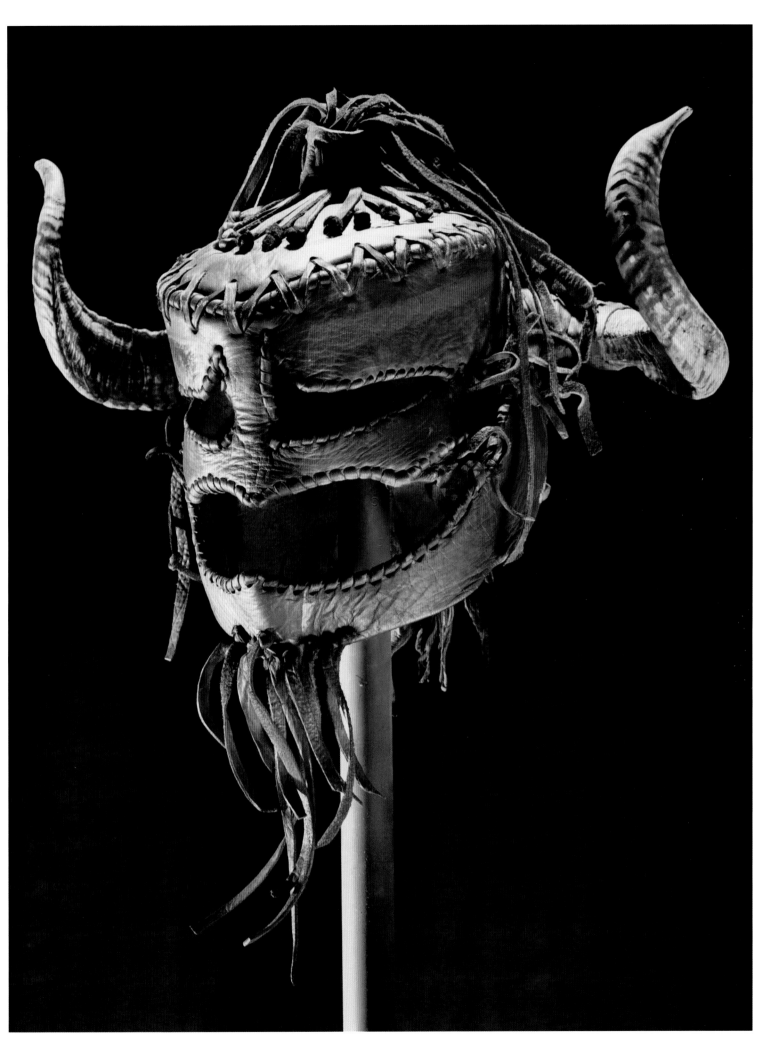

Bruce D. Mitchell

Photographer: Lola Mitchell *Title:* Aries *Size:* 38Hx43Wx36Dcm *Medium:* Leather & ram horn

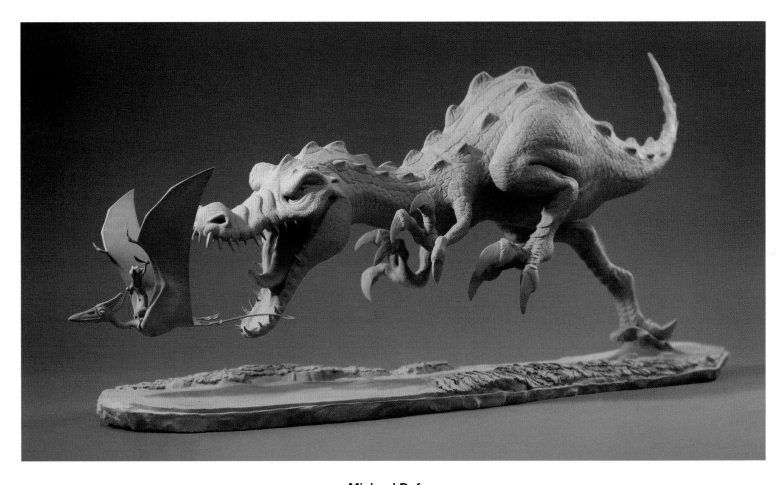

Michael Defeo

Art Diretor: Michael Knapp *Designer:* Peter de Sève *Client:* Blue Sky Studios *Title:* Rudy [*Ice Age 3*] *Size:* 28"x12"x10" *Medium:* Resin

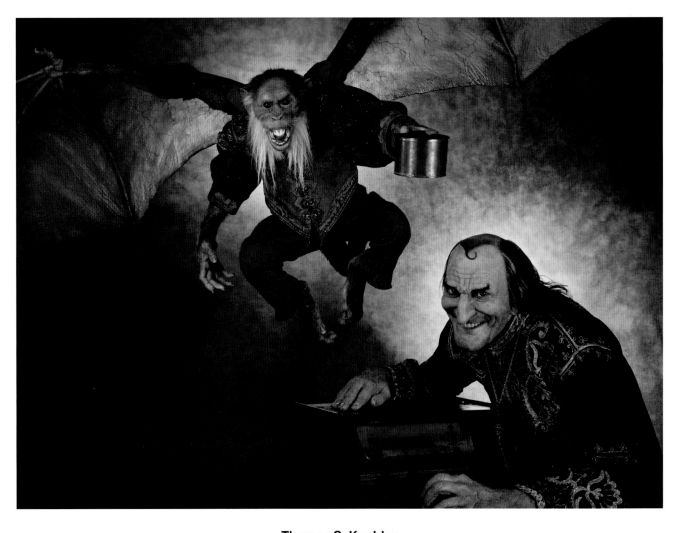

Thomas S. Kuebler

Title: The Monkey & the Organ Grinder *Size:* Life size *Medium:* Silicone/mixed

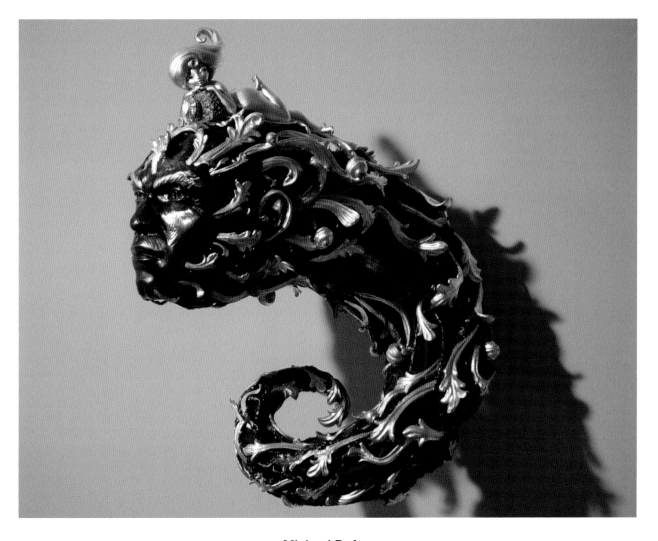

Michael Defeo

Art Director: Michael Defeo *Client:* MDSD *Title:* Helix *Size:* 18"x18"x9" *Medium:* Resin/gold leaf/mixed

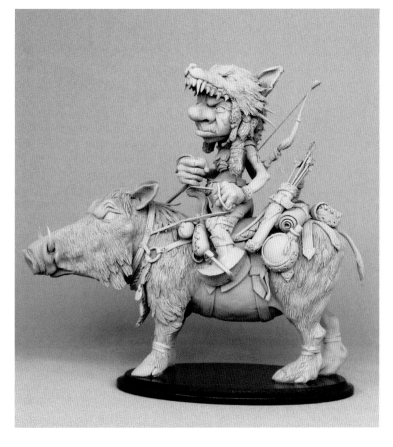

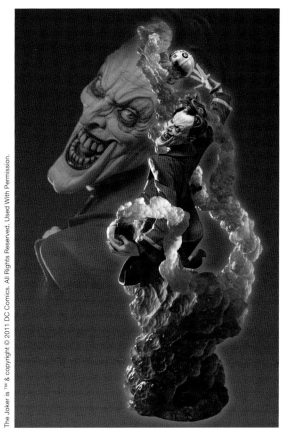

Javier Diaz

Photographer: Ana Milena Diaz *Title:* Hunter Goblin
Size: 21x22cm *Medium:* Super Sculpey

Tim Bruckner

Art Director: Tim Bruckner/Georg Brewer *Client:* DC Direct
Title: DC Dynamics: The Joker *Size:* 11.75"H *Medium:* Painted resin

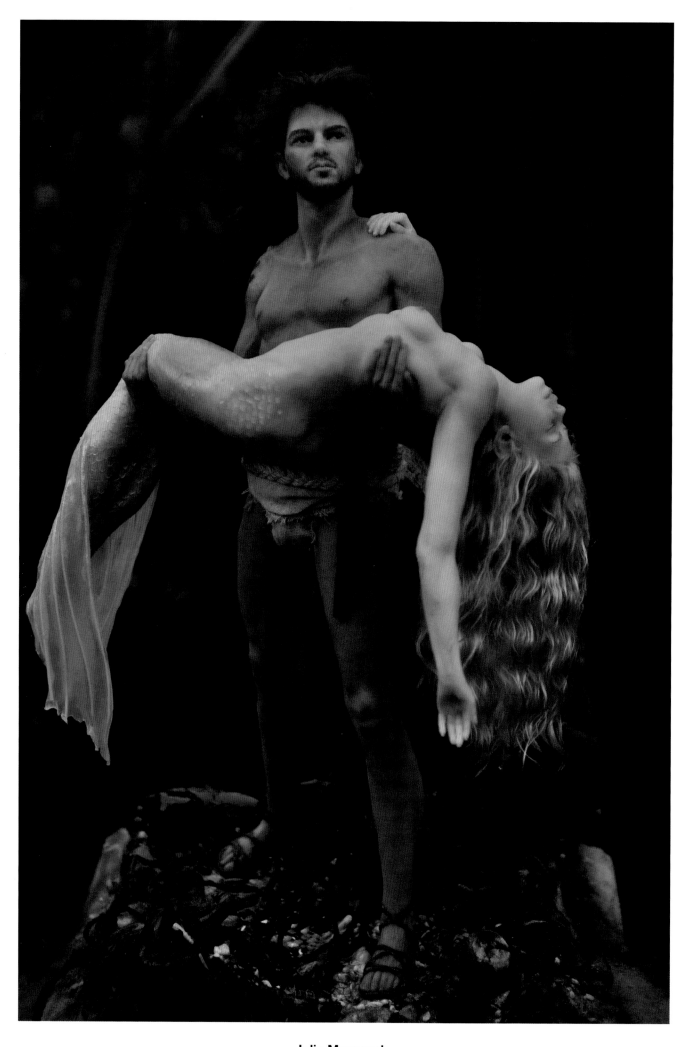

Julie Mansergh

Designer: Faeries In the Attic (FITA) *Client:* Private collection *Title:* Mermaid Rescue *Size:* 10.5"H *Medium:* Polymer clay

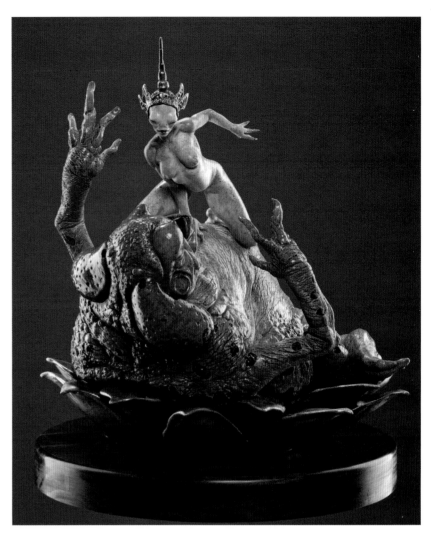

Deak Ferrand

Client: Hatch Productions *Title:* Guardian Helmet

Size: 14"H *Medium:* Plastic

David Meng

Photographer: Steve Unwin *Title:* Amphibiana *Size:* 14"H *Medium:* Resin

Julie Mansergh

Designer: Faeries In the Attic (FITA) *Client:* Private collection *Title:* Pond Mermaid *Size:* 9" *Medium:* Polymer clay

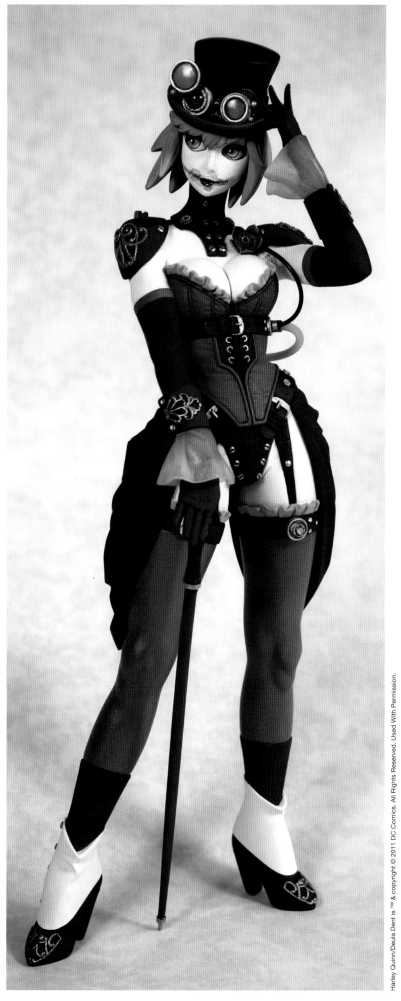

Jeremy Pelletier
Client: Amok Productions, Inc. *Title:* Trainer of the Hounds
Size: 9"Hx9"Lx5"W *Medium:* Polymer clay

Jonathan Matthews
Art Director: Jim Fletcher *Art Director:* Jonathan Matthews/Jim Fletcher
Client: DC Direct *Title:* Deula Dent *Size:* 9"H *Medium:* Painted resin

Benoit Polveche & Chrisine Pocis
Title: To Infinity and Beyond *Size:* 60cm *Medium:* Blacksmith steel

Mike Rivamonte

Title: Scout *Size:* 27"H *Medium:* Collected objects

Lawrence Northey
Title: Wasabe Malisada: The Treasure of Chantecler Eldorado *Size:* 25"Hx40"W *Medium:* Mixed

Cassia Harries
Photographer: *Sean Kraft* Title: Steampunk Willie *Size:* 5.5"Hx6"W
Medium: Super Sculpey, munny, acrylic paint

Levi Fitch
Photographer: *Brent Jones* Title: Chiron
Size: 21"Hx12"Wx8"W *Medium:* Oil-based clay

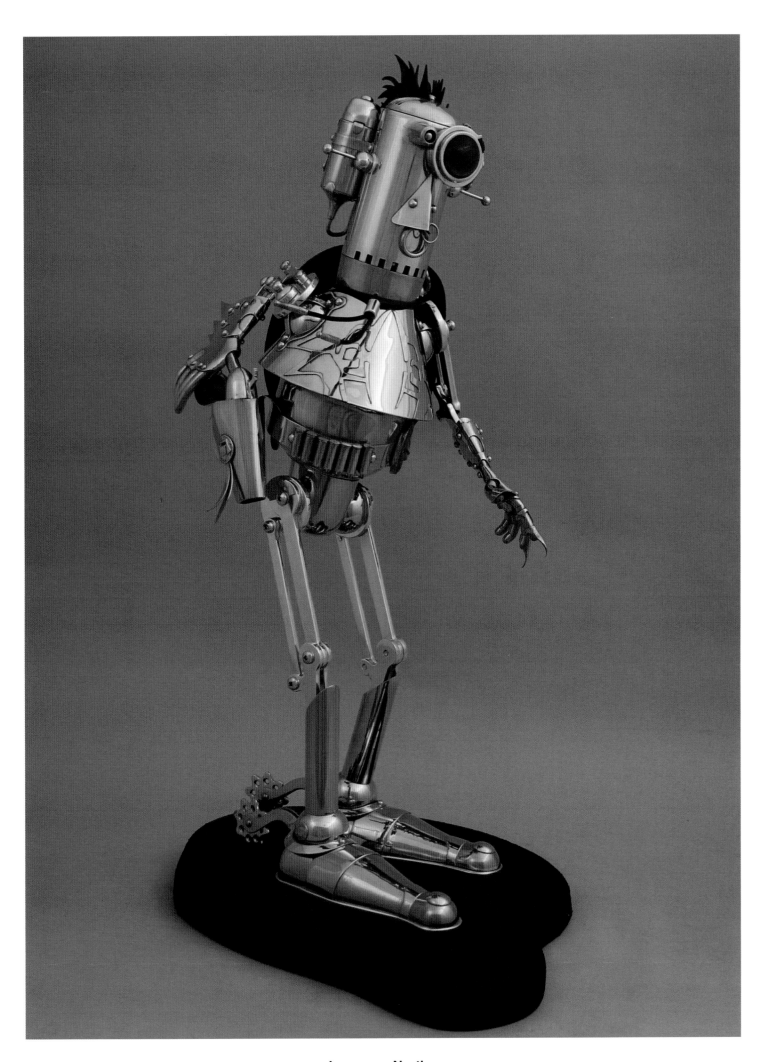

Lawrence Northey
Title: Deadeye Dick: The Treasure of Chantecler Eldorado *Size:* 32"Hx19"W *Medium:* Metal & glass

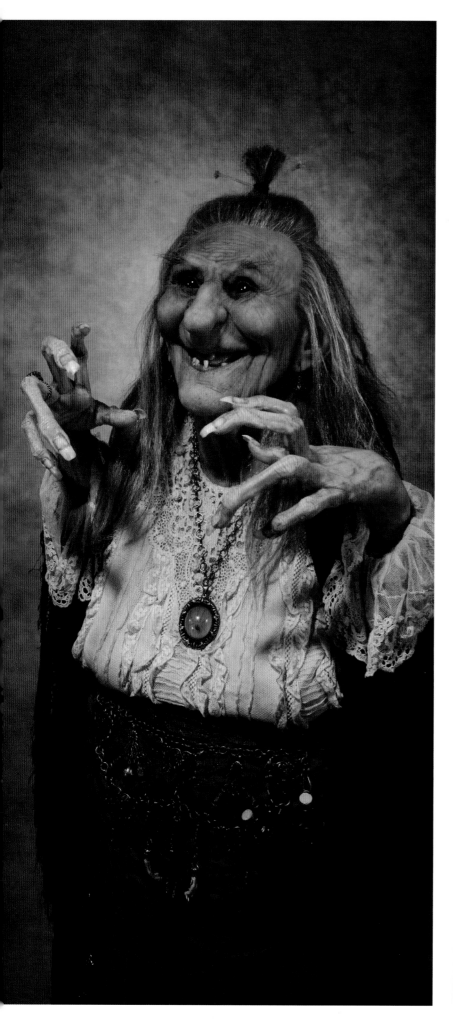

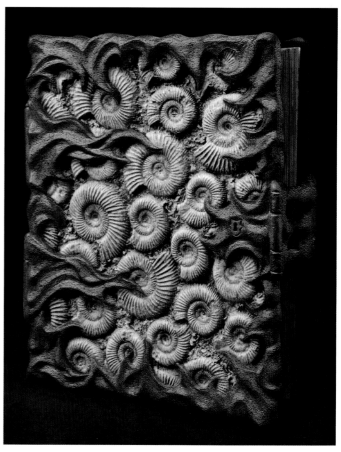

Tim Baker
Title: Second Book of the Arcane *Size:* 9.5"x12" *Medium:* Mixed

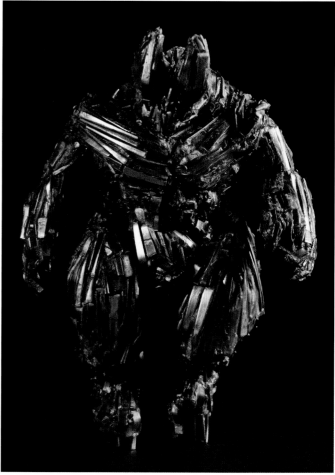

Thomas S. Kuebler
Title: Baba Yaga
Size: Life size *Medium:* Silicone/mixed

Cameron Shojaei
Photographer: Adam Ferriss *Title:* Little Demon Imwijina
Size: 10"H *Medium:* Fork tines & hot glue

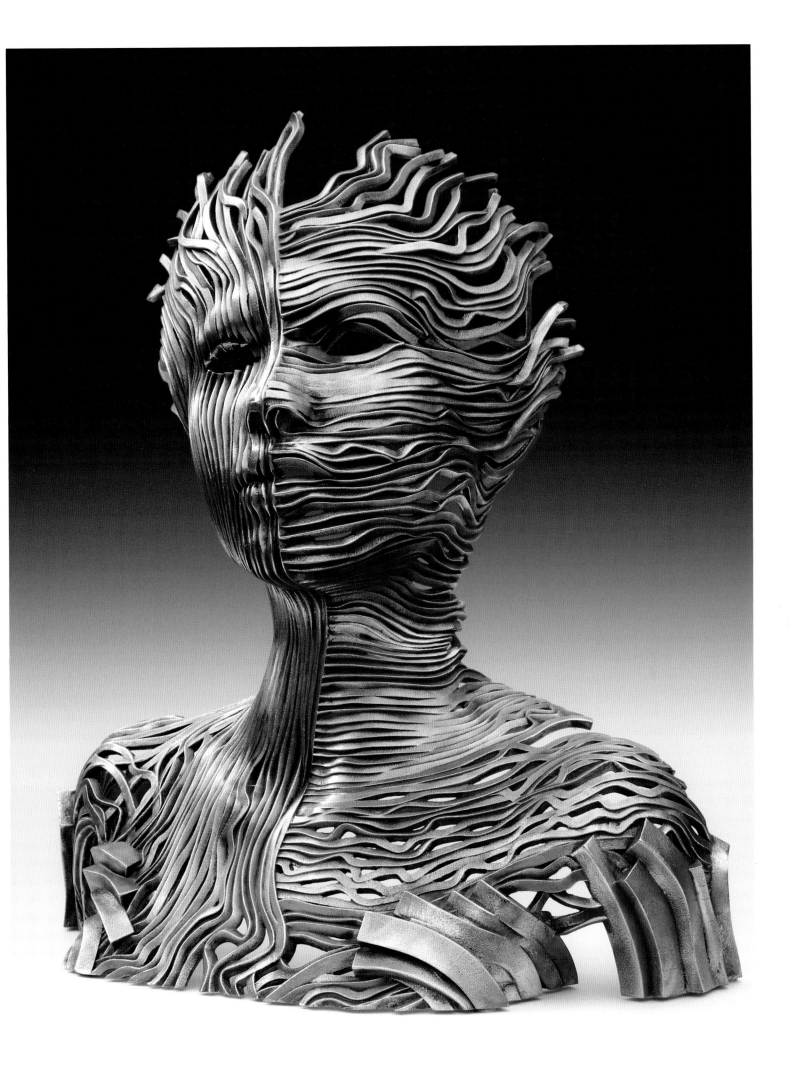

Gil Bruvel

Title: Dichotomy *Size:* 28.75"x16.5"x14.5 *Medium:* Cupro nickel

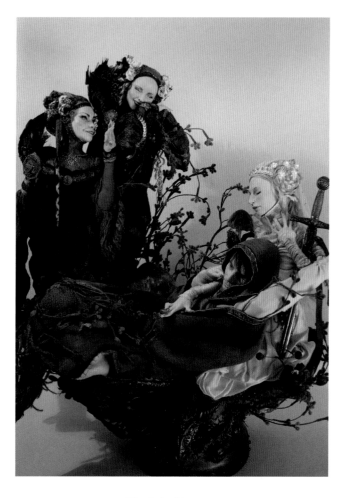

Virginie Ropars
Client: Centre de l'imaginaire Arthurien, France
Title: Lanval *Size:* 65cm *Medium:* Mixed

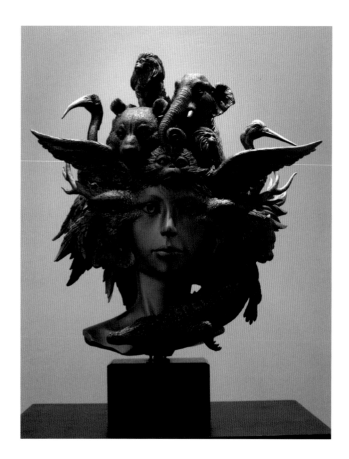

leewiART
Art Director: Ding Ding/Hugues Martel *Designer:* Android Jones
Client: Wild Animals Cultural Project Fund *Title:* Share One Planet
Size: 55Hx57Wx47Dcm *Medium:* Polystone

Colin Christian
Title: Fuck You! *Size:* 9'H *Medium:* Silicone & fiberglass

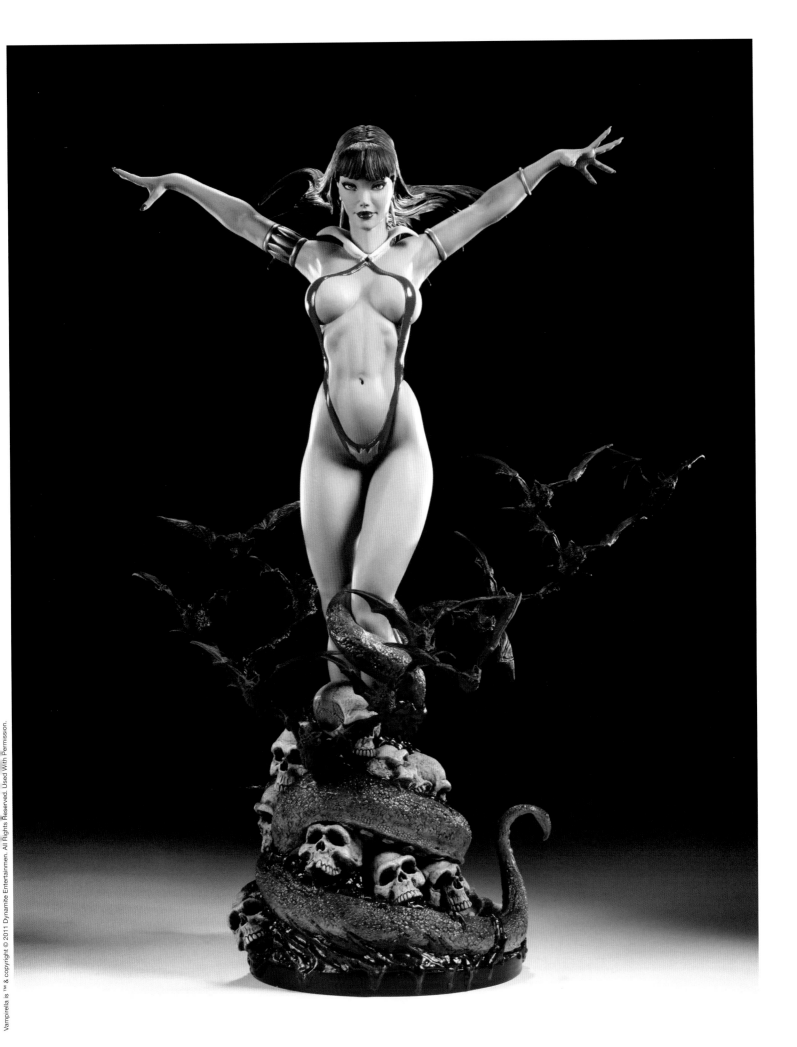

Tony Cipriano

Art Director: Seth Rinaldi *Designer:* David Igo *Photographer:* Ginny Gurman *Painter:* Kat Sapene *Client:* Sideshow Collectibles

Title: Vampirella Comiquette *Size:* 18"H *Medium:* Mixed

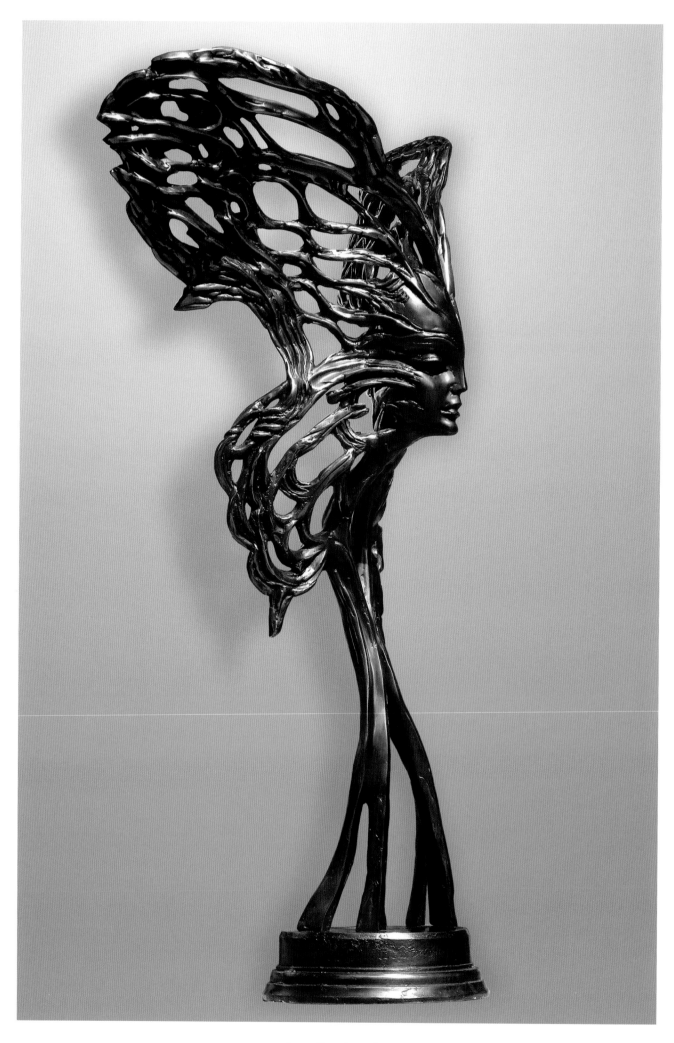

Igor Grechanyk
Title: Night Flight *Size:* 77Hcm *Medium:* Bronze

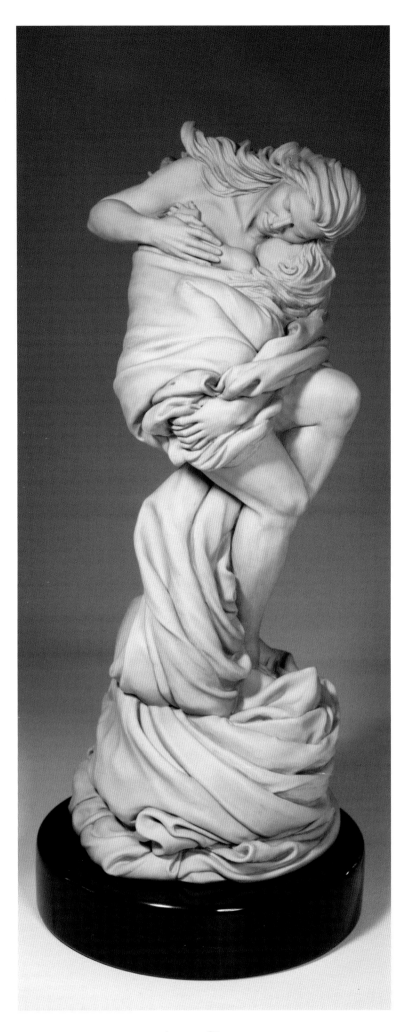

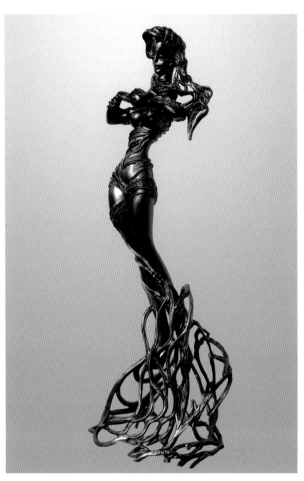

Igor Grechanyk
Title: Journey of Soul Violette *Size:* 100Hcm *Medium:* Bronze

James Shoop
Client: Shoop Sculptural Design, Inc.
Title: Warm Azure *Size:* 17"Hx7"Dx7"W *Medium:* Resin

Jamie Brick
Client: In a Heartbeat Gallery *Title:* Venus
Size: 37"x22"x18" *Medium:* Wood/resin/acrylic

Virginie Ropars

Title: Acanthophis I, Black Adders Sene *Size:* 60cm *Medium:* Mixed

Vincent Villafranca

Client: Villafranca Sculpture *Title:* The Dogs of War *Size:* 30"x24"x14" *Medium:* Bronze

Android Jones

Art Director: Leta Liu *Client:* leewiART *Title:* Share One Planet *Medium:* Corel Painter

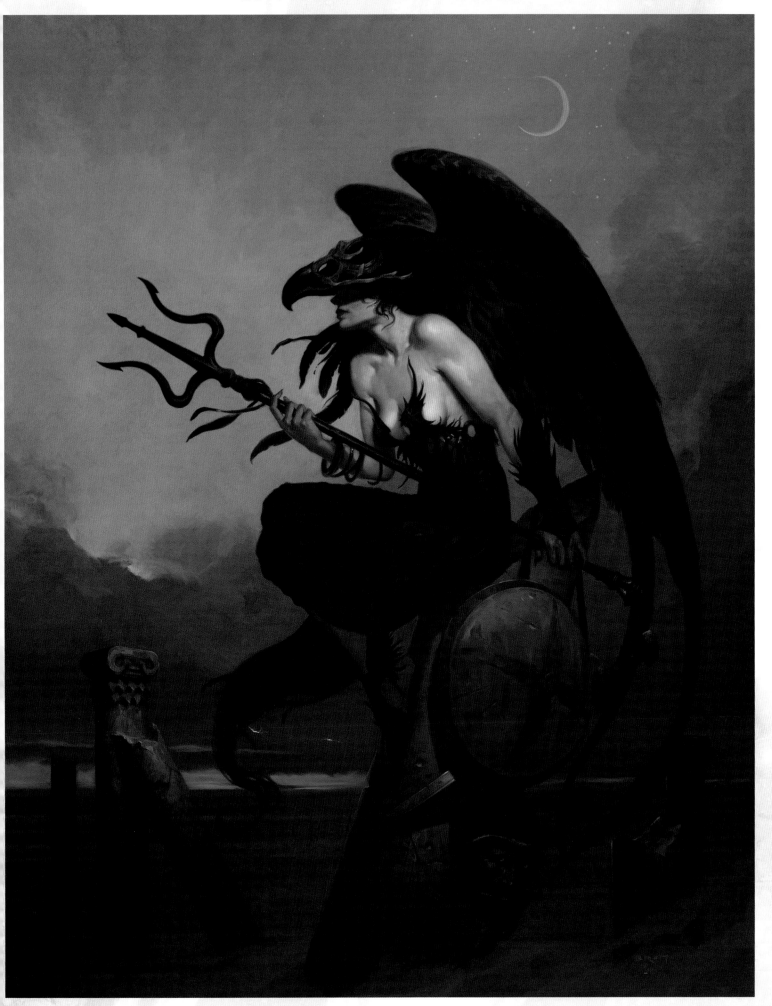

Brom

Art Director: Amber Racy *Client:* Realms of Fantasy *Title:* Red Wing *Medium:* Oil on board

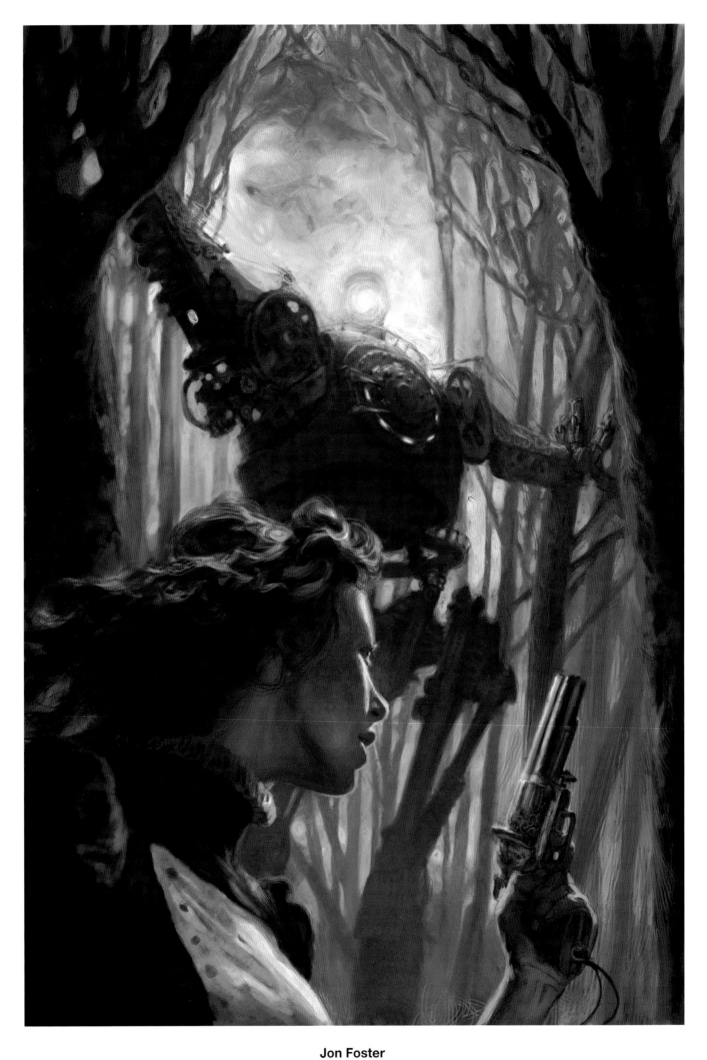

Jon Foster
Art Director: Irene Gallo *Client:* Tor.com *Title:* DreadNought Revisted *Medium:* Digital

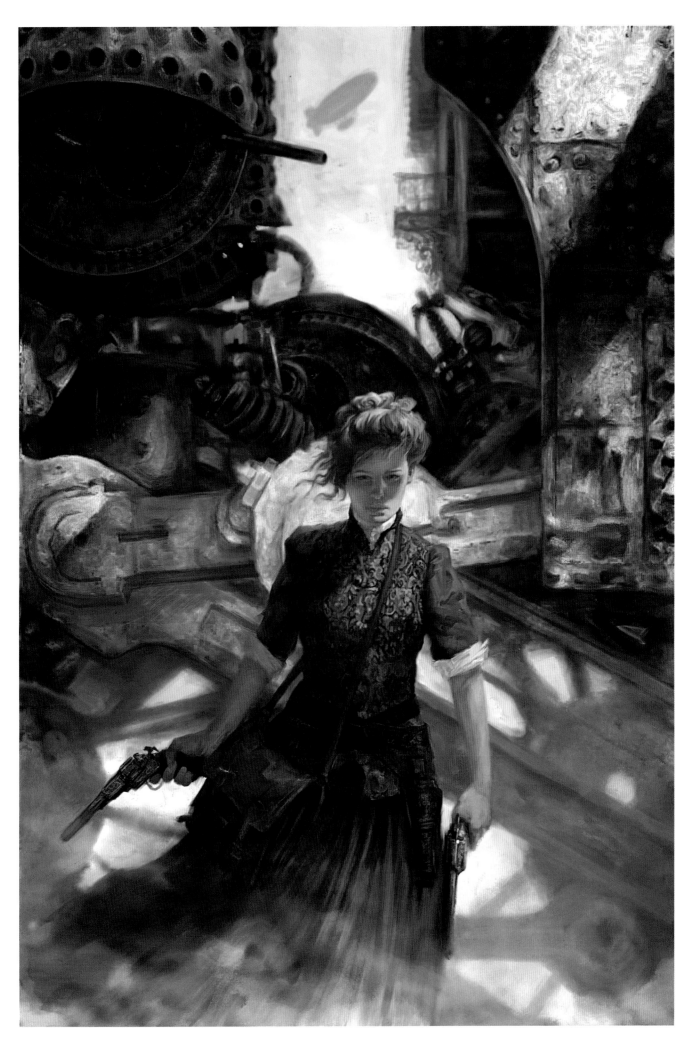

Jon Foster

Art Director: Irene Gallo *Client:* Tor.com *Title:* DreadNought *Medium:* Digital

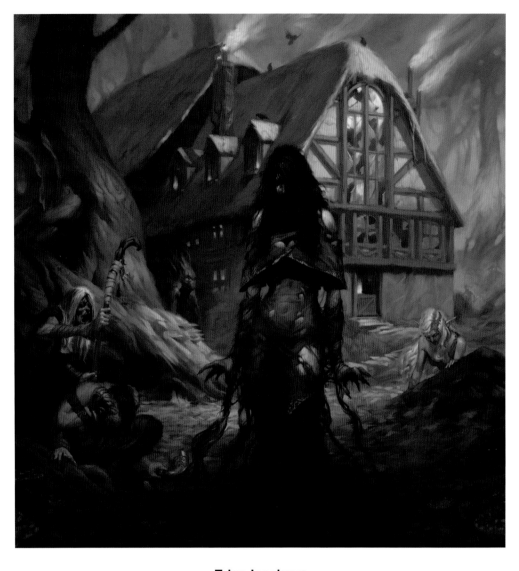

Tyler Jacobson
Art Director: Jon Schindehette *Client:* Wizards of the Coast *Title:* Dungeon #185 [cover]
Size: 22"x22" *Medium:* Digital

Tyler Jacobson
Art Director: Jon Schindehette
Client: Wizards of the Coast *Medium:* Digital

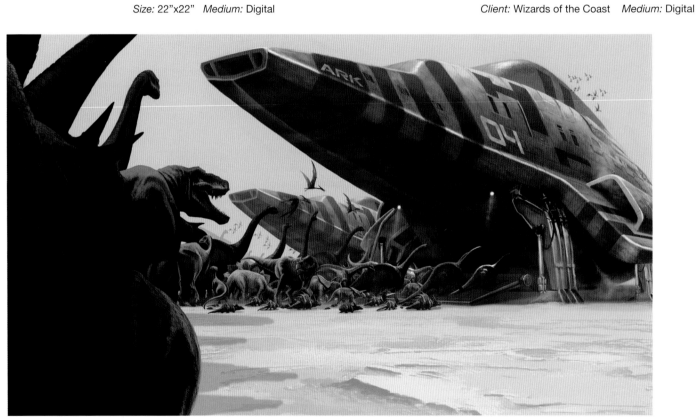

Peter Oedekoven
Client: ImagineFX *Title:* The Ark *Medium:* Photoshop

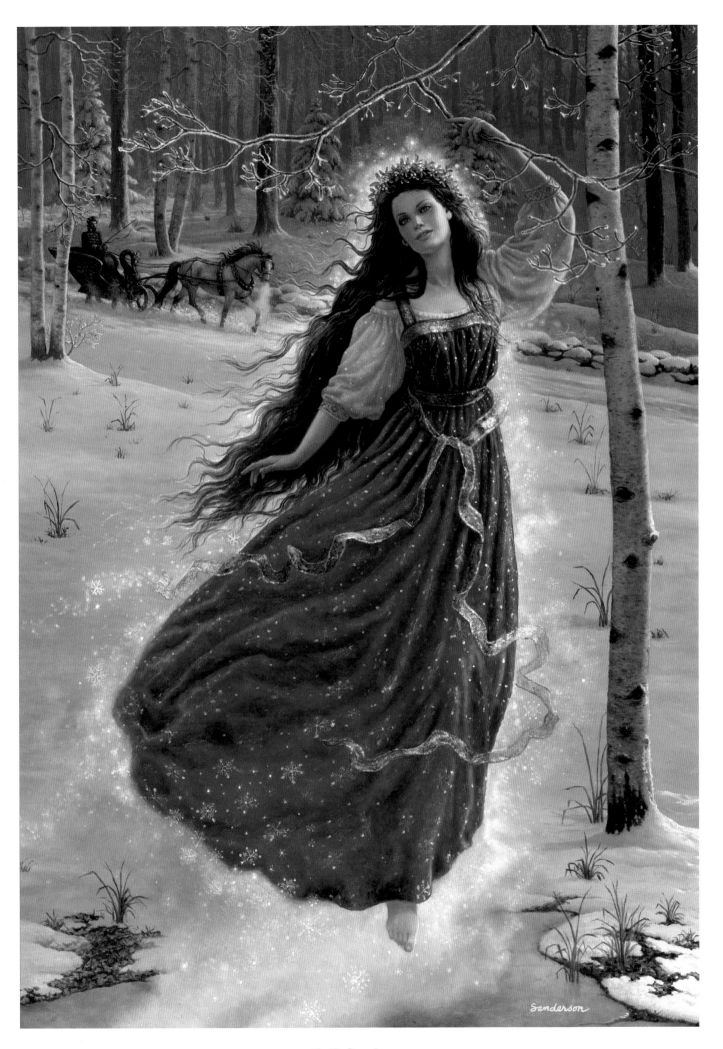

Ruth Sanderson

Client: Realms of Fantasy *Title:* The Swan Troika Size: 24"x36" *Medium:* Oil on panel

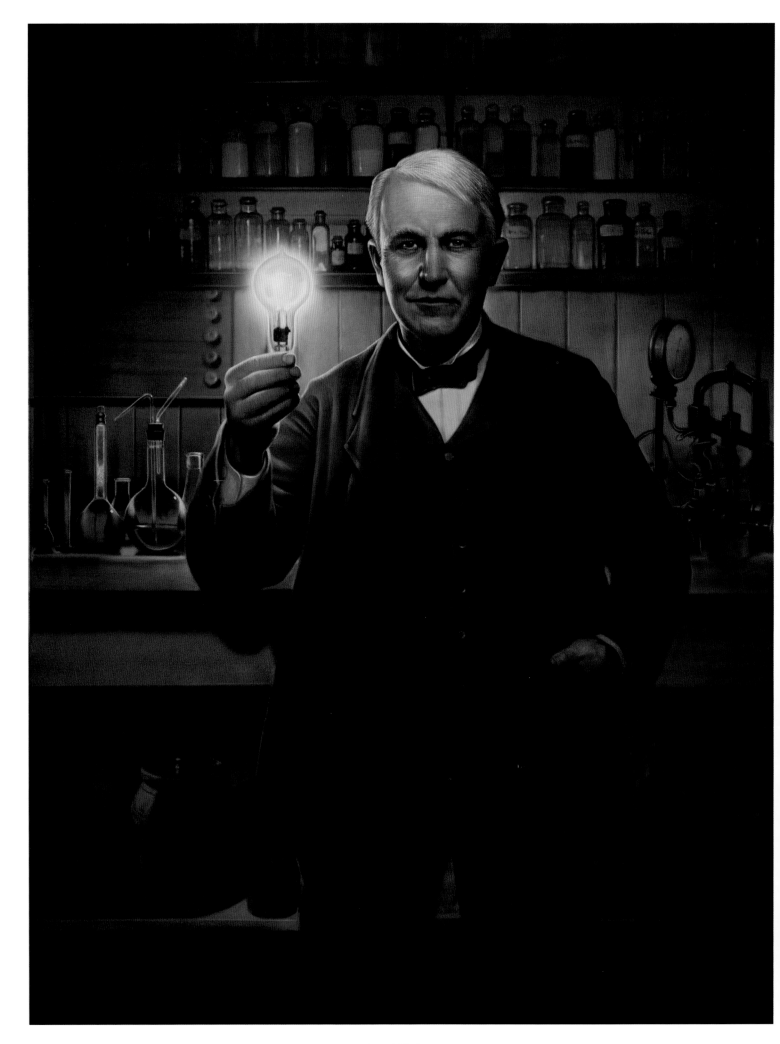

Tim O'Brien

Art Director: D.W. Pine *Client:* Time Magazine *Title:* Thomas Edison [cover] *Size:* 10"x14" *Medium:* Oil/mixed on panel

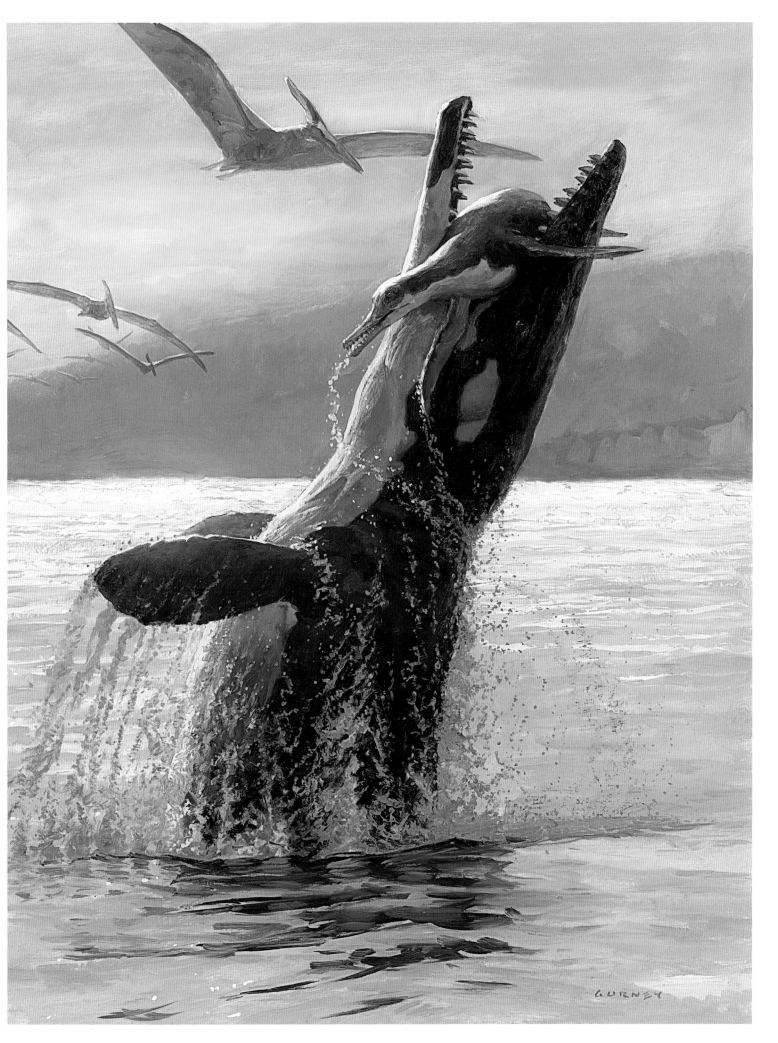

James Gurney

Art Director: Donna Miller *Client:* National Wildlife Federation *Title:* Tylosaurus *Size:* 14"x18" *Medium:* Oil

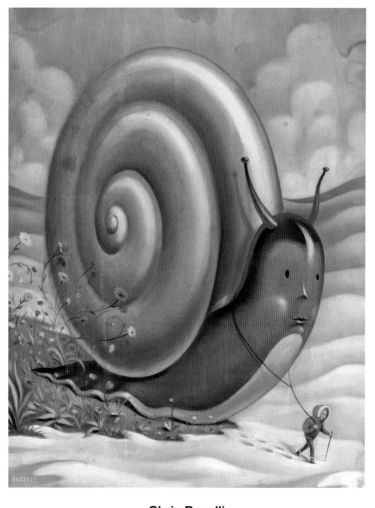

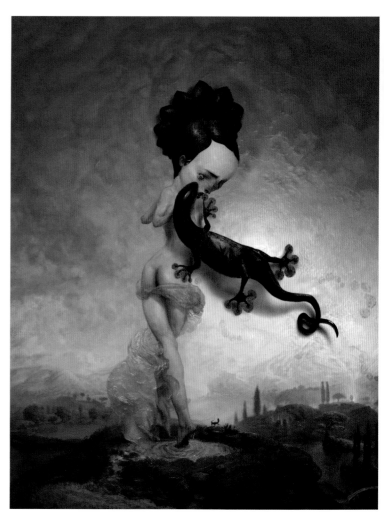

Chris Buzelli
Art Director: Laura Zavetz *Client:* Financial Advisor Magazine
Title: Thawing Out Size: 15"x20" *Medium:* Oil on board

Burton Gray
Title: Kelley! Size: 24"x36" *Medium:* Digital

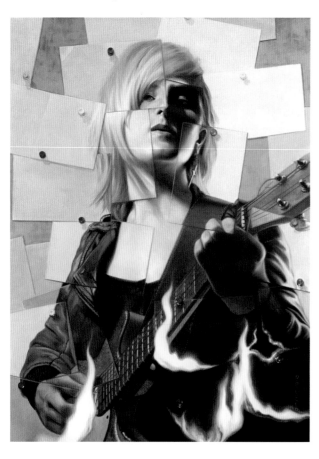

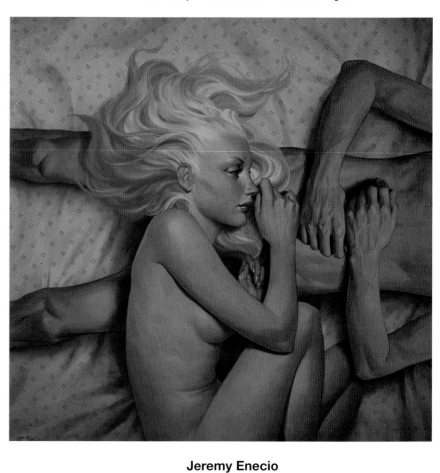

David Palumbo
Art Director: Doug Cohen *Client:* Realms of Fantasy
Title: Is Your Soul for Sale Size: 12"x16" *Medium:* Oil

Jeremy Enecio
Art Director: Cody Tilson *Client:* Playboy *Title:* Joanna Silvestri *Medium:* Digital

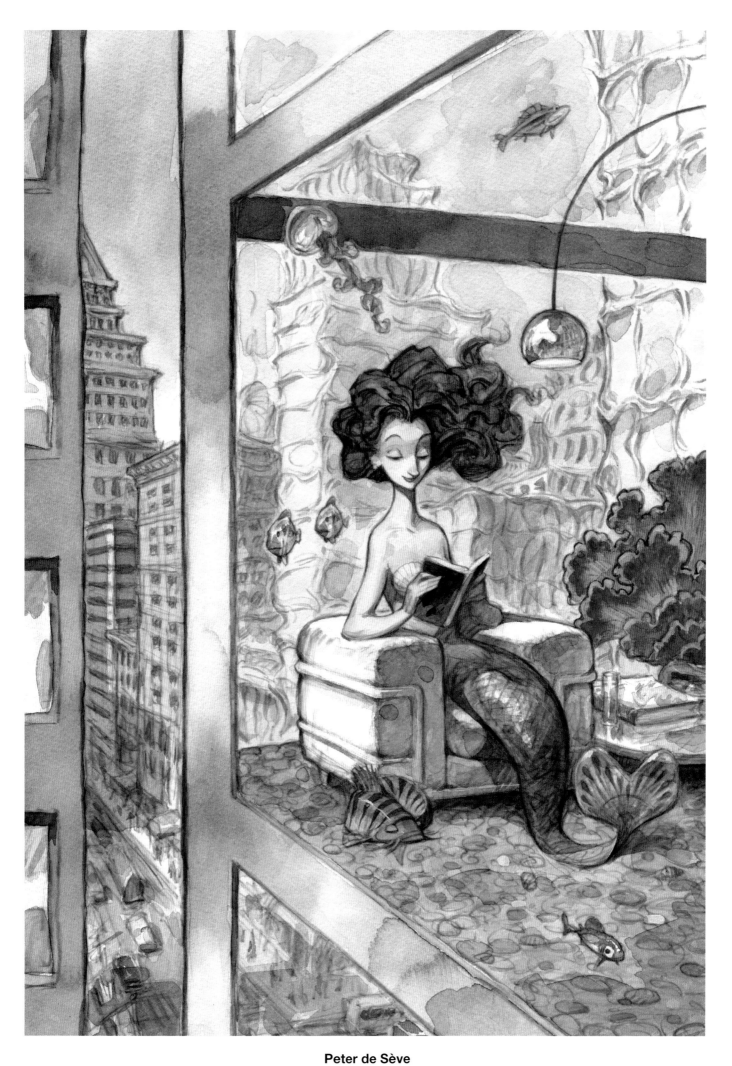

Peter de Sève

Art director: Françoise Mouly *Client:* The New Yorker *Title:* Life in a Fishbowl Size: 11"x15" *Medium:* Watercolor/ink

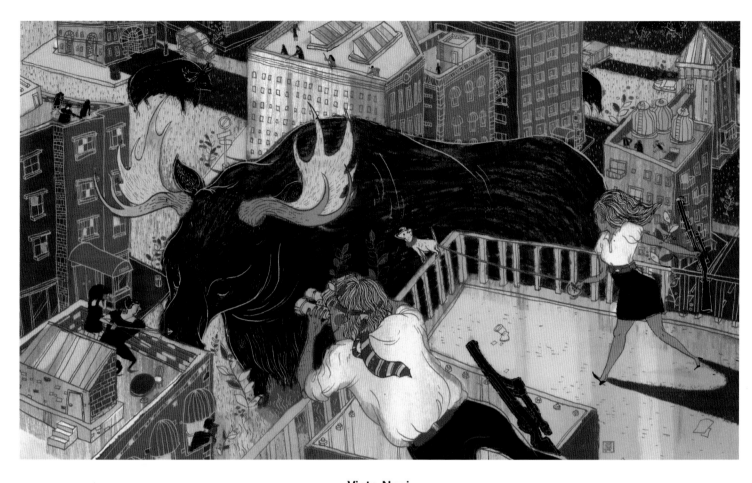

Victo Ngai

Art Director: SooJin Buzelli *Client:* Asset International *Title:* Metropolitan Hunting Season *Size:* 17"x10" *Medium:* Mixed

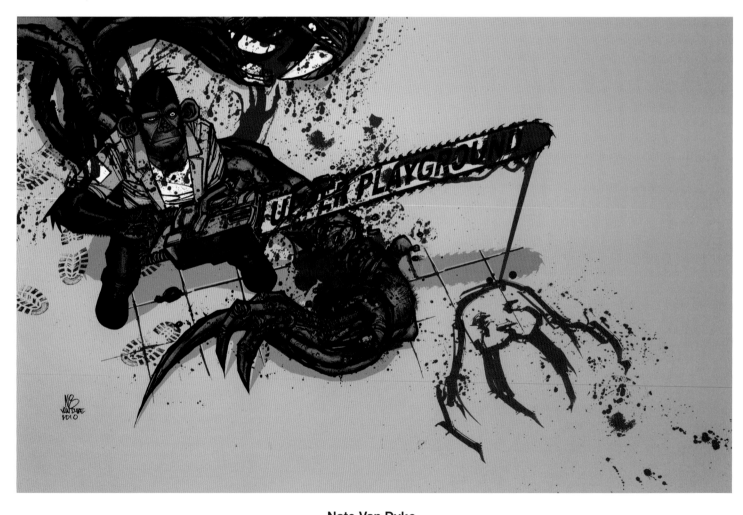

Nate Van Dyke

Art Director: Evan Pricco *Client:* Juxtapoz Magazine *Title:* Upper Palyground *Size:* 24"x15.5" *Medium:* Ink/digital color

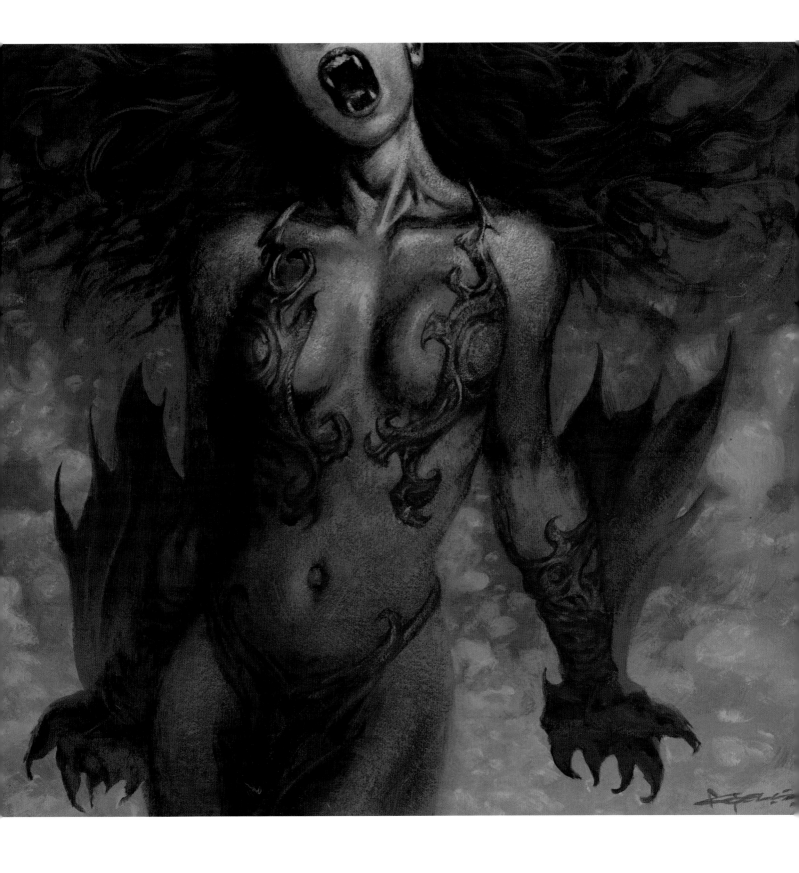

Christopher Moeller
Art director: Jeremy Jarvis *Client:* Wizards of the Coast *Title:* Vampire's Bite *Size:* 12"x10" *Medium:* Acrylic

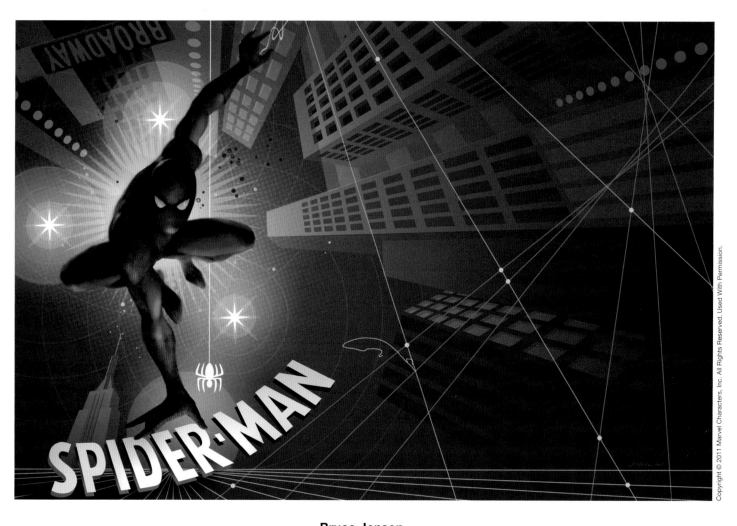

Bruce Jensen
Art Director: Robert Corujo *Client:* 60 Minutes *Title:* Spider-Man *Size:* 15"x10" *Medium:* Digital

Brynn Metheney
Art director: Ian Dean *Client:* ImagineFX *Title:* Elegant Hunters *Size:* 14"x9" *Medium:* Photoshop CS3

Edward Kinsella

Art director: Joannah Ralston *Client:* Milken Institute Review *Title:* Zombie Economics Size: 10.75"x15.25" *Medium:* Ink/gouache

João Ruas
Art Director: Alyson Waller *Client:* The London Times *Title:* Monsters
Size: 10.6"x8.7" *Medium:* Graphite, watercolor, gouache, digital

Alessandro "Talexi" Taini
Client: Namco Bandai Games
Title: Trip—Enslaved *Medium:* Photoshop

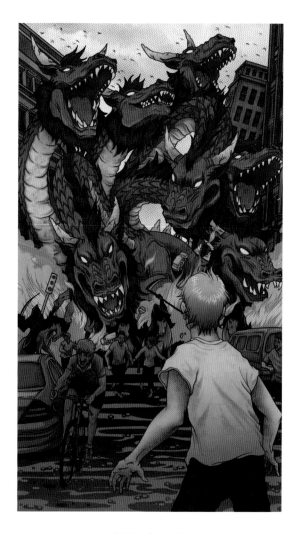

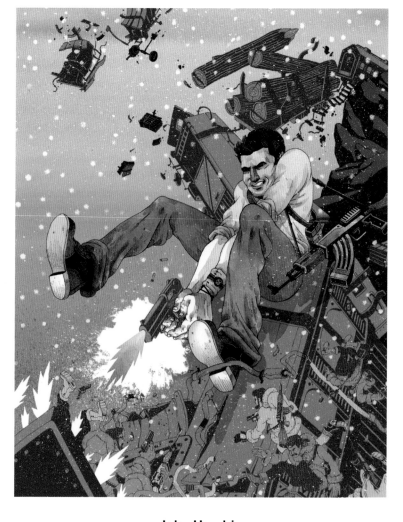

Yuta Onoda
Art director: Alice Cho *Client:* Wired Magazine
Title: Revelation *Size:* 10"x17" *Medium:* Mixed

John Hendrix
Art director: Michael Schnaidt *Client:* Entertainment Weekly
Title: Uncharted 2 *Size:* 8"x10" *Medium:* Ink/acrylic

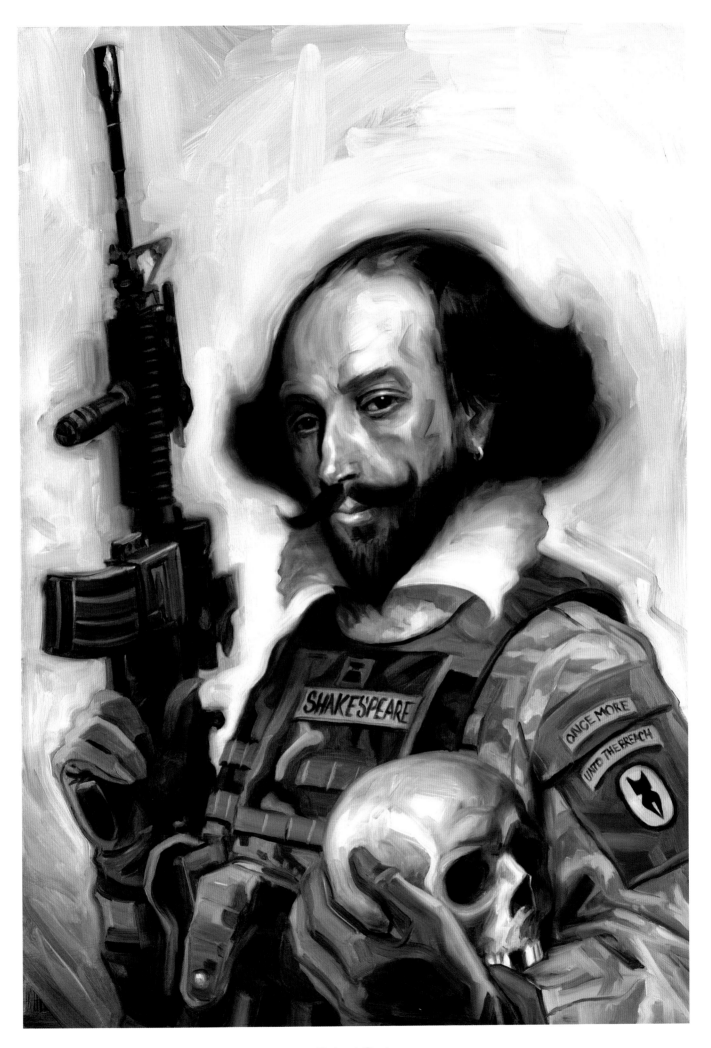

Robert Carter

Art director: Tim Kelly *Client:* Northshore Magazine *Title:* Sgt. Shakespeare Size: 13.75"x20" *Medium:* Oil

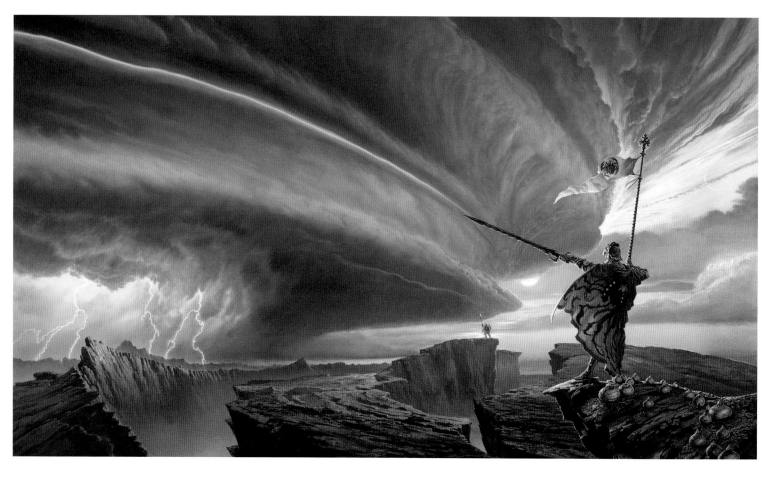

Michael Whelan
Art Director: Irene Gallo *Client:* Tor.com *Title:* The Way of Kings *Size:* 40"x24" *Medium:* Acrylic on panel

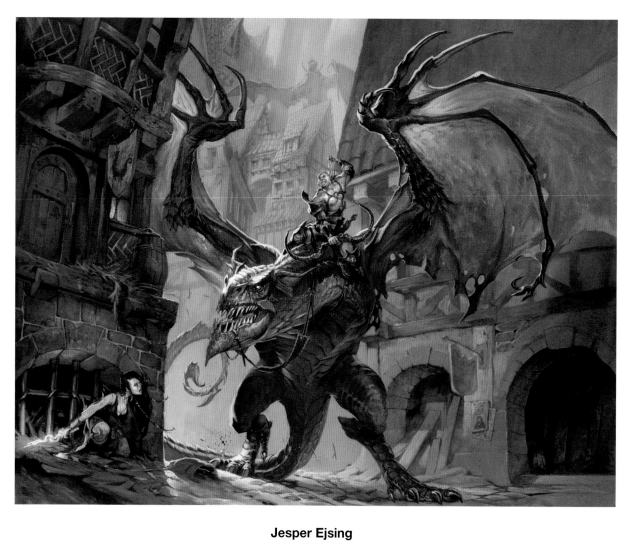

Jesper Ejsing
Art Director: Jon Schindehette *Client:* Wizards of the Coast *Title:* Dungeon #389 [cover] *Size:* 11"x11"

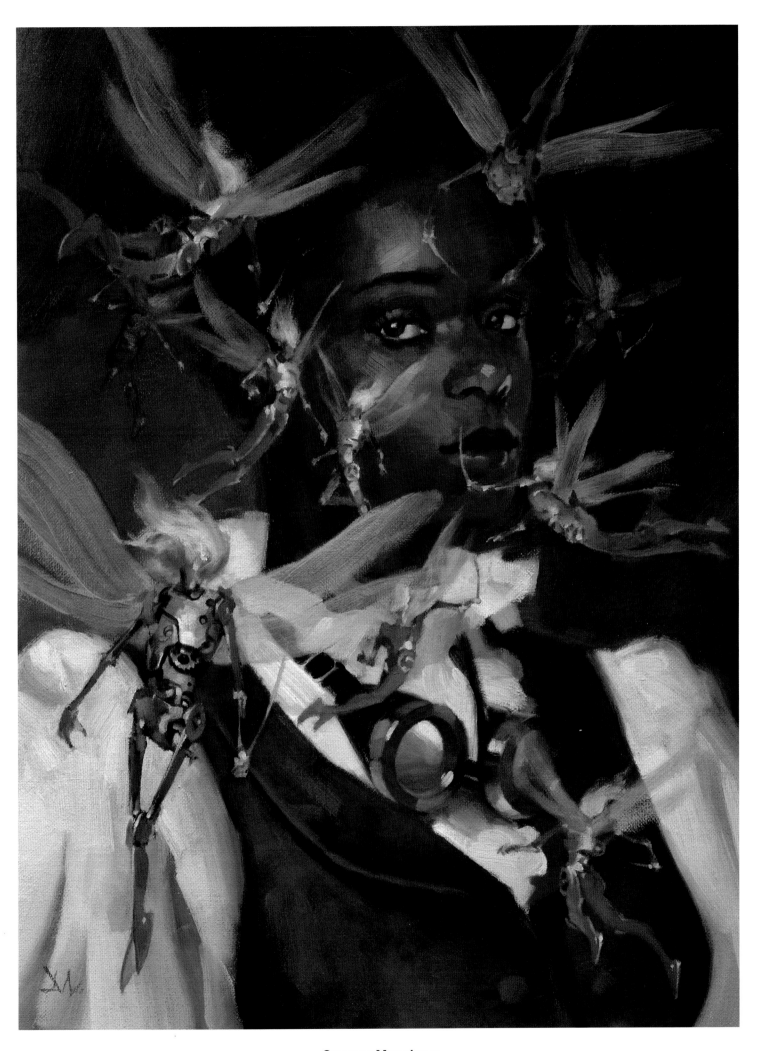

Gregory Manchess

Art Director: Irene Gallo *Client:* Tor.com *Title:* Clockwork Fairies *Size:* 18"x20" *Medium:* Oil on linen

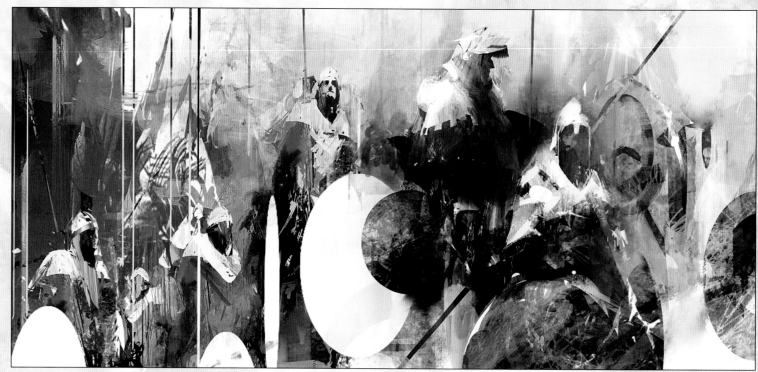

detail

Richard Anderson

Art Director: Daniel Dociu *Client:* ArenaNet *Title:* Knight March *Size:* 19"x12" *Medium:* Digital

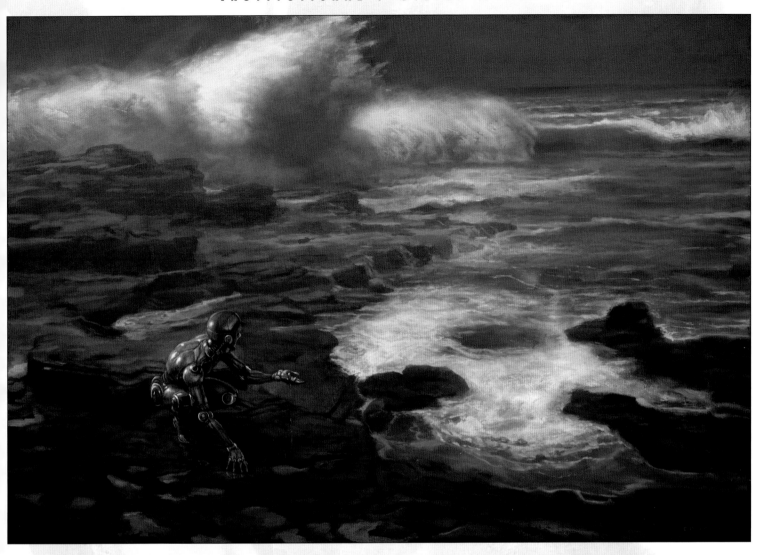

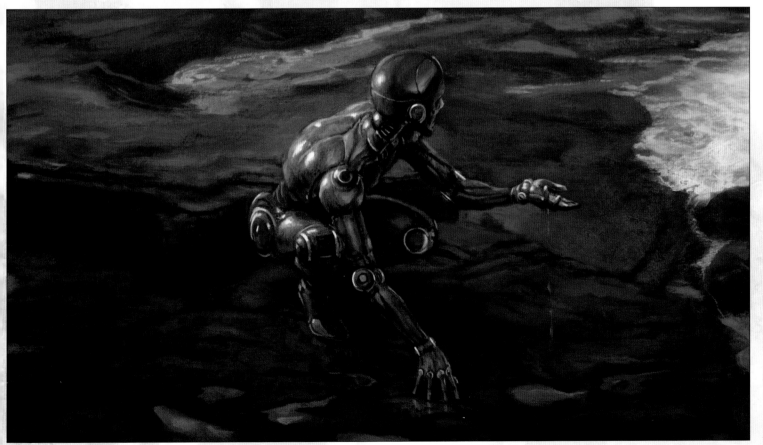

detail

Donato Giancola
Title: Mind Machine *Size:* 24"x18" *Medium:* Oil on panel

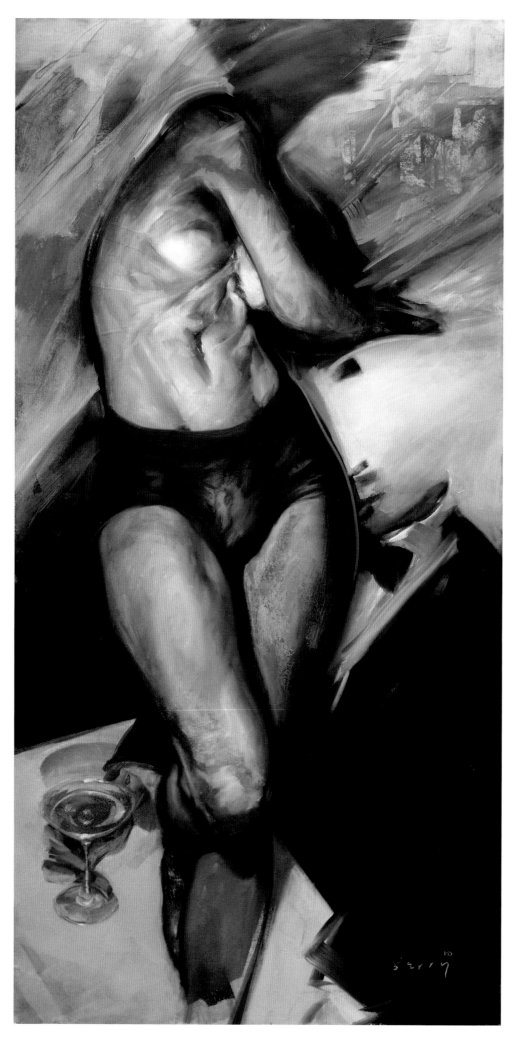

Rick Berry
Client: A.R.T. Productions: *Cabaret* starring Amanda Palmer *Title:* To Absent Friends *Size:* 24"x48" *Medium:* Oil on panel

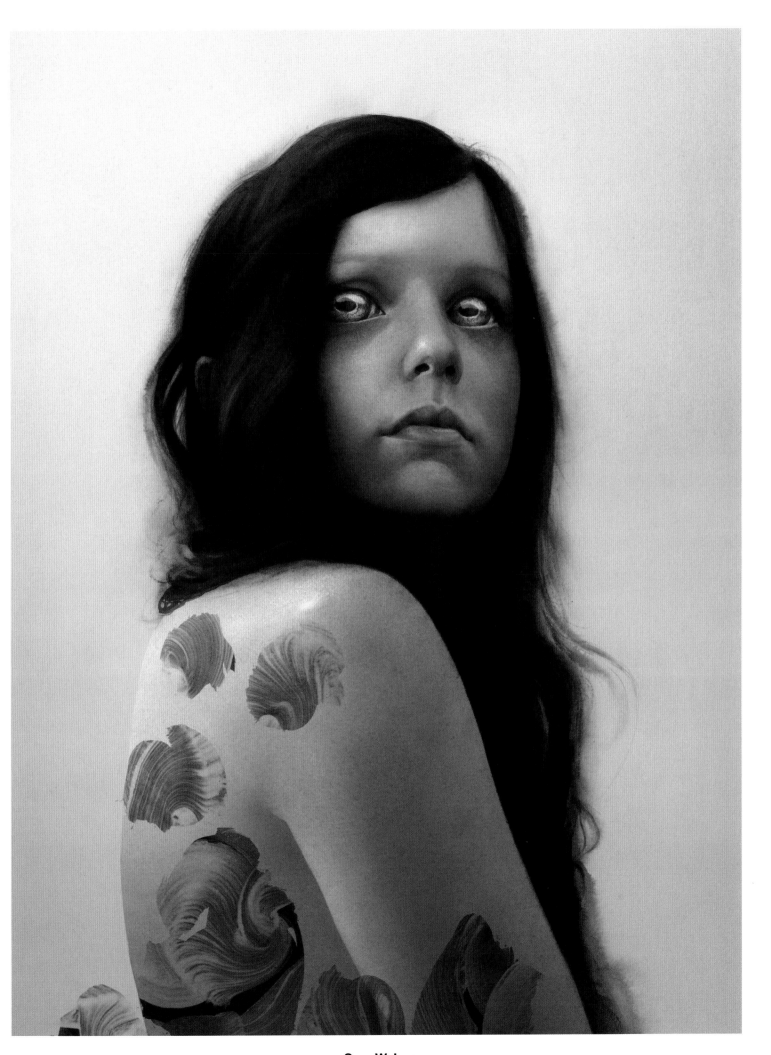

Sam Weber

Art Director: Jim Burke *Client:* Dellas Graphics *Title:* Oryx *Medium:* Acrylic/digital

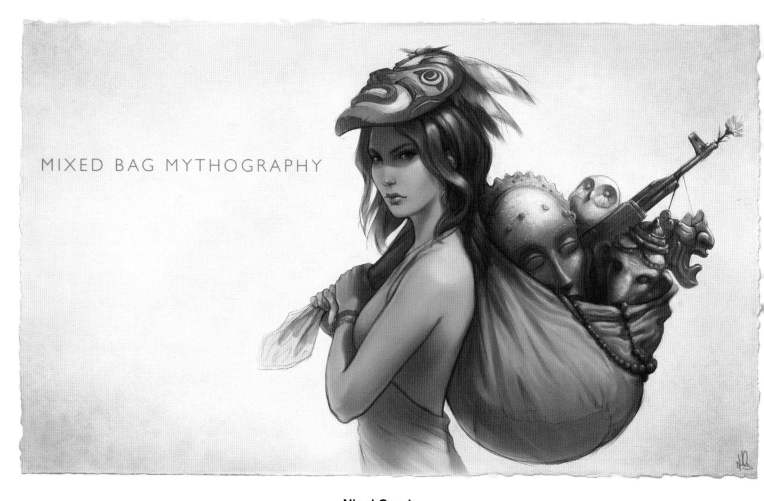

Nigel Quarless
Client: Mixed Bag Mythography *Title:* Mixed Bag Mythography II *Size:* 12.5"x7.8" *Medium:* Graphite/digital

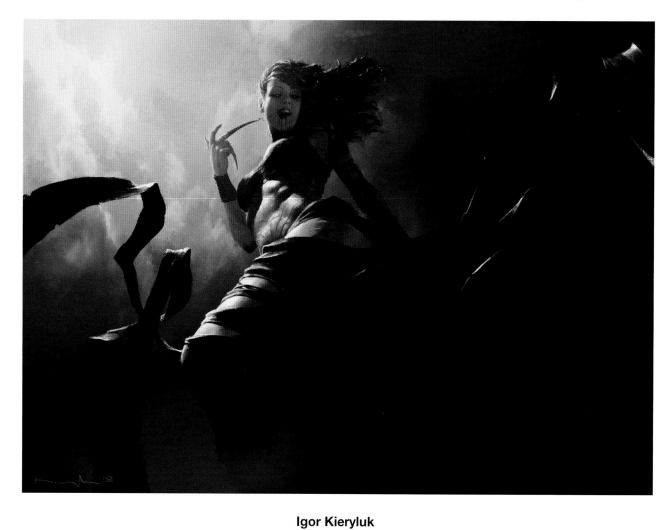

Igor Kieryluk
Art Director: Jeremy Jarvis *Client:* Wizards of the Coast *Title:* Sangromancer *Medium:* Digital

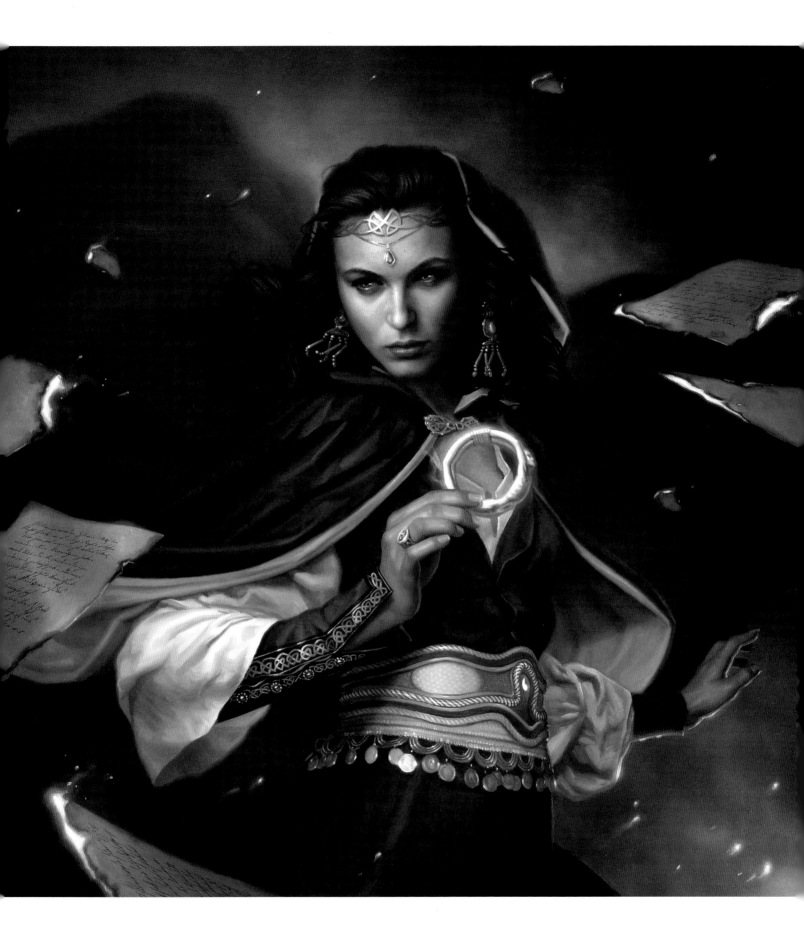

Dan Dos Santos

Art Director: Irene Gallo *Client:* Tor.com *Title:* The Fires of Heaven *Medium:* Oil on board

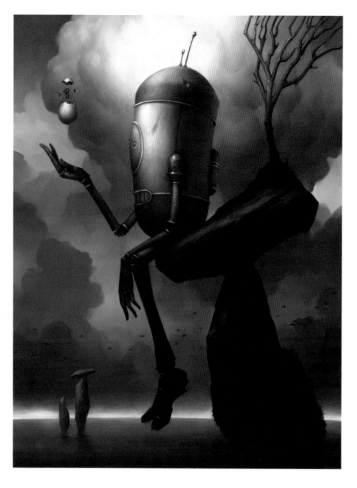

Brian Despain

Title: No Man *Size:* 30"x40" *Medium:* Oil on wood panel

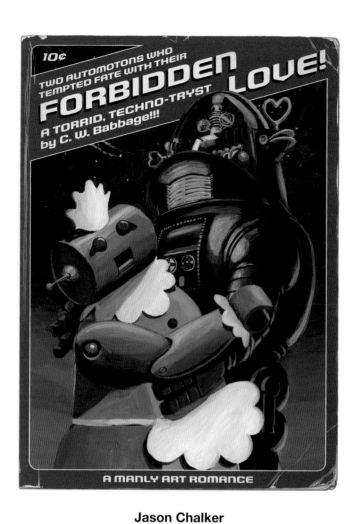

Jason Chalker

Title: Forbidden Love *Size:* 10"x15" *Medium:* Acrylic/digital type

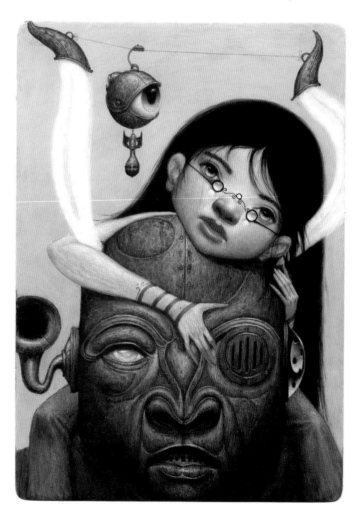

Bill Carman

Client: Microvisions *Title:* Gondola Security *Size:* 5"x7" *Medium:* Acrylic

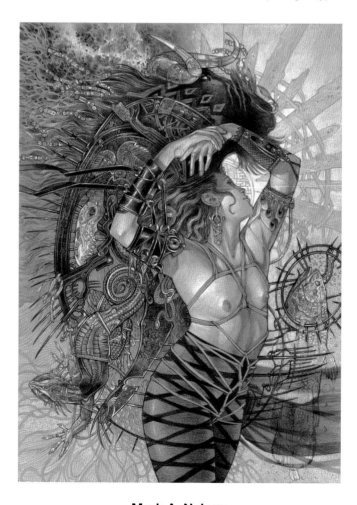

Mark A. Nelson

Client: Grazing Dinosaur Press *Title:* TT: Circle of Life
Size: 10.5"x14.5" *Medium:* Colored pencil on toned paper

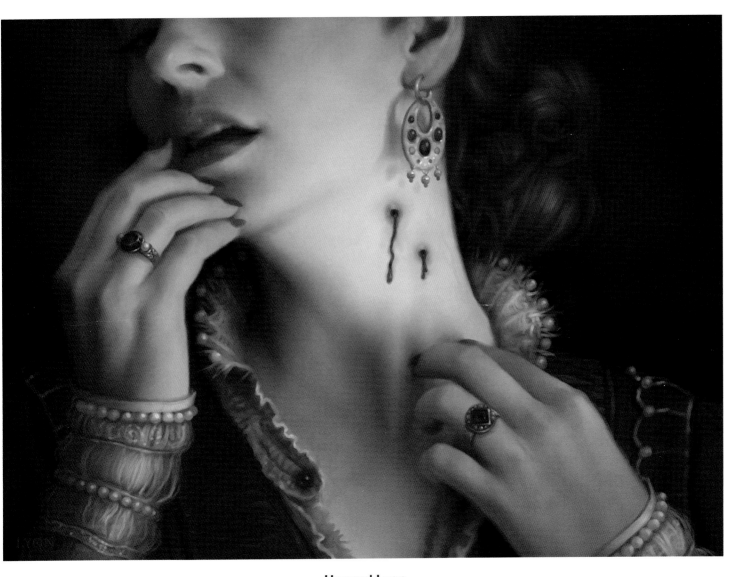

Howard Lyon

Art Director: Jeremy Jarvis *Client:* Wizards of the Coast *Title:* Taste the Pain *Size:* 14"x10.2" *Medium:* Digital

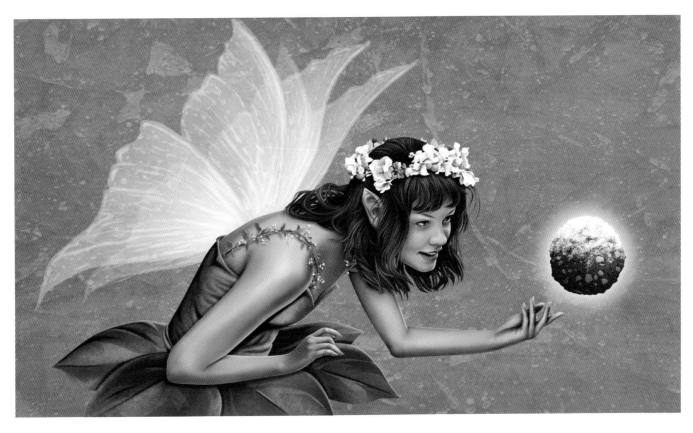

Tracy Sabin

Client: Seafarer Baking Company *Title:* Sugar Plum *Size:* 12"x7.5" *Medium:* Digital

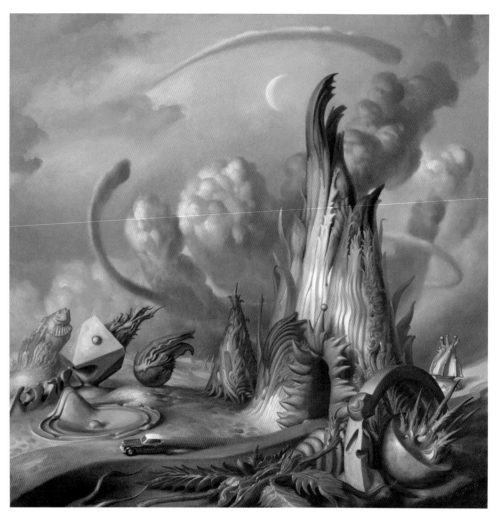

Gil Bruvel
Title: Road Trip #9: The Rally *Size:* 24"x24" *Medium:* Oil on board

Rick Berry
Title: Serafs *Size:* 24"x48" *Medium:* Oil on panel

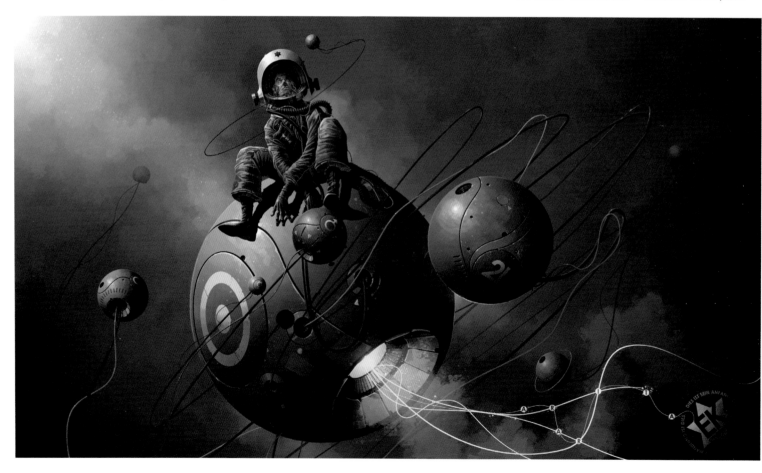

Derek Stenning
Client: Born in Concrete *Title:* A.R.A.R.I.T.A *Size:* 23"x13" *Medium:* Mixed

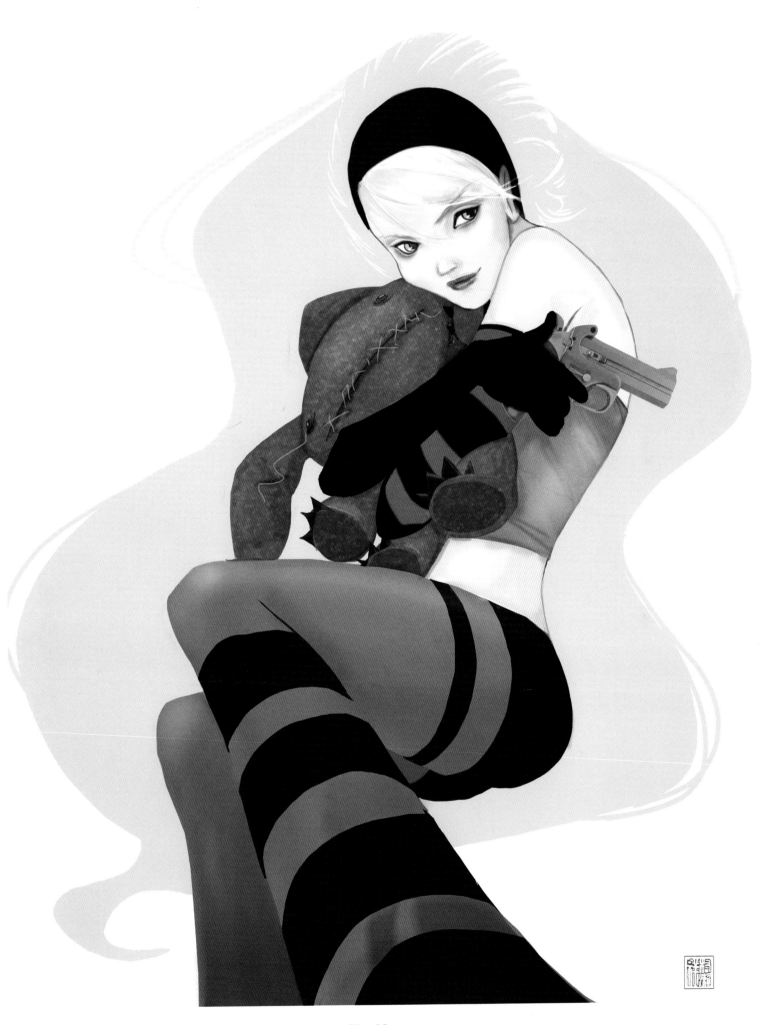

Sho Murase

Title: Pink *Size:* 18"x25" *Medium:* Graphite/digital color

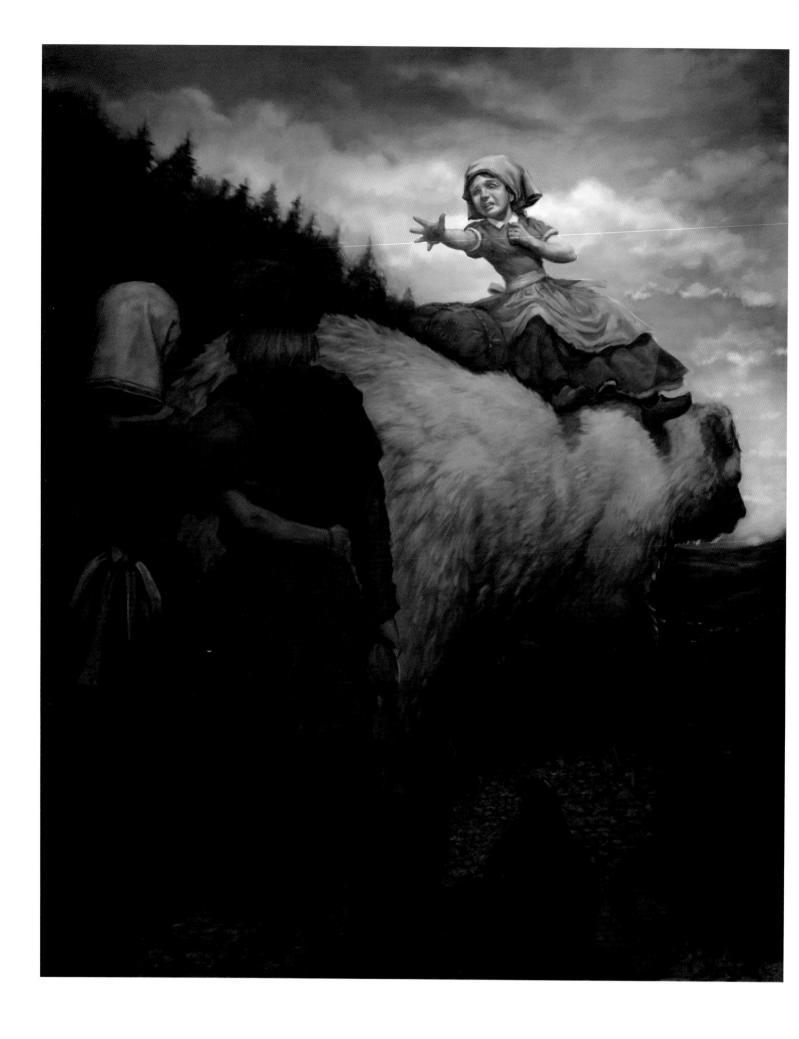

Chris Beatrice

Title: The White Bear *Size:* 11"x13.5" *Medium:* Digital

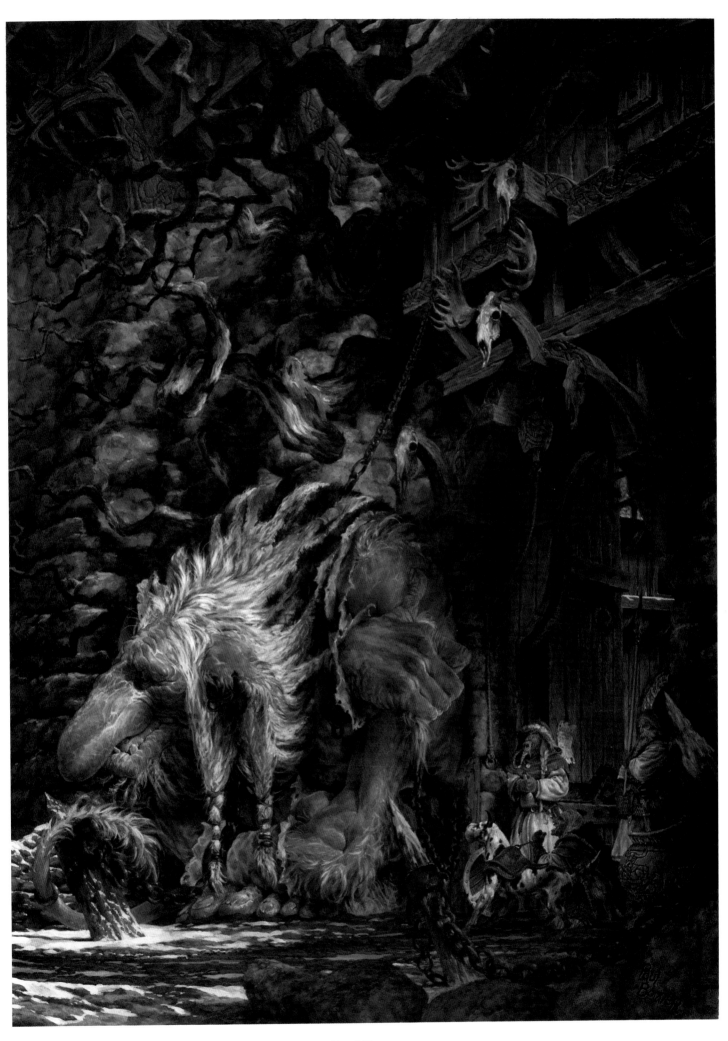

Paul Bonner

Art Director: Theo Bergquist *Client:* Riotminds *Title:* Jarntunga *Size:* 35x49cm *Medium:* Watercolor

Wayne Reynolds
Art Director: Jeremy Jarvis *Client:* Wizards of the Coast
Title: Feed the Machine *Medium:* Acrylic

William Stout
Art Director: Arnie Fenner *Client:* Andrews McMeel Publishing
Title: Pumpkin Brains *Medium:* Oil on board

David Ho
Client: Pop Gallery Sante Fe *Title:* Where Sparrows Run to Hide *Size:* 30"x24" *Medium:* Mixed

Michael C. Hayes
Art Director: Jeremy Jarvis *Client:* Wizards of the Coast *Title:* Distress *Size:* 18"x13" *Medium:* Oil on paper on board

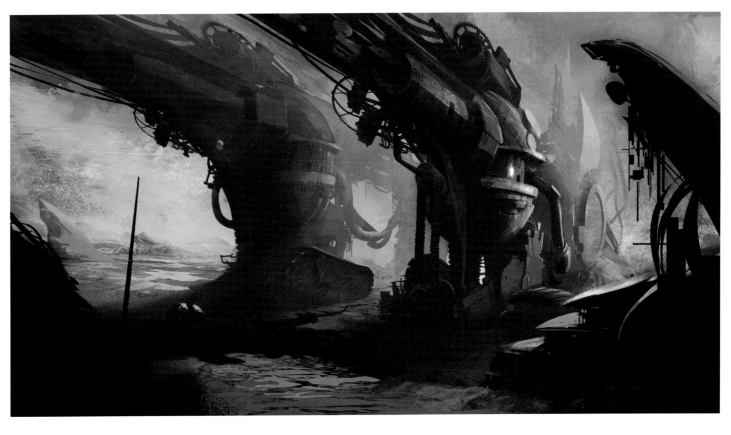

Jason Stokes
Client: Future Poly *Title:* Desert Bridge *Size:* 16"x9" *Medium:* Photoshop

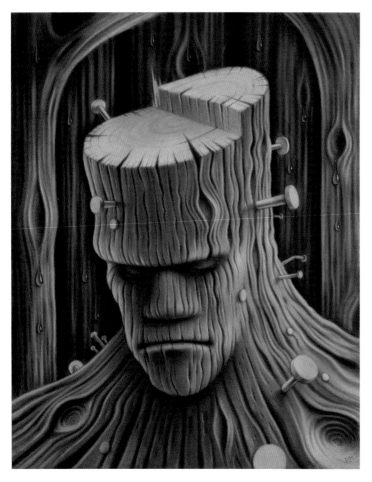

Dan L. Henderson
Title: SAP *Size:* 20"x26" *Medium:* Chacoal on paper

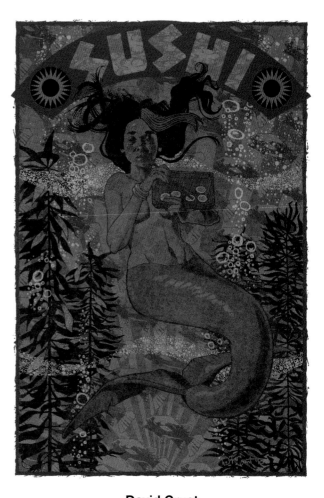

David Crust
Client: Crustdesign *Title:* Sushi *Size:* 12"x18" *Medium:* Ink/digital

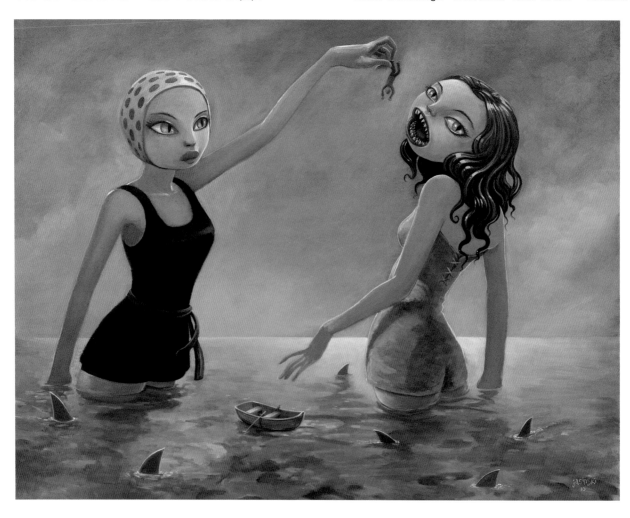

Aaron Jasinski
Client: Screaming Sky Gallery *Title:* Maneater *Size:* 30"x24" *Medium:* Acrylic on wood

Scott Bakal

Art Director: Stephen Gardner *Client:* Society of Illustrators *Title:* Red Fish *Size:* 18"x24" *Medium:* Acrylic/ink

David Delamare

Art Director: Wendy Ice *Client:* Bad Monkey Productions *Title:* The Levitation *Size:* 40"x30" *Medium:* Oil on canvas

Tim W. Kuzniar

Title: Toasters *Size:* 16"x8" *Medium:* Digital

Scott Gustafson

Art Director: Tammy Severe *Client:* Ed-Comm,LLC/National Geographic *Title:* Woodland Santas *Size:* 28"x20" *Medium:* Oil

Chris Buzelli

Art Director: Lar Buri *Client:* DDB Berlin *Title:* The Tale of Clumsy Atomic *Size:* 26"x16" *Medium:* Oil on board

Brian Despain
Title: The Deference Engine *Size:* 30"x40" *Medium:* Oil on wood panel

Steven Belledin

Art Director: Jeremy Jarvis *Client:* Wizards of the Coast *Title:* Surrender *Size:* 16"x20" *Medium:* Oil

Eric Joyner
Client: Sanrio *Title:* Hello Topiary *Size:* 40"x28" *Medium:* Oil on panel

Andrew Mitchell
Client: Black & White & Red All Over 2010 Calendar *Title:* Lost in Manhattan *Size:* 7"x5.5" *Medium:* Ink/watercolor

David Delamare

Art Director: Wendy Ice *Client:* Bad Monkey Productions *Title:* The Spinning Web *Size:* 40"x30" *Medium:* Oil on canvas

Scott Brundage

Art Director: Irene Gallo *Title:* Tor.com *Title:* Ada Lovelace Day *Medium:* Watercolor

William Stout

Art Director: Joan Adan *Designer:* Randall Dahlk *Client:* Forest Lawn Museum *Title:* Menagerie: Everybody's a Critic *Size:* 60"x48" *Medium:* Oil

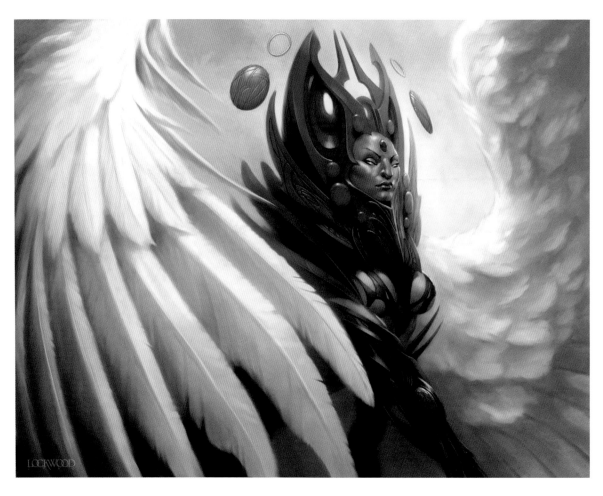

Todd Lockwood

Art Director: Jeremy Jarvis *Client:* Wizards of the Coast *Title:* Sharuum *Medium:* Digital

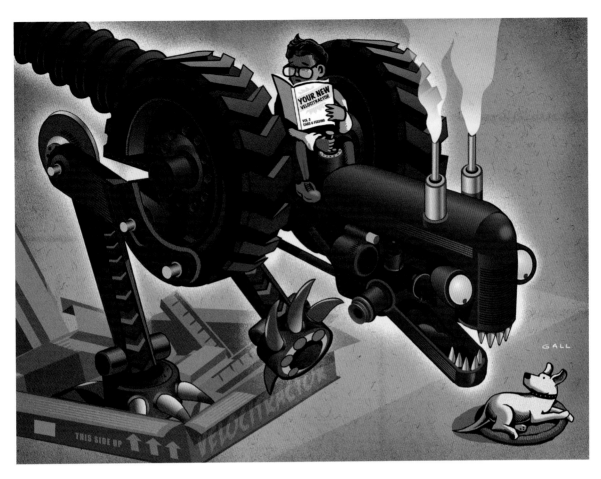

Chris Gall

Client: Kids Need To Read Calendar *Title:* Velocitractor *Size:* 12"x9" *Medium:* Scratchboard/digital color

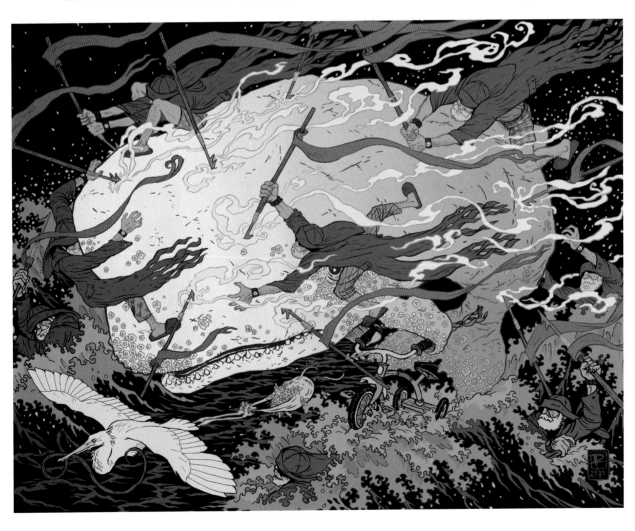

Peter Diamond

Art Director: Michael Gray Kimber *Client:* Michael Gray Kimber *Title:* Treading Water *Size:* 14.5"x11.5" *Medium:* Ink/digital

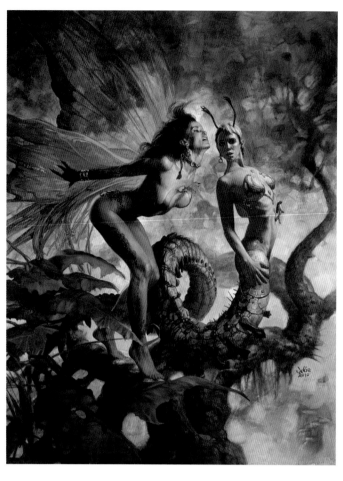

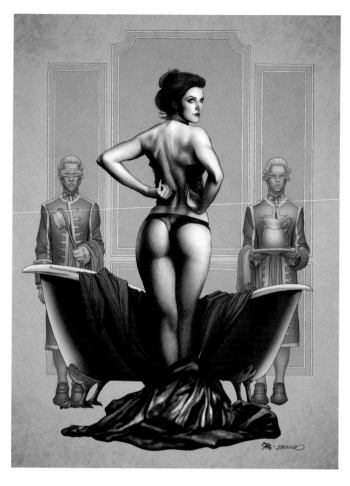

Julie Bell
Client: Workman Publishing *Title:* Transformer
Size: 18"x24" *Medium:* Oil on masonite

Frank Cho
Colorist: Brandon Peterson *Title:* Queen's Bath
Size: 14"x21" *Medium:* Ballpoint pen/digital color

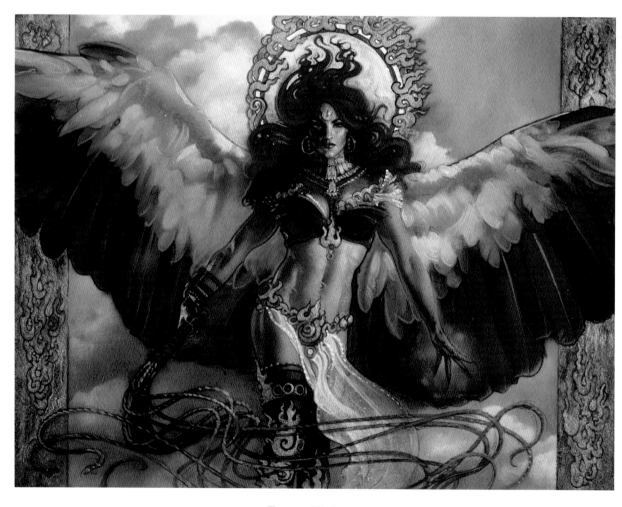

Terese Nielsen
Art Director: Jeremy Jarvis *Client:* Wizards of the Coast *Title:* Basandra, Battle Seraph *Medium:* Mixed

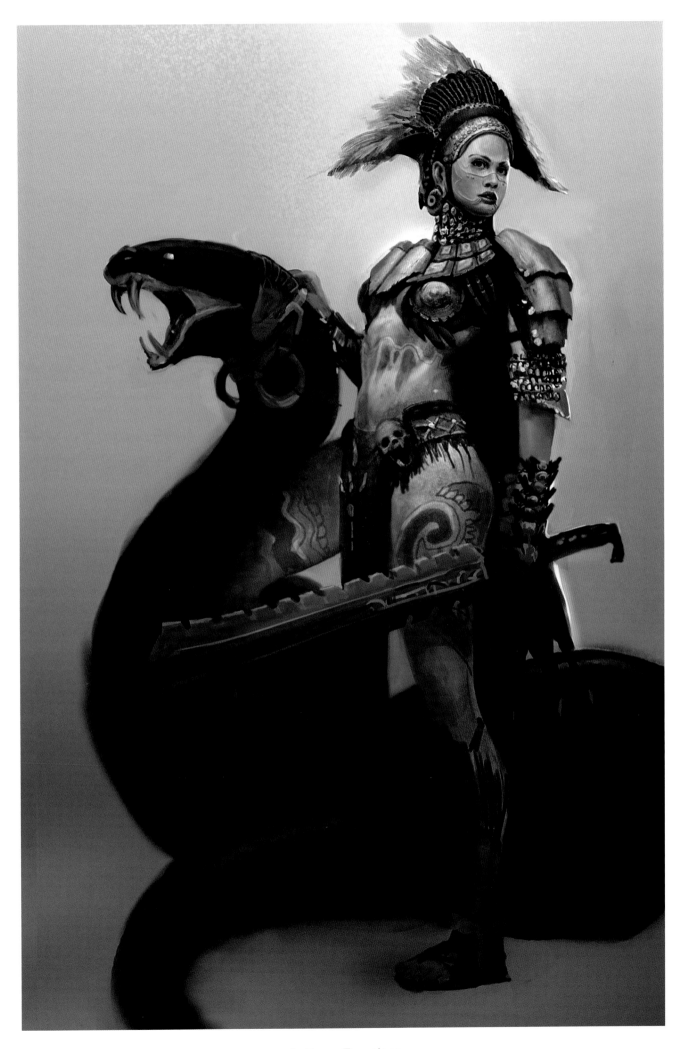

Anthony Francisco

Title: ER: Snake Princess *Medium:* Digital

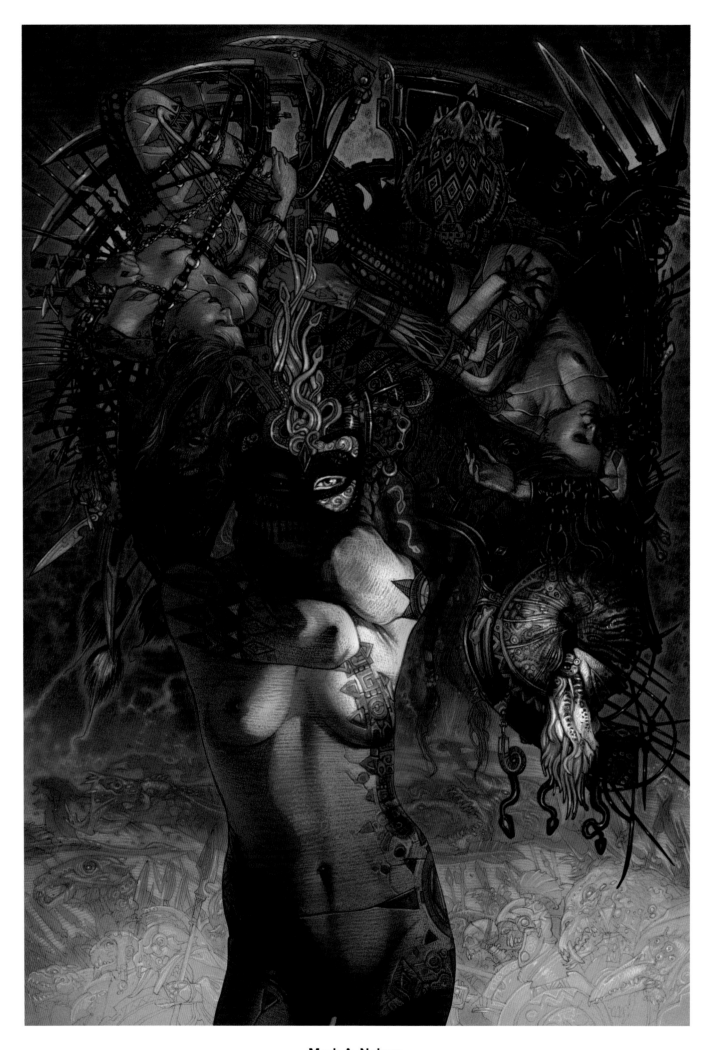

Mark A. Nelson
Client: Grazing Dinosaur Press *Title:* RHTT: Prytania *Size:* 11"x16" *Medium:* Pencil/digital color

Aleksi Briclot
Art Director: Jeremy Jarvis *Client:* Wizards of the Coast *Title:* Primordial Hydra *Medium:* Digital

Jerry Lofaro
Client: The Mountain *Title:* Against the Wall *Medium:* Digital

Konatsu
Art Director: Mark Nagata *Client:* Max Toy Co. *Size:* 15"x20" *Medium:* Ink

Michael Komark

Art Director: Jeremy Jarvis *Client:* Wizards of the Coast *Title:* Elspeth Tirel *Medium:* Digital

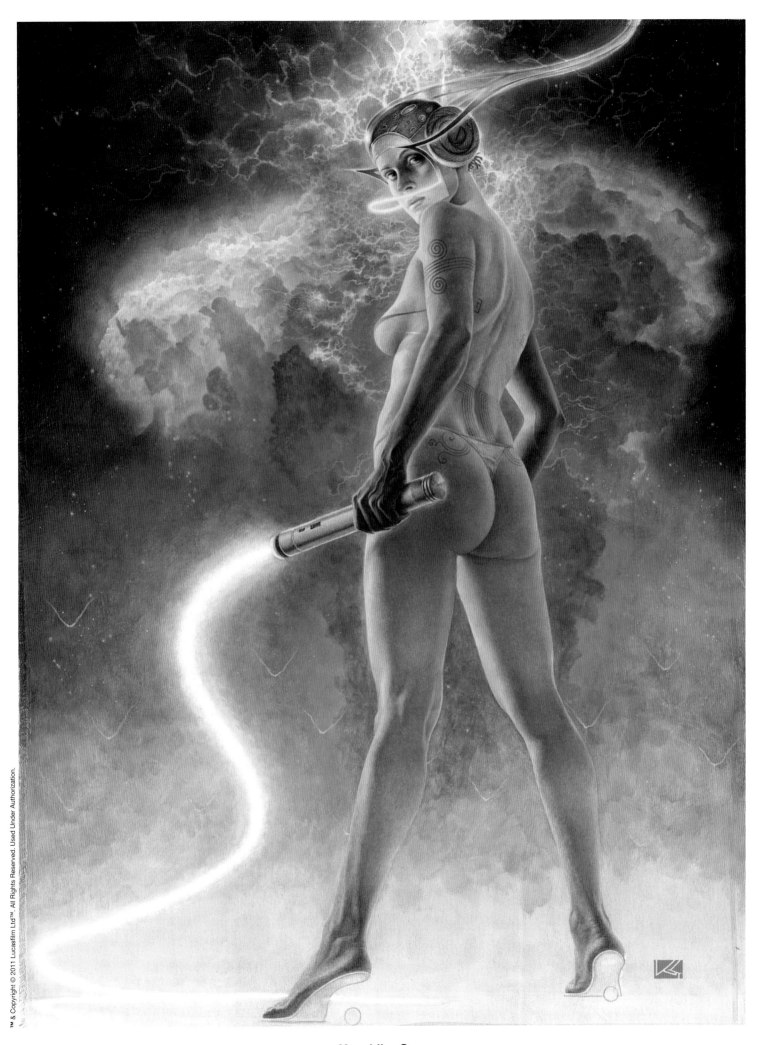

Kazuhiko Sano

Client: Lucasfilm Ltd.™ *Title:* Space Bitch *Size:* 24"x32" *Medium:* Acrylic

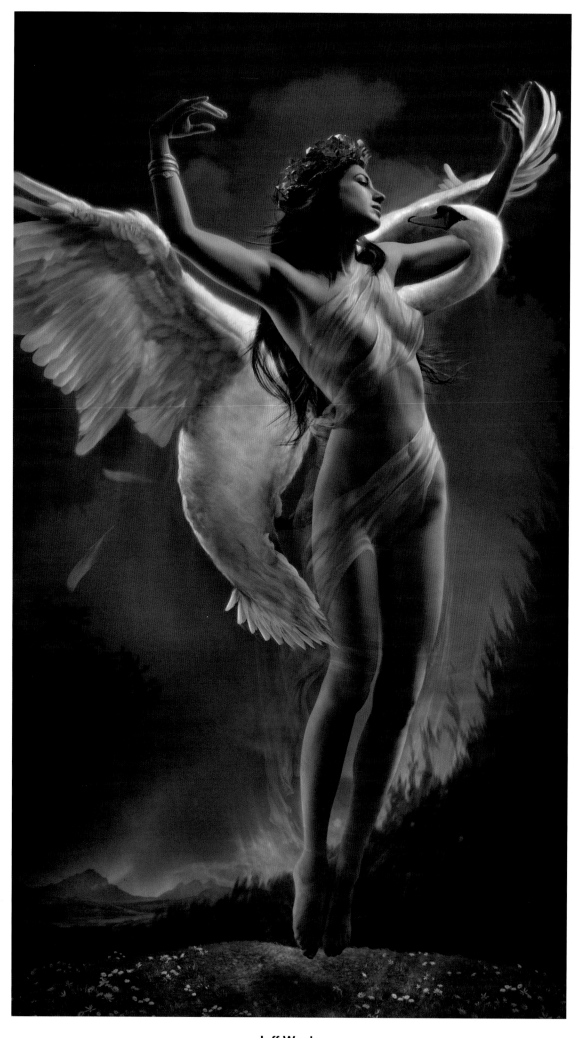

Jeff Wack

Client: Sensuous Muse Collection *Title:* Leda and the Swan *Size:* 16"x28" *Medium:* Digital

Sho Murase

Client: Artblocks for Ghana *Title:* "Yeey, going back home" *Size:* 10"x10" *Medium:* Mixed

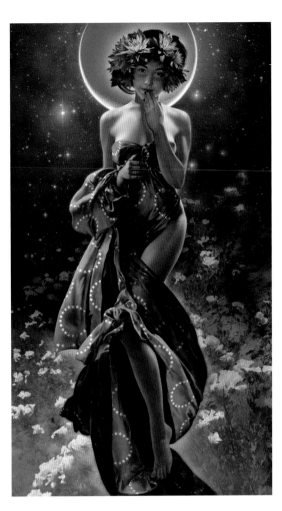

Jeff Wack

Title: The Moon *Size:* 16"x28" *Medium:* Digital

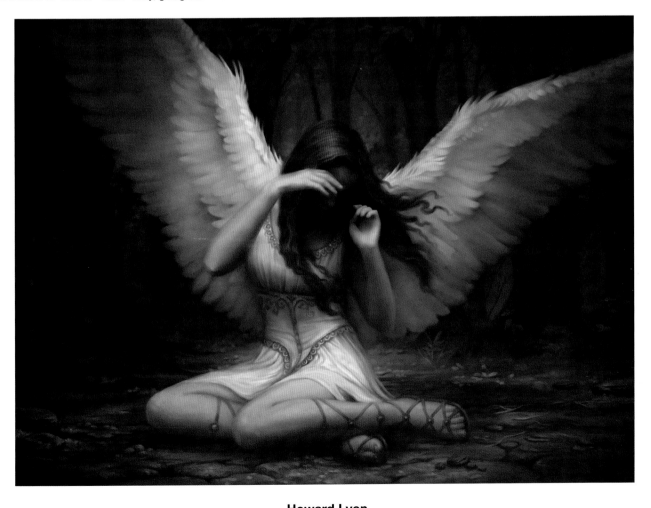

Howard Lyon

Art Director: Jeremy Jarvis *Client:* Wizards of the Coast *Title:* Guide of the Souls *Size:* 14"x10.2" *Medium:* Digital

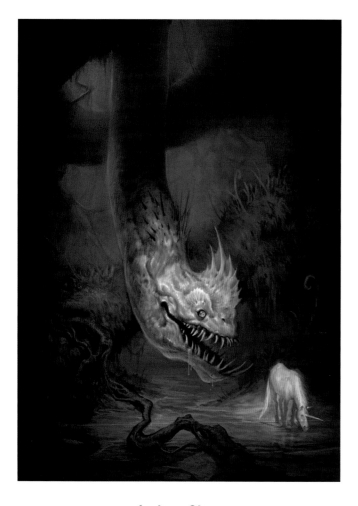

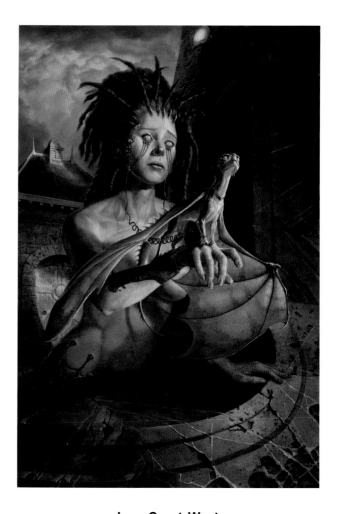

Andrew Olson
Art Director: David Kubalak/Brad Crow *Client:* Robot Entertainment
Title: The Last Unicorn *Medium:* Digital

Lars Grant-West
Client: Pat & Jeannie Wilshire *Title:* Pact of the Blind
Size: 24"x36" *Medium:* Oil on canvas

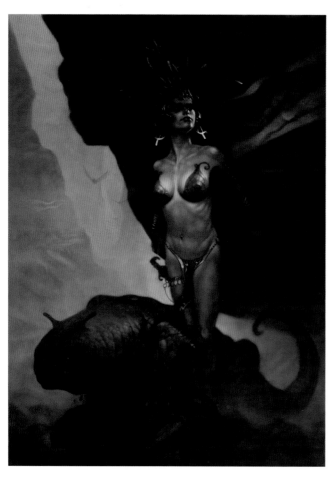

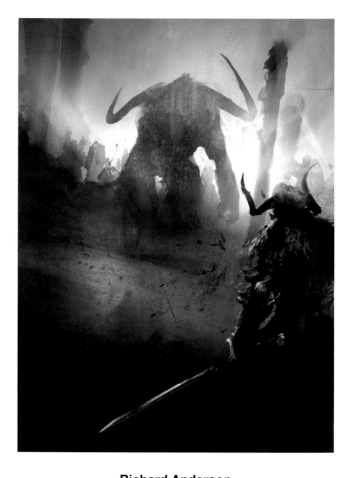

Patrick J. Jones
Client: PJArtworks.com *Title:* The Lost World *Size:* 18.5"x25" *Medium:* Oil

Richard Anderson
Art Director: Daniel Dociu *Client:* ArenaNet
Title: Minotaur Shadow *Size:* 12"x19" *Medium:* Digital

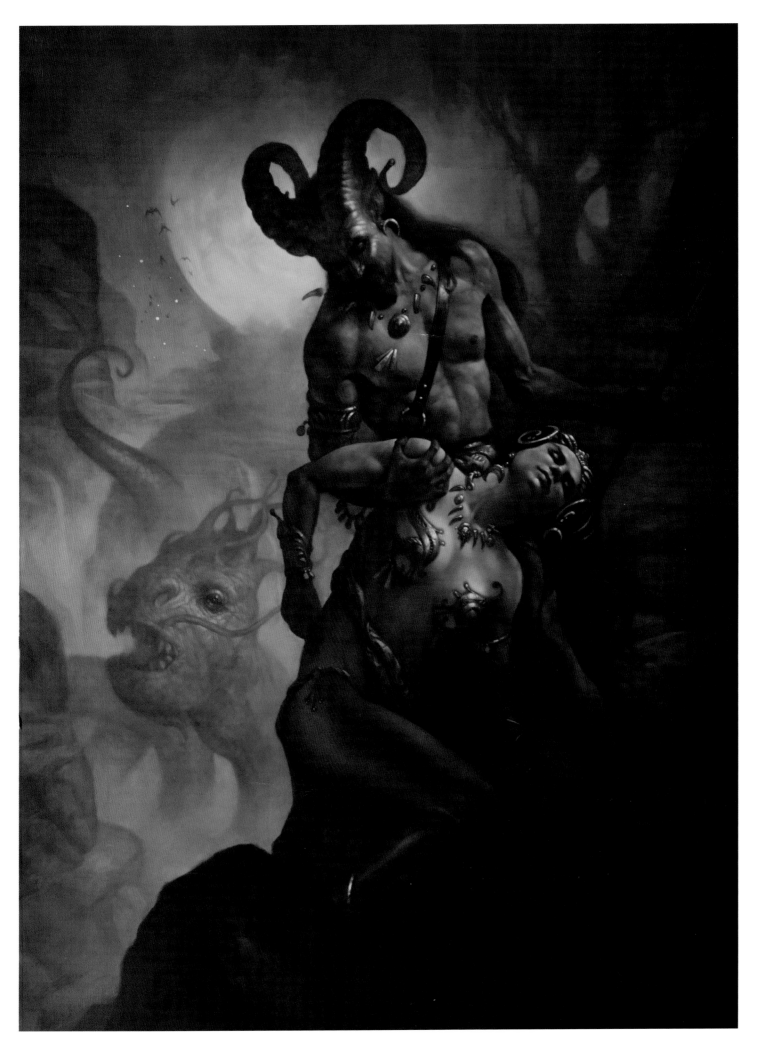

Patrick J. Jones

Client: PJArtworks.com *Title:* Valley of the Serpent *Size:* 18.5"x25" *Medium:* Oil

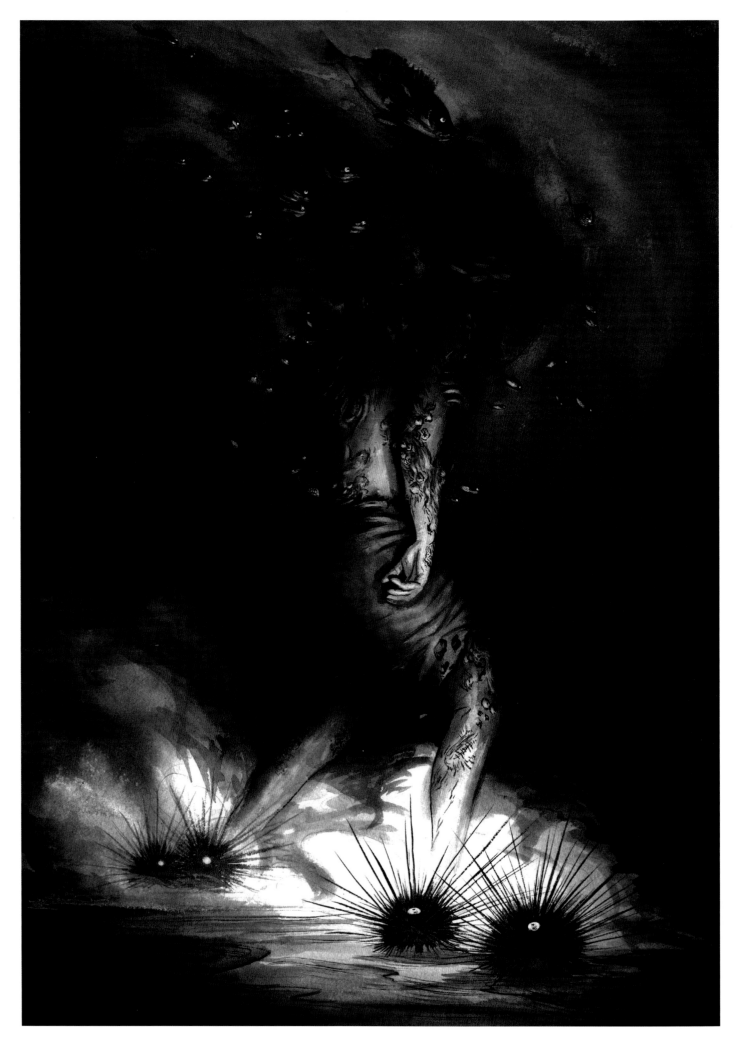

Michael Manomivibul

Title: Journey *Medium:* Sumi ink

Corinne Reid

Title: Wild Dog *Size:* 12.5"x18" *Medium:* Digital

John Stanko

Art Director: Derek Herring *Client:* Sony Online Entertainment
Title: Luck of the Stars Size: 20"x30" *Medium:* Digital

D. Alexander Gregory

Art Director: Jeremy Jarvis *Client:* Wizards of the Coast
Title: Chandra, The Firebrand *Medium:* Digital

Edward Binkley
Title: His Majesty's (2nd) Most Esteemed Royal-Pet Walker *Size:* 19"x15" *Medium:* Digital

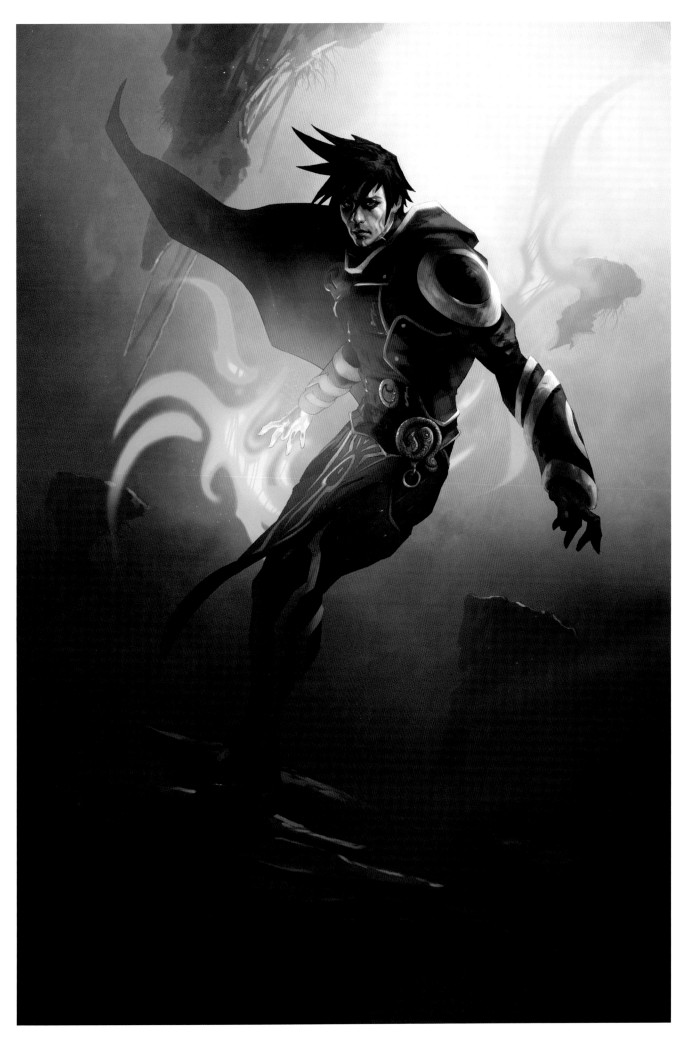

D. Alexander Gregory

Art Director: Jeremy Jarvis *Client:* Wizards of the Coast *Title:* Jace, Memory Adept *Medium:* Digital

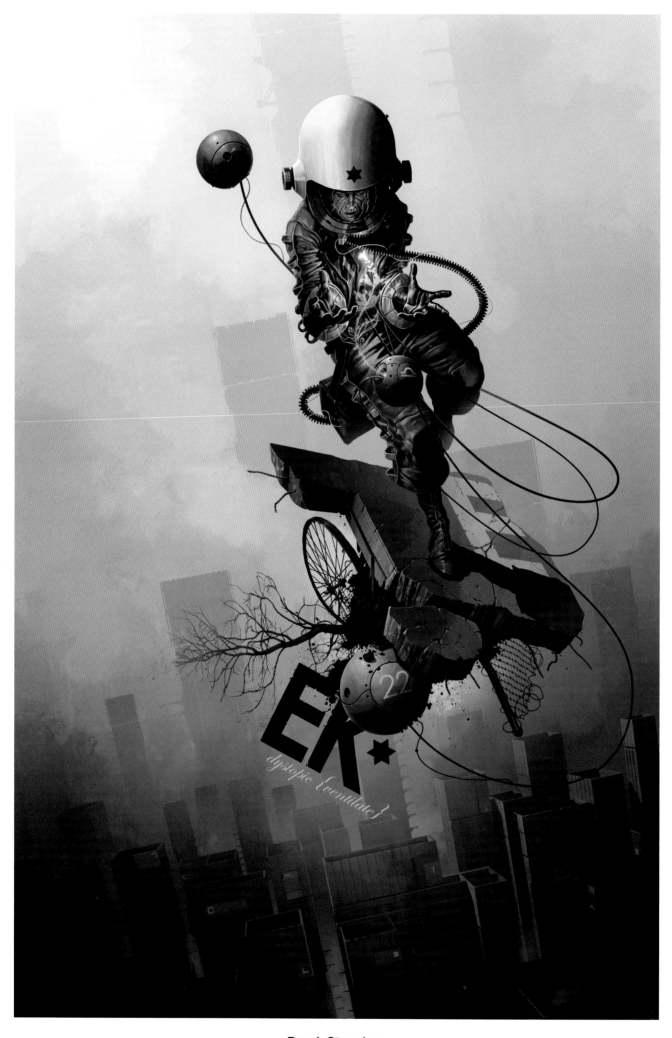

Derek Stenning
Client: Born in Concrete *Title:* Dystopic *Size:* 24"x36" *Medium:* Mixed

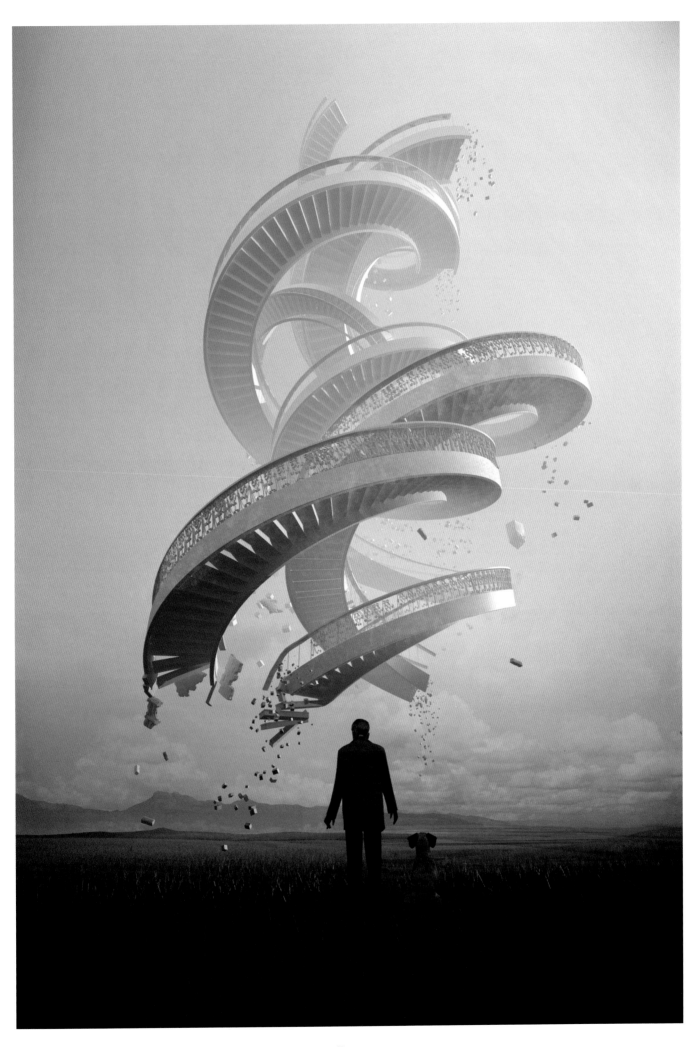

Jiema

Title: The Ladder *Size:* 45x66cm *Medium:* Digital

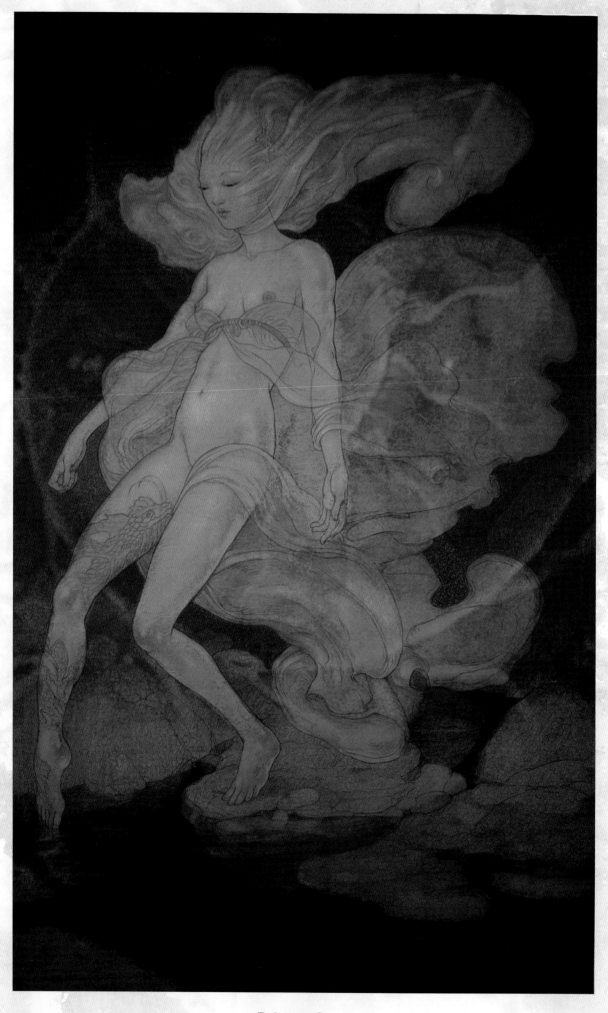

Rebecca Guay
Title: Pandora *Size:* 23"x30" *Medium:* Ink/pencil/mixed

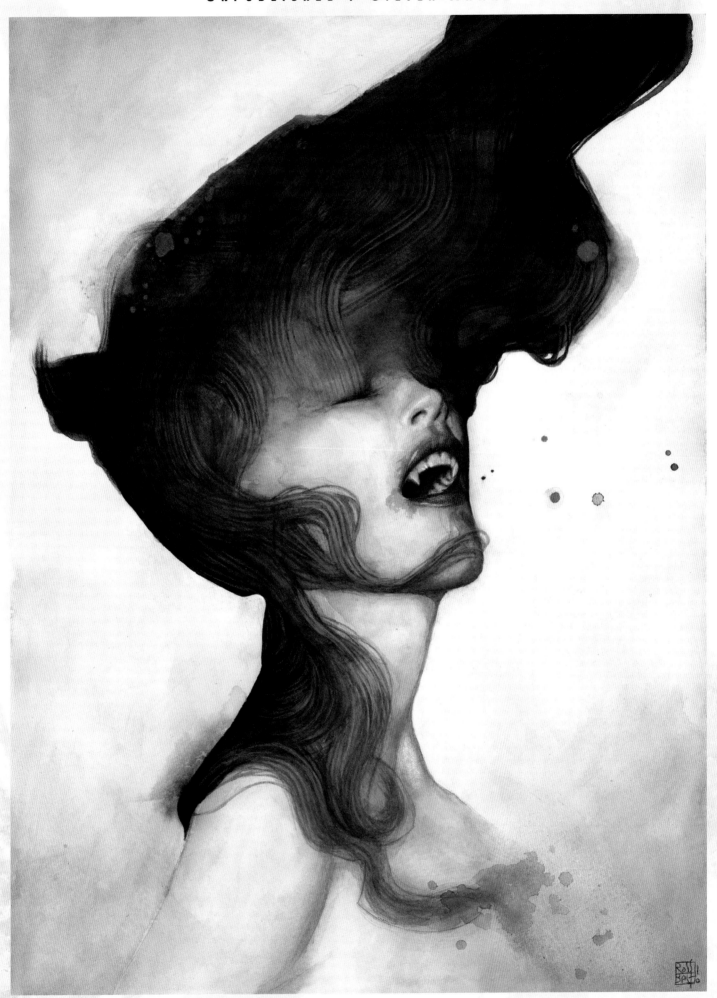

J.S. Rossbach

Title: White Heat *Size:* 29x39cm *Medium:* Watercolor

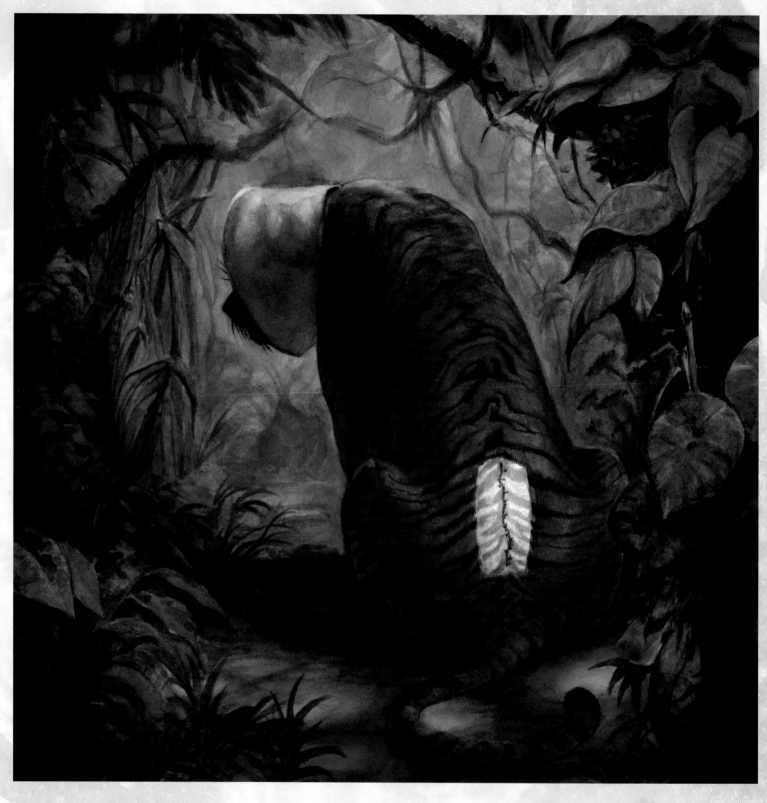

Scott Brundage
Title: Tigers Have Striped Skin, Not Just Striped Fur *Size:* 10.25"x10.25" *Medium:* Watercolor

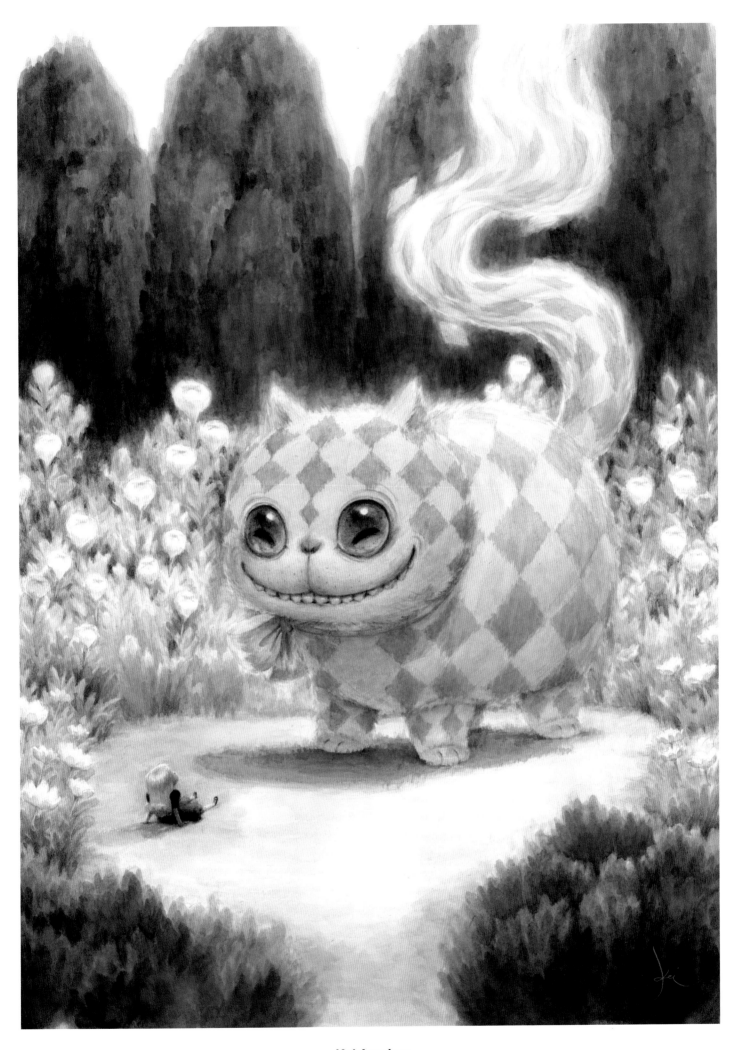

Kei Acedera

Title: Cheshire Surprise *Size:* 18"x24" *Medium:* Gouache on paper

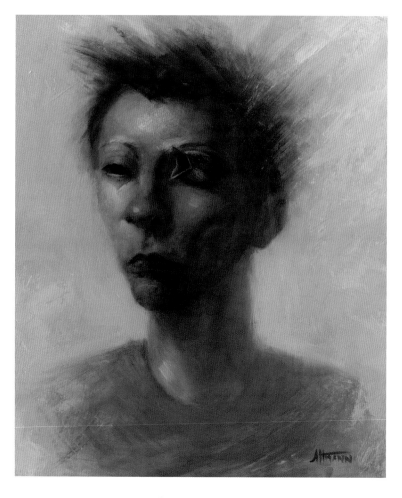

Scott Altmann
Title: Hatch *Size:* 16"x20" *Medium:* Oil on panel

Christopher Moeller
Title: Diana *Size:* 30"x40" *Medium:* Acrylic

Miran Kim
Title: The Empress *Size:* 36"x36" *Medium:* Acrylic on canvas

Marc Scheff
Title: Me King *Medium:* Digital

Barron Storey

Art Director: Carl Wyckaert *Client:* Carl Wyckaert/Petits Papiers *Title:* Judgement *Size:* 14.5"x22.5" *Medium:* Mixed

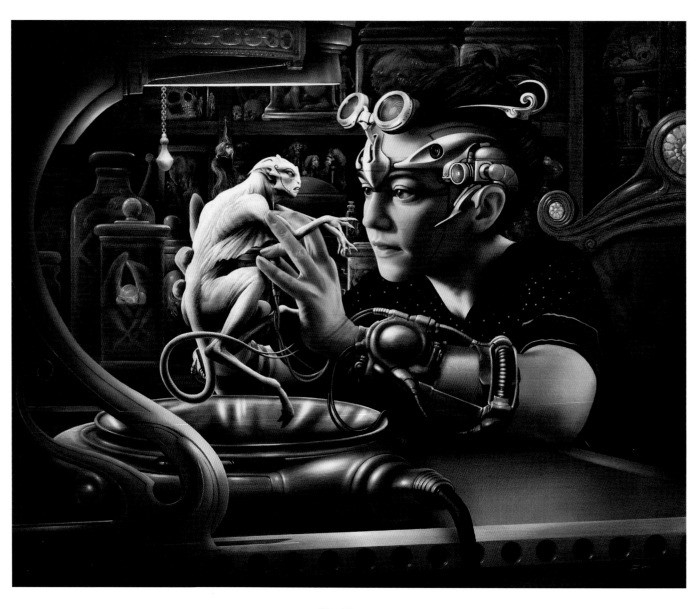

Jim Burns

Title: The Homuncularium *Size:* 32"x25" *Medium:* Acrylic on canvas

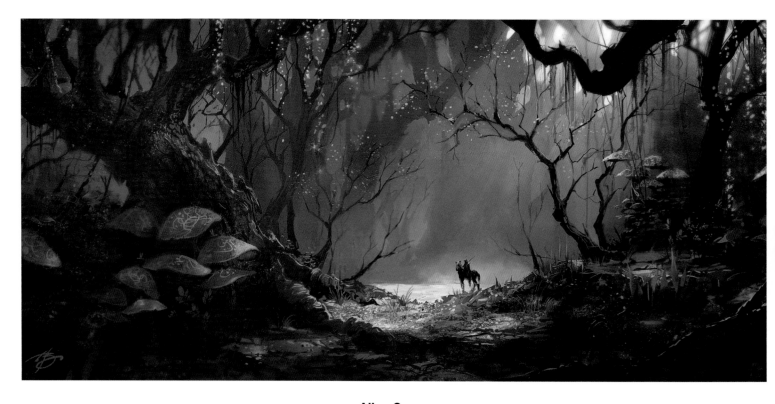

Allen Song

Title: Arrival *Medium:* Digital

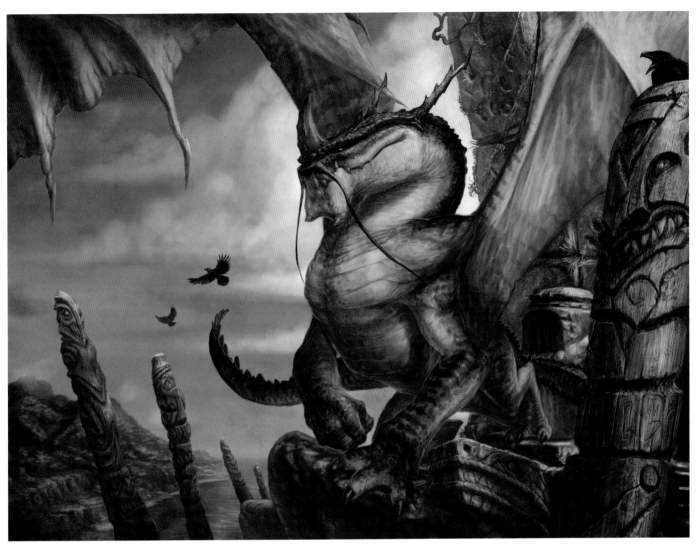

Michael Phillippi

Client: Sloth Productions LLC *Title:* Moving On *Size:* 11.5"x9" *Medium:* Digital

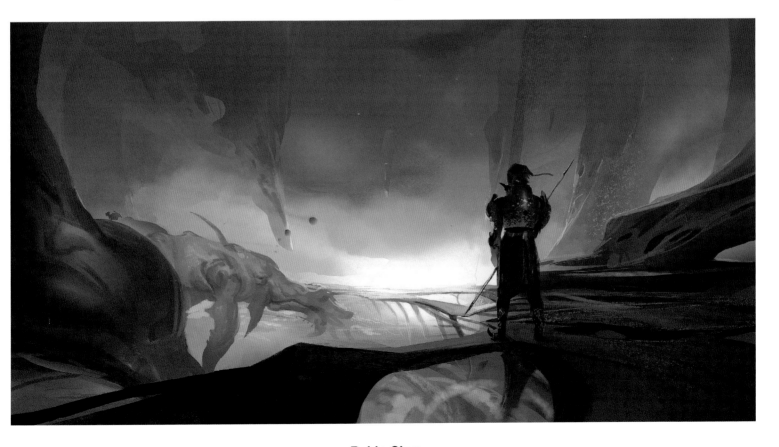

Robin Chyo

Title: The Slumbering Isles of Vastyr *Medium:* Digital

Steven Tabbutt
Title: Tourist *Size:* 12.5"x16.8" *Medium:* Mixed

Kelley Hensing
Title: Time Killer *Size:* 18"x24" *Medium:* Oil on board

Jerome Podwil
Title: A Litttle Night Music *Size:* 25.5"x39" *Medium:* Oil

Mark Zug
Title: Argon *Size:* 24"x24" *Medium:* Oil on canvas

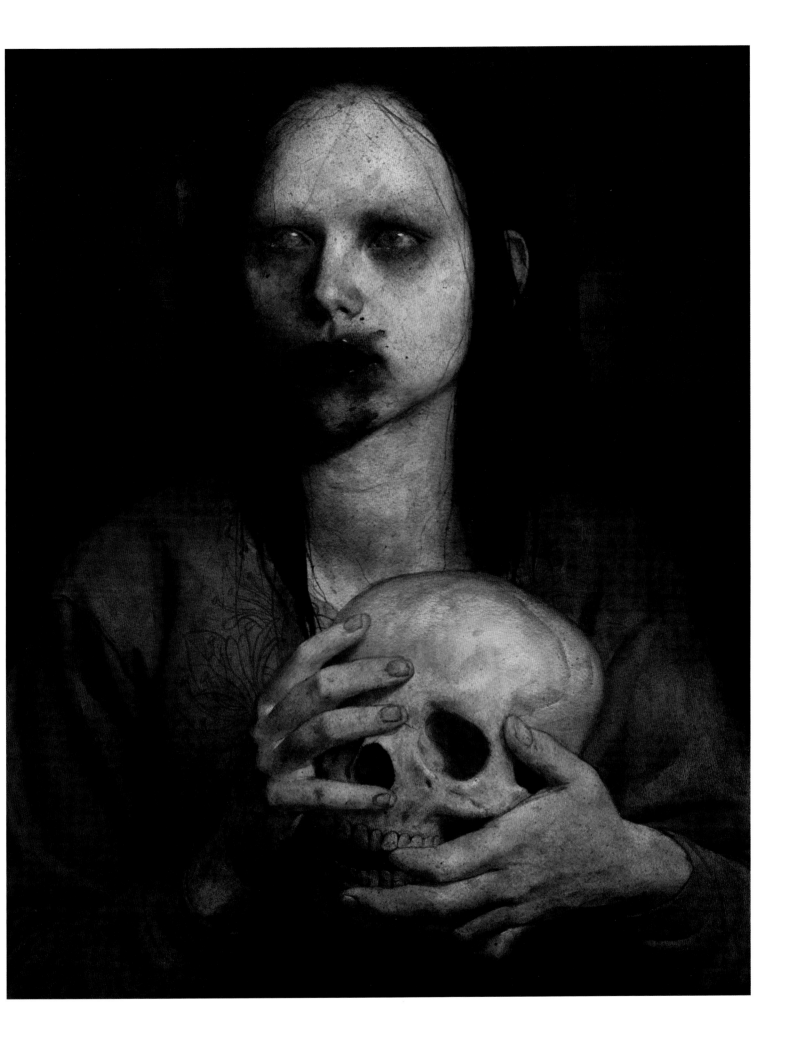

Jeremy Enecio

Title: Skin Deep *Size:* 16"x20" *Medium:* Acrylic/watercolor

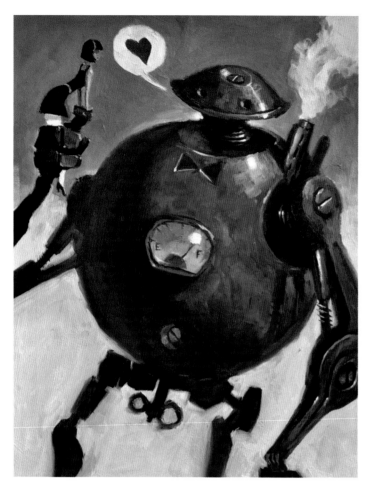

Emerson Tung
Title: Robot Love *Size:* 18"x24" *Medium:* Oil on canvas

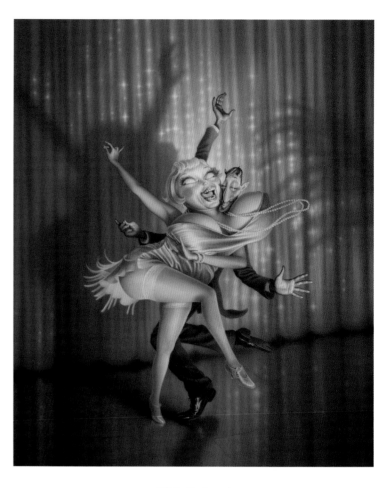

Kirk Reinert
Client: Animazing Gallery NYC: Hootch, Cooch, & Scootchin' Show
Title: The Devil's Music *Size:* 30"x40" *Medium:* Acrylic

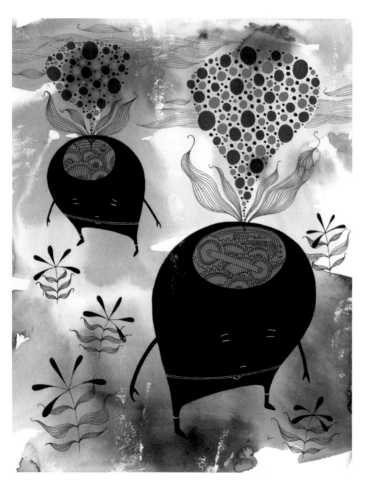

Scott Bakal
Client: Space 242 Gallery *Title:* Two Alien Robots
(and the Hope For Real Existence) *Size:* 11"x14" *Medium:* Mixed

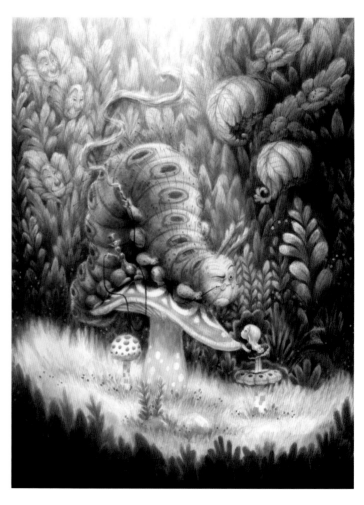

Kei Acedera
Title: Advice from Caterpillar *Size:* 18"x24" *Medium:* Gouache/oil

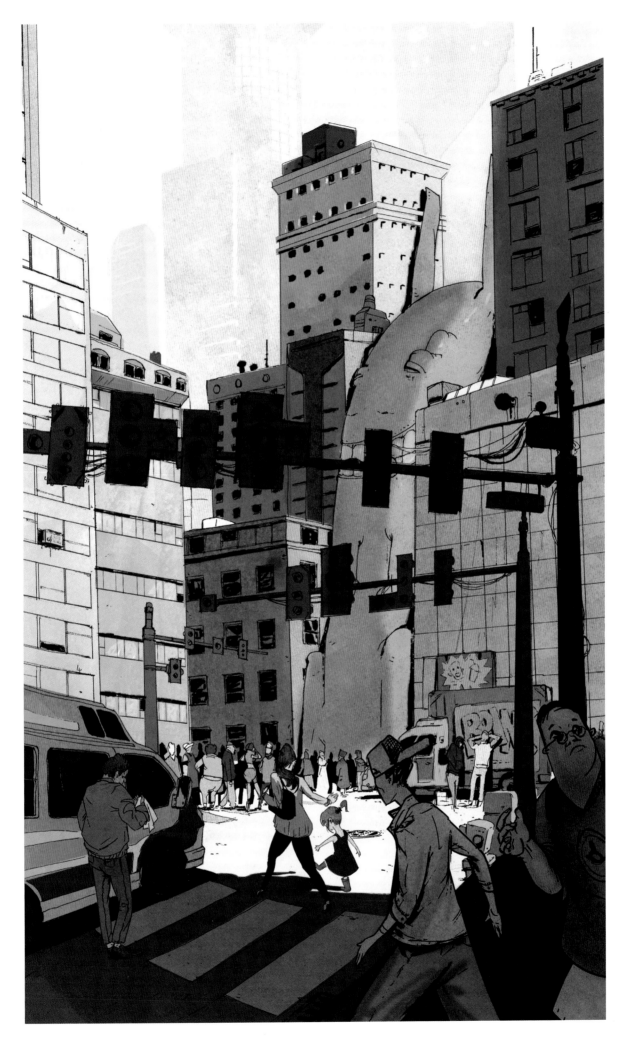

Adam Volker

Title: Austin, TX *Size:* 11"x16" *Medium:* Ink/digital

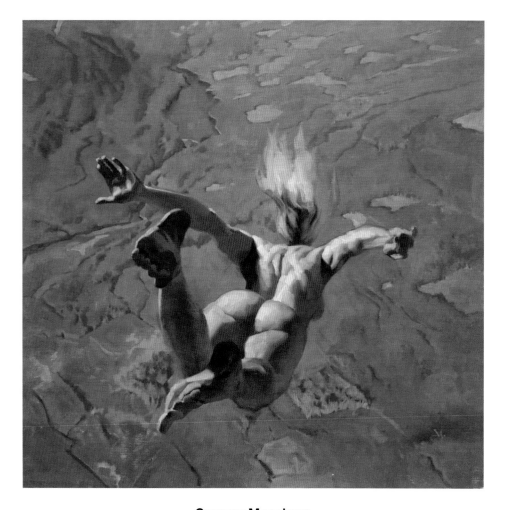

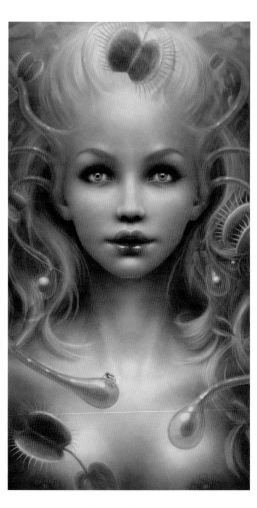

Gregory Manchess
Client: Earth: Fragile Planet Show *Title:* Committment *Size:* 30"x29" *Medium:* Oil on linen

Tanya Wheeler
Title: Dionaea *Medium:* Digital

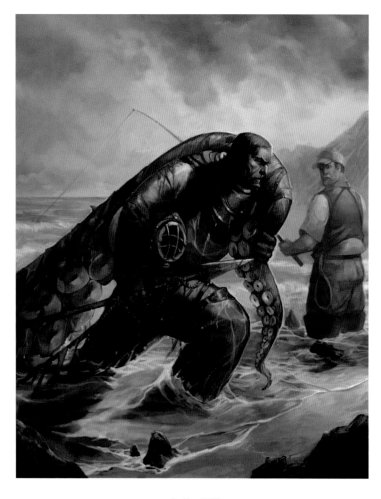

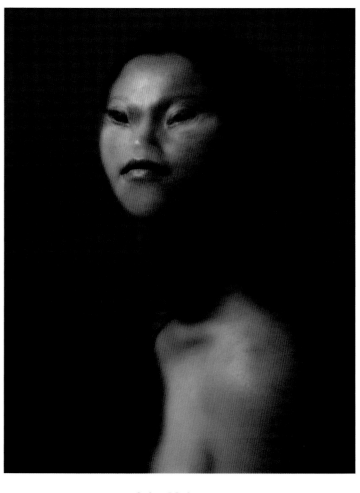

Julie Dillon
Title: Diver's Haul *Size:* 8"x10" *Medium:* Photoshop

John Mahoney
Title: Breathless *Size:* 10"x13.5" *Medium:* Mixed

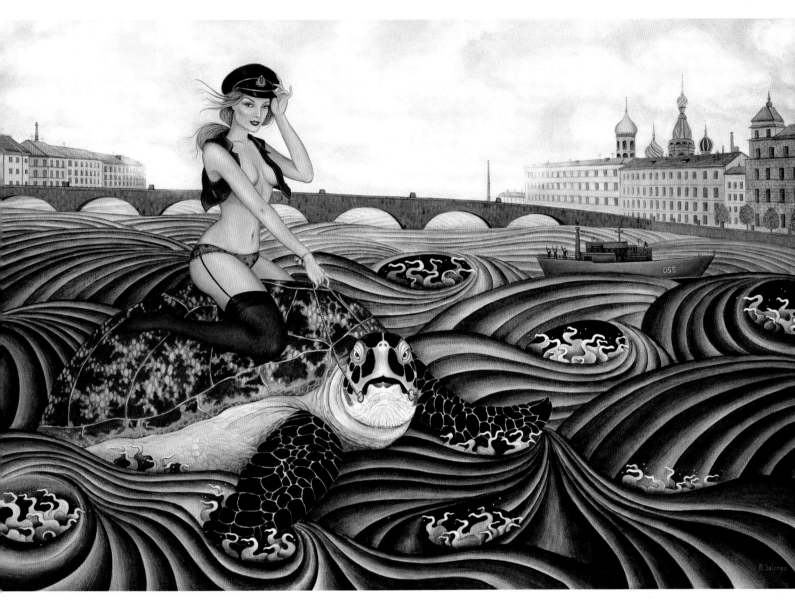

Solongo Monkhooroi

Title: White Night *Size:* 36"x24" *Medium:* Acrylic

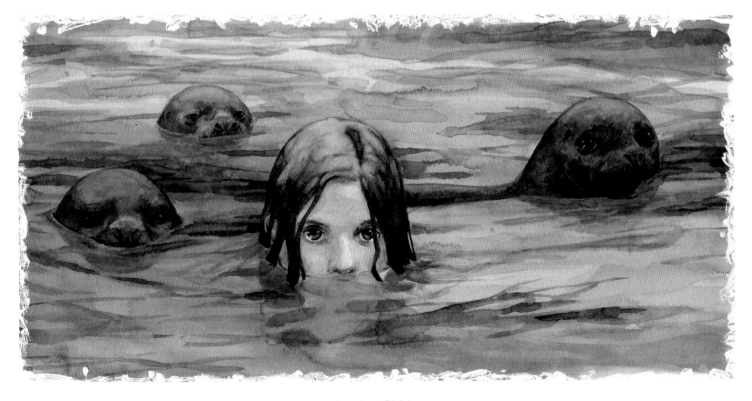

Jessica Shirley

Title: The Selkie *Size:* 16.25"x8" *Medium:* Watercolor

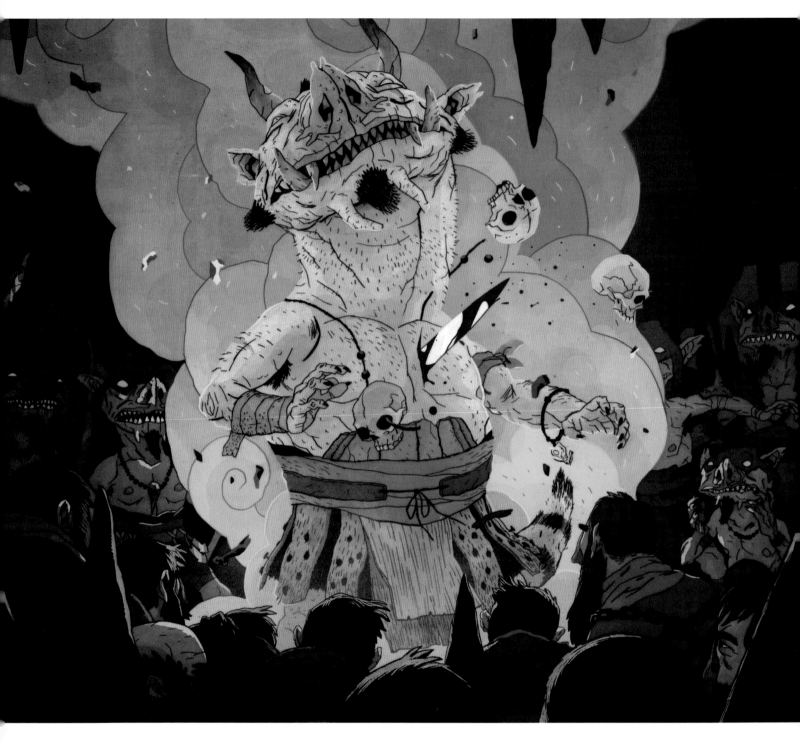

Sam Bosma
Client: Picture Book Report *Title:* The Great Goblin *Size:* 17"x12.5" *Medium:* Digital

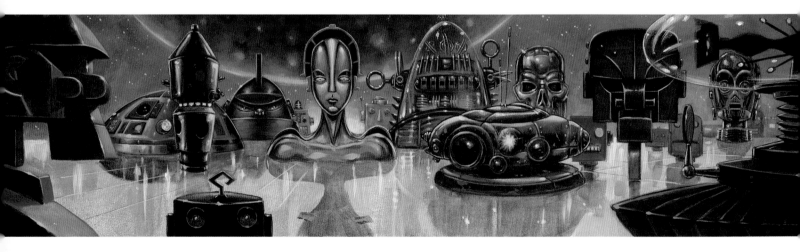

Augie Pagan
Title: Robots on the Horizon *Size:* 6'x2' *Medium:* Acrylic on masonite

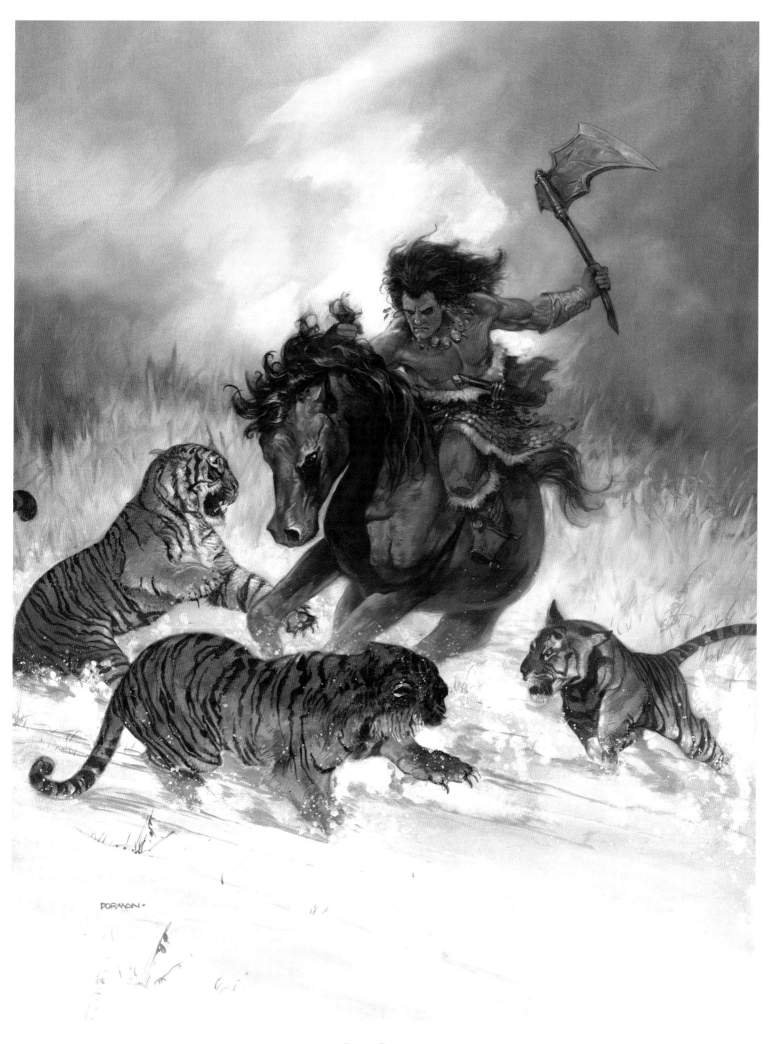

Dave Dorman

Title: Winter Warrior *Size:* 24"x36" *Medium:* Oil/acrylic

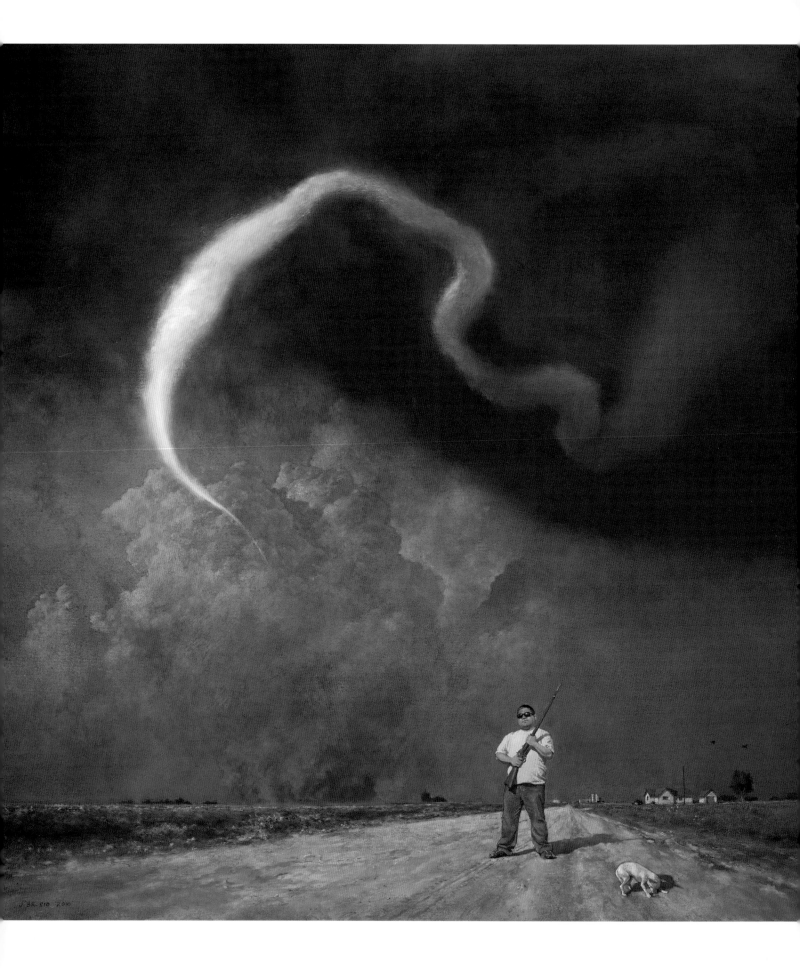

John Brosio

Title: Jerk in a Road *Size:* 36"x36" *Medium:* Oil on canvas

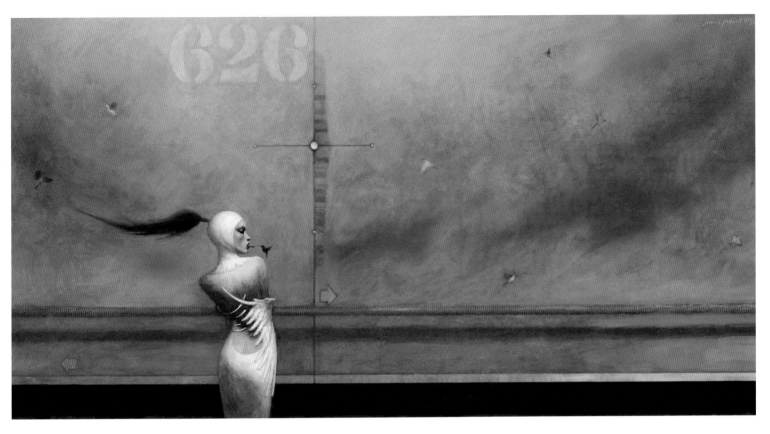

Jerome Podwil
Title: Aviary *Size:* 38"x19.25" *Medium:* Oil

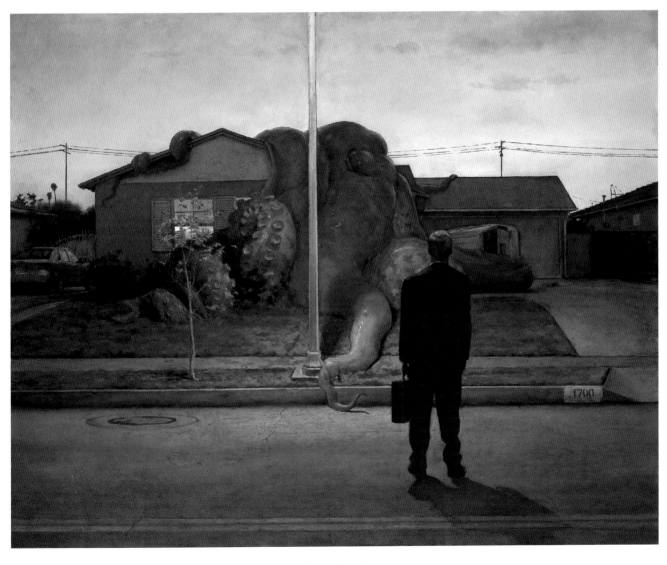

John Brosio
Title: Fatigue *Size:* 60"x48" *Medium:* Oil on canvas

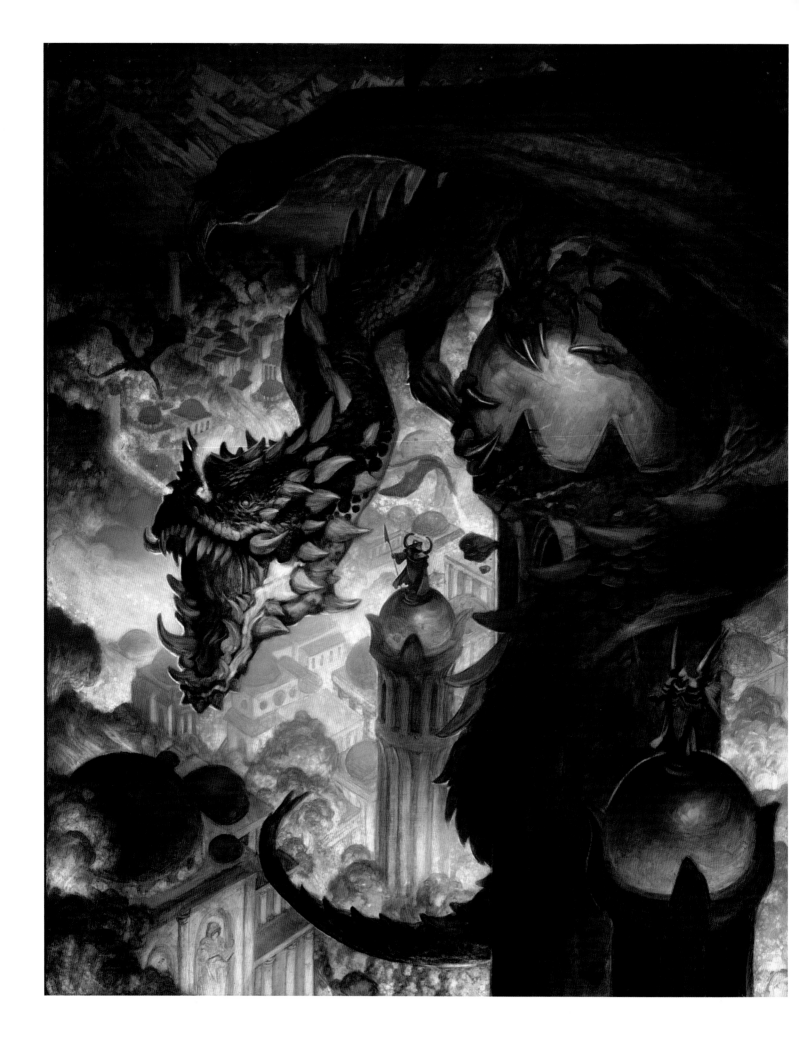

Justin Gerard

Title: T.S.I. No.1 *Size:* 16"x20" *Medium:* Watercolor/oil/digital

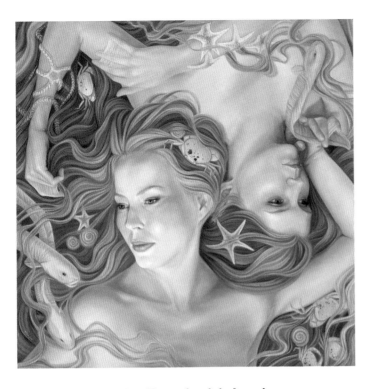

Marjon Fatemizadeh Aucoin

Title: An The Swam Among Threads of Gold *Size:* 24"x24" *Medium:* Oil

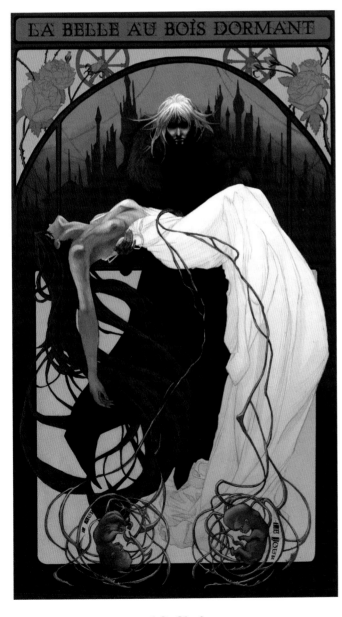

J.S. Choi
Title: La Belle Au Bois Dormant *Size:* 16.9"x29.8" *Medium:* Digital

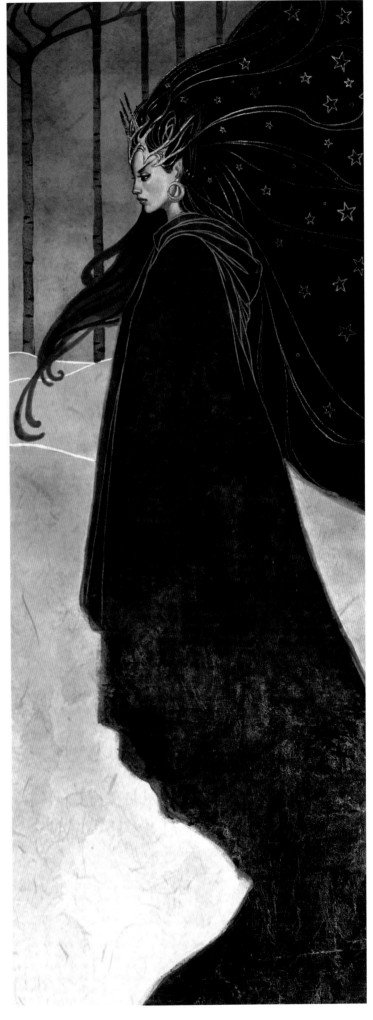

Aly Fell
Title: The Winter Queen *Medium:* Digital

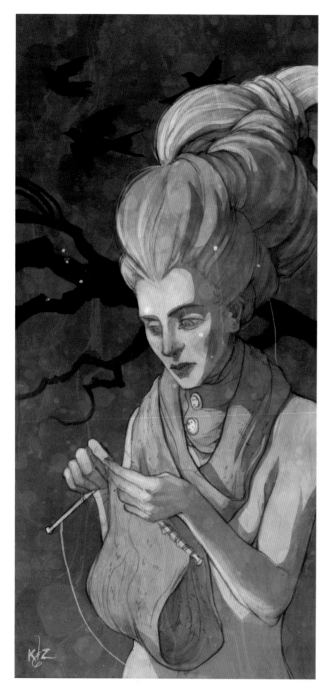

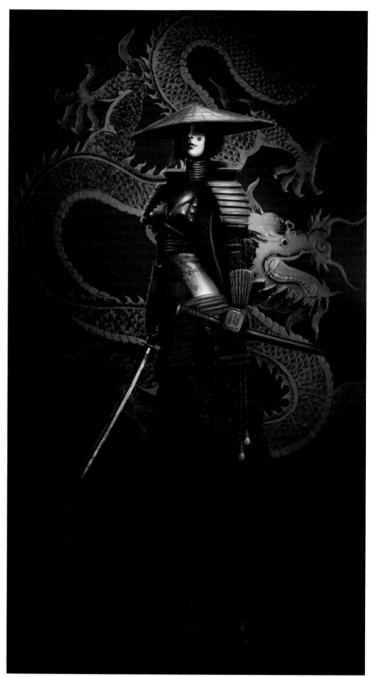

Kurt Huggins/Zelda Devon

Client: Illustration Friday *Title:* Gathering Wool *Medium:* Digital

Diosdado Mondero

Title: Kabuki Kato *Medium:* Digital

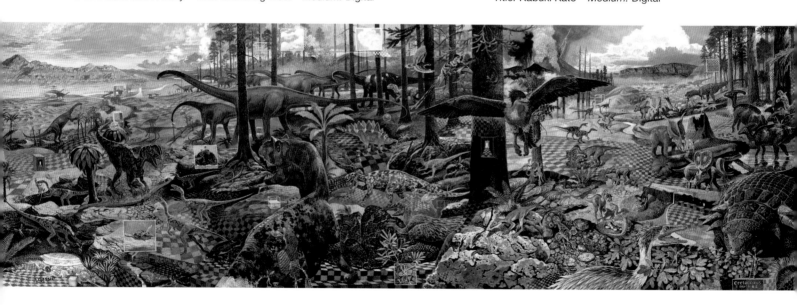

John D. Dawson

Designer: Kathie Dawson *Title:* A Checkered Past *Size:* 114"x17.25" *Medium:* Acrylic

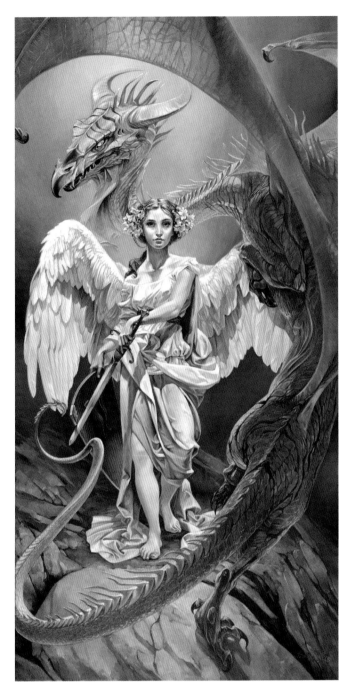

Heather Theurer

Title: Temptation *Size:* 24"x48" *Medium:* Oil on canvas

Tristan Elwell

Title: Morgana *Size:* 8"x17" *Medium:* Oil on board

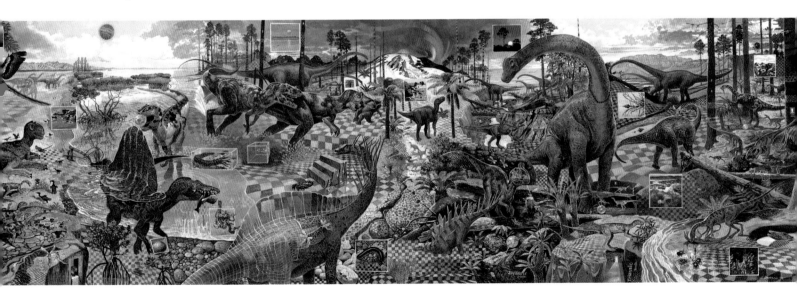

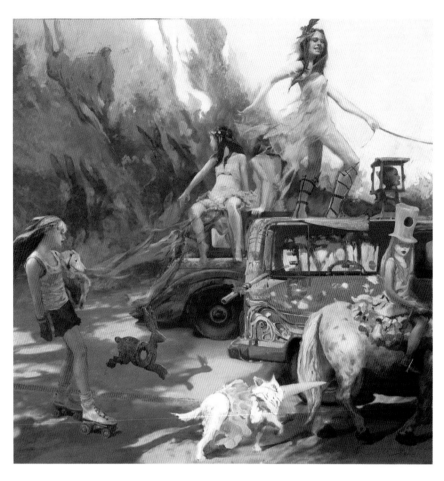

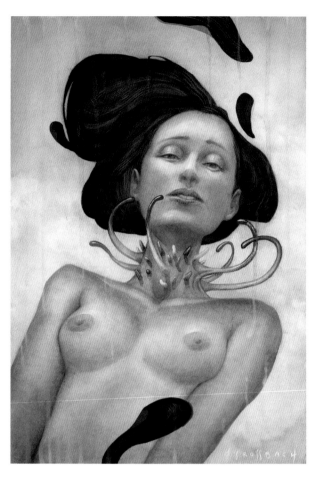

Michele Moen
Title: Shadow Rabbit *Size:* 30"x28" *Medium:* Oil/digital

J.S. Rossbach
Title: Guts *Size:* 35.5x52cm *Medium:* Watercolor

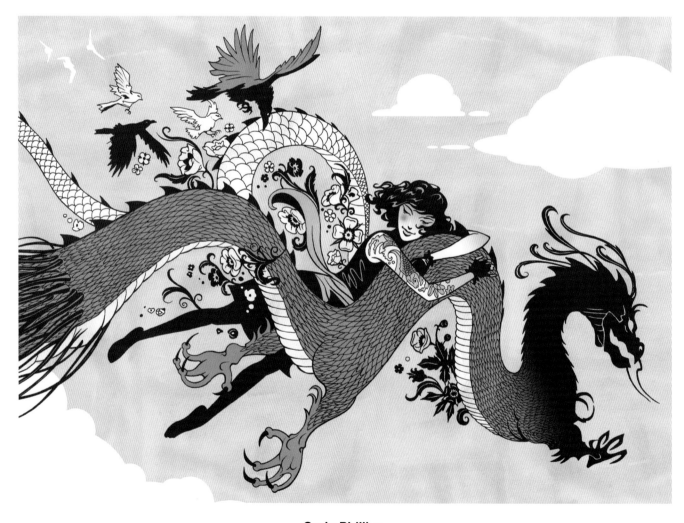

Craig Phillips
Title: Day Dreams *Medium:* Ink/digital CS2

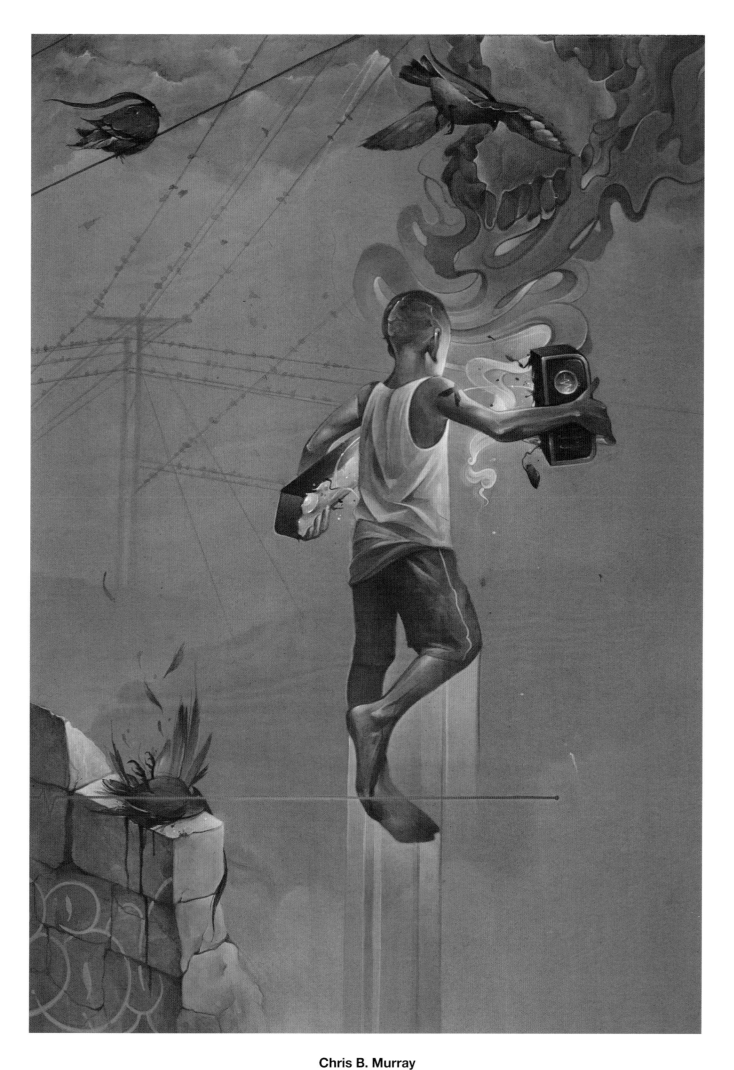

Chris B. Murray

Title: Radio Dead *Size:* 9"x12" *Medium:* Acrylic

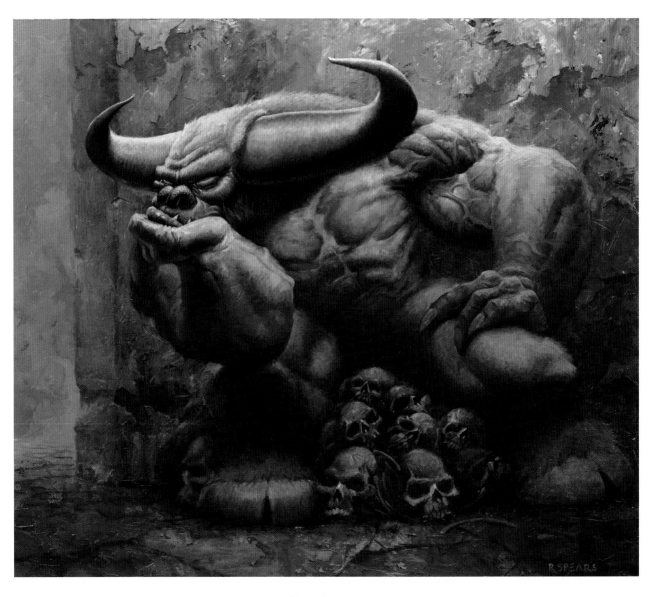

Ron Spears
Title: Minotaur *Size:* 14"x12" *Medium:* Oil on board

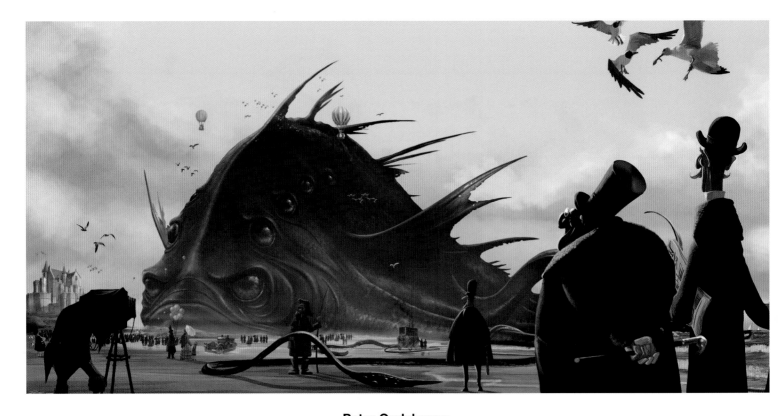

Peter Oedekoven
Title: Stranded *Size:* 20"x10" *Medium:* Photoshop

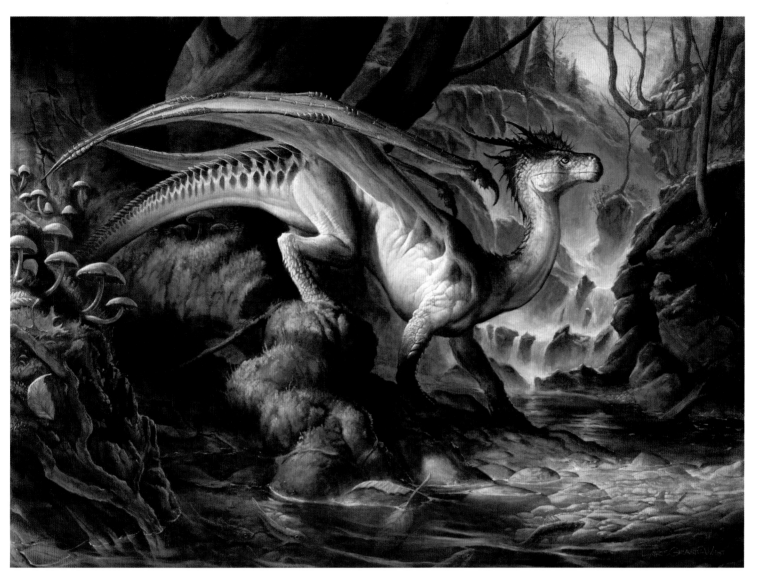

Lars Grant-West

Title: Autumn Dragon *Size:* 30"x22" *Medium:* Oil on canvas

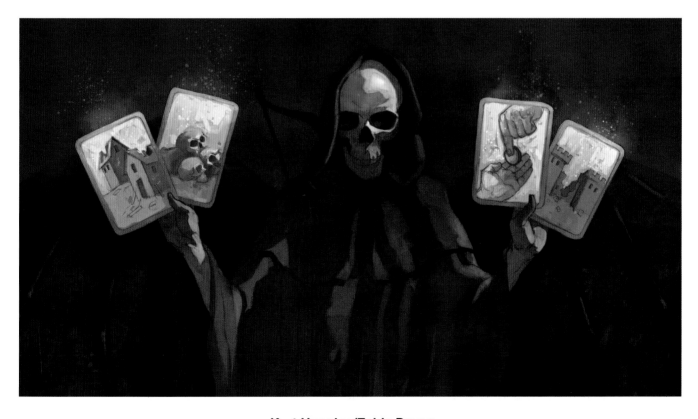

Kurt Huggins/Zelda Devon

Client: Pearson Education *Title:* Black Death *Medium:* Digital

Bill Carman
Title: Oh Crap, Sorry *Size:* 8.5"x11" *Medium:* Mixed

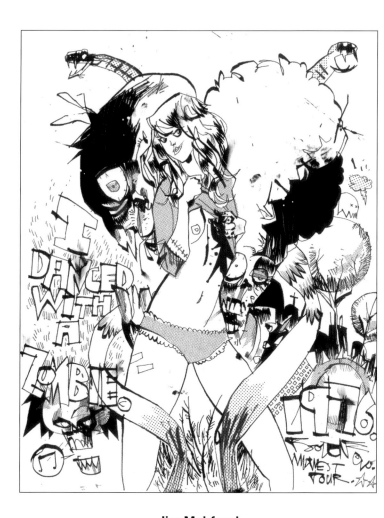

Jim Mahfood
Title: I Danced With a Zombie 1976 *Size:* 11"x14" *Medium:* Ink

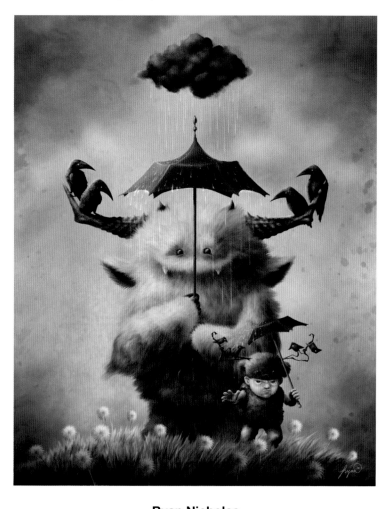

Ryan Nicholas
Title: Rainy Friends *Size:* 11"x14" *Medium:* Digital

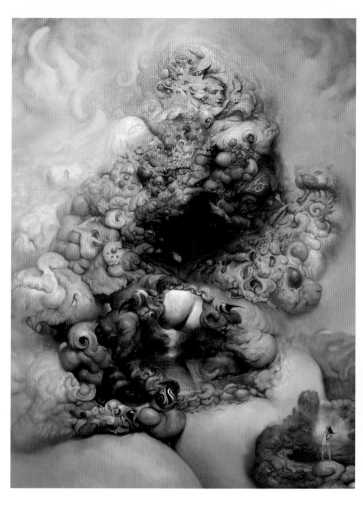

Burton Gray
Title: Blue Gold: Fantasia No. 1 *Size:* 40"x60" *Medium:* Digital

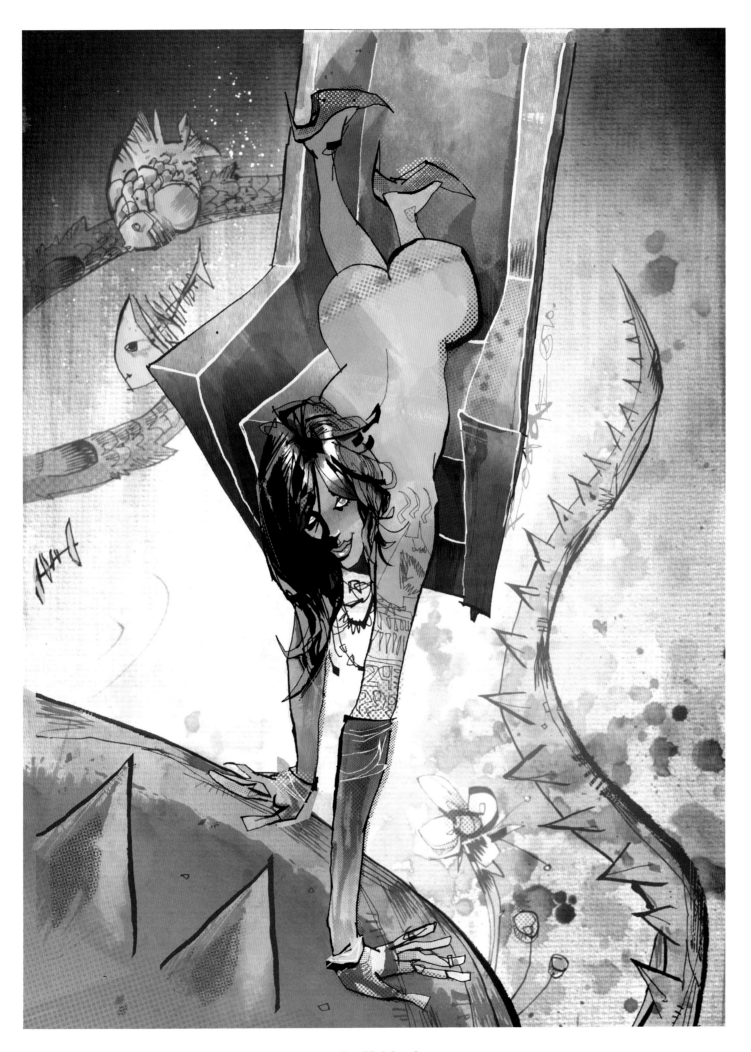

Jim Mahfood

Colorist: Jose Garibaldi *Title:* Aqua Chair Girl *Size:* 11"x17" *Medium:* Ink

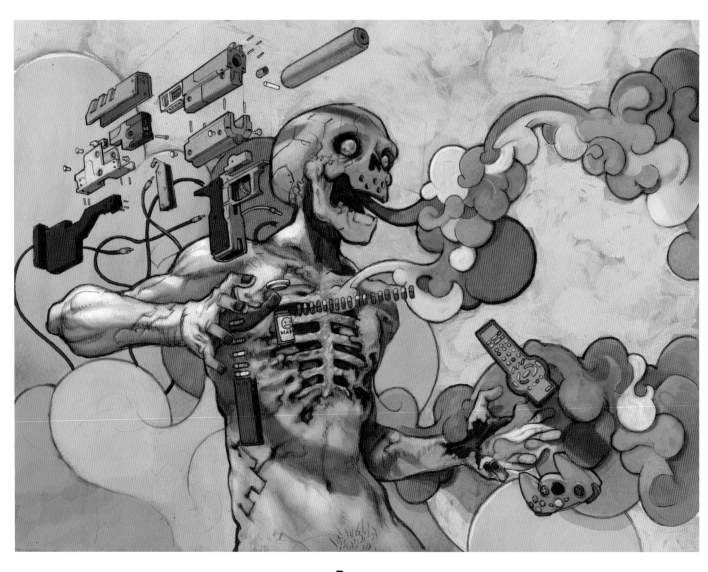

Deseo
Title: Fusion *Size:* 17"x14" *Medium:* Pencil/acrylic/digital

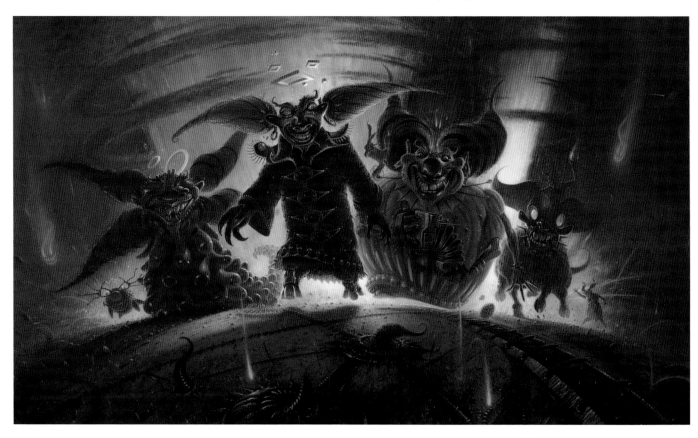

Marc Gabbana
Title: Clown Apocalypse *Size:* 34"x20" *Medium:* Acrylic

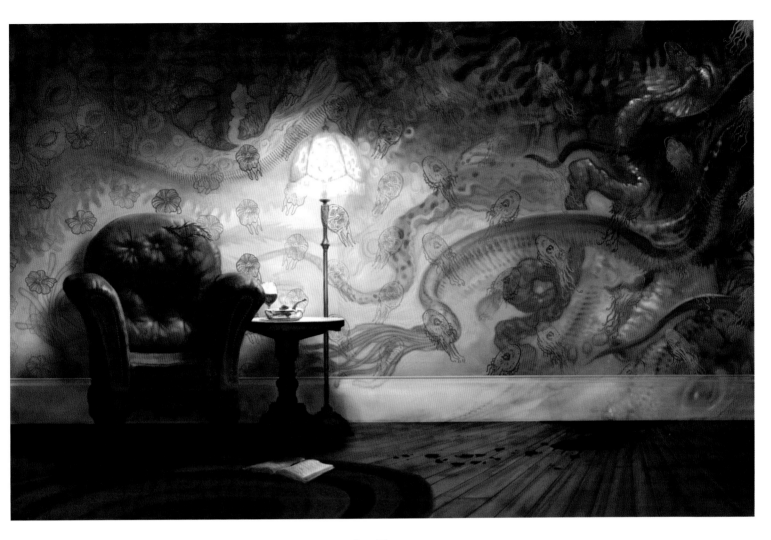

Jon Foster

Client: Gallery Nucleus *Title:* Creeping Suspicion *Medium:* Digital

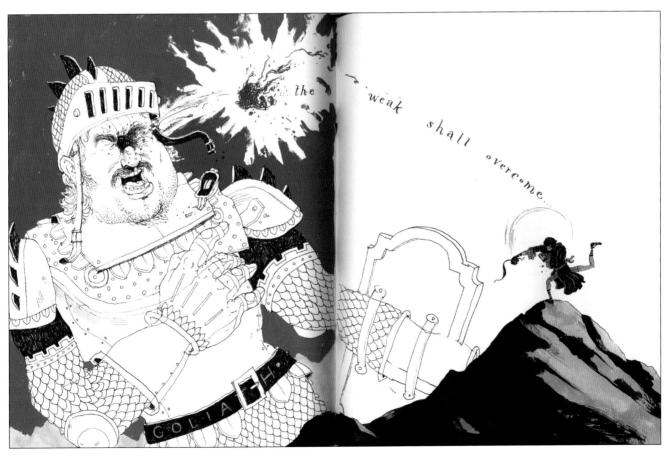

John Hendrix

Title: Goliath Goes Down *Size:* 16"x12" *Medium:* Ink/mixed [sketchbook drawing]

Annie Wu

Title: The Birds *Size:* 11"x14" *Medium:* Digital

Katya Tal

Title: A Melancholy Princess and a Wicked Dog

Size: 9"x16" *Medium:* Digital

Cam de Leon

Client: happypencil.com *Title:* The Kiss *Size:* 12"x12" *Medium:* Oil

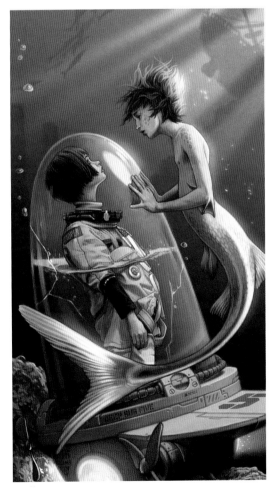

Mark E. Miltz

Title: The Rising Muse *Size:* 40"x37" *Medium:* Oil on canvas

Ryan Mauskopf

Title: Farewell *Size:* 12"x22" *Medium:* Digital

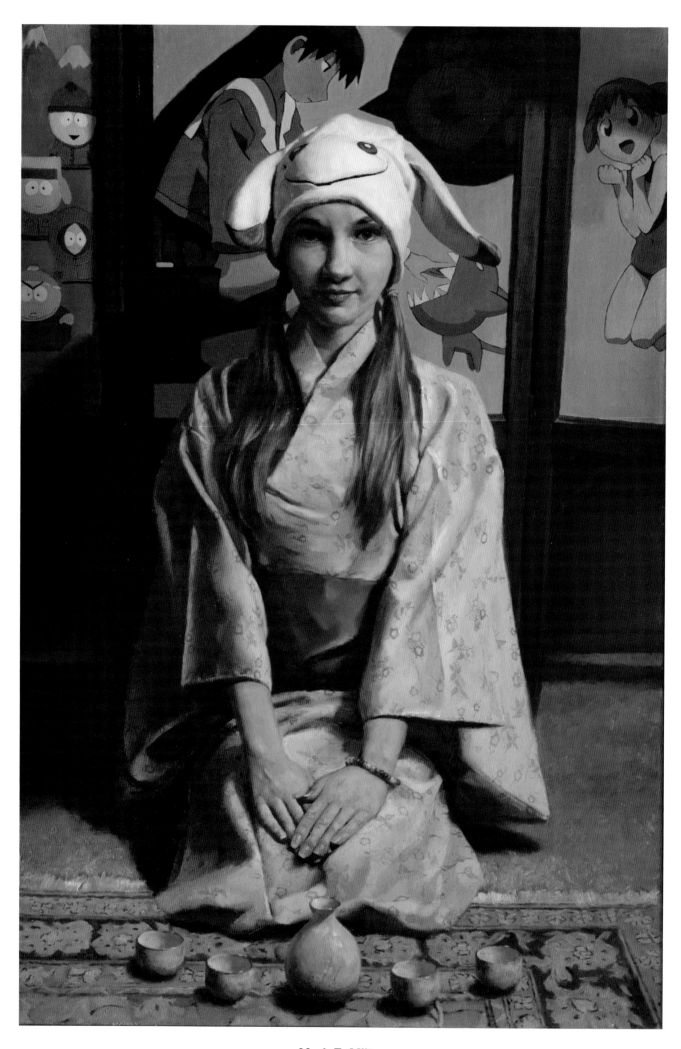

Mark E. Miltz

Title: American Otaku *Size:* 24"x36" *Medium:* Oil

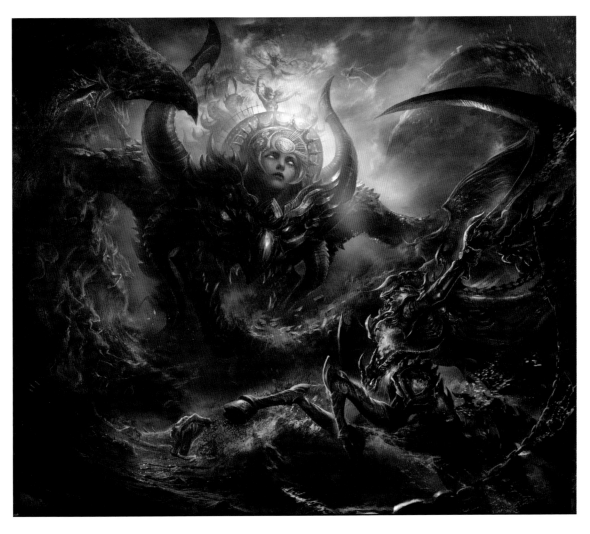

Rongrong Wang

Title: Technomage Vs War General *Medium:* Photoshop

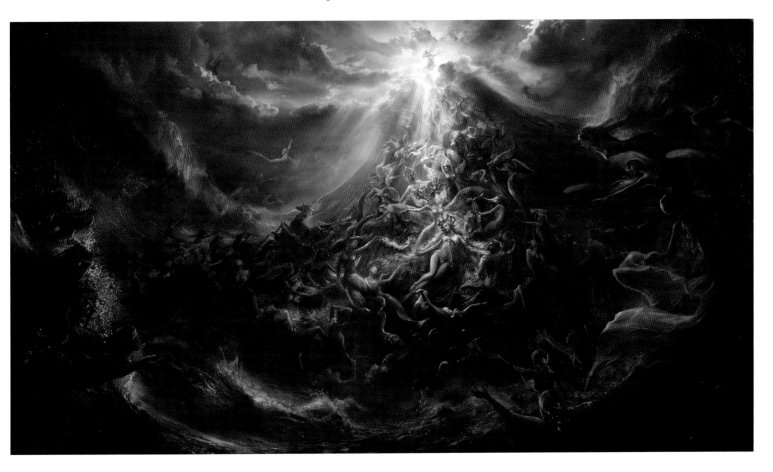

Rongrong Wang

Title: Ocean *Medium:* Photoshop

Eric Fortune
Title: Luna *Size:* 16.5"x26" *Medium:* Acrylic

Eric Fortune
Title: Saying Goodnight *Size:* 22"x30" *Medium:* Acrylic

Ritche Sacilioc
Title: Week Night *Medium:* Digital

Eric Fortune

Title: The Vanishing *Size:* 22"x30" *Medium:* Acrylic

Joshua Rizer
Title: Down, Down, and Away *Size:* 48"x36" *Medium:* Oil on canvas

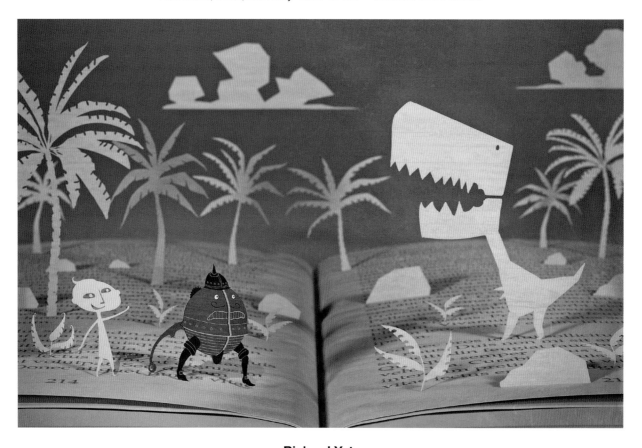

Richard Yot
Title: Into the Past *Size:* 12"x8" *Medium:* Digital

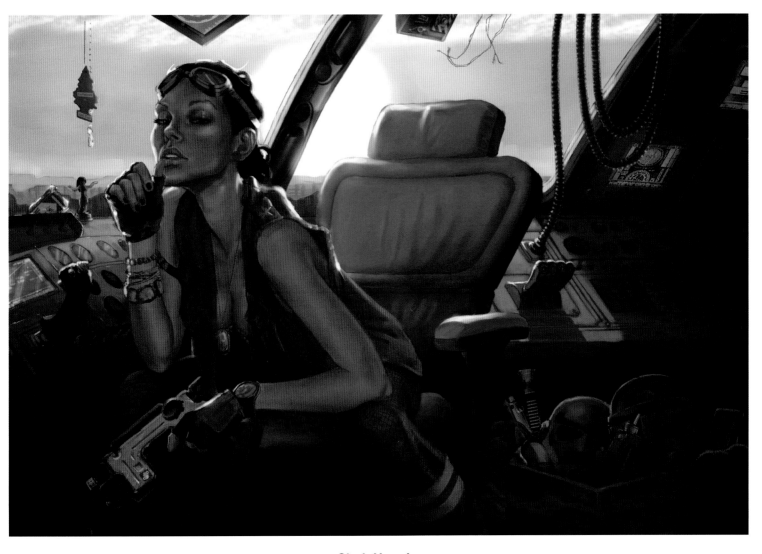

Clark Huggins
Title: Smuggler's Cove *Size:* 14"x10" *Medium:* Digital

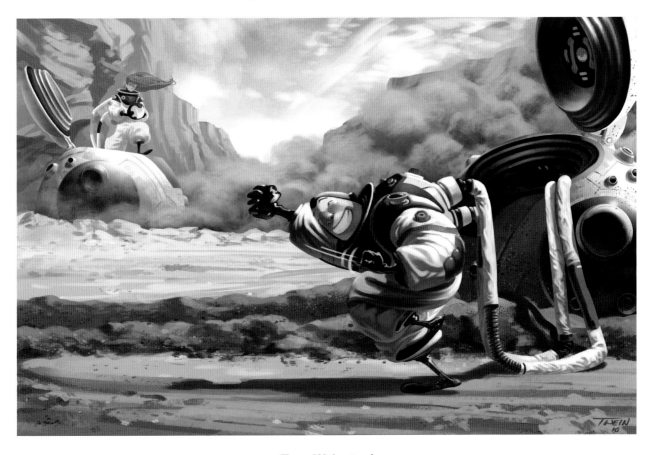

Tony Weinstock
Title: YES! *Size:* 10"x7" *Medium:* Digital

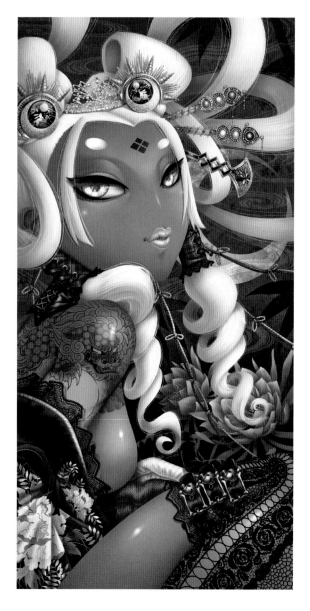

Misa Tsutsui

Title: Gekko Girl *Size:* 15.7"x31.5" *Medium:* Digital

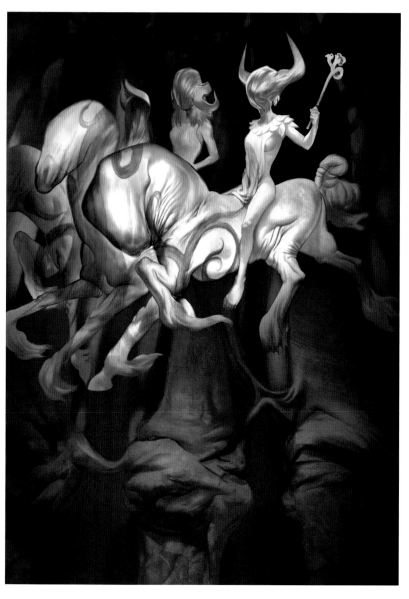

Yukari Masuike

Title: Fairy Cavalryman *Size:* 3508x4961pix *Medium:* Photoshop

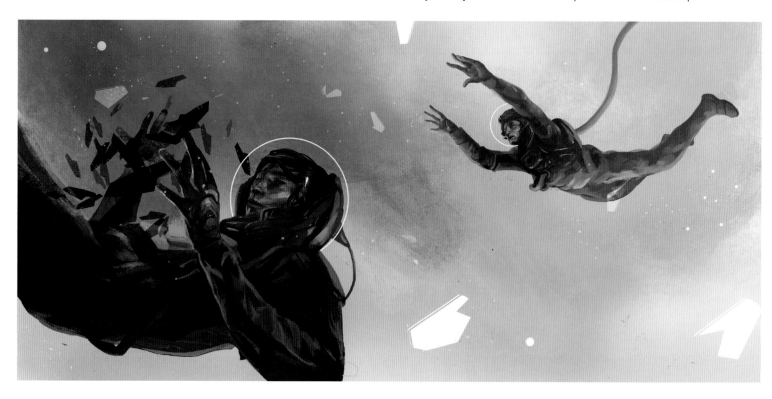

Zach Montoya

Title: Between Threads *Size:* 16"x7.5" *Medium:* Digital

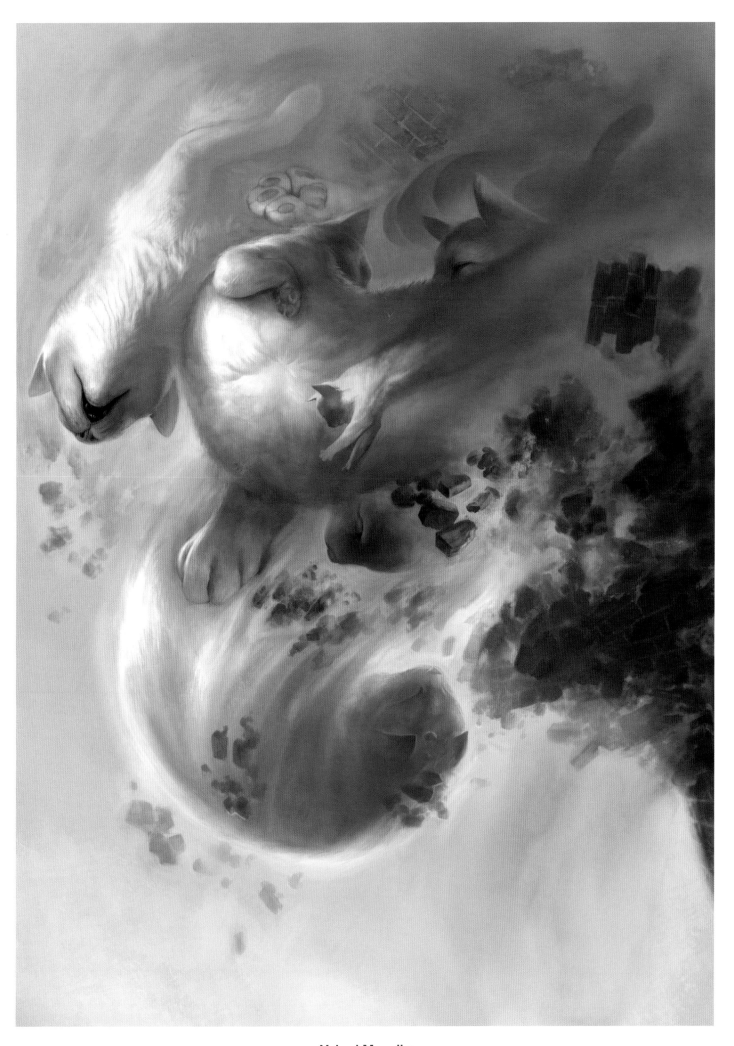

Yukari Masuike

Title: Sleep Down *Size:* 3660x5100pix *Medium:* Photoshop

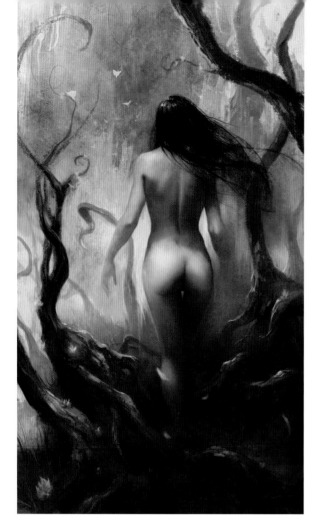

Daarken
Title: Into the Beautiful Grim *Size:* 9"x16" *Medium:* Photoshop

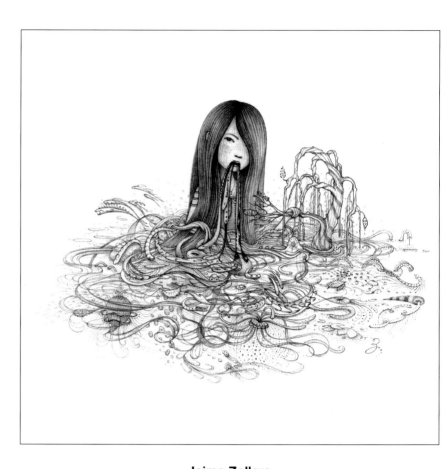

Jaime Zollars
Title: Living Water *Size:* 10"x8" *Medium:* Graphite

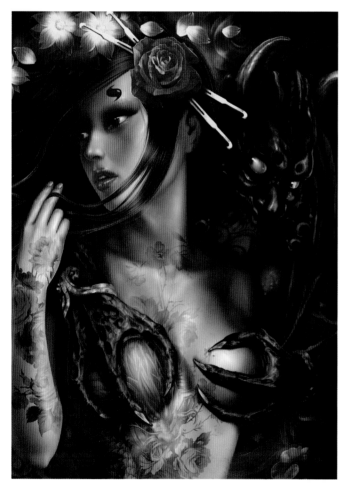

Jianyi Zhang
Title: Prajna *Size:* 2480x3425pix *Medium:* Digital

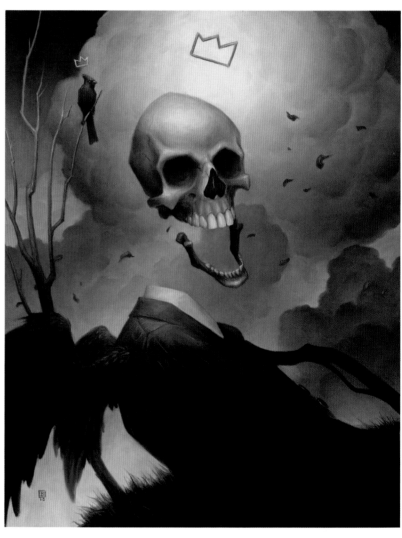

Brian Despain
Title: Autumn Kings *Size:* 11"x14" *Medium:* Oil on wood panel

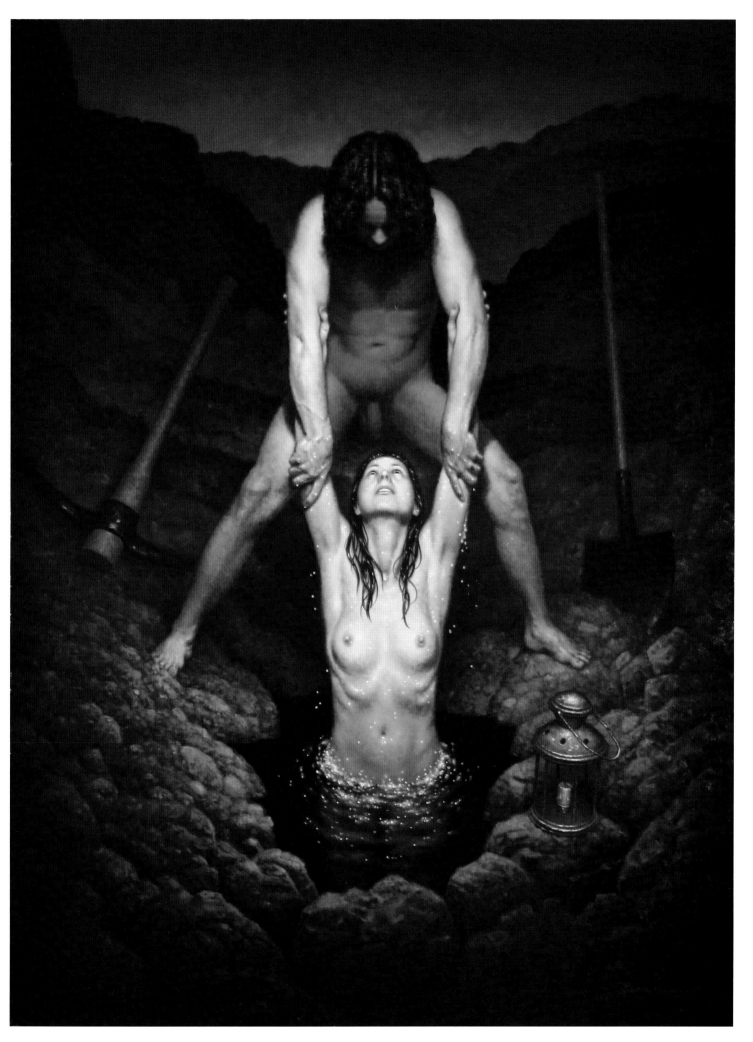

Steven Kenny
Title: Unification *Size:* 36"x48" *Medium:* Oil on canvas

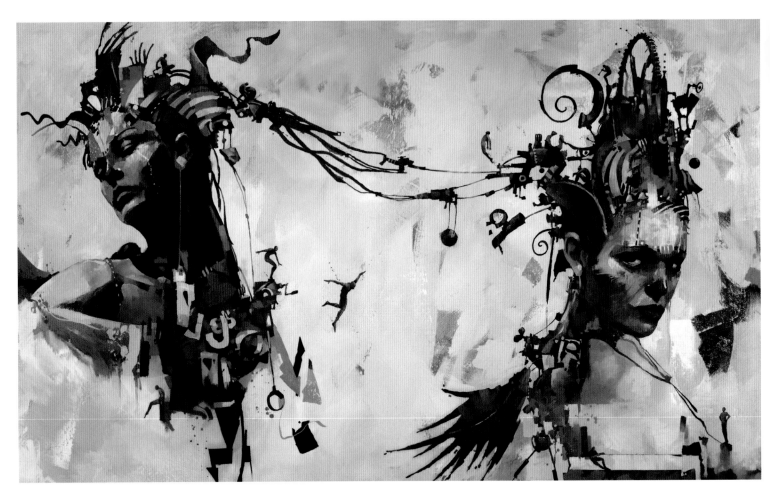

Bruce Holwerda
Title: Download In Progress *Size:* 60"x36" *Medium:* Acrylic

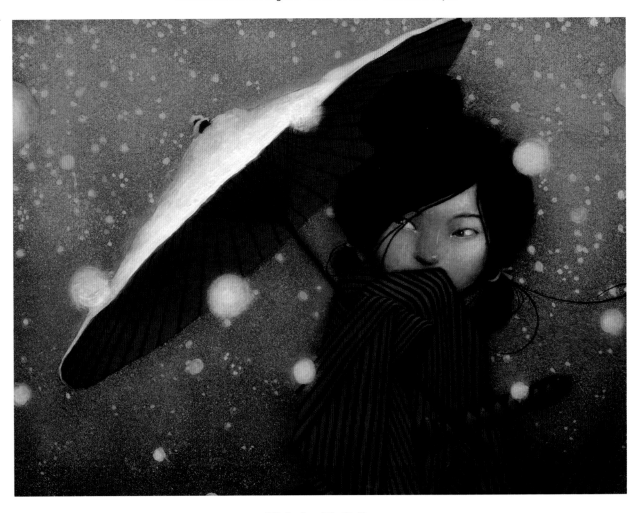

Nicholas McNally
Title: Shirayuki *Size:* 12"x9" *Medium:* Acrylic

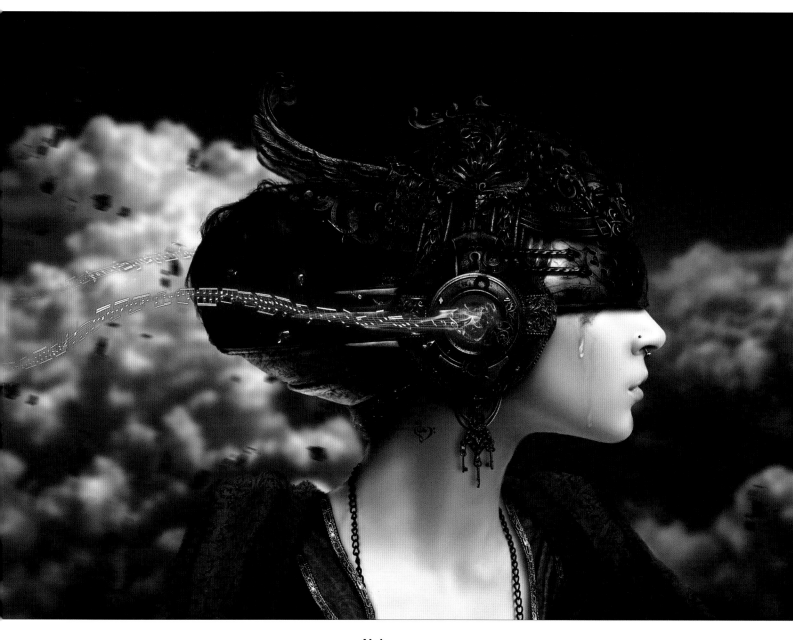

Nekro

Title: Music For My Eyes *Medium:* Digital

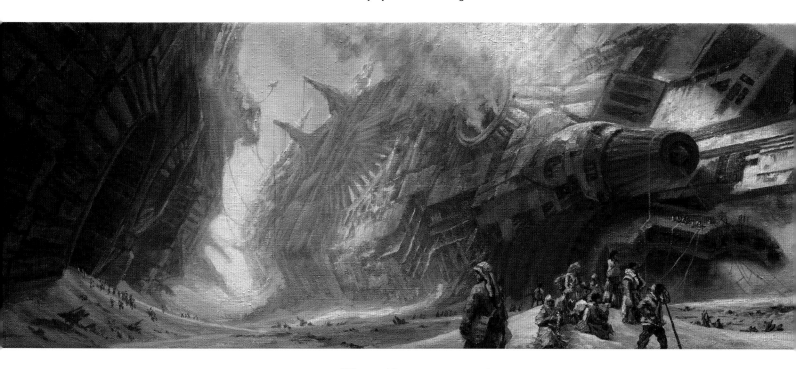

Wayne Haag

Title: Sky Burial #1 *Size:* 40"x15" *Medium:* Oil on canvas

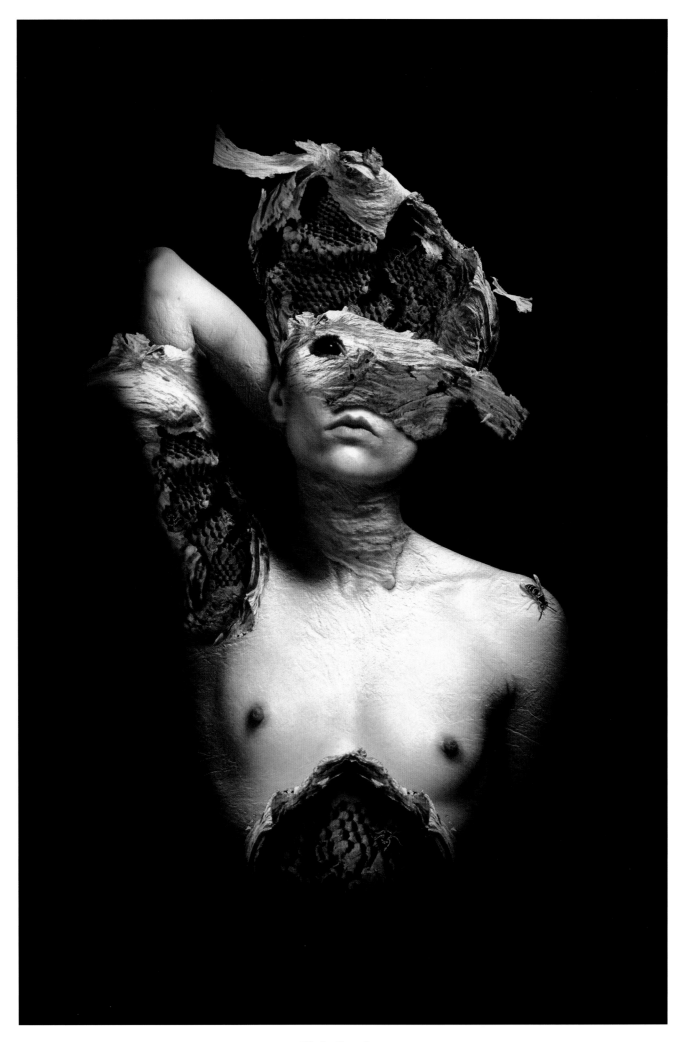

Chris Guarino

Title: The Bee Queen *Size:* 33"x48" *Medium:* Photoshop

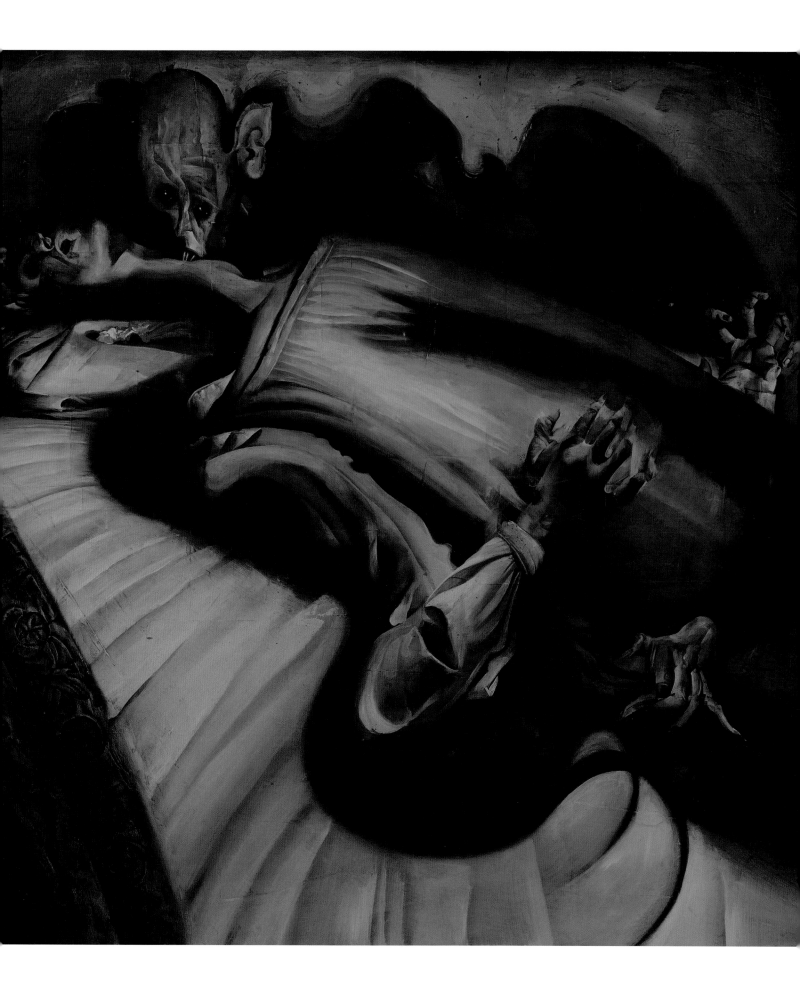

Dave McKean

Art Director: Allen Spiegel *Designer:* Dave McKean *Client:* Hourglass *Title:* Nitrate: Nosferatu *Size:* 4'x4' *Medium:* Mixed

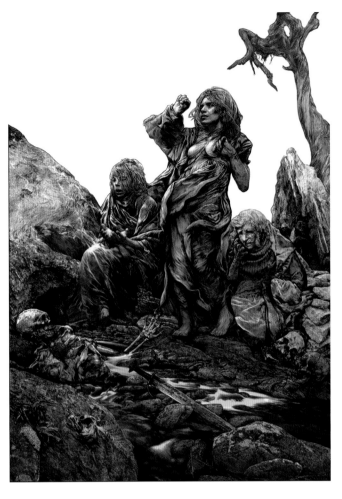

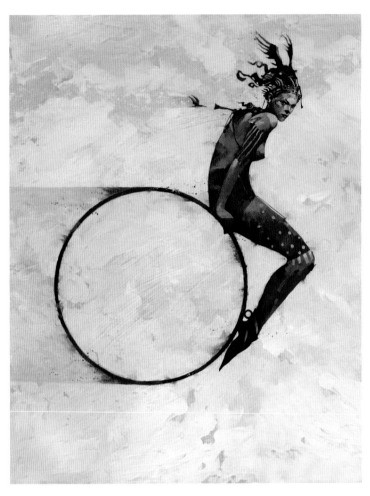

Nate Furman
Title: The Three Fates *Size:* 5"x7" *Medium:* Digital

Bruce Holwerda
Title: Humming Bird Feeder *Size:* 17"x22" *Medium:* Acrylic

Mia
Client: Corey Helford Gallery *Title:* The Priestess *Size:* 48"x36" *Medium:* Acrylic on wood

Tran Nguyen

Title: If the World Keeps Churning, Turning *Size:* 16"x13" *Medium:* Acrylic/colored pencil

Edward Kinsella

Client: Gallery Nucleus *Title:* Winter 1 *Size:* 18"x12" *Medium:* Ink/gouache

Karla Ortiz
Title: The First Hunt *Size:* 8.5"x11" *Medium:* Digital

Abital I. Larson

Title: Death and the Maiden *Size:* 9"x13" *Medium:* Mixed

Matt Stewart

Client: Bill Johnson *Title:* Waterfall Dragons
Size: 32"x40" *Medium:* Oil on board

Lindsey Messecar

Title: Dungeon Delve *Size:* 10.5"x22.5" *Medium:* Oil on board

Cory Godbey
Title: The Gryphon *Size:* 16"x20" *Medium:* Watercolor/digital

Omar Rayyan
Title: Acorn Brandy *Size:* 10"x14" *Medium:* Watercolor

Omar Rayyan
Title: Full Gallop *Size:* 14"x11" *Medium:* Watercolor

Omar Rayyan

Title: The Favorite *Size:* 16"x20" *Medium:* Oil on panel

Sean Andrew Murray
Title: Wizard Alley *Medium:* Digital

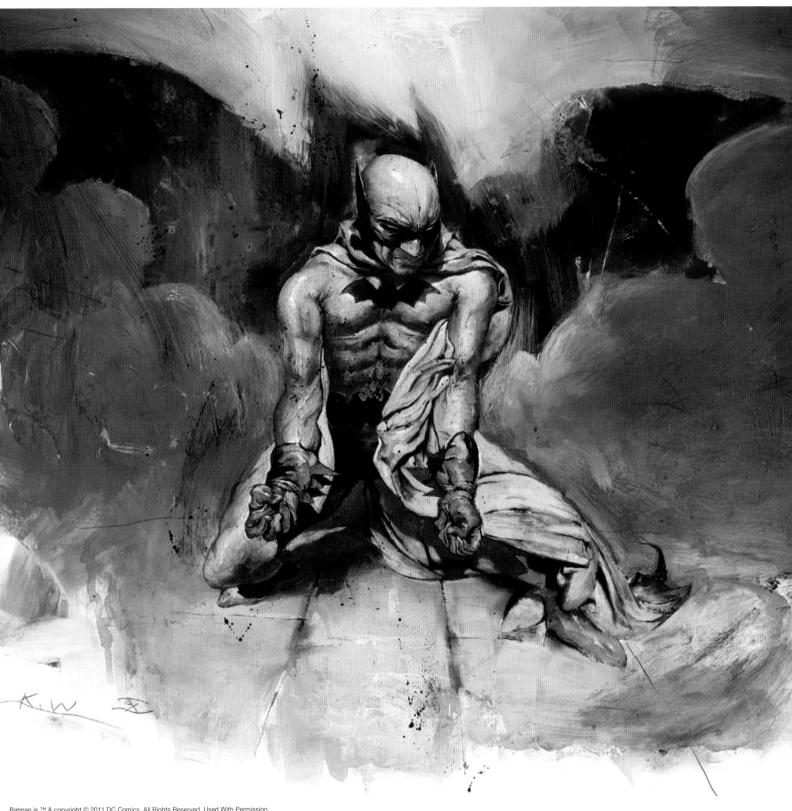

Kent Williams

Art Director: Greg Spatz *Client:* Greg and Yvette Spatz *Size:* 25"x22" *Medium:* Watercolor/oil/mixed on paper

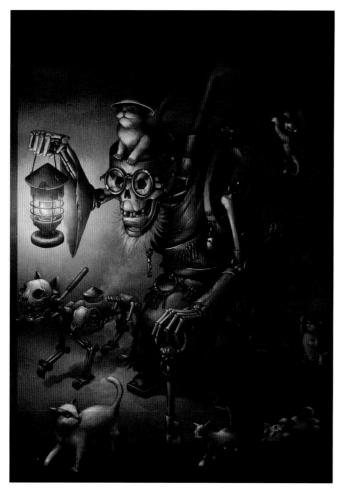

James Ng

Title: Key Keeper *Size:* 11.5"x16.5" *Medium:* Pencil/digital

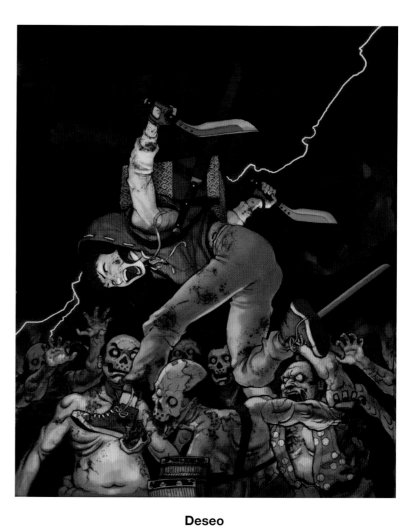

Deseo

Title: The Last Spark *Size:* 14"x17" *Medium:* Pencil/digital

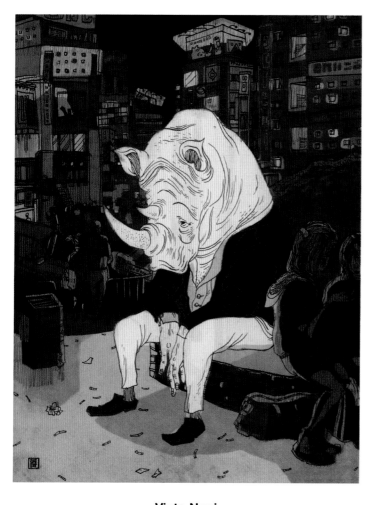

Victo Ngai

Title: Lost in Translation *Size:* 10.5"x14" *Medium:* Mixed

Brad Parker

Title: The Kreature from Kona *Size:* 11"x14" *Medium:* Acrylic on canvas

Kevin Molen

Client: The Aftermath Project *Title:* Dewey Dog *Medium:* Digital

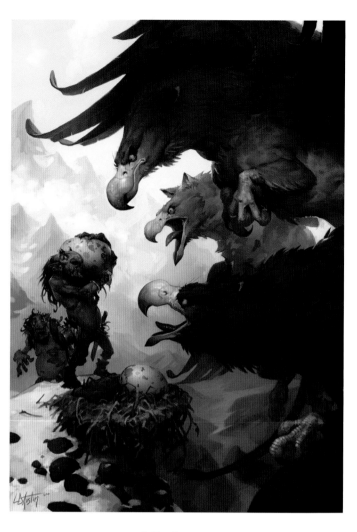

Tohru Patrick Awa
Client: Picture Book Project Foundation
Title: Innocent When You Dream *Medium:* Acrylic on wood

L.D. Austin
Title: The Egg Thief *Medium:* Digital

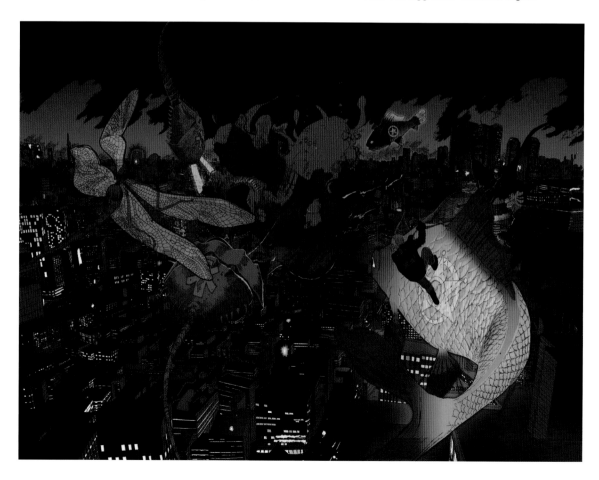

Antoine Revoy
Title: The Seed *Size:* 15.25"x11.5" *Medium:* Ink/digital color

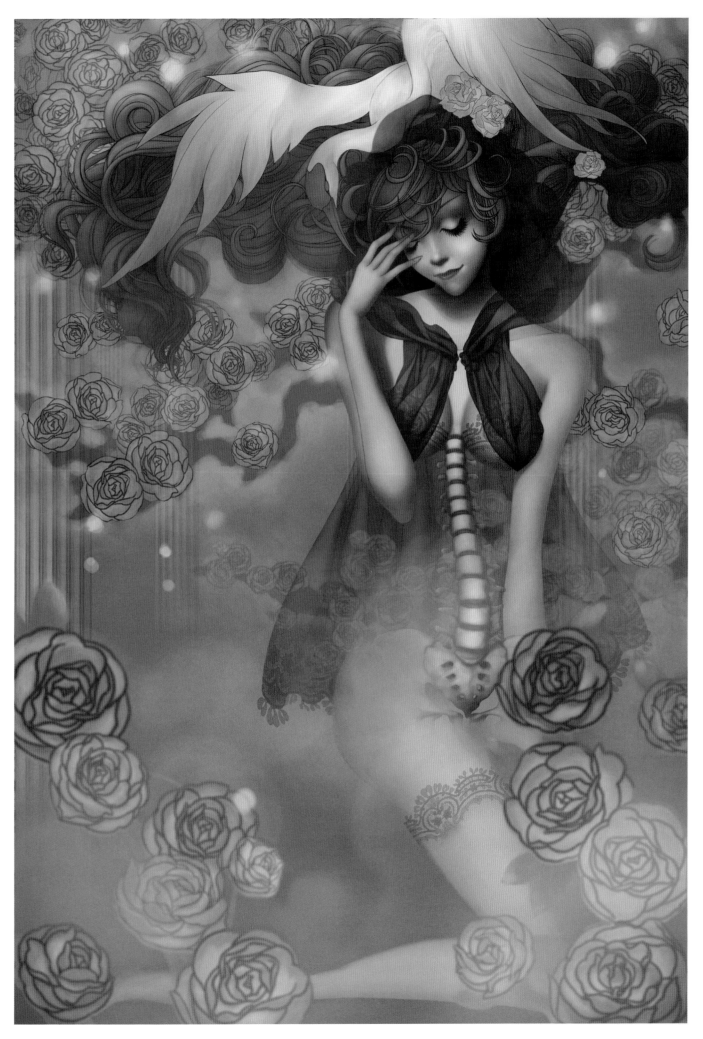

Fiona Meng

Title: Crane Fairy *Size:* 11"x14" *Medium:* Photoshop

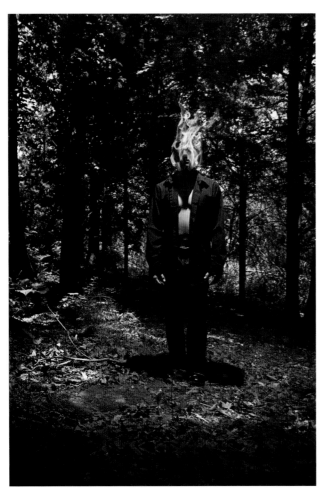

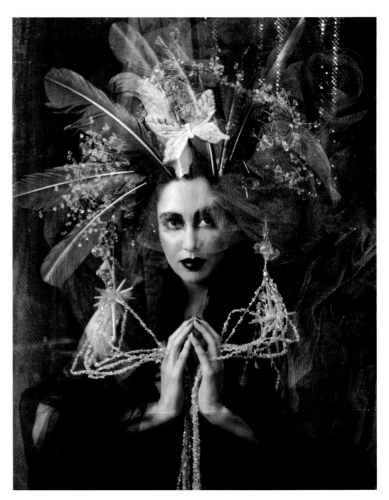

Victor Chalfant
Title: The Matchstick Man *Medium:* Photography/digital

Nina Pak
Title: Tribute *Medium:* Mixed/digital

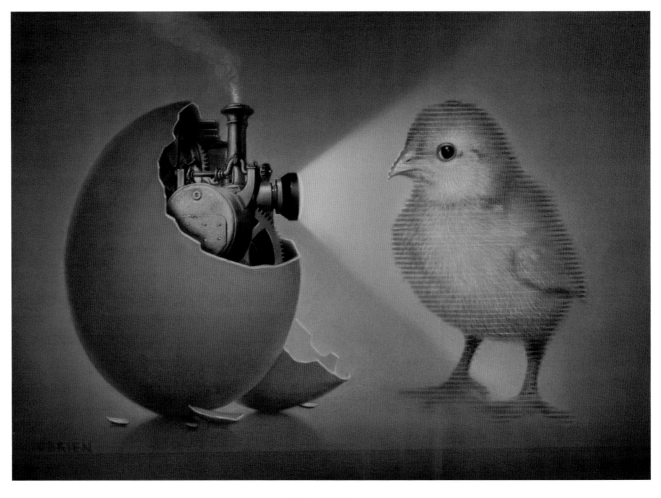

Tim O'Brien
Art Director: Tim O'Brien/Irene Gallo *Client:* Society of Illustrators/Microvisions *Title:* Chicken and the Egg *Size:* 10"x7" *Medium:* Oil/mixed

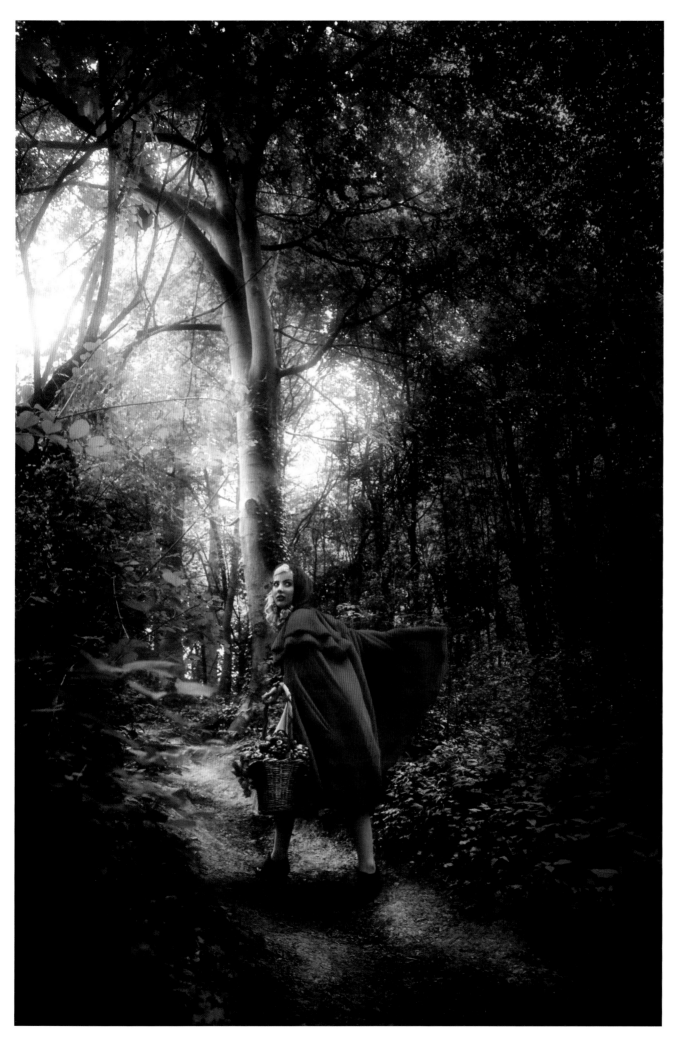

Viona Ielegems

Title: Little Red Riding Hood *Size:* 70x100cm *Medium:* Photography

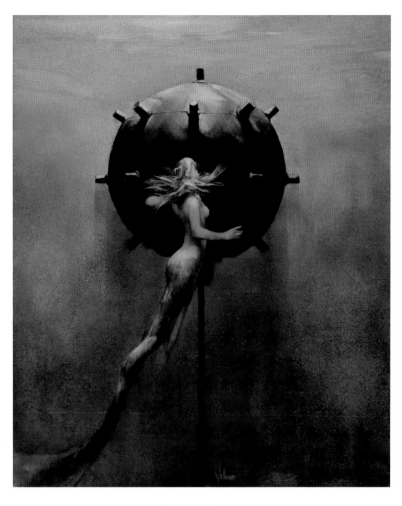

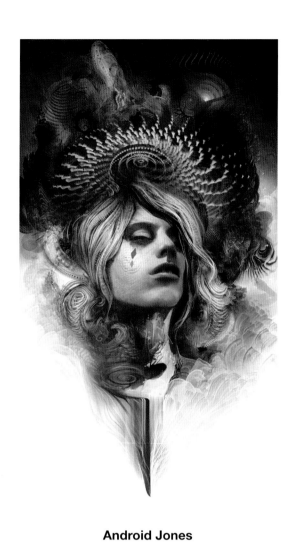

Eric Velhagen
Title: Alien Invader *Size:* 16"x20" *Medium:* Oil

Android Jones
Client: Breanna Levine *Title:* Divine Levine *Medium:* Corel Painter

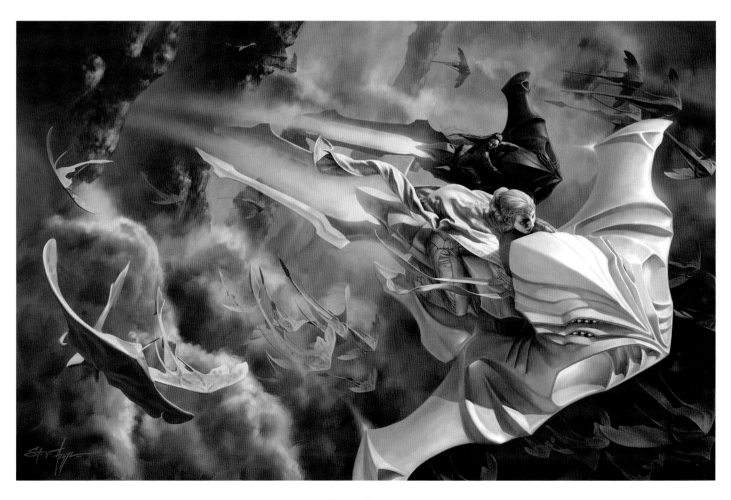

Steve Argyle
Art Director: Illustration Master Class *Title:* Getaway *Medium:* Digital

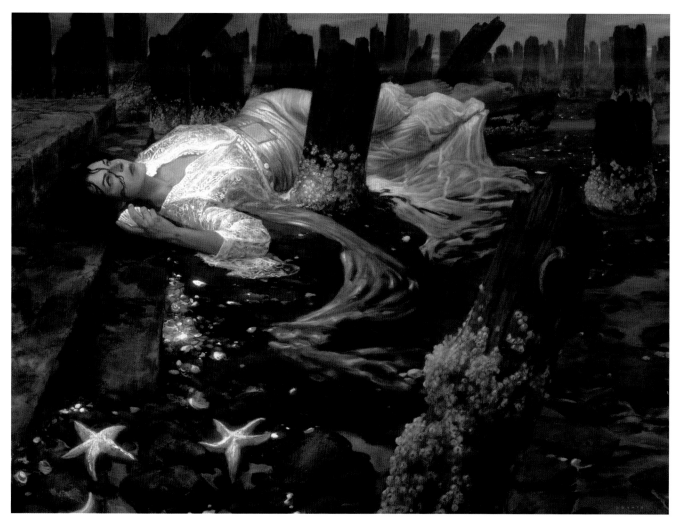

Donato Giancola
Client: Richard J. Demato Gallery *Title:* Waiting *Size:* 48"x36" *Medium:* Oil on panel

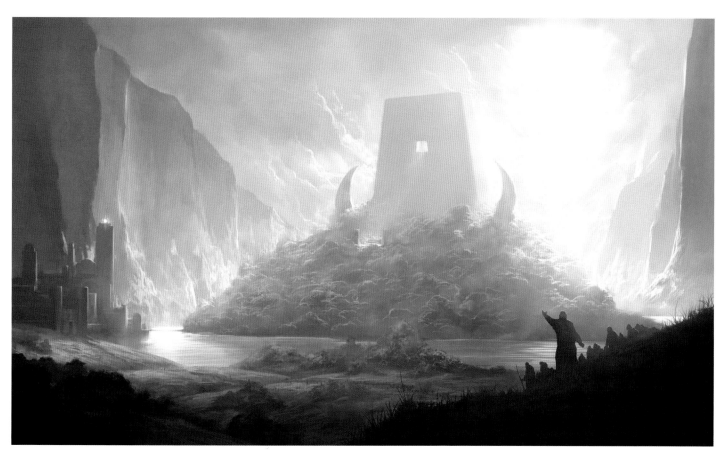

Noah Bradley
Title: The End of Sorrow *Size:* 20"x12" *Medium:* Digital

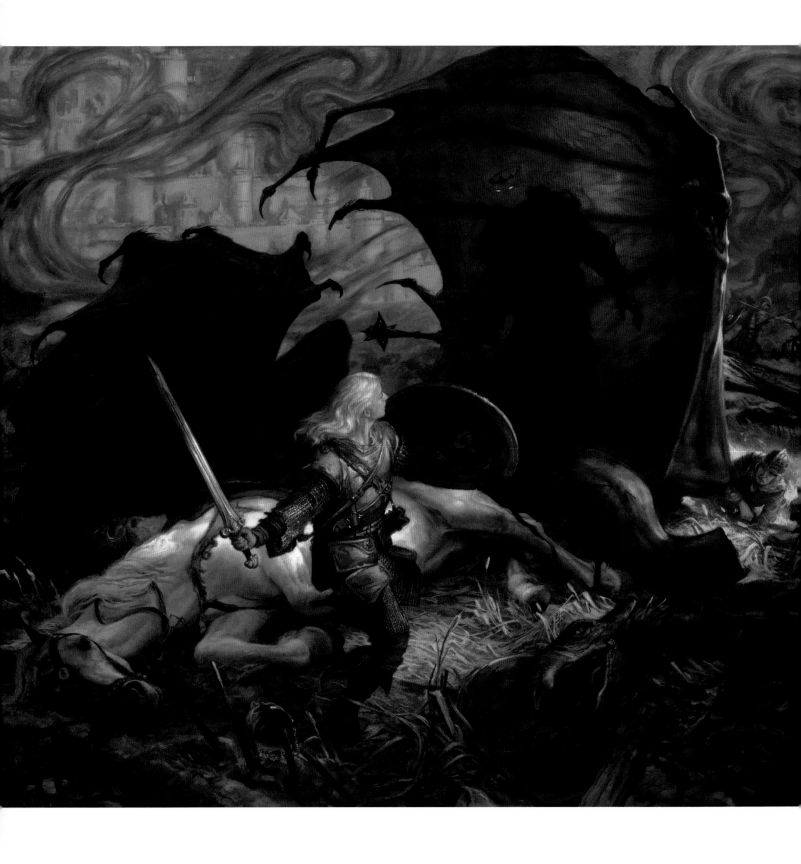

Donato Giancola

Client: Greg Obaugh *Title:* Eowyn and the Lord of the Nazgûl *Size:* 39"x34" *Medium:* Oil on panel

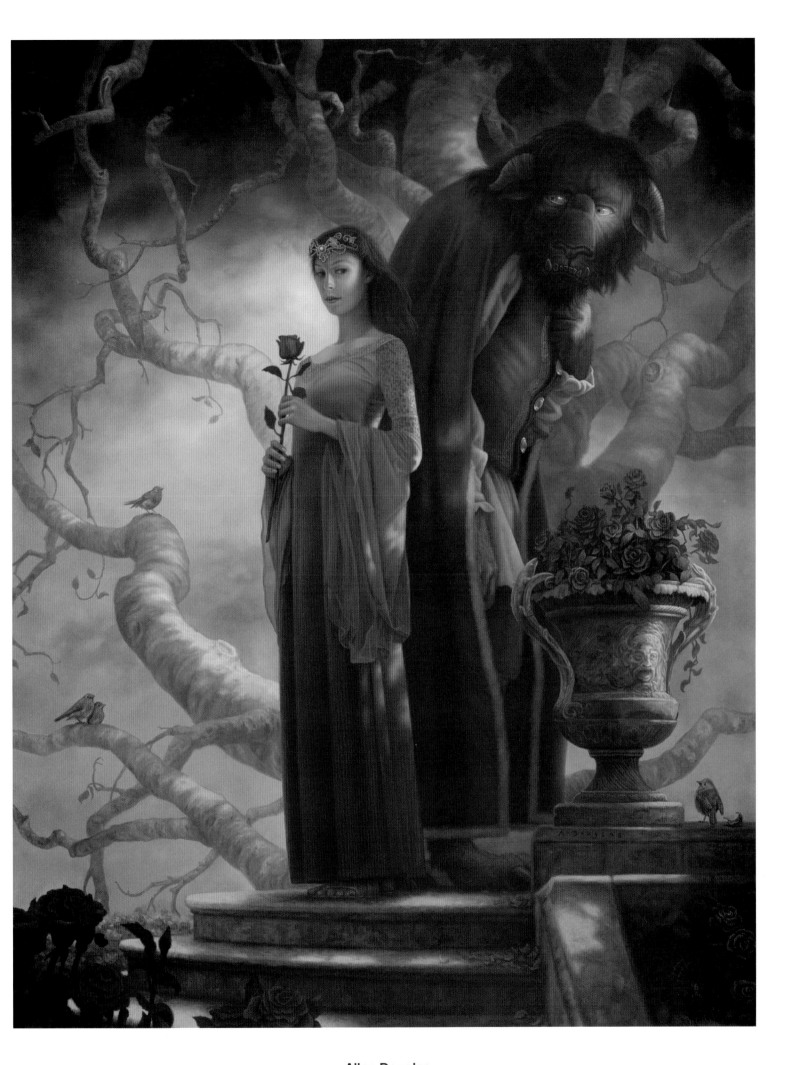

Allen Douglas

Title: Beauty and the Beast *Size:* 24"x30" *Medium:* Oil on panel

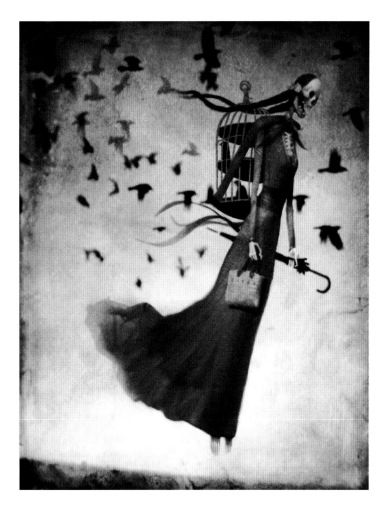

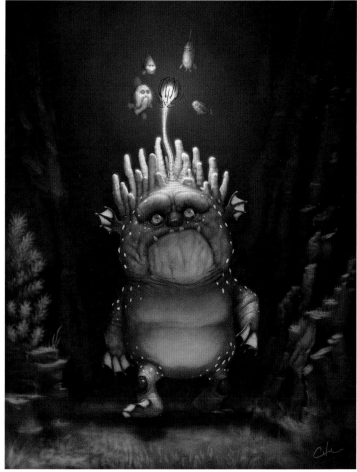

Dave Laub
Title: The Bird Lady *Size:* 8"x10" *Medium:* Digital

Bobby Chiu
Client: Imaginism Studios *Title:* Guiding Light *Size:* 11"x14" *Medium:* Digital

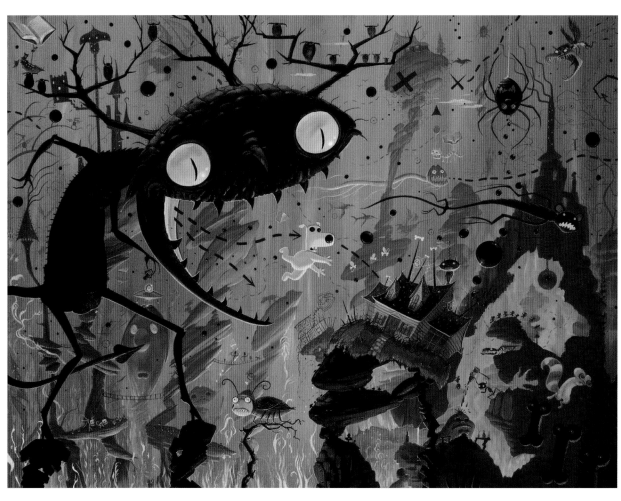

Joe Vaux
Title: Homage *Size:* 4'x3' *Medium:* Acrylic on wood panel

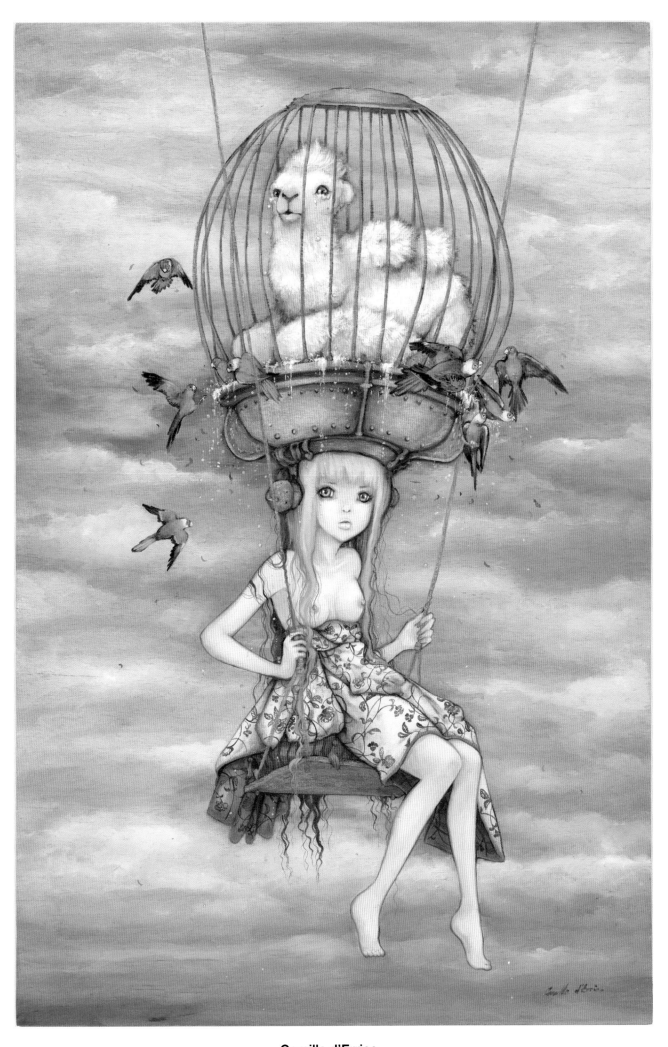

Camilla d'Errico

Title: Weeping Camel *Size:* 21"x30" *Medium:* Oil on wood

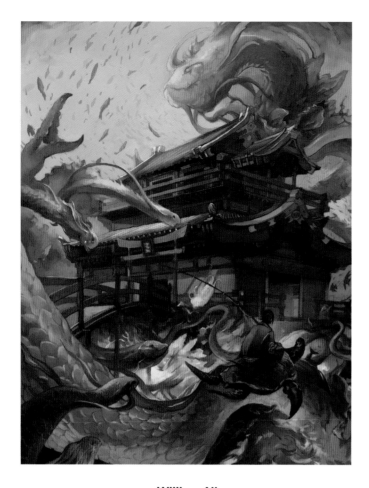

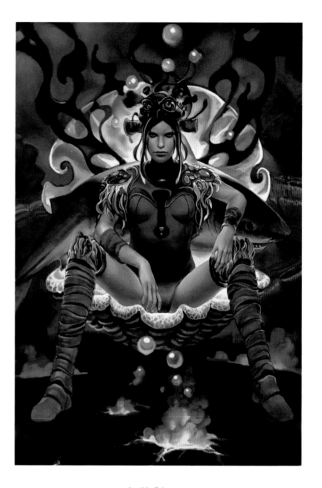

William Niu

Art Director: Daniel Krall *Title:* Ryu Gu Jo *Size:* 8.5"x11" *Medium:* Digital

Jeff Chang

Title: Discontent of the Drowned *Medium:* Digital

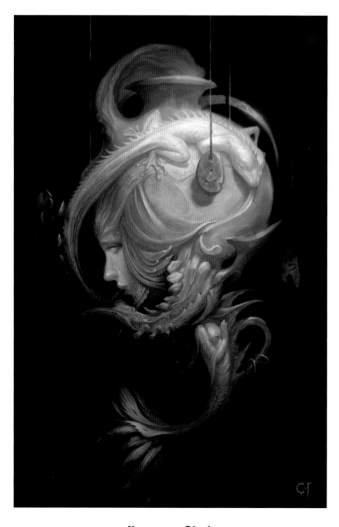

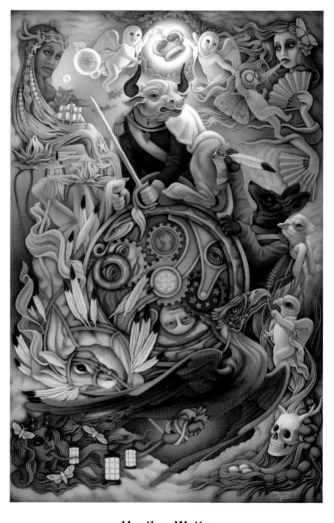

Jiansong Chain

Title: The Illusion *Size:* 3508x5315pix *Medium:* Digital

Heather Watts

Title: Wheel of Fortune *Size:* 12"x18" *Medium:* Acrylic on panel

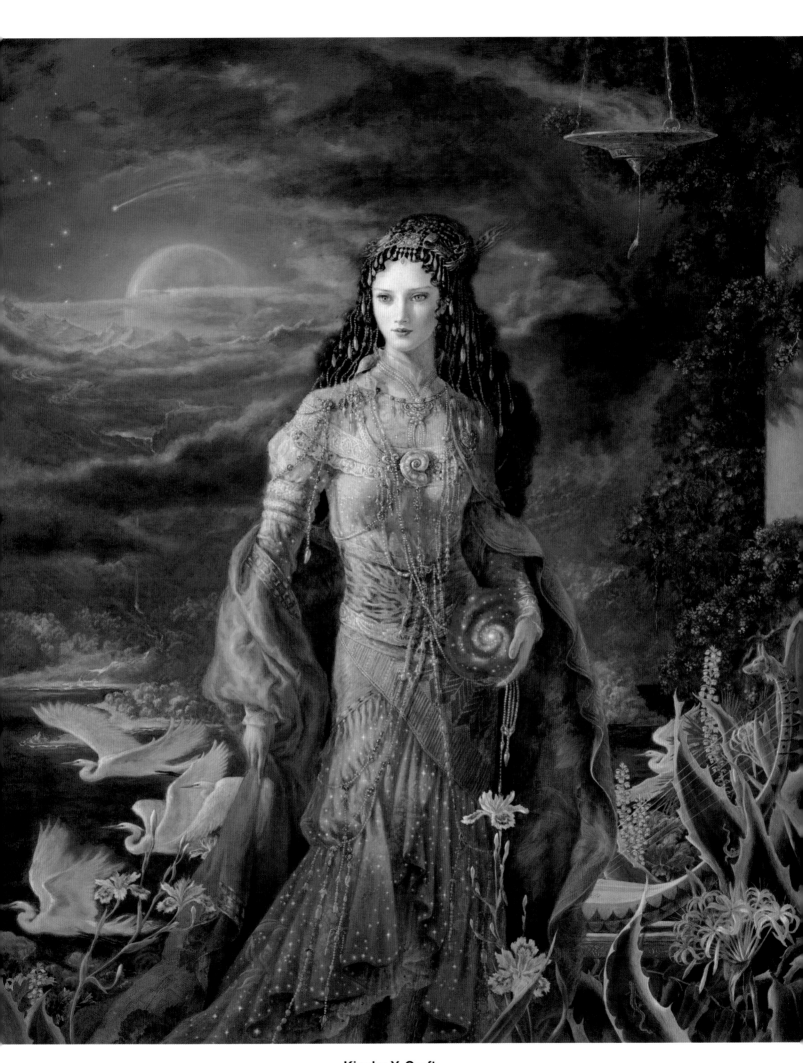

Kinuko Y. Craft
Title: Isis, Goddess of the Universe *Size:* 23.5"x27" *Medium:* Oil on gesso board

Peter Mohrbacher
Title: City On a Hill *Medium:* Photoshop

Christina Hess
Title: Queen Cat *Size:* 9"x13" *Medium:* Digital

McLean Kendree
Client: www.mcleanart.com *Title:* Parade *Medium:* Digital

Matt Cavotta
Client: Paul Lizotte *Title:* Voyager's Menagerie *Size:* 13"x18" *Medium:* Acrylic

Kristina Carroll

Client: Richard Saja *Title:* Elevation *Size:* 20"x24" *Medium:* Oil on panel

Joe Vaux
Title: Citizens of Mongo Beware *Size:* 16"x20" *Medium:* Acrylic on wood panel

Bill Carman

Title: One, Two, or Three *Size:* 8"x10" *Medium:* Acrylic

Solongo Monkhooroi
Title: The Goddess of Death *Size:* 21"x16" *Medium:* Gouache

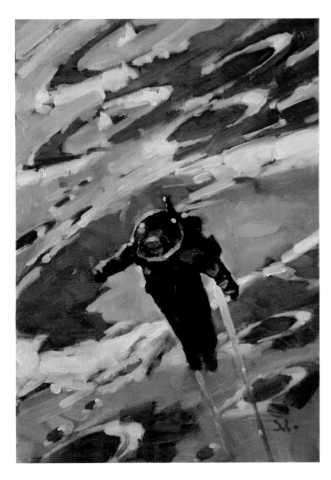

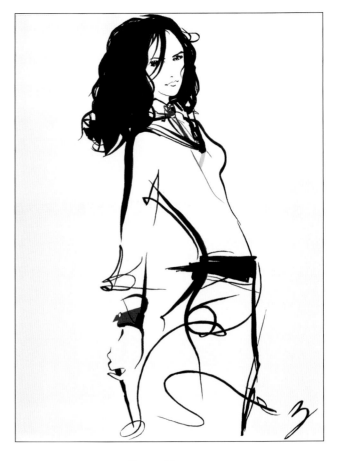

Gregory Manchess
Client: Microvisions *Title:* Touchdown *Size:* 5"x7" *Medium:* Oil on board

Peter Breese
Title: Oh, Are You Doing Magic? Let's See Then
Size: 22"x30" *Medium:* Ink/gouache

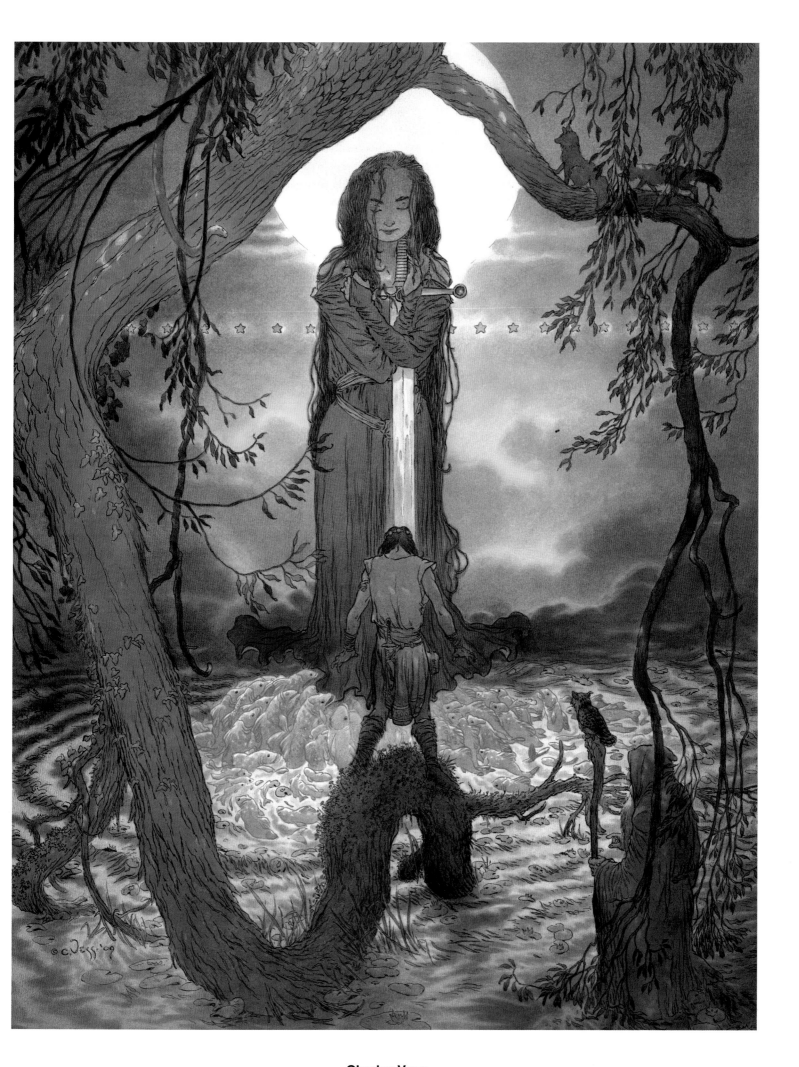

Charles Vess

Title: A Once and Future King *Size:* 22"x28" *Medium:* Colored inks

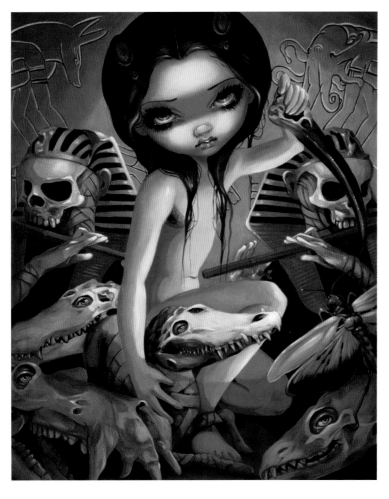

Jasmine Becket-Griffith
Title: Priestess of Nyarlathotep *Size:* 16"x20" *Medium:* Acrylic on panel

Laura Diehl
Title: Golden Fish *Size:* 12"x18" *Medium:* Digital

Charles Vess
Client: Jacqueline Le Frak *Title:* A Woodland Tryst
Size: 22"x28" *Medium:* Colored inks

Keita Morimoto
Title: Maze II *Size:* 2'x3' *Medium:* Oil

Ryan Pancoast
Title: The Victor *Size:* 24"x30" *Medium:* Oil on canvas

Lance Richlin

Title: Portrait of Randol Schoenberg *Size:* 48"x52" *Medium:* Oil on canvas

Billy Norrby

Client: CoproGallery *Title:* Epihany *Size:* 32"x50" *Medium:* Oil on canvas

Jaime Zollars

Title: She Who Put Her Faith in Dragons *Size:* 8"x10" *Medium:* Graphite

Matt Dangler
Title: Kult Des Alchemist Spiegels Size: 16"x20" Medium: Oil

Winona Nelson
Title: Jetbike Getaway Size: 15"x24" Medium: Oil

Greg Capullo
Title: The Sentinel Size: 10.5"x15.5" Medium: Digital

J.S. Rossbach
Title: Pallas Size: 31x41cm Medium: Watercolor/digital

Mark Poole
Title: Snow Blind *Size:* 22"x30" *Medium:* Oil/acrylic

Jessica Oyhenart
Title: Wizard of Oz: Dorothy *Medium:* Digital

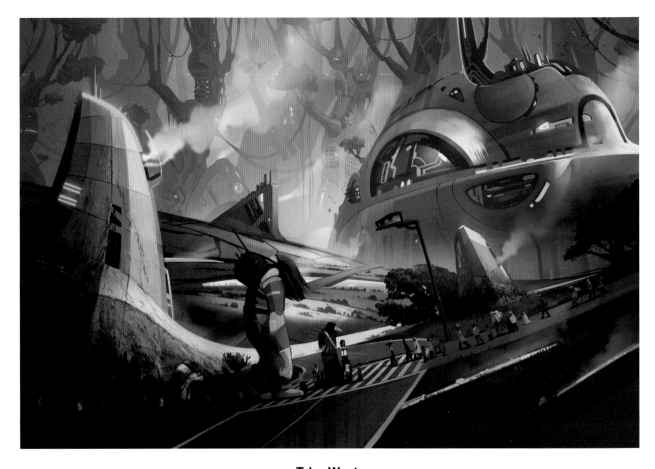

Tyler West
Title: The Colony *Medium:* Photoshop

Shelly Wan

Art Director: Gregory Manchess *Client:* Society of Illustrators *Title:* Matricide *Size:* 16"x20" *Medium:* Digital

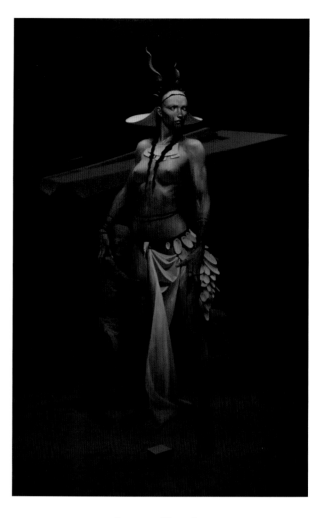

Edward F. Howard
Title: Revealed *Size:* 18"x30" *Medium:* Oil on panel

Jeremy Enecio
Title: Tribal Tech *Medium:* Digital

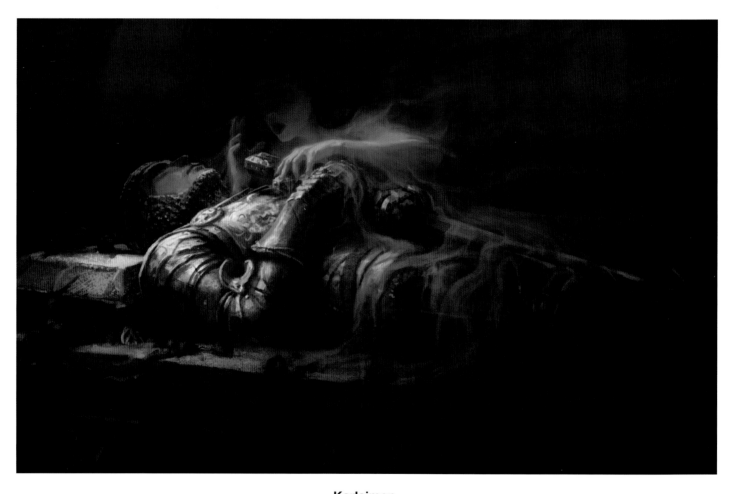

Karlsimon
Title: Sword Thief Medium: Digital

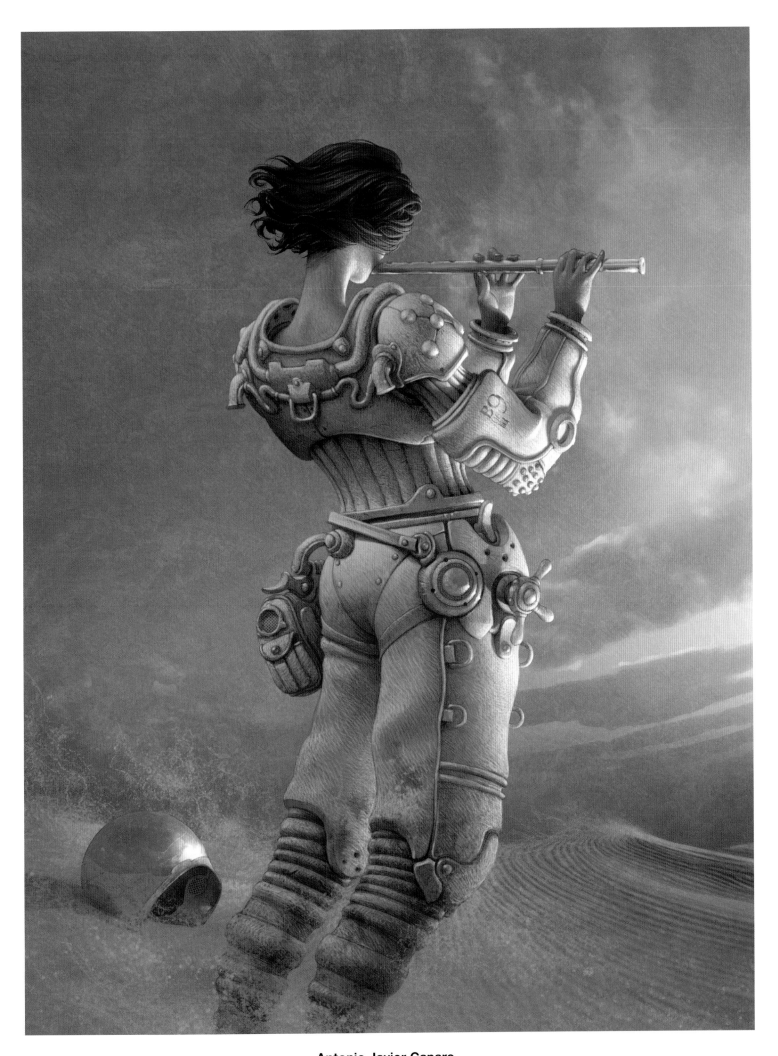

Antonio Javier Caparo

Title: Mars Sonata *Size:* 11.8"x15.7" *Medium:* Digital

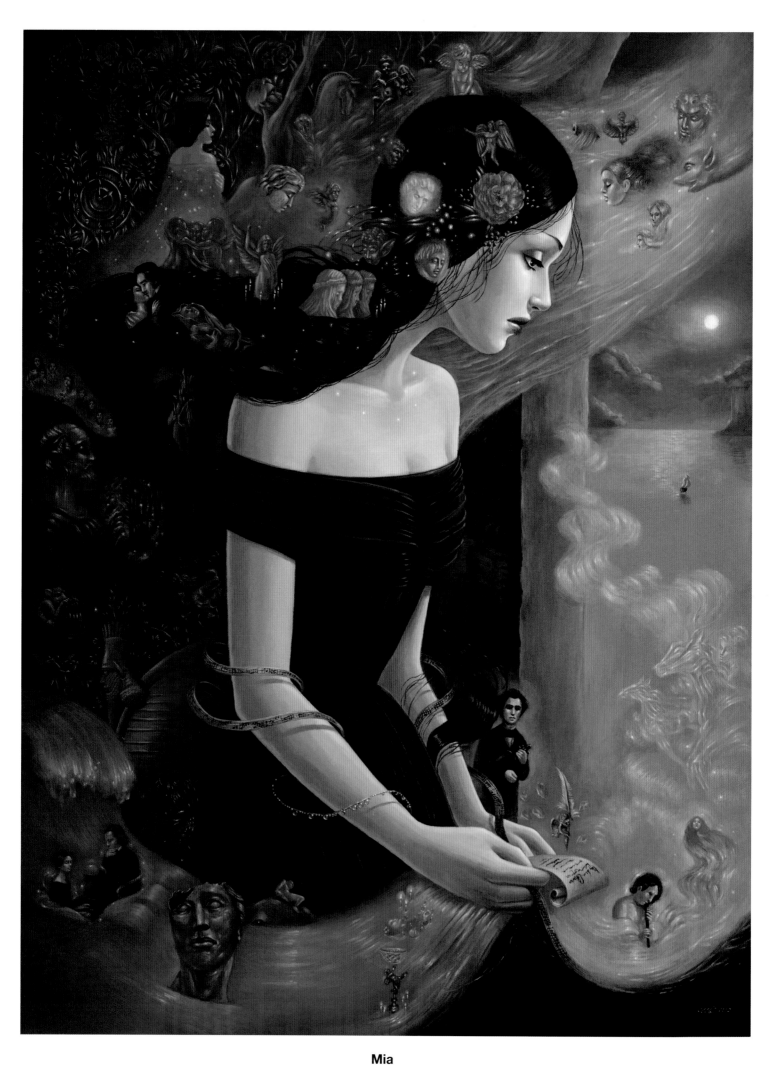

Mia

Client: Corey Helford Gallery & Bristol City Museum *Title:* Two Spirits *Size:* 18"x24" *Medium:* Acrylic on wood

Michael Whelan

Client: Tree's Place Gallery *Title:* Ellie's Dream *Size:* 36"x48" *Medium:* Acrylic on canvas

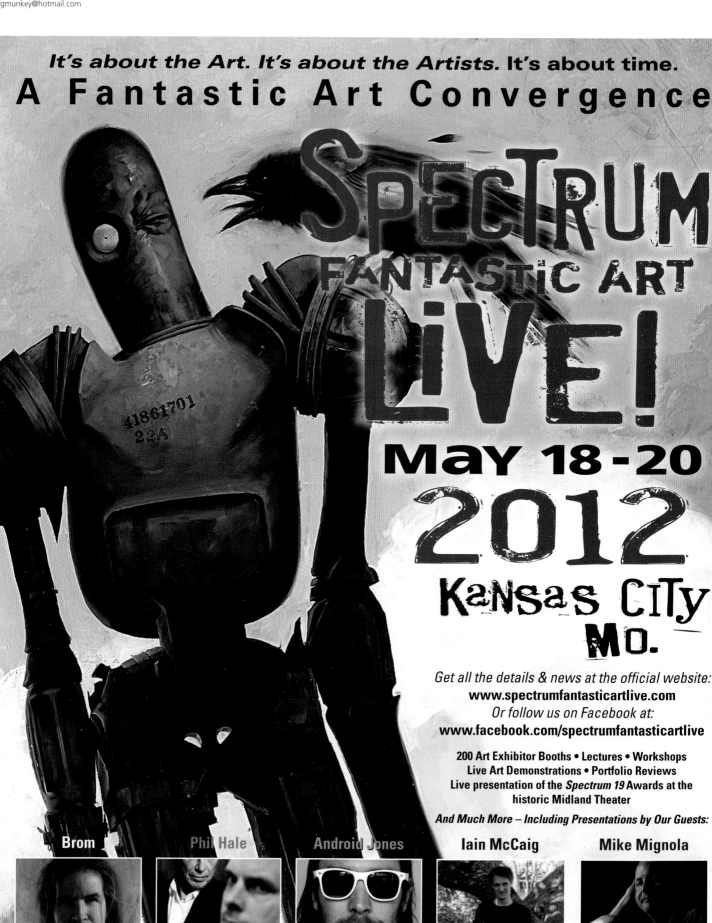

It's about the Art. It's about the Artists. It's about time.

A Fantastic Art Convergence

SPECTRUM FANTASTIC ART LIVE!

MAY 18-20 2012

KANSAS CITY MO.

Get all the details & news at the official website:
www.spectrumfantasticartlive.com
Or follow us on Facebook at:
www.facebook.com/spectrumfantasticartlive

200 Art Exhibitor Booths • Lectures • Workshops
Live Art Demonstrations • Portfolio Reviews
Live presentation of the *Spectrum 19* Awards at the
historic Midland Theater

And Much More – Including Presentations by Our Guests:

Brom **Phil Hale** **Android Jones** **Iain McCaig** **Mike Mignola**

"Crowbot" by & © Jon Foster • www.jonfoster.com